To Marrion+
Flo. Sweet
collectors and friends

Paul Haig

Marla Shelb
Enjoy!

THREADS OF GOLD
CHINESE TEXTILES
MING TO CH'ING

THREADS OF GOLD

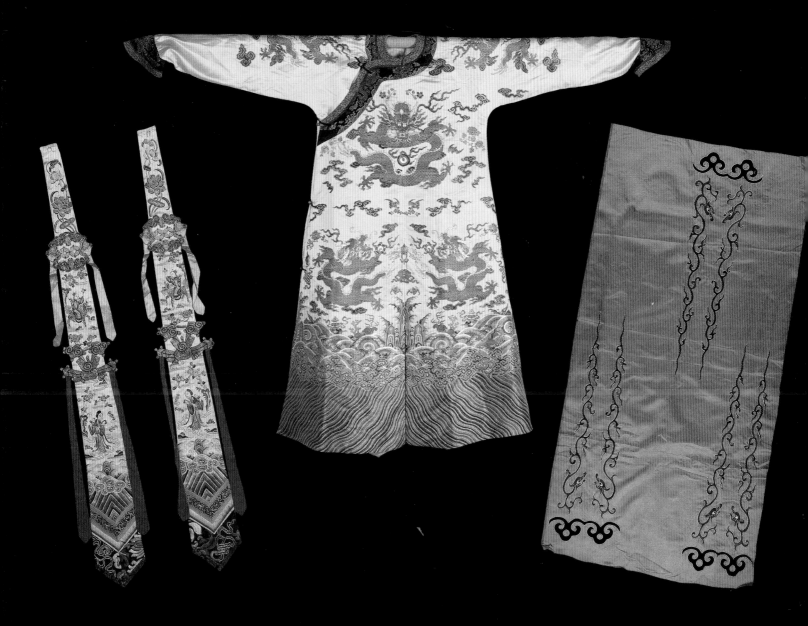

CHINESE TEXTILES
MING TO CH'ING

PAUL HAIG & MARLA SHELTON

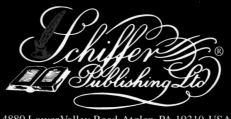

Schiffer Publishing Ltd

4880 Lower Valley Road, Atglen, PA 19310 USA

Other Schiffer Books on Related Subjects
Chinese Country Antiques, Andrea & Lynde McCormick
Old Style/New China: Antique Furniture & Accessories, Andrea
 & Lynde McCormick
Antique Chinese Accessories, Marjorie Yates
Southeast Asian Textiles, Claire & Steven Wilbur
The Ceramics of China: 5000 B.C. to 1900 A.D., Gloria & Rob-
 ert Mascarelli

Library of Congress Cataloging-in-Publication Data:

Haig, Paul.
 Threads of gold : Chinese textiles, Ming to Ch'ing / Paul
Haig & Marla Shelton.
 p. cm.
 ISBN 0-7643-2538-8 (hardcover)
 1. Textile fabrics—China—History—Ming-Qing dynasties,
1368-1912.
 I. Shelton, Marla. II. Title.
 NK8883.A1H35 2006
 677.00951'09—dc22

 2006015459

Designed by John P. Cheek
Cover design by Bruce Waters
Type set in New Baskerville

ISBN: 0-7643-2538-8
Printed in China
1 2 3 4

Published by Schiffer Publishing Ltd.
4880 Lower Valley Road
Atglen, PA 19310
Phone: (610) 593-1777; Fax: (610) 593-2002
E-mail: Info@schifferbooks.com

For the largest selection of fine reference books on
this and related subjects, please visit our web site at
www.schifferbooks.com
We are always looking for people to write books on
new and related subjects. If you have an idea for a
book please contact us at the above address.

This book may be purchased from the publisher.
Include $3.95 for shipping.
Please try your bookstore first.
You may write for a free catalog.

In Europe, Schiffer books are distributed by
Bushwood Books
6 Marksbury Ave.
Kew Gardens
Surrey TW9 4JF England
Phone: 44 (0) 20 8392-8585;
Fax: 44 (0) 20 8392-9876
E-mail: info@bushwoodbooks.co.uk
Website: www.bushwoodbooks.co.uk
Free postage in the U.K., Europe; air mail at cost.

Dedications

I dedicate this book to my wife, Diane, and daughter, Eileen, who are always patient in my many efforts to acquire, conserve, and market new textiles.

—Paul Haig

I dedicate this book to the memory of my parents, Larry and Martha Shelton who raised their daughter to be caring and observant, and to my many, long-suffering friends who supported me through "the book".

—Marla Shelton

Prologue
Reasons for Writing This Book

Being in the antique business we have become aware of the increased interest for knowledge concerning Chinese textiles, and we hope this book may serve as a guide to the evaluation of those textiles available to collectors and anyone interested in this beautiful art form.

Writing this book has been a great experience. We welcome any and all comments on all areas of the book, hoping that in the process of receiving feedback we can help bring this area of collecting to a more understandable level. We hope this will give further clarity to the large field of collectible Chinese textiles.

Acknowledgments

I would like to acknowledge and thank my staff at our office who have spent many hours printing and organizing the information to assist Marla and myself. I would also like to thank the helpful staff at Schiffer Publishing Ltd. who have assisted us through all of our trials and tribulations with great patience, and also Jiu-Hwa-Lo Upshur, Vince Comer, and David Hugus for patiently answering a lot of questions from left-field.
—Paul Haig

I would like to thank the dedicated staff of Haig's of Rochester for all of their support and hard work and for their understanding each time I requested "just one more measurement". I would also like to thank Diane Haig for her understanding of all the time Paul and I spent together, and most of all, to Paul for getting me "on-board" for this project.
—Marla Shelton

Contents

Introduction

The Chinese have produced textiles for thousands of years, although most of the ones we find today are from the last 200 to 300 years. Many are in very good to excellent condition while others have not led as protected a life. Others, still, have found new lives by being remodeled into Western style clothing or salvaged fragments of them have been made into decorative panels.

The Chinese textile market has changed dramatically today through increased awareness brought on by factors such as the internet, the currently emerging Chinese economy, and a rising number of Asian collectors in China. The Asians value their textiles as more than just garments and decorative pieces and we are able to find collectible pieces in the marketplace that well exceed a hundred years old. Adaptive reuse, either by the Chinese or other end-users, has extended the amount of surviving material over the years. For example, Tibetan and Japanese monasteries kept and reused the "tribute" pieces they were given.

During the final years of the Ch'ing Dynasty, and the turmoil that followed its fall, textiles were looted from the imperial warehouses, and also, Westerners and wealthy Chinese who were able to leave China for western ports brought textiles with them. During the 1920s and 30s major collections were purchased in China and brought to the west, often being broken up and resold.

As in any growing market for collectibles, many modern reproductions of varying quality have come to light. Most are easily distinguished by their crude work and improper imagery, but there have been some that were good enough to be featured in major auction catalogs. Some of these were discovered before they were sold and subsequently pulled, and others have been sold as genuine. As the demand for these textiles increase, the number and quality of the reproductions increase.

This book is organized by the types of textiles most commonly found and collected today. Its purpose is to give general evaluations of Chinese textiles available on today's market and help the reader recognize what gives value to similar pieces. We have also set up a website www.antiquechinesetextiles.com to create an interactive forum where readers may share and offer their input.

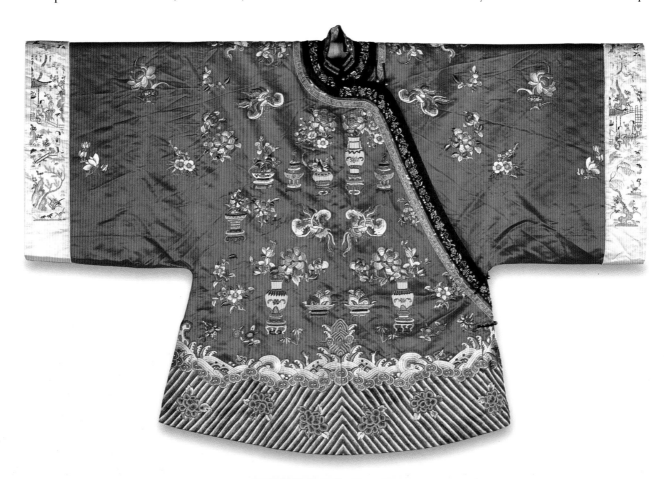

Chapter 1
Appraisals of Textiles

Appraisals of textiles can vary greatly in their accuracy and values assigned to the pieces. One reason for this is that there are different types of appraisals. A verbal appraisal can run from no charge into the low hundreds of dollars depending on the credentials, experience, and reputation of the appraiser. An informal appraisal is generally a short written statement with a brief description and value. A formal appraisal is more involved and usually includes research that often cites related pieces from museums or renowned published collections and may include auction price comparisons of similar pieces. Many formal appraisals include a set of photos both to identify the item and define the condition. Formal appraisals may be as short as one page or as lengthy as a many page "study." Regardless of the length of the document, written appraisals are only as good as the experience and reputation of the appraiser and can vary greatly over time based on market trends. Most appraisal forms have standard disclaimers that protect the appraiser against any legal actions that can be taken against the appraiser or business based on his or her evaluations.

The values being used throughout this book are replacement and insurance values and the reader should be aware that these are not resale values. Replacement or insurance appraisal values act as a strong and immediate direct replacement value for a lost or damaged item by an "exact" duplicate item. Retail replacement value is less than insurance value as it refers to replacement by a similar or compariable item, not an exact replacement of a specific piece. Many people after reading a valuation book are disappointed to find that an item they think is very valuable will realize only one third or one quarter of the stated value when they try to sell or otherwise liquidate it. When selling an item you may expect to receive approximately 75 to 80 percent of the low end of an auction estimate range of a group of similar pieces.

Show Me Another One!

When you're dealing with antiques, in this case antique textiles, you often hear "I've never seen another one like it." This uniqueness is a source of concern when establishing value, since comparison gives us an important aspect to consider. With many of these textiles it is hard to find comparisons to help establish like values, as many are one of a kind due to their being handmade in small workshops or even at home. If there were comparable pieces they may have been destroyed or lost over the years, leaving few examples, and even those surviving pieces are often damaged, making a comparison difficult at best. These are some of the aspects that create the value.

Evaluating Textiles

We are often approached by people who say, "We have a dragon robe. It's blue with dragons done in gold thread. How much is it worth?" We in turn, give them the analogy of, "I have a vehicle. It's blue and has four wheels. How much is it worth?" There is a big difference between a new blue Lamborghini and a ten-year-old blue rusted out VW micro bus with a blown engine!

We have devised an evaluation system over the years to help us determine values based on color or hue, condition, quality, and rarity. This helps us determine what we should pay for a piece and what it can be sold for, giving everyone the best value. The prices quoted throughout the book are considered the replacement appraisal value.

All of the above stated factors and any irregularities, or combination of these, will affect the value of a piece. Size is not necessarily a consideration in assessing value. Children's pieces can often bring as much or more as adult pieces due to their rarity, and a twelve-inch rank badge or mandarin square may (and quite often does) have more value than a large temple embroidery.

Hue & Color

Hue or color is usually the first thing that is noticed when evaluating textiles. The best pieces have all their original colors, whether in the background, the embroidery, or painting. Any variation from the original colors through staining or fading will effect the grading. Aniline dyes were first introduce in the 1860s, and from that time forward the colors became brighter and more light fast, but still subject to spreading or "running" when they came into contact with liquids. Most noticeable are the brilliant pinks and purples. The natural dyes were often able to achieve the same brilliance but were very susceptible to light damage. Another situation concerns black and many greens and browns. The pre-aniline blacks were achieved by using an iron mordant, and browns and greens utilized

copper salts to set the colors. With time, the metal salts have disintegrated the silk fibers causing major loss of both background fabric and embroidery threads. This will be discussed in the section on condition.

Color can be an indicator of the rank the of the person who wore or used the piece, especially robes. Imperial yellow, of course, was reserved for the emperor, empress, and empress dowager, whether it is in robes or items for their personal use, such as kang (cushion) covers and bed and wall hangings. Imperial yellow items were also gifted through the emperor as tribute to a person or groups for special allegiance or service to the court. Members of the imperial family wore variations of yellow, brown, peach, burgundy, red, and sometimes orange. Orange and a more vivid reddish orange were also used for wedding robes, festival robes, and idols' robes.

Condition

Condition is another major factor in determining a textile's value. Unused or little used pieces are the most sought after and usually bring the highest prices. They are, of course, the most difficult to locate. They must be extremely close to the original color, have original drape, no alterations, and no signs of wear. There should be no thread or fabric loss of any kind, or any stains or dry rot. Textiles in this condition are classified as "Excellent" and have the highest value.

Somewhat easier to find are those classified as "Very Good." These may show a slight amount of wear, but have been generally very well cared for. They would require very little, if any, restoration, the tacking of a few loose threads or the like. This group may also include pieces that have been resized, but without loss of material or color so that they may be returned to their original shape and size. These may have very slight color variations from the original. This level falls into the grade of "Gently worn with no flaws."

Those that fall into the "Good" condition group are probably most commonly found in collections. They show average wear for the age of the piece and may include some staining, foxing, and/or fading. They may also need moderate stabilization and tacking of loose threads. Alterations and minor material loss are allowable but should be in areas that do not detract from the over-all appearance. Also included in this group are past repairs and restorations that are in keeping with the integrity of the textile and are not obvious. These pieces can usually be stabilized and/or conserved without too much difficulty. This condition may be described as "slight wear with any flaws noted" or "notable flaws, repairable or wearable as is."

"Poor" condition is another fairly large group and consists of pieces showing excessive wear, major alteration, and/or material loss. It may also include some pieces with dry rot, light use of adhesives, improper past restorations, and some damage from incorrect cleaning. These pieces require major restoration and conservation and unless extremely unusual or of particular sentimental value, may not warrant the additional expense. An item of this grade may have "major flaws, but good design or fabric."

The last category is "Very Poor" and generally includes those pieces that are worn or damaged beyond repair. These may exhibit excessive use of adhesives, major dry rot, alterations, and loss of material, excessive staining, and irreversible damage from improper cleaning. They are most likely not worth restoring.

As stated in the section on color there can be thread loss in both the background fabric and embroidery threads of the older pieces due to the use of metal salts to "set" the natural dyes. These salts were also used to vary the colors of the dyestuffs. As explained in *The Textile Conservator's Manual* by Sheila Landi, the use of madder as the dye: with an alum mordant it will give a rust red; with tin it will give orange; with chrome it will become maroon; copper creates yellow to brown; and iron will make it brown and black. Unfortunately, the metals will degrade the silks overtime, and as a result many earlier pieces have sections of affected colors completely missing. This is helpful in dating a piece, but disappointing in the loss. These pieces must be handled very carefully and as little as possible because agitation or abrasion can cause additional loss.

Quality

Quality is the third element we look at in evaluating textiles. The classification of "Excellent" includes those pieces with extremely fine weaving, and may include intricately woven details such as in the k'o-ssu, or slit woven tapestry. It may also include multiple techniques such as k'o-ssu with painting and/or embroidery. The pieces with embroidery are more valuable than those with painted details, and the premiere pieces generally would incorporate only minimal painting. The very fine pieces may also have intricately crafted linings and matching cuffs and collars.

The use of many integrated techniques and secondary materials such as cording, wrapped metallic threads, integrated peacock feathers and various embroidery techniques as well as the fineness of threads, can also be a determining factor.

A "Very Good" classification would include consistency in design, good proportion, and balance. The piece should be aligned properly and constructed such that the patterns meet correctly at the seams. It should be woven or embroidered consistently, so that the piece appears continuous in design. Dye lots and colors should be uniform and embroidered designs planned and executed with skill.

"Good" is a classification for pieces that are acceptable, but lack fine detail work and are not as carefully planned or executed. These may include dragon robe sections that were woven at different times or places so the design elements do not line up quite correctly, embroidery by more than one person that shows a variation of skill levels, and pieces that are not consistent in color and dye lot. Various workshops produced pieces that used silk of different qualities so a single piece may have varying qualities of materials in it.

A "Poor" grade is given to textiles that do not match in color or design within the piece. The lack of proper support of heavier embroideries causes the background to break down prematurely, so pieces, especially hangings, will sag over time.

There are times when pieces can be dated at a glance, due to the erratic nature of the weaving and design. During the last years of the Ch'ing dynasty, many pieces of lower quality were more common, due to less quality control and mass-production. There were many variations of styles and quality control did not keep up with the mass production of textiles. Many pieces were made for a larger market of people who could now afford to present themselves in a deceptively pretentious manner, rather than through court merit. Like our current knock-offs of fine designer lines, the Chinese at the end of the Ch'ing dynasty used regulated patterns made in many small workshops, to buy their way into a higher level of court and/or social status. In effect, rank and position could become merely a financial option for an ostentatious show of wealth. Also, many areas broke off into small governmental enclaves of warlords and regional factions that were striving to individually represent themselves through their attire and actions, becoming increasingly disconnected from government controls. One aspect of these variations will be covered under Chapter 3, where we provide a comparison of one level of rank badge, and its many styles and qualities.

Rarity

Rarity is definitely a major factor in assessing value. As previously stated, values are based on comparisons in the market. The value of a more common item or form is not as great as for an item or form that has been rarely seen. An example of this would be the imperial idols robe in Chapter 4, and at the other end of the price spectrum is the small embroidered panel in Chapter 8. Both of these pieces are considered rare, but the small piece has very little importance or desirability compared to the robe.

A small panel of red silk embroidered with silk and metallic gold threads and fine silver metallic leather inserts. Early twentieth century. 9.75" x 10.5. $275.

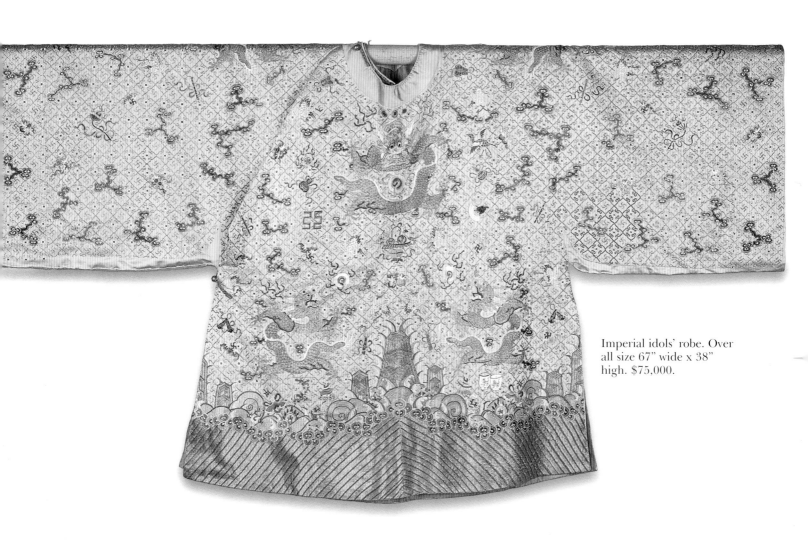

Imperial idols' robe. Overall size 67" wide x 38" high. $75,000.

The category of "very rare" denotes that the object is one of a kind, very rarely obtainable, or an example in stellar condition or quality for its age or type. The second category, "rare," denotes an item that may be featured in a few major collections but is of an age, quality, or style seldom seen. The third category, "somewhat rare," would be an item seen as a foundation or building block element of most major collections. The fourth, "common," would denote an object that would be found in most beginning or intermediate collections. The fifth level, "very common," would connote items that are easily found and available in a moderate price range.

Evaluation System for Textiles

This evaluation scale will be used for each piece in the book, so that the reader may understand how we arrived at the stated values. The categories are color or hue, "H"; condition, "C"; quality, "Q"; and rarity, "R." Each category will be assigned a number corresponding to the chart. An example of this would be: H2, C3, Q3, R3 meaning, hue (color) is "very good", condition is "good", quality is "good", and rarity is "somewhat rare.

Color or Hue—"H"

H1—Excellent: bright, original colors throughout; no fading

H2—Very Good: slight, all-over fading; colors still even

H3—Good: all-over fading and some uneven areas

H4—Poor: faded colors or very uneven coloration

H5—Very Poor: excessive fading, little or almost no color left

Condition—"C"

C1—Excellent: like new, little or no usage

C2—Very Good: slight wear, needing little or no restoration

C3—Good: normal wear for the age of the piece; may have minor alterations; minor stains or foxing; minor material loss; may need some restoration

C4—Poor: excessive wear for age; visible alterations and/or material loss; light use of adhesives; some dry rot; major staining; major material loss; some damage from incorrect cleaning; may need substantial restoration

C5—Very Poor: damaged or worn beyond repair; excessive stains and/or alterations; major dry rot; major material loss; excessive use of adhesives; major damage from incorrect cleaning; probably not restorable.

Quality—"Q"

Q1—Excellent: extremely fine weaving, embroidery, and workmanship

Q2—Very Good: fine weaving, embroidery, and workmanship

Q3—Good: average weaving, embroidery, and workmanship

Q4—Poor: loosely woven; large stitches in either embroidery and/or construction

Q5—Very Poor: very loose weaving; large embroidery stitches; structurally does not hold together under its own weight.

Rarity—"R"

R1—Very Rare: rarely obtainable and no known similar pieces

R2—Rare: occasional availability; occasional sources

R3—Somewhat Rare: limited availability; limited sources

R4—Common: easily availability; limited sources

R5—Very Common: easily available through multiple sources.

Chapter 2
Official Robes & Other Court Dress

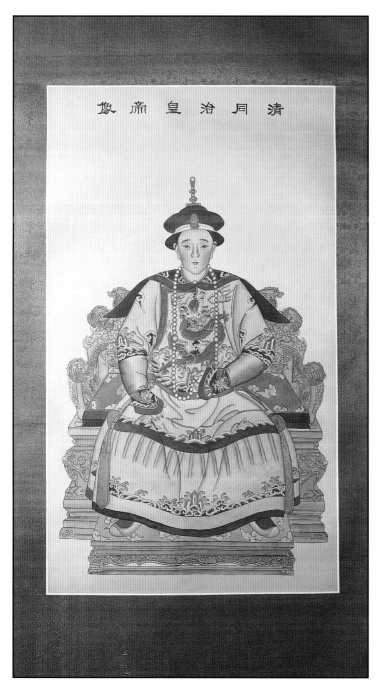 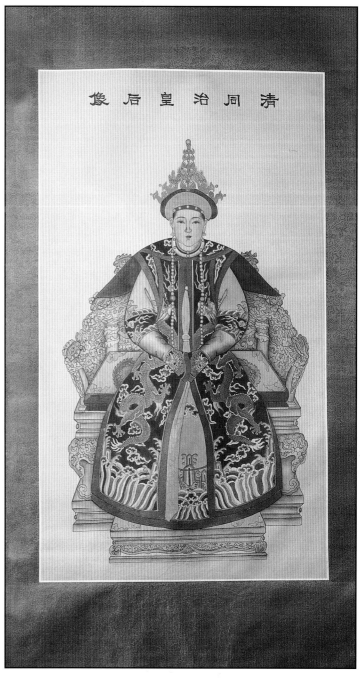

A pair of twentieth century export scrolls in the style of ancestor portrait of the
Emperor T'ung-chih (reign 1862-1874) and his empress. 32.75" x 19" each

Ch'ao-Fu:
First Level Robes of State

This is the most formal of all the official robes. It was worn for important court occasions and imperial sacrifices usually associated with the solstices. The complete attire included not only the robe, but an accompanying hat, collar, surcoats, belt, and necklace. Full ch'ao-fu are much rarer than other official robes for two reasons. First, as it was the most formal of robes it was often used as the burial robe. Second not many full robes were produced because a ch'ao-fu skirt could be worn under the other required overcoat and it would appear as a full outfit. Ch'ao-fu ground color was black except for the emperor's, which was yellow. This pre-aniline black background often appeared either blue-black or brown-black depending on the dyes and mordants. With the advent of aniline dyes it became a true black.

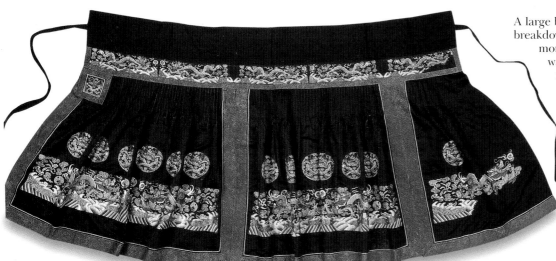

A large blue-black ch'ao-fu skirt with extensive breakdown in the background due to the iron mordant used to set the dyes. This piece was made to be worn under a p'u-fu to represent a complete ch'ao-fu robe and is a good example of the use of abbreviated costume to conserve money. When worn with an official robe, or even a simple robe, and under a p'u-fu it would appear the wearer was fully robed in the most formal court attire. (It has been conserved with acid free backing.) Circa 1850. Size 114" x 39". $1400 in its present condition. If perfect, $2100. H2,C3,Q3,R3

A pair of uncut brocade-woven ch'ao-fu skirt panels in black and gold. Circa 1880. 47" x 60". $450. H1,C1,Q3,R3

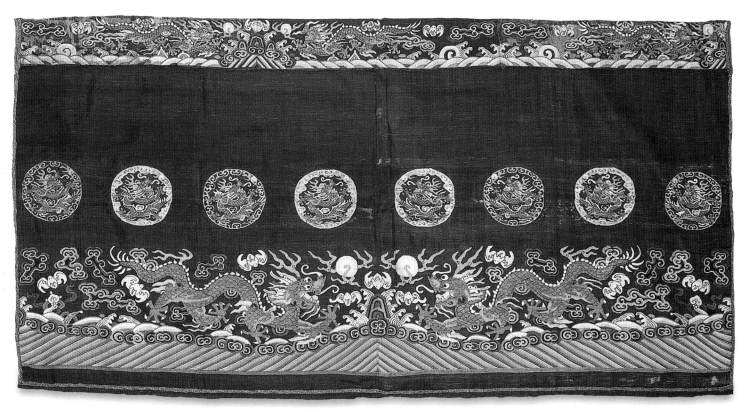

A good k'o-ssu woven ch'ao-fu skirt panel. There is some damage in the form of discoloration and breakdown. Circa 1880. 46" x 23". $275. If perfect, $475. H2,C3,Q3,R4

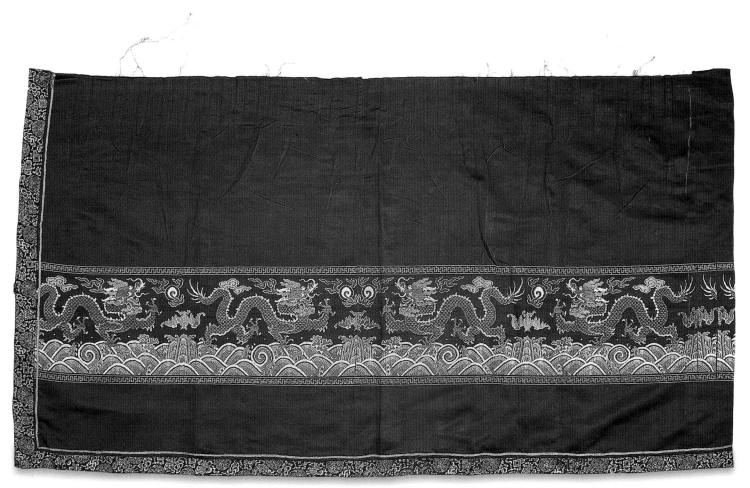

This is an incomplete section of a very finely woven late brocade ch'ao-fu skirt panel. Circa 1900. 23.5" x 47". $275. H1,C1,Q2,R3

A ch'ao-pao, which is a variation of a ch'ao-fu, has the same basic style as the more common ch'i-fu or dragon robe, but the top section is designed as a lobed yoke with a dragon or dragons circling it and the lower skirt section has a simpler band with dragons.

Shown are two interesting examples of ch'ao-pao reuses. One yoke section was used as a table cover, which closely re-sembles an example in plate five of Schuyler Camman's book *Chinese Dragon Robes*. Another uncut robe was put into adaptive reuse as a Japanese priest's robe by cutting it into a prescribed format. One can see that, if the cut sections are rearranged, it is more recognizable as coming from an uncut Chinese ch'ao-pao. It likely served as a piece of trib-ute cloth and was presented to a Japanese temple or priest.

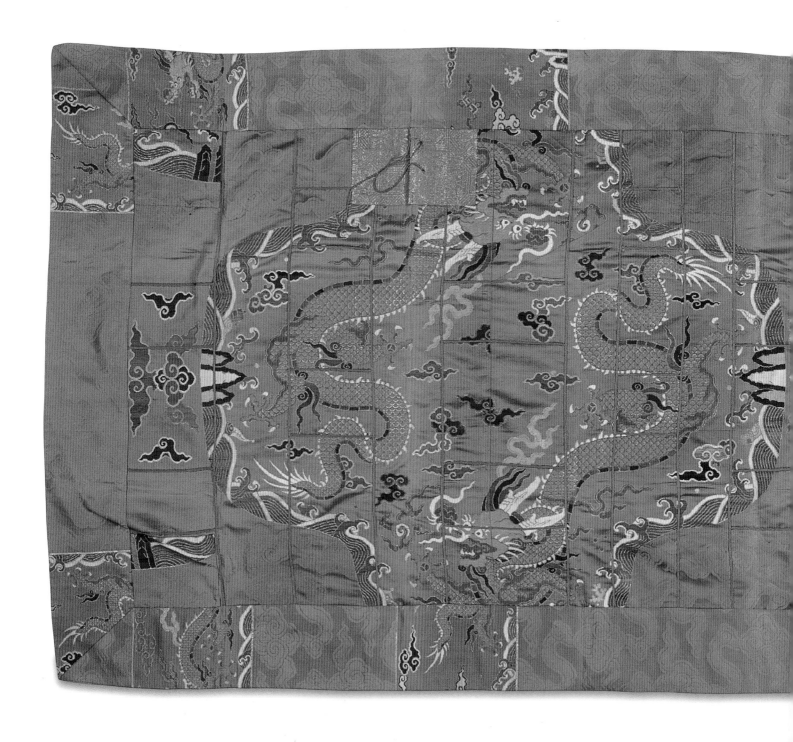

A table cover made from the yoke and upper section of a formal ch'ao-pao robe. The imagery reflects a Ming era design, but it was likely made in the mid-nineteenth century. The condition of the blue-black background suggests a date previous to 1860 as it has a good amount of degradation. 41" x 43". $900 as is. If perfect, $2000.
H2,C2,Q3,R3

A Japanese priest's kesa made from yardage for a Chinese ch'ao-pao. This followed roughly the same form as the Kashaya on page 117. It shows exquisite workmanship and is an unusual application. Circa first half of the nineteenth century. 80" x 46". $6000.
H1,C1,Q2,R2

Ch'i-Fu:
Second Level Robes of State,
More Commonly Known as Dragon Robes

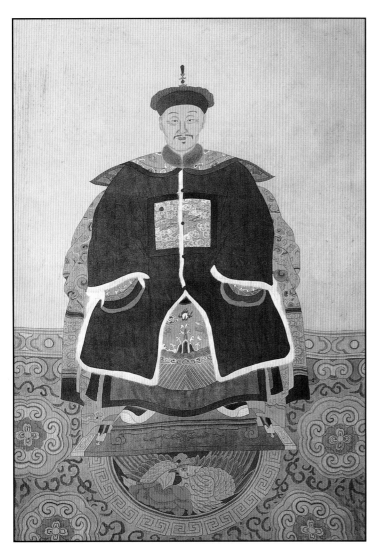 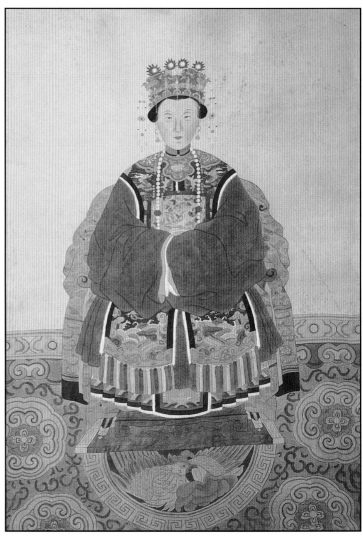

A pair of ancestor portraits showing formal court dress

Generally, the most elaborate textiles found on the market today are dragon robes. These ch'i-fu, or official court robes, have been made for generations. Examples range from late brocades with bright aniline dye colors and fine, earlier k'o-ssu, to those with silk embroidery on silk. The design is based on a nomadic riding coat of the Manchus, originally cut from animal skins. The semi-formal court or dragon robe opens down the right side with an over-flap. The skirt of the robe has long slits in both the front and back for men, originally to facilitate horseback riding, and on the sides for women, and is fastened with round, ball-style buttons and loops. The sleeves are long and close-fitting and have flaring "horseshoe" cuffs that, as on a riding coat, would go over the hands to protect them from the elements. The values for these can range from below five hundred dollars to many hundred-thousands dollars depending on condition and rarity.

The dragon robe, or ch'i-fu, was worn under the p'u-fu and was regulated in its design. In the Ming and Ch'ing

Dynasties, official edicts were issued which regulated all levels of court attire by color, form, and other elements. During the late Ch'ing dynasty, from about 1860 to 1911, the government had become weak and unstable. This was reflected in court dress robes, many of which were excessively decorated with auspicious and good luck symbols, and designs usually drawn from Buddhist and Taoist symbolism.

At some time during the eighteenth century, rank became a commodity that could be purchased under special conditions. After the Taiping rebellion, 1850-1864, the imperial treasuries were all but depleted and government positions could be purchased by wealthy individuals. During the reign of Tao-kuang there were even price lists available. This trend led to the deterioration of quality in the official garments and the rise of mass production.

Even as the edicts on court attire were increasingly ignored, the one aspect that didn't change regarded the base colors of the garments. Only the emperor, empress, and empress dowager were allowed to wear the beautiful

and striking yellow robes and these were usually reserved for ceremonial occasions. The family, consorts, and favored attendants were allowed to wear variations of the imperial yellow such as brown, apricot, and burgundy. Blue was generally reserved for the civil and military officers; however, the emperor also wore blue.

Today there are thousands of robes in museums and private collections. Most are in original condition. Unfortunately, we find that some of these robes have taken on new lives, as they were re-fashioned into Western designs to wear to cocktail parties and grand events, or sections have been put together to be used as flat wall hangings.

The following robes are arranged by type of manufacture so that the reader will see comparisons of workmanship and overall quality of various robes within a category, which will help explain how we arrive at individual values.

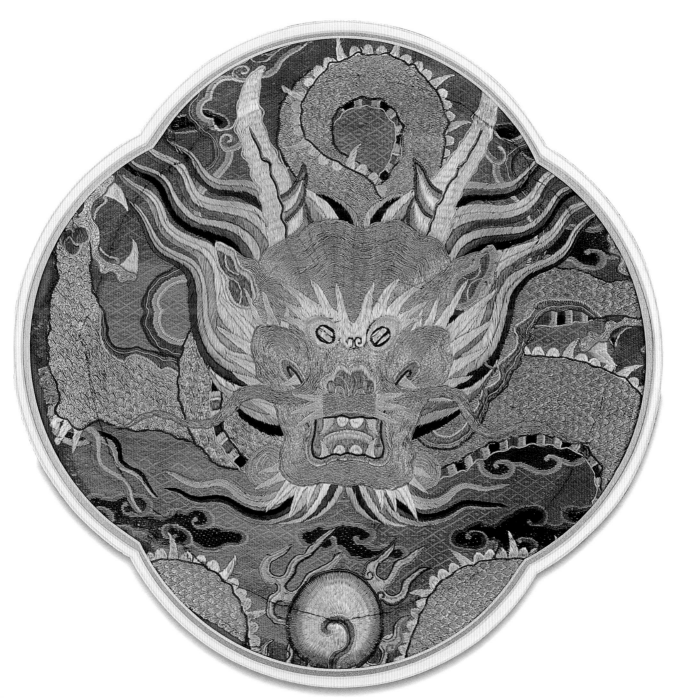

A portion of a duke's robe that is embroidered and is an extremely fine, fluid example of the workmanship of the late Ming or early Ch'ing Dynasty. Unfortunately it is a fragment and not only has color loss, but also ink marks from previous framing. Actual fabric size, 12.25" x 12.25". $2500. H3,C3,Q1,R2

Excerpt from a letter of authenticity from John Vollmer: "Stylistically the cartoon and mixture of embroidery stitches resemble work attributed to the reign of the Wanli emperor (r. 1573-1619)(see, Rutherford, et al., *Celestial Silks: Chinese Religious and Court Textiles*, Sydney, Australia, 2004, p. 75). The clouds, which mark the background to the dragon, are atypical of this period and may point to a date later in the 17th century. A roundel like this may have adorned (or been cut from) an Imperial overcoat."

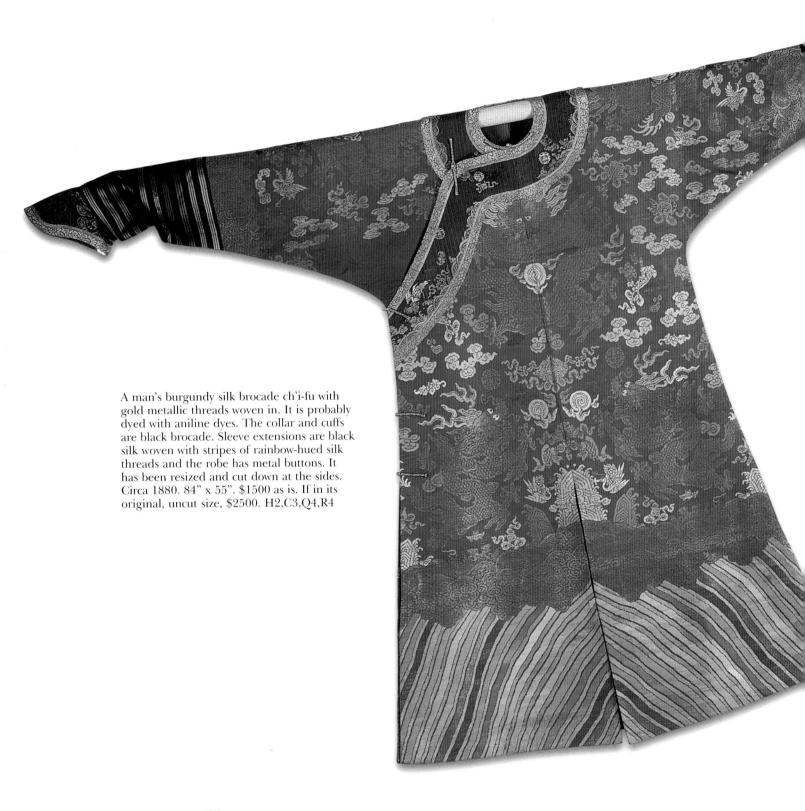

A man's burgundy silk brocade ch'i-fu with gold metallic threads woven in. It is probably dyed with aniline dyes. The collar and cuffs are black brocade. Sleeve extensions are black silk woven with stripes of rainbow-hued silk threads and the robe has metal buttons. It has been resized and cut down at the sides. Circa 1880. 84" x 55". $1500 as is. If in its original, uncut size, $2500. H2,C3,Q4,R4

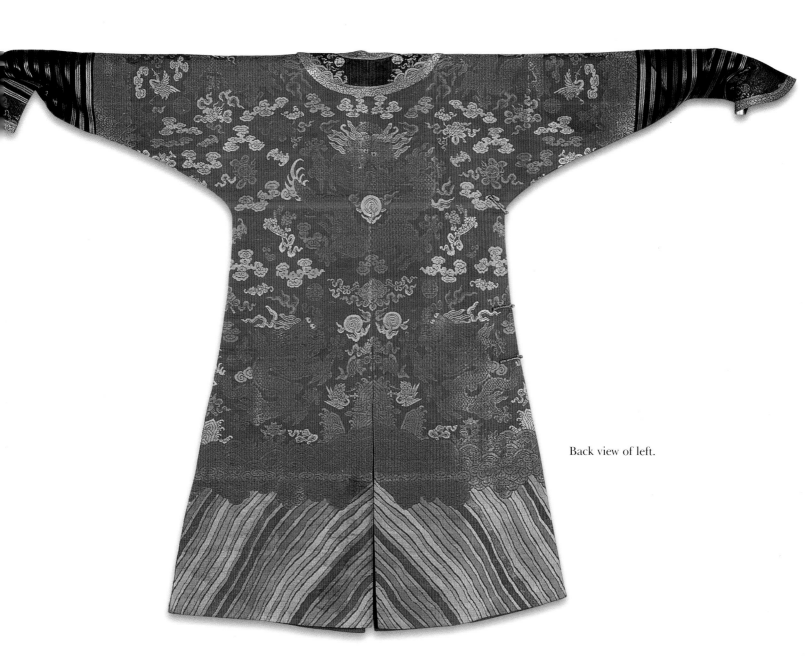

Back view of left.

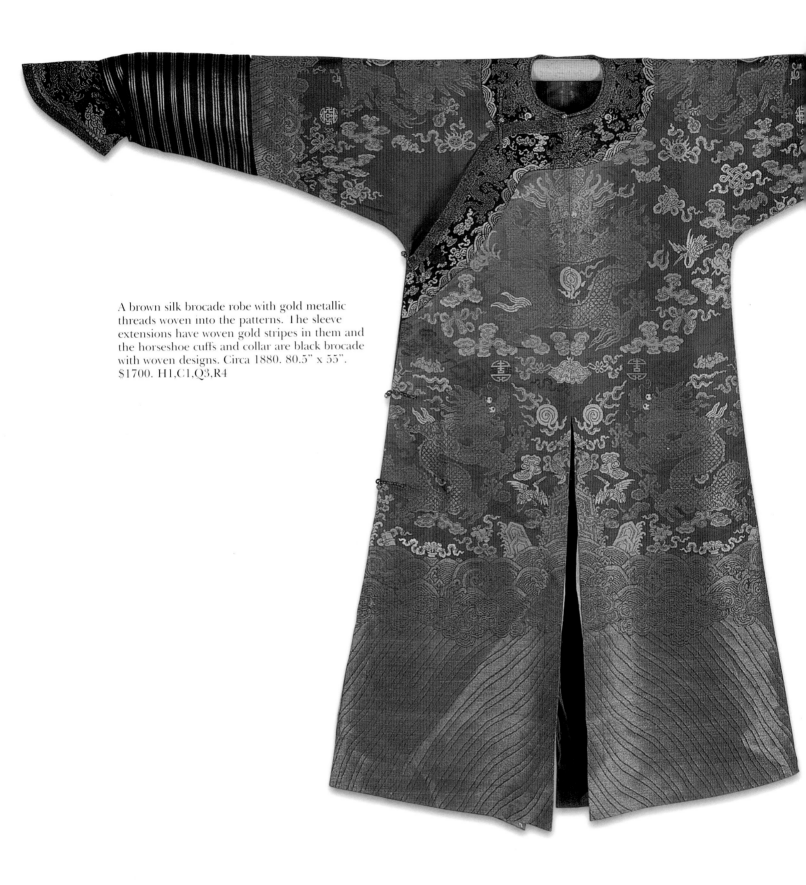

A brown silk brocade robe with gold metallic threads woven into the patterns. The sleeve extensions have woven gold stripes in them and the horseshoe cuffs and collar are black brocade with woven designs. Circa 1880. 80.5" x 55". $1700. H1,C1,Q3,R4

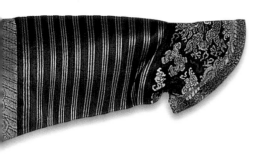

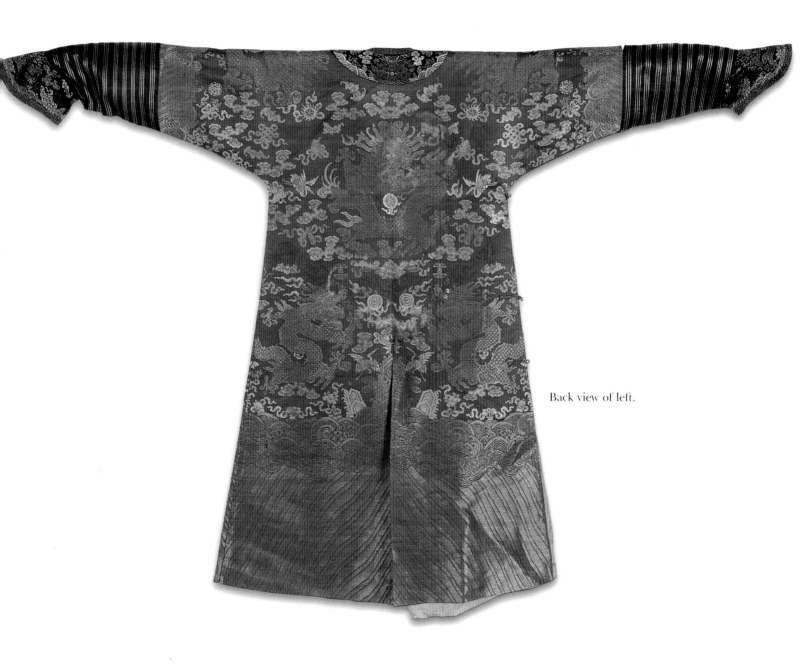

Back view of left.

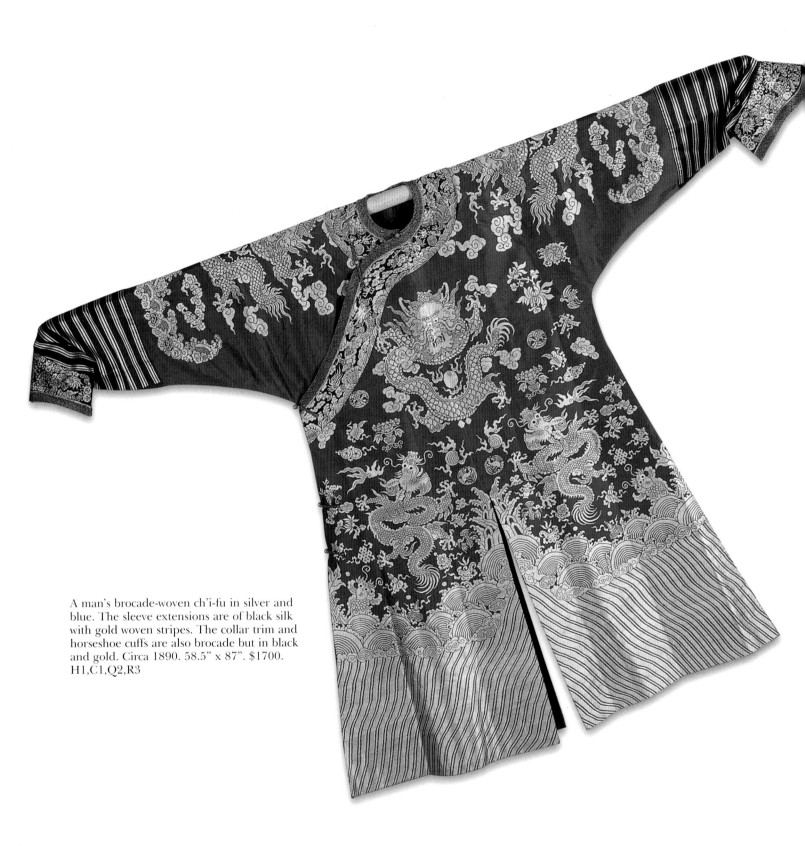

A man's brocade-woven ch'i-fu in silver and
blue. The sleeve extensions are of black silk
with gold woven stripes. The collar trim and
horseshoe cuffs are also brocade but in black
and gold. Circa 1890. 58.5" x 87". $1700.
H1,C1,Q2,R3

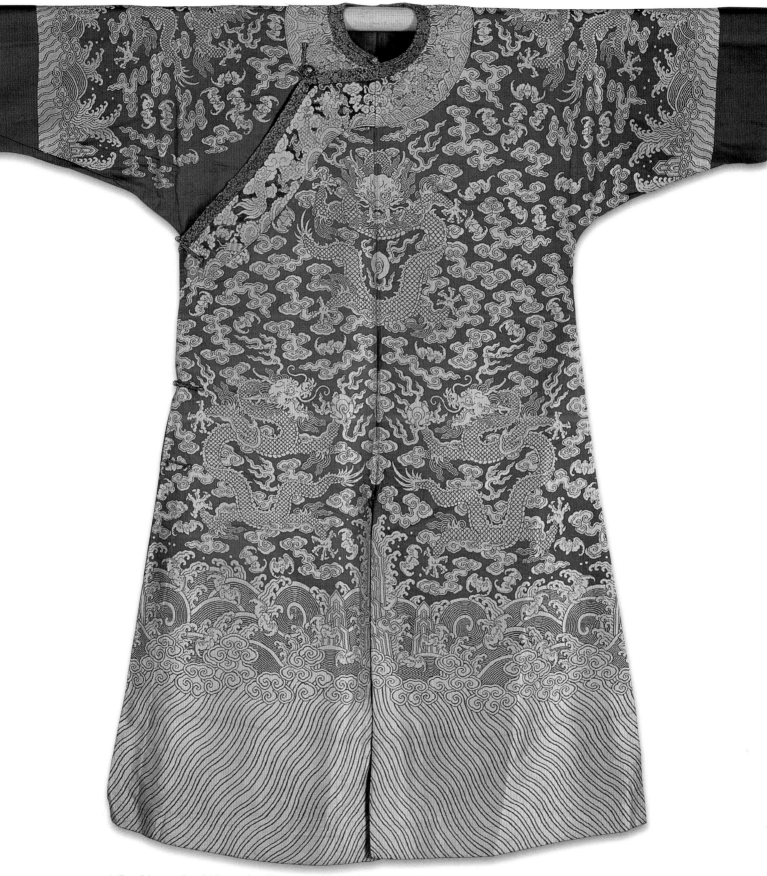

A fine blue and gold brocade silk man's ch'i-fu with woven dragons, waves, and bats. The original sleeve inserts and horseshoe cuffs are missing. It has also been cut down on the sides, decreasing its value. However, this robe is quite interesting in its limited use of symbols consisting of only dragons, bats, mountains, and waves on a cloud background. Circa 1850. 55" X 50". $1700 as is. If it were complete and unaltered it would be in the $4000-$6000 range. H1,C2,Q2,R2

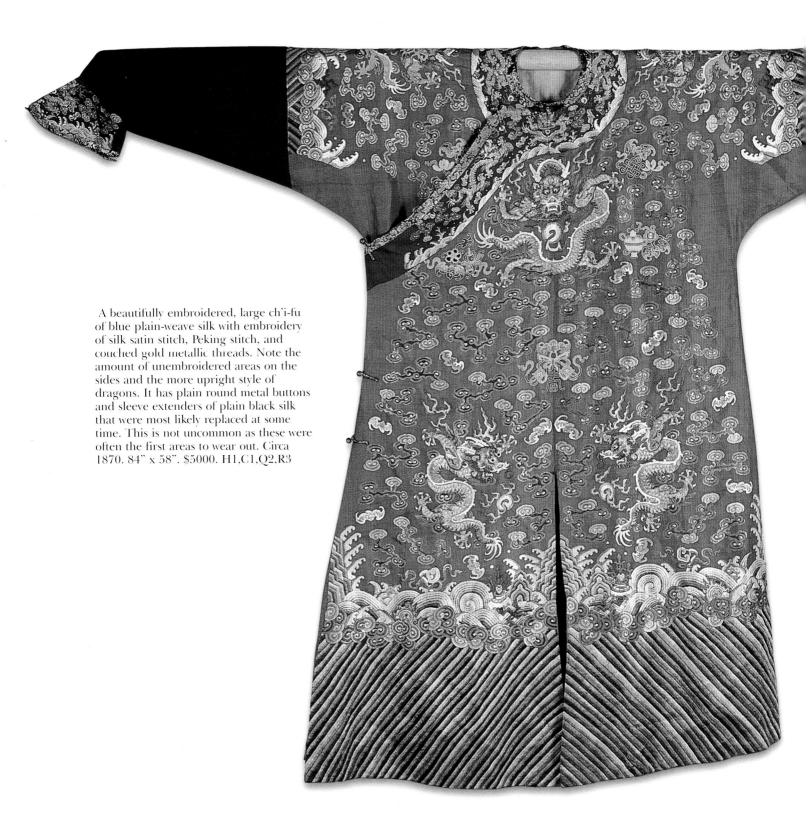

A beautifully embroidered, large ch'i-fu of blue plain-weave silk with embroidery of silk satin stitch, Peking stitch, and couched gold metallic threads. Note the amount of unembroidered areas on the sides and the more upright style of dragons. It has plain round metal buttons and sleeve extenders of plain black silk that were most likely replaced at some time. This is not uncommon as these were often the first areas to wear out. Circa 1870. 84" x 58". $5000. H1,C1,Q2,R3

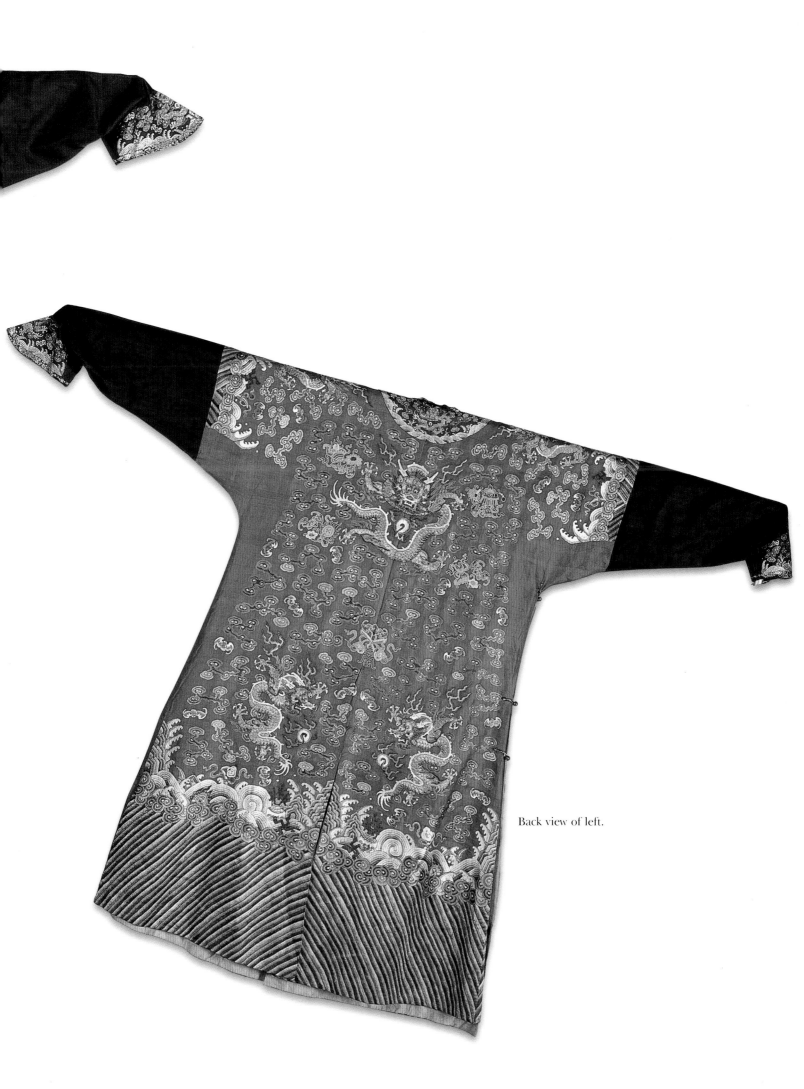

Back view of left.

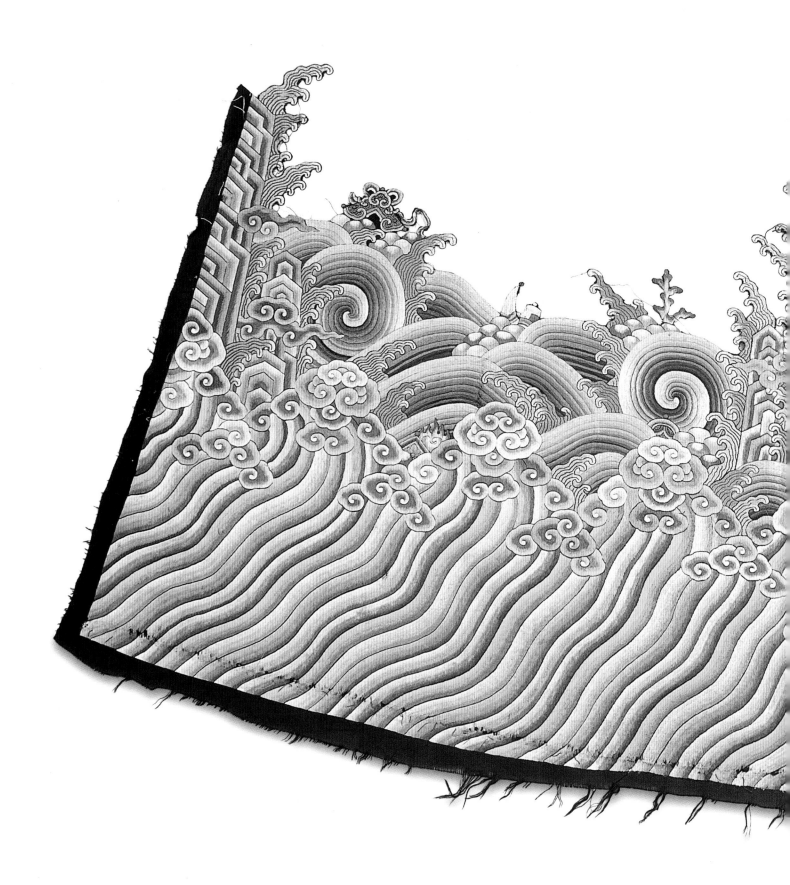

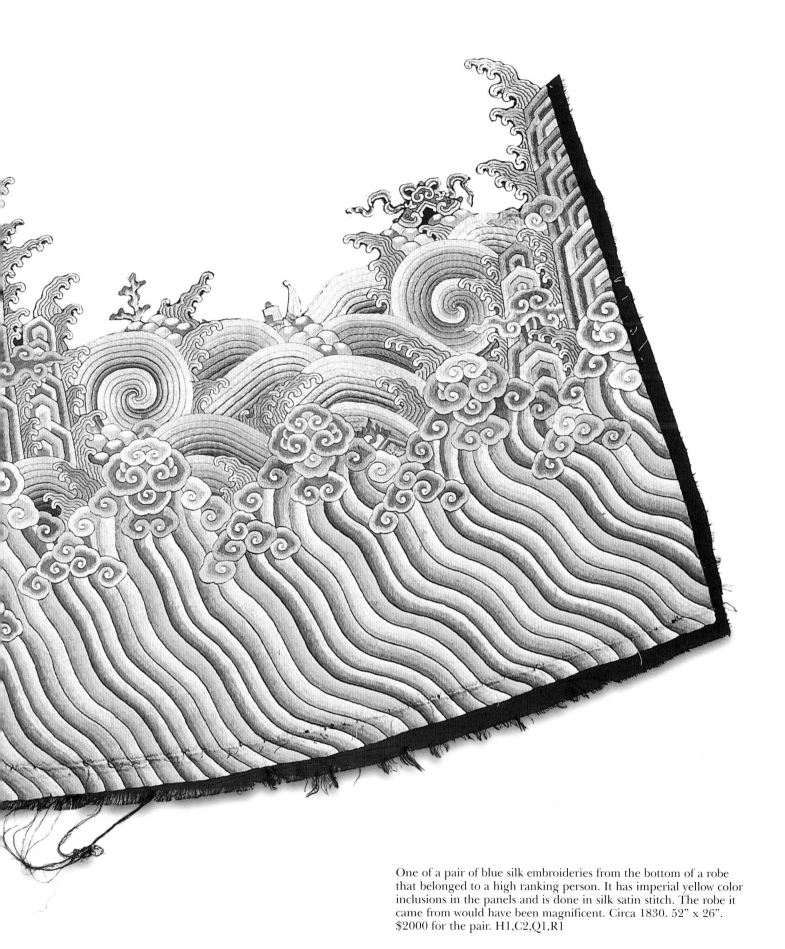

One of a pair of blue silk embroideries from the bottom of a robe that belonged to a high ranking person. It has imperial yellow color inclusions in the panels and is done in silk satin stitch. The robe it came from would have been magnificent. Circa 1830. 52" x 26". $2000 for the pair. H1,C2,Q1,R1

Detail of below fu-lion.

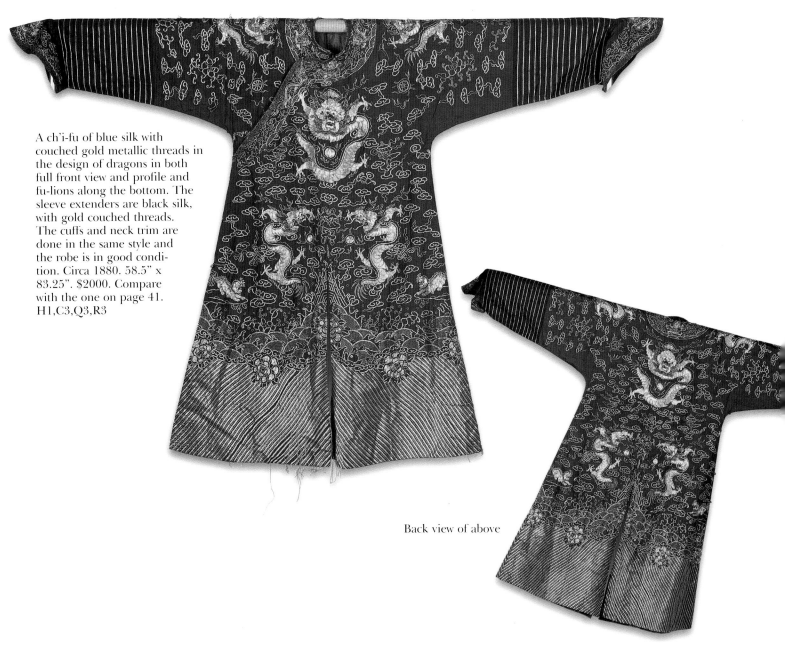

A ch'i-fu of blue silk with couched gold metallic threads in the design of dragons in both full front view and profile and fu-lions along the bottom. The sleeve extenders are black silk, with gold couched threads. The cuffs and neck trim are done in the same style and the robe is in good condition. Circa 1880. 58.5" x 83.25". $2000. Compare with the one on page 41. H1,C3,Q3,R3

Back view of above

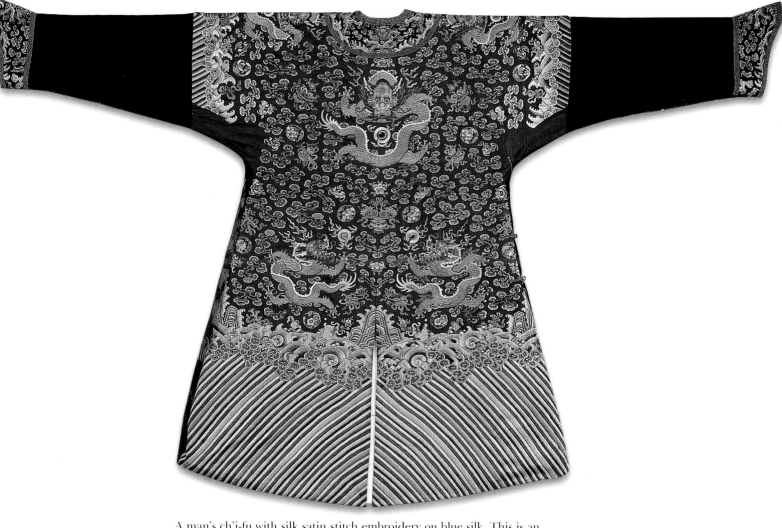

A man's ch'i-fu with silk satin stitch embroidery on blue silk. This is an unusual robe due to the large floral roundels and shades of green used in the embroidery. Circa 1870. 56.25" x 78". $6500. H1,Q1,C3,R3

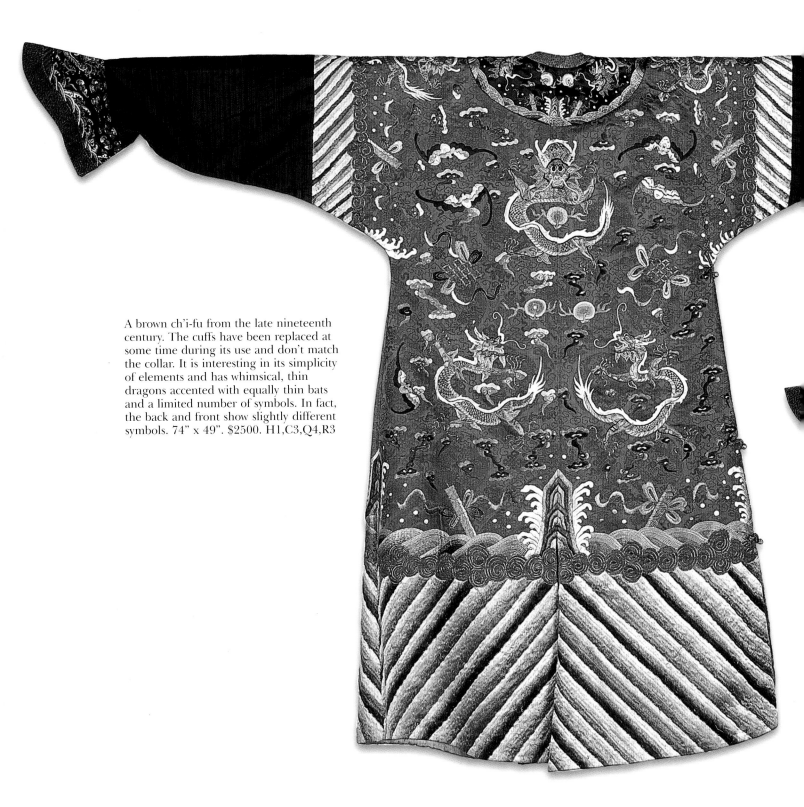

A brown ch'i-fu from the late nineteenth century. The cuffs have been replaced at some time during its use and don't match the collar. It is interesting in its simplicity of elements and has whimsical, thin dragons accented with equally thin bats and a limited number of symbols. In fact, the back and front show slightly different symbols. 74" x 49". $2500. H1,C3,Q4,R3

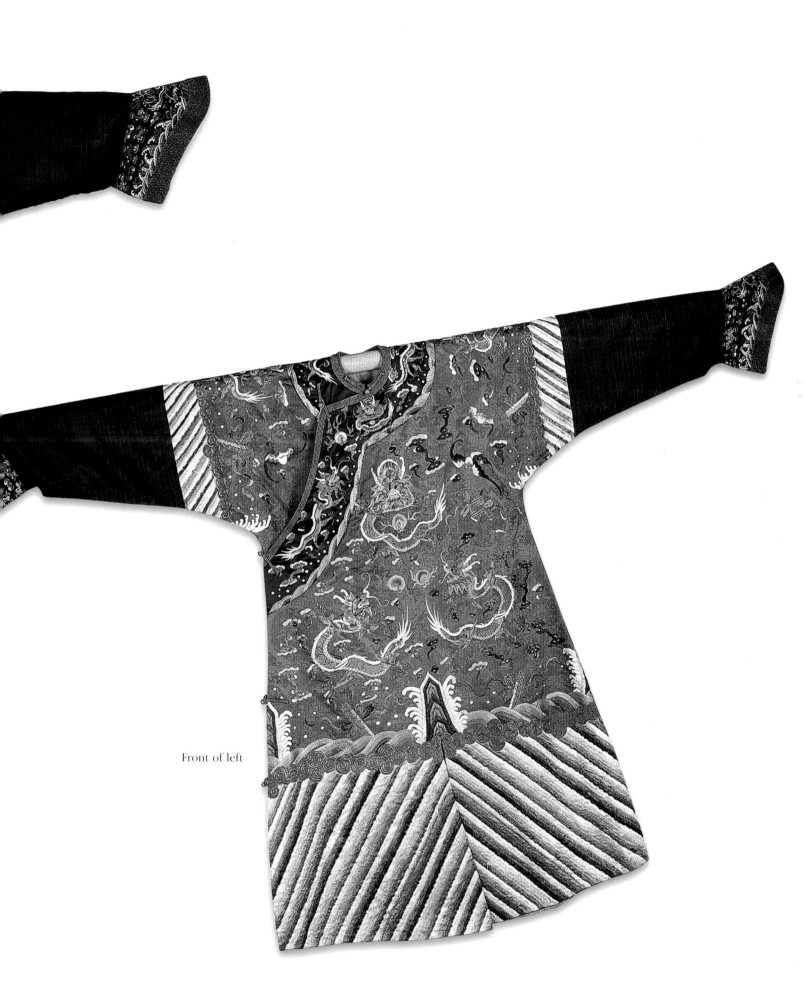

Front of left

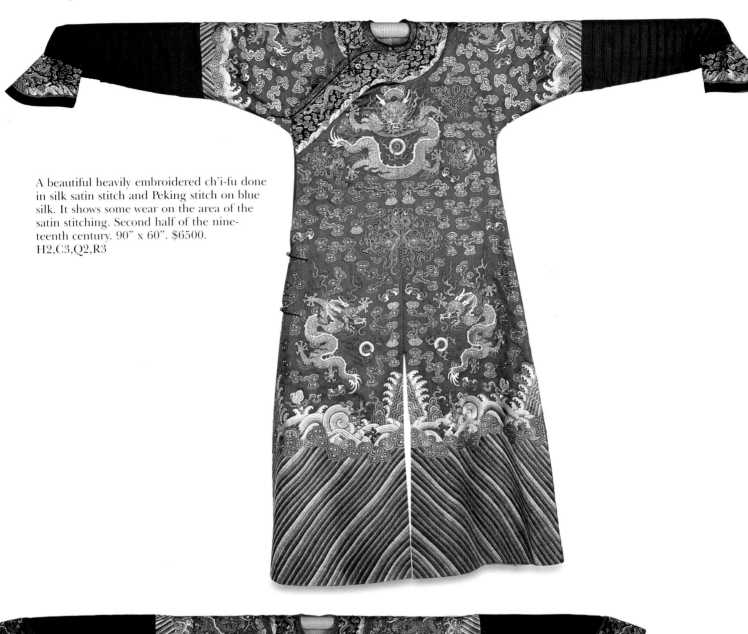

A beautiful heavily embroidered ch'i-fu done in silk satin stitch and Peking stitch on blue silk. It shows some wear on the area of the satin stitching. Second half of the nineteenth century. 90" x 60". $6500. H2,C3,Q2,R3

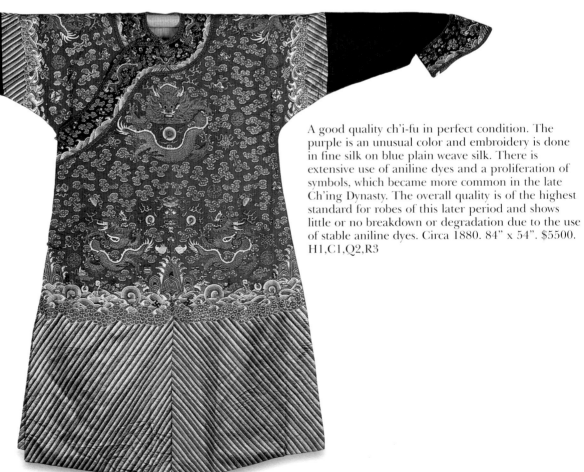

A good quality ch'i-fu in perfect condition. The purple is an unusual color and embroidery is done in fine silk on blue plain weave silk. There is extensive use of aniline dyes and a proliferation of symbols, which became more common in the late Ch'ing Dynasty. The overall quality is of the highest standard for robes of this later period and shows little or no breakdown or degradation due to the use of stable aniline dyes. Circa 1880. 84" x 54". $5500. H1,C1,Q2,R3

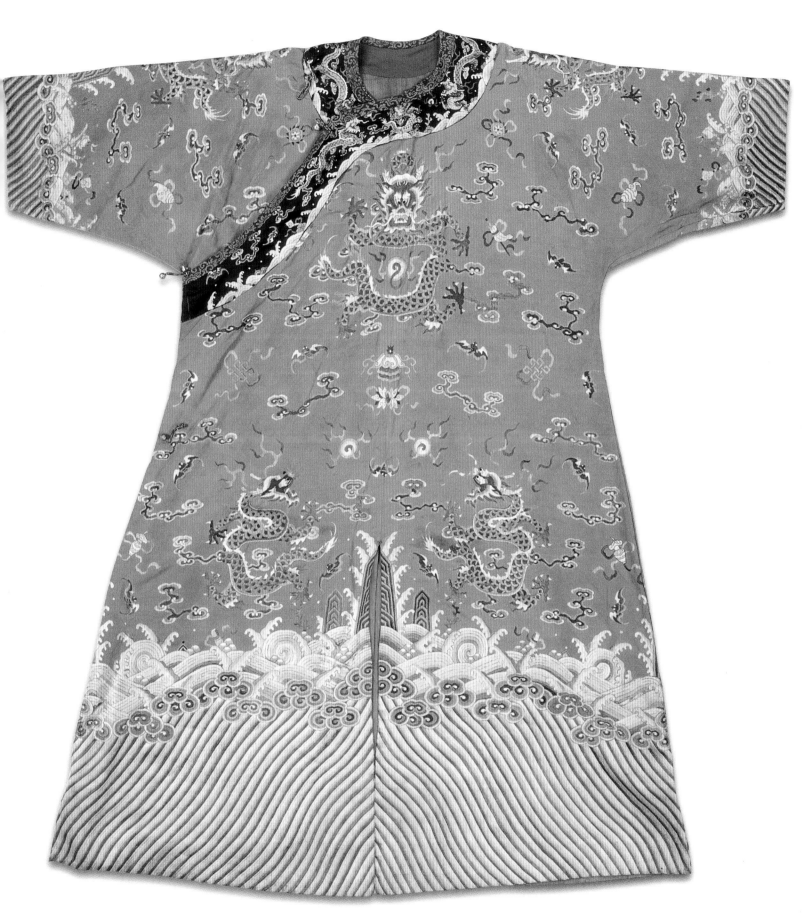

A brown ch'i-fu, beautifully embroidered, but showing wear and damage. The sleeve extenders and cuffs are missing and there is some staining. Circa 1860. 58" x 47". $2500. If complete and in perfect condition, $10,000. H3,C4,Q2,R3

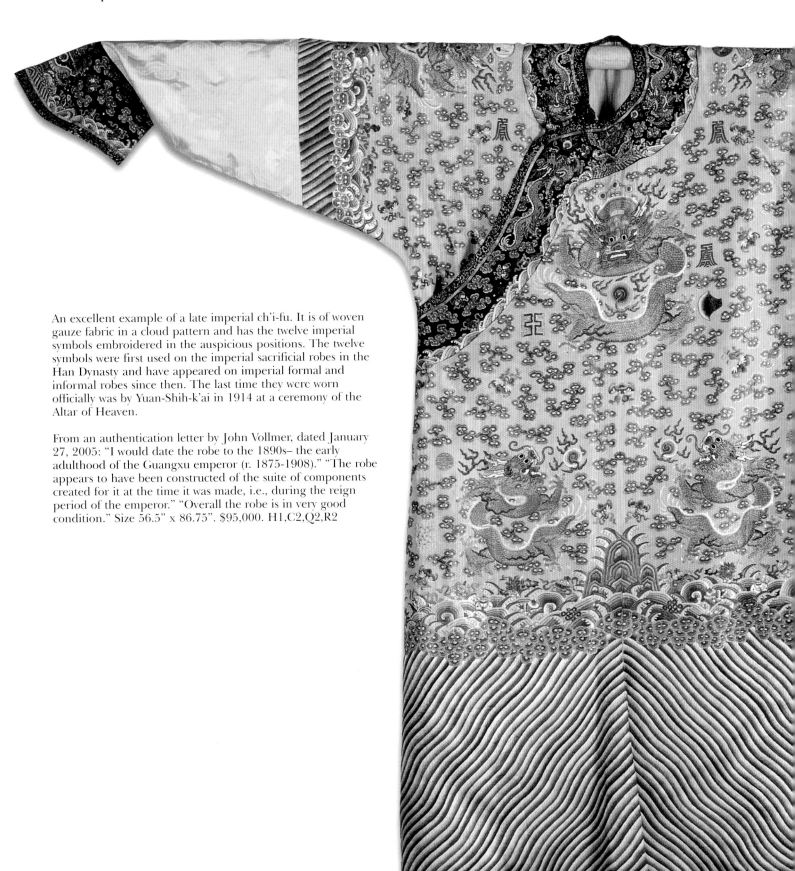

An excellent example of a late imperial ch'i-fu. It is of woven gauze fabric in a cloud pattern and has the twelve imperial symbols embroidered in the auspicious positions. The twelve symbols were first used on the imperial sacrificial robes in the Han Dynasty and have appeared on imperial formal and informal robes since then. The last time they were worn officially was by Yuan-Shih-k'ai in 1914 at a ceremony of the Altar of Heaven.

From an authentication letter by John Vollmer, dated January 27, 2005: "I would date the robe to the 1890s– the early adulthood of the Guangxu emperor (r. 1875-1908)." "The robe appears to have been constructed of the suite of components created for it at the time it was made, i.e., during the reign period of the emperor." "Overall the robe is in very good condition." Size 56.5" x 86.75". $95,000. H1,C2,Q2,R2

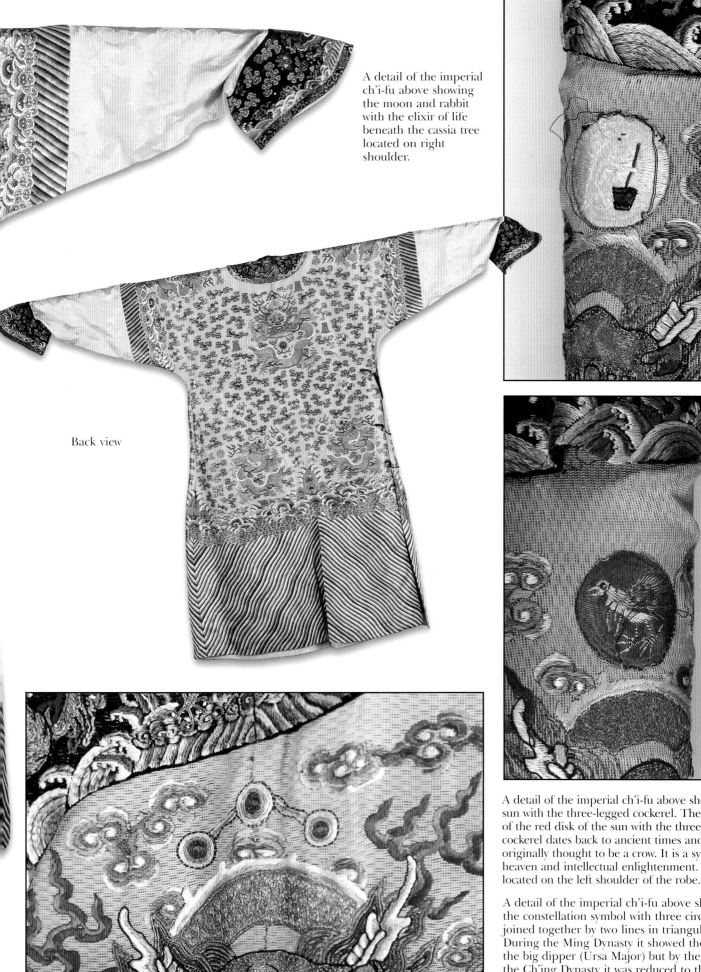

A detail of the imperial ch'i-fu above showing the moon and rabbit with the elixir of life beneath the cassia tree located on right shoulder.

Back view

A detail of the imperial ch'i-fu above showing the sun with the three-legged cockerel. The symbol of the red disk of the sun with the three-legged cockerel dates back to ancient times and was originally thought to be a crow. It is a symbol of heaven and intellectual enlightenment. This is located on the left shoulder of the robe.

A detail of the imperial ch'i-fu above showing the constellation symbol with three circles joined together by two lines in triangular form. During the Ming Dynasty it showed the stars of the big dipper (Ursa Major) but by the time of the Ch'ing Dynasty it was reduced to three stars connected by two bars. It is located on the upper center of the front of the robe.

A detail of the imperial ch'i-fu on page 36 showing the "fu," a symbol made up of two opposing lines that represent the winter solstice, judgment and discrimination, and good and evil. It is located at the middle of the right front.

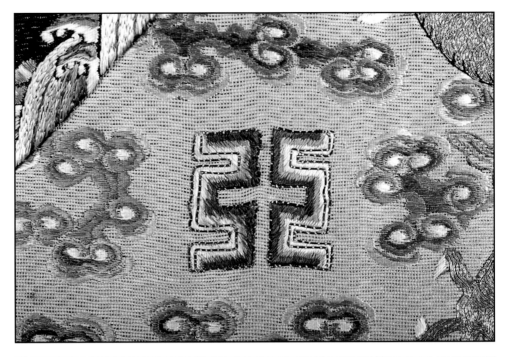

A detail of the imperial ch'i-fu on page 36 showing the ax, representing the autumn equinox, power, and authority, located at the middle of the left front.

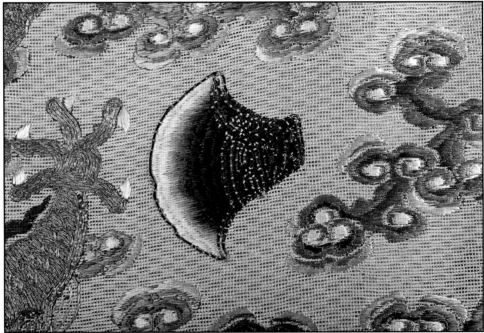

A detail of the imperial ch'i-fu on page 36 showing the water weed, symbolizing water and purity and located at the lower right front of the robe.

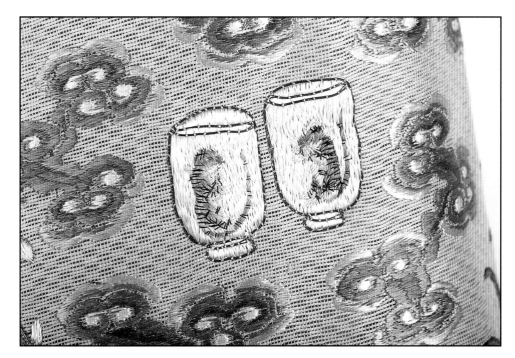

A detail of the imperial ch'i-fu on page 36 showing the pair of bronze cups with a tiger on one and a monkey on the other, representing filial piety and the element of metal. In later years of the Ch'ing dynasty they became two cups with a more composite creature on them. Located on the lower left portion of the robe.

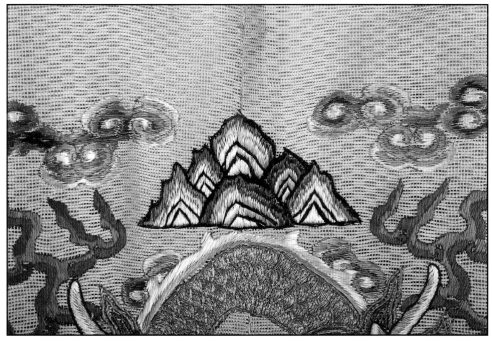

A detail of the imperial ch'i-fu on page 36 showing the mountain rock located at the center of the upper back, which symbolizes the earth and steadfastness.

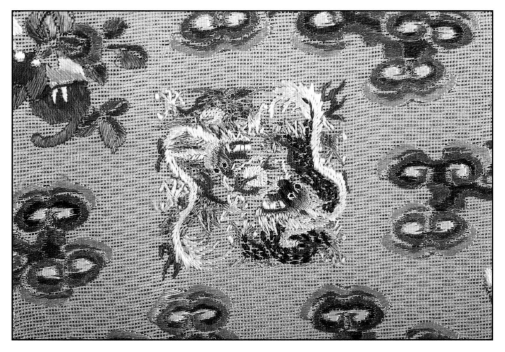

A detail of the imperial ch'i-fu on page 36 showing the double dragons which represent the summer solstice and renewal, located on the left upper back of the robe.

A detail of the imperial ch'i-fu on page 36 showing the golden pheasant, representing the spring equinox and literary refinement, located at the upper right side of the back of the robe.

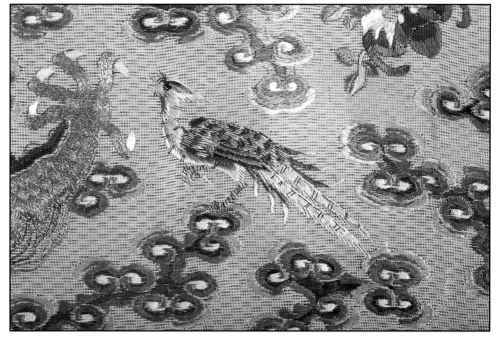

A detail of the imperial ch'i-fu on page 36 showing the element of fire located at the lower left back of the robe, representing intellectual and spiritual brilliance.

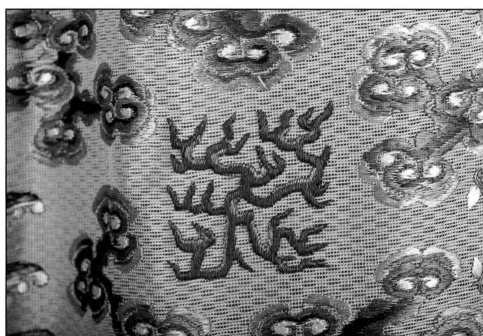

A detail of the imperial ch'i-fu on page 36 showing the bowl of millet as a disk containing grains scattered across it. Located at the lower right of the back of the robe, it represents the emperor's responsibility to feed his people and also the element of wood.

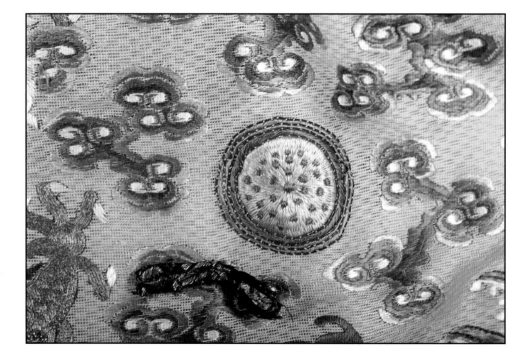

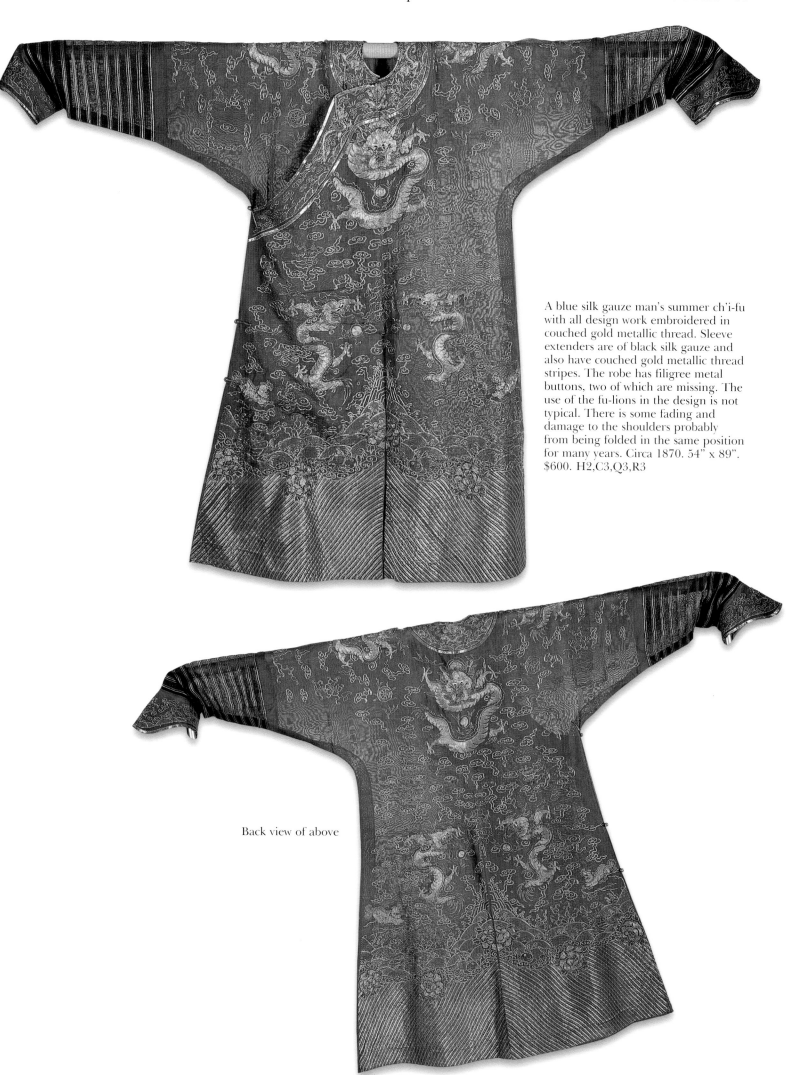

A blue silk gauze man's summer ch'i-fu with all design work embroidered in couched gold metallic thread. Sleeve extenders are of black silk gauze and also have couched gold metallic thread stripes. The robe has filigree metal buttons, two of which are missing. The use of the fu-lions in the design is not typical. There is some fading and damage to the shoulders probably from being folded in the same position for many years. Circa 1870. 54" x 89". $600. H2,C3,Q3,R3

Back view of above

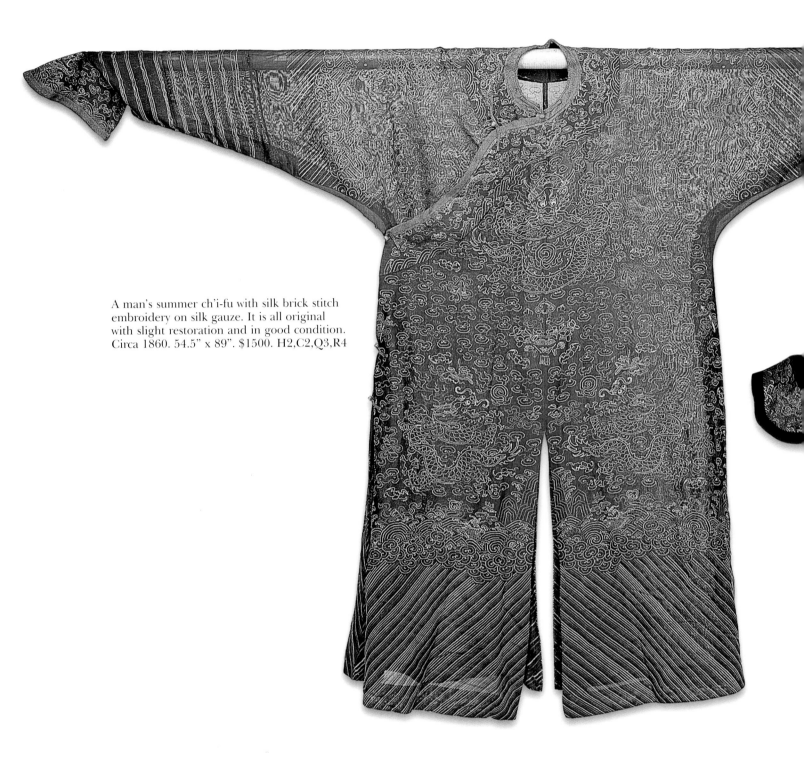

A man's summer ch'i-fu with silk brick stitch
embroidery on silk gauze. It is all original
with slight restoration and in good condition.
Circa 1860. 54.5" x 89". $1500. H2,C2,Q3,R4

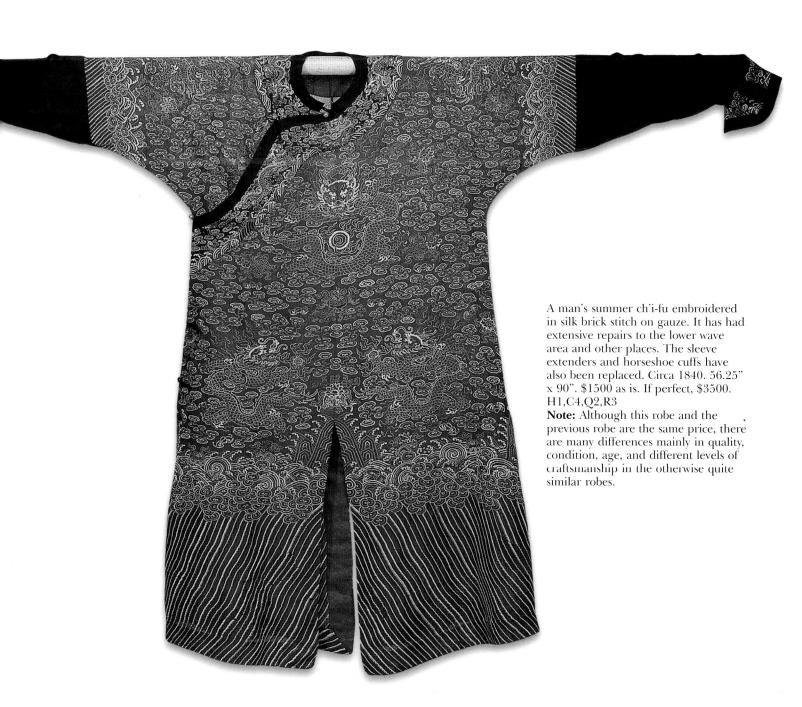

A man's summer ch'i-fu embroidered in silk brick stitch on gauze. It has had extensive repairs to the lower wave area and other places. The sleeve extenders and horseshoe cuffs have also been replaced. Circa 1840. 56.25" x 90". $1500 as is. If perfect, $3500. H1,C4,Q2,R3

Note: Although this robe and the previous robe are the same price, there are many differences mainly in quality, condition, age, and different levels of craftsmanship in the otherwise quite similar robes.

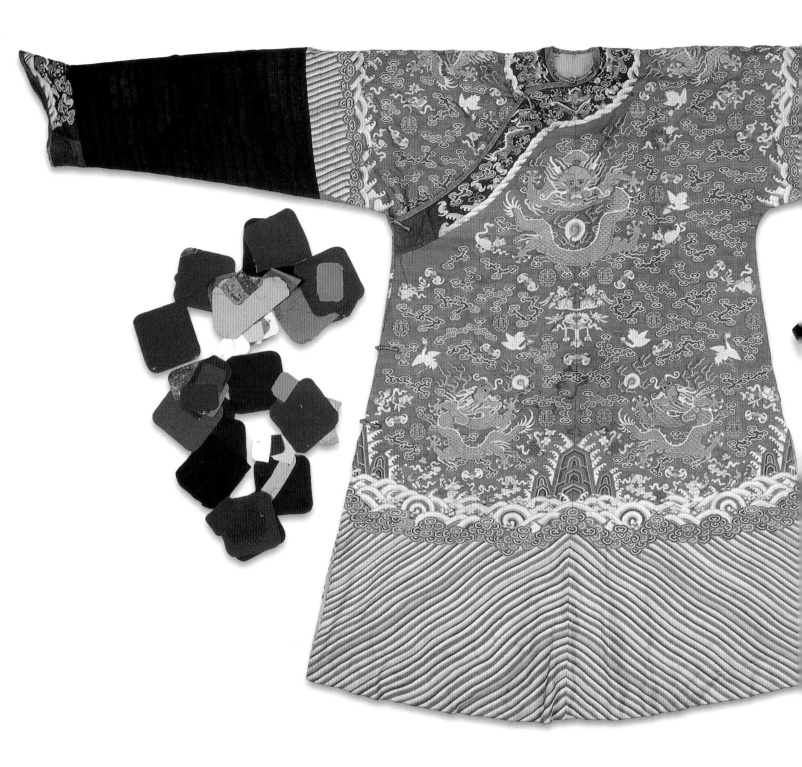

This is a very large, finely woven k'o-ssu ch'i-fu and is quite dramatic in its bold color and strong design format. Note that it also has roundels woven within the black sleeve extenders. This is a good example of how not to conserve a robe. In restoring this robe there were more than fifty pieces of iron-on jeans repair patches of various sizes and colors, which are shown to the left of the robe. Most of them could be removed, although some of the smaller ones were left in as they could not be removed without creating more damage. After removing the numerously layered patches, a thin, fusible non-acidic, webbing was installed to stabilize the previously "patched" areas. There are also issues with staining. Although the overall condition detracts from its value, the full scope, including size and presence, adds value. Circa 1880. 57" x 92. $5500. If perfect, $12,000 to $15,000. H2,C4,Q3,R5

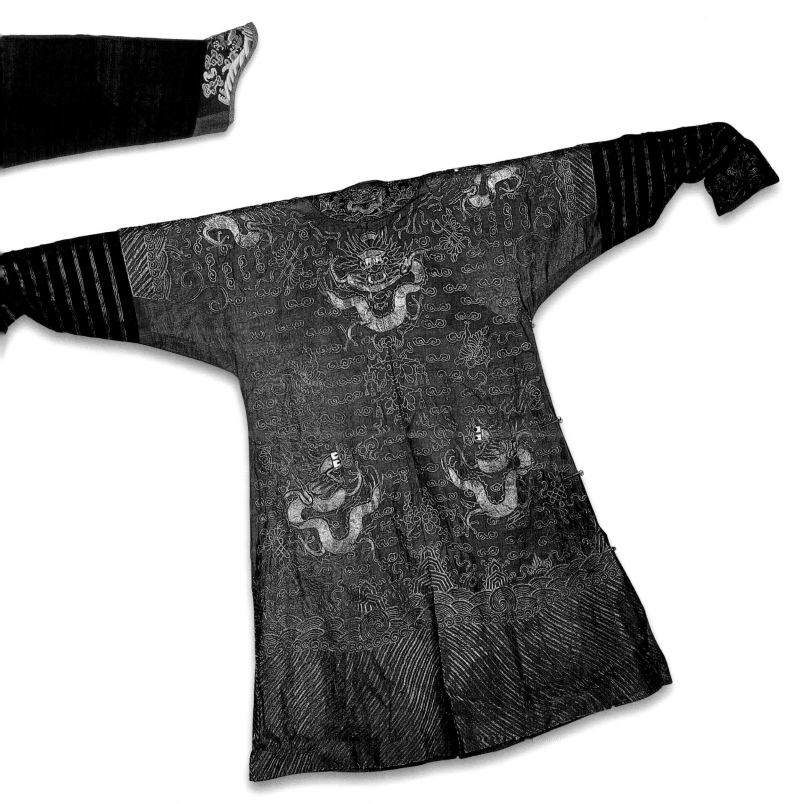

The back view of a blue gauze, summer ch'i-fu. It has a good number of loose threads. It has an unusual design, bearing four clawed dragons with large bulging eyes. The dragons are embroidered in a basket stitch with gold wrapped metallic threads. The cloud background is couched in a straight pattern of horizontal rows across the robe. There is slight breakdown in shoulder area. Its large scale and crudeness of design is a good indication of its overall low quality and of late production, when rank was for sale and anyone with money could purchase it. Very late nineteenth or early twentieth century. 86" x 52". $900. H2,C4,Q4,R4

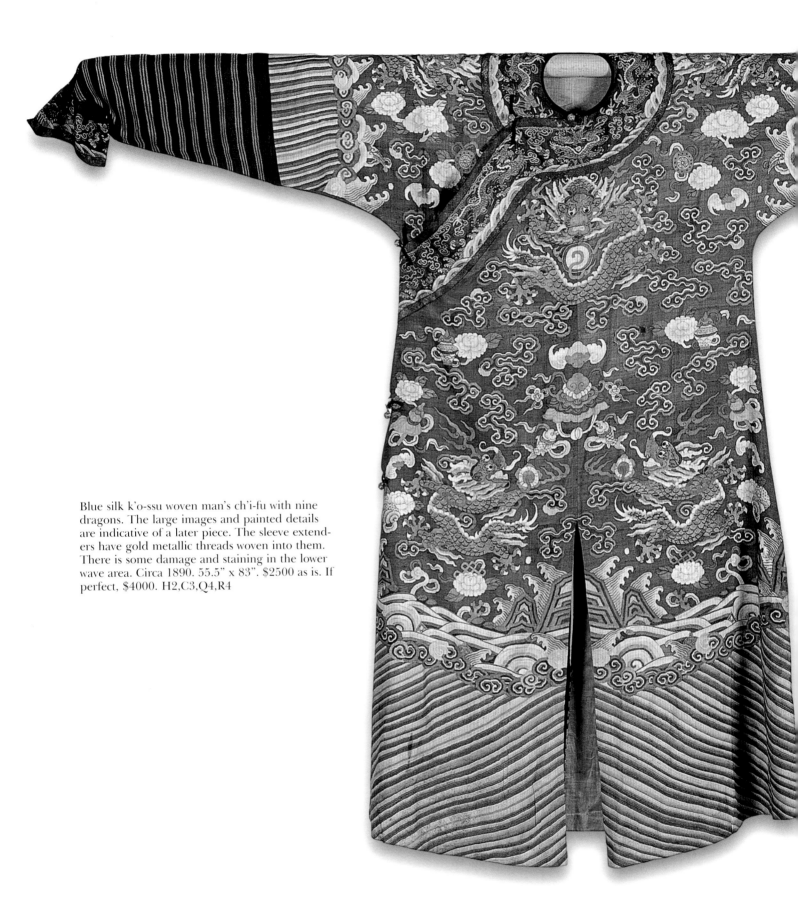

Blue silk k'o-ssu woven man's ch'i-fu with nine dragons. The large images and painted details are indicative of a later piece. The sleeve extenders have gold metallic threads woven into them. There is some damage and staining in the lower wave area. Circa 1890. 55.5" x 83". $2500 as is. If perfect, $4000. H2,C3,Q4,R4

A portion of a very late unused k'o-ssu ch'i-fu. It is very crudely woven with widely spaced warp and weft threads. The details, as such, are painted and show a quick and untrained hand. This was definitely a piece to be sold and may even have been for export. This is a very good example of the extreme decay in quality that was seen at the end of the Ch'ing Dynasty. Circa twentieth century. 40" x 117". $450. H1,C2,Q4,R4

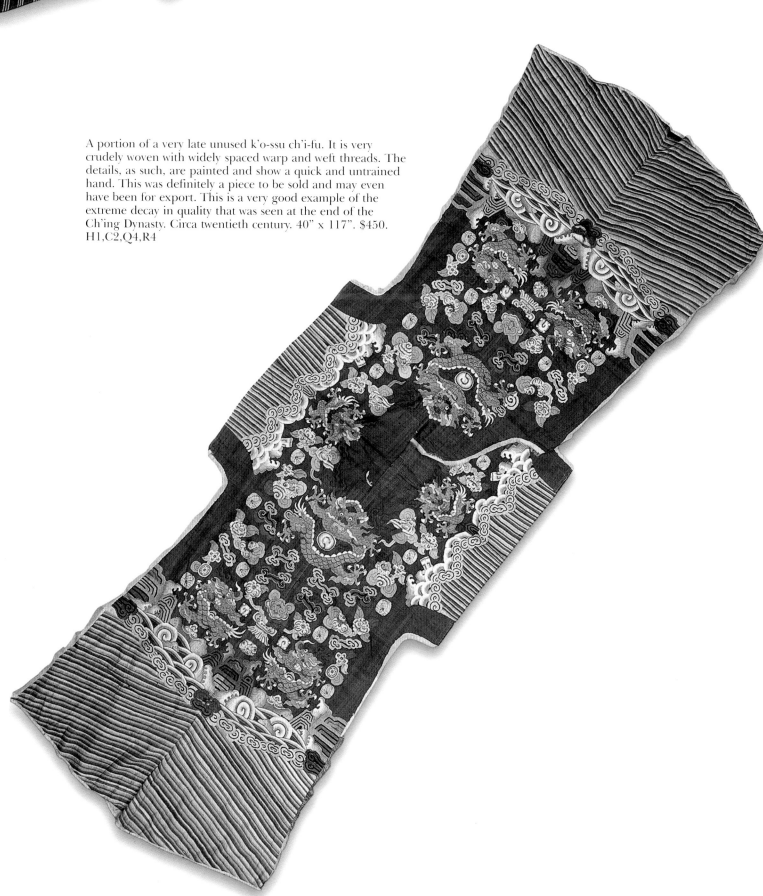

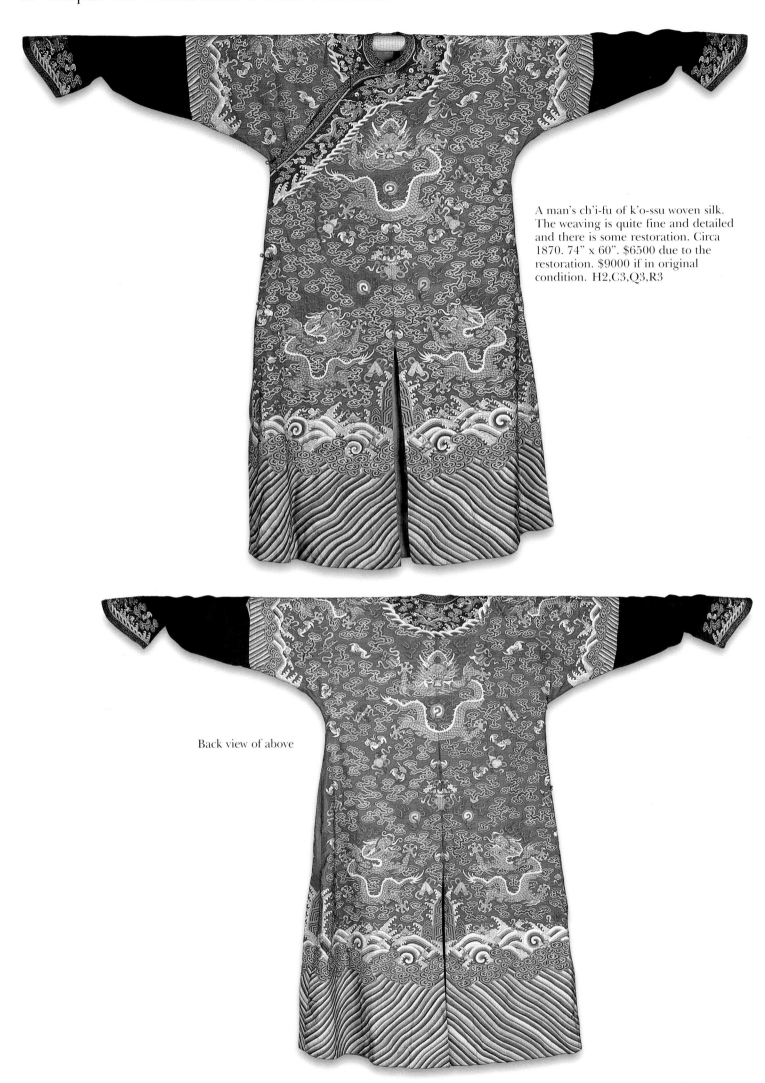

A man's ch'i-fu of k'o-ssu woven silk.
The weaving is quite fine and detailed
and there is some restoration. Circa
1870. 74" x 60". $6500 due to the
restoration. $9000 if in original
condition. H2,C3,Q3,R3

Back view of above

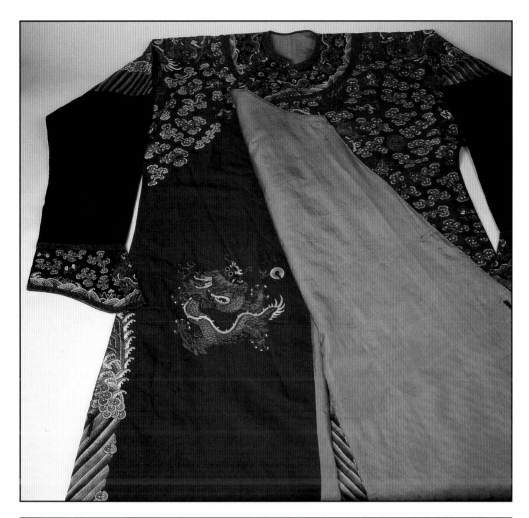

Inside front of a robe, showing the ninth dragon. Nine was considered a perfect and auspicious number.

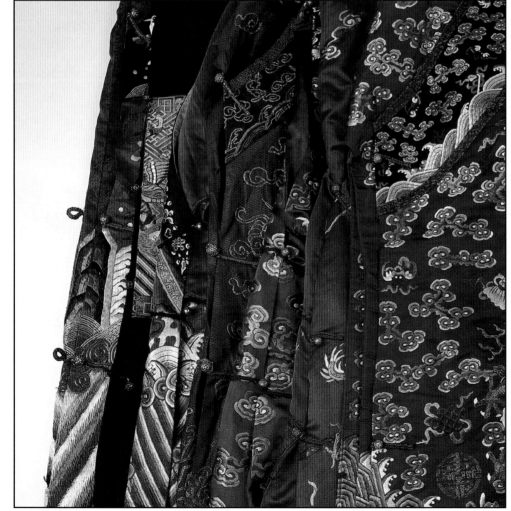

A group of seven robes, both ch'i-fu (dragon) and p'u-fu, showing some of the different styles of buttons used. They were generally made of a base metal such as bronze and sometimes plated with gold.

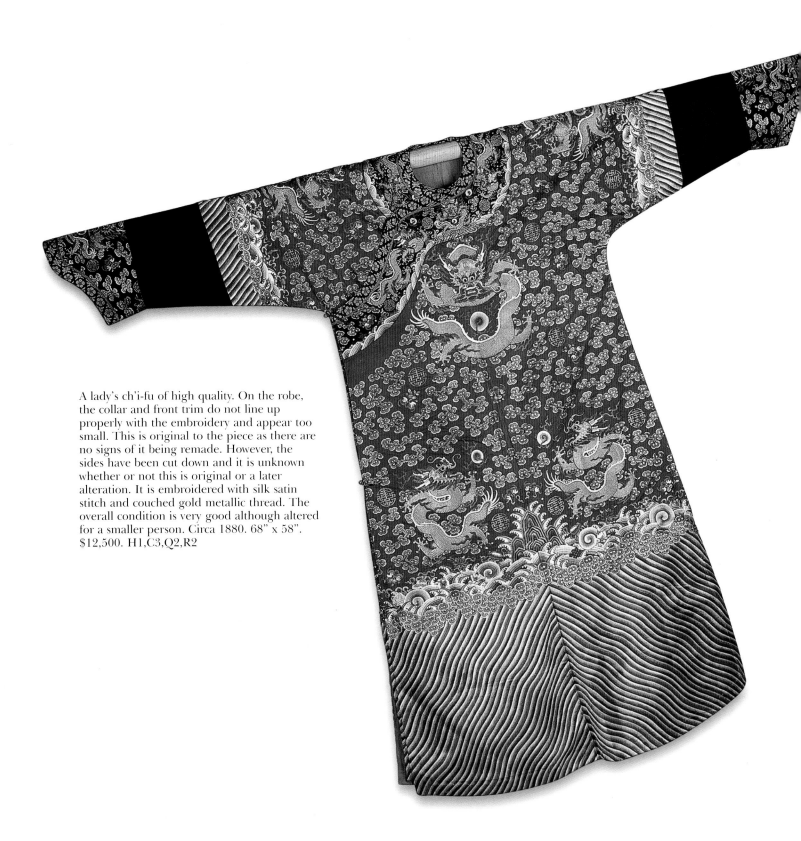

A lady's ch'i-fu of high quality. On the robe, the collar and front trim do not line up properly with the embroidery and appear too small. This is original to the piece as there are no signs of it being remade. However, the sides have been cut down and it is unknown whether or not this is original or a later alteration. It is embroidered with silk satin stitch and couched gold metallic thread. The overall condition is very good although altered for a smaller person. Circa 1880. 68" x 58". $12,500. H1,C3,Q2,R2

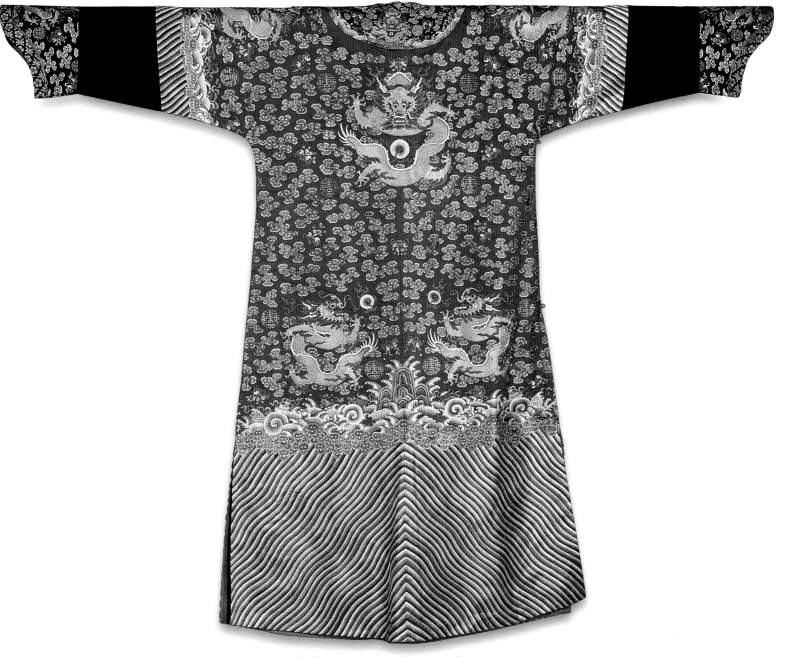

Back view of left. Note the misalignment of the neck trim.

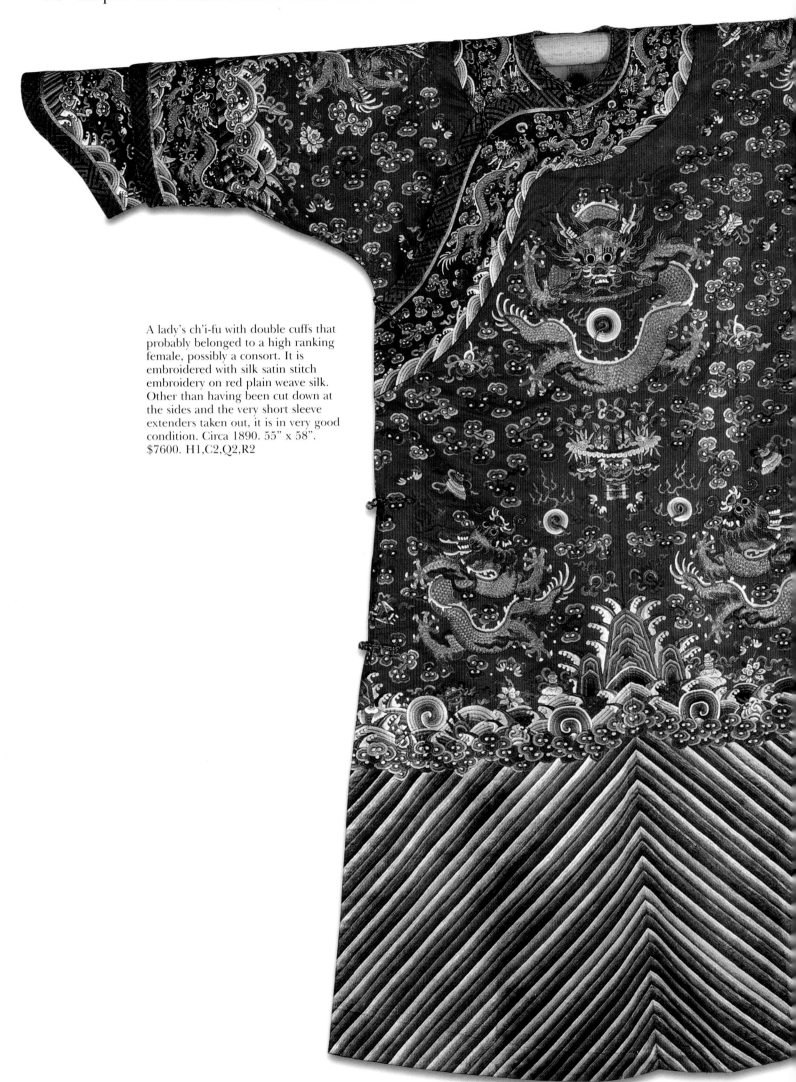

A lady's ch'i-fu with double cuffs that probably belonged to a high ranking female, possibly a consort. It is embroidered with silk satin stitch embroidery on red plain weave silk. Other than having been cut down at the sides and the very short sleeve extenders taken out, it is in very good condition. Circa 1890. 55" x 58". $7600. H1,C2,Q2,R2

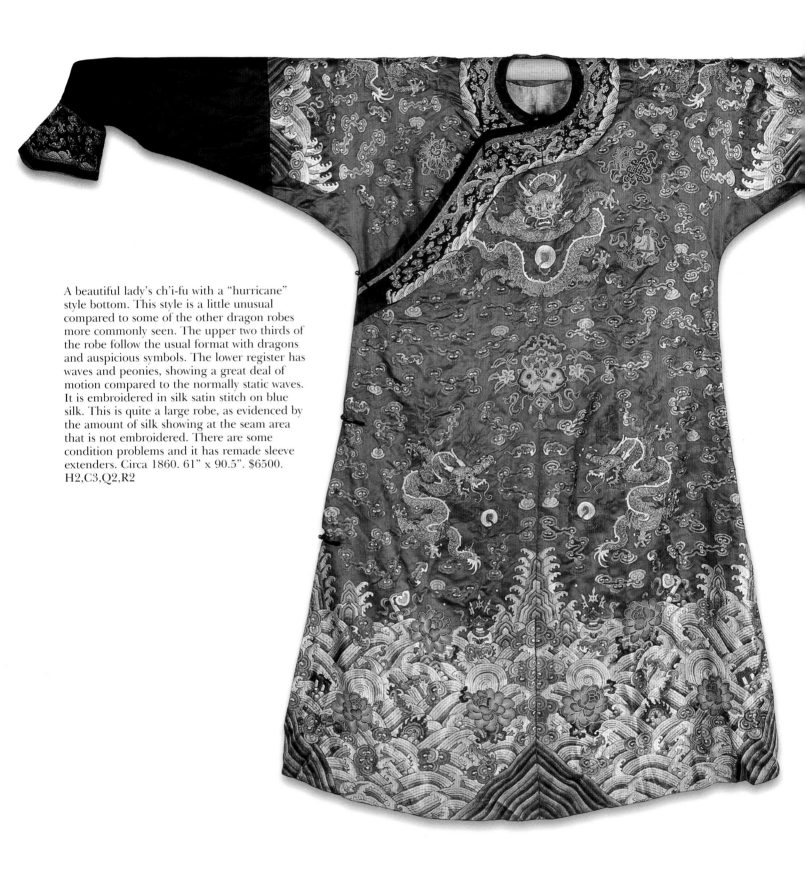

A beautiful lady's ch'i-fu with a "hurricane" style bottom. This style is a little unusual compared to some of the other dragon robes more commonly seen. The upper two thirds of the robe follow the usual format with dragons and auspicious symbols. The lower register has waves and peonies, showing a great deal of motion compared to the normally static waves. It is embroidered in silk satin stitch on blue silk. This is quite a large robe, as evidenced by the amount of silk showing at the seam area that is not embroidered. There are some condition problems and it has remade sleeve extenders. Circa 1860. 61" x 90.5". $6500. H2,C3,Q2,R2

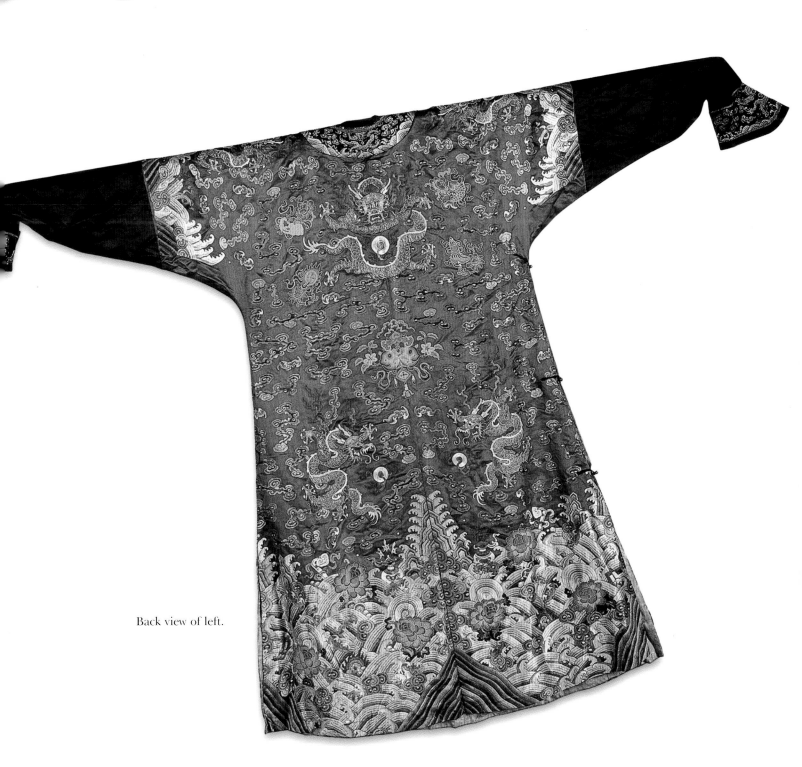

Back view of left.

Ch'ang-fu:
Third Level, Informal Court Attire,
Including Scholar's Robes and Chuba

These robes are similar in construction to ch'i-fu, but tend to be much fuller, with wide sleeves and additional bands between the large cuffs and shoulder. The collar, bands, and cuff designs all matched. Most have eight roundels; three in front and three in back, with one on each shoulder. They were cut with an overlapped flap to the right. Women's official dress was also regulated by court guidelines. The robes of the wives of the officials conformed with the ranks of their husbands. However, the wives, consorts, daughters, and other female relatives of the emperor were allowed special robes of state.

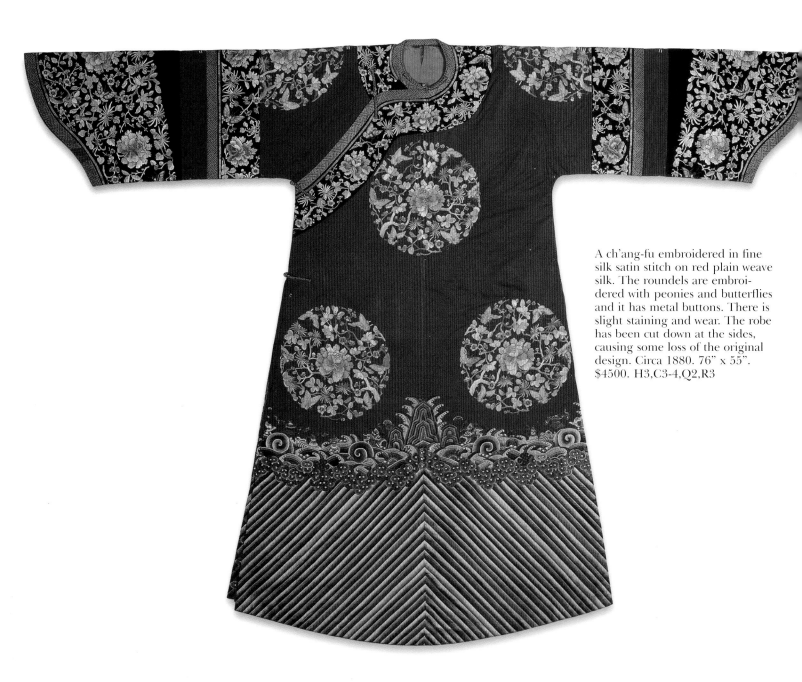

A ch'ang-fu embroidered in fine silk satin stitch on red plain weave silk. The roundels are embroidered with peonies and butterflies and it has metal buttons. There is slight staining and wear. The robe has been cut down at the sides, causing some loss of the original design. Circa 1880. 76" x 55". $4500. H3,C3-4,Q2,R3

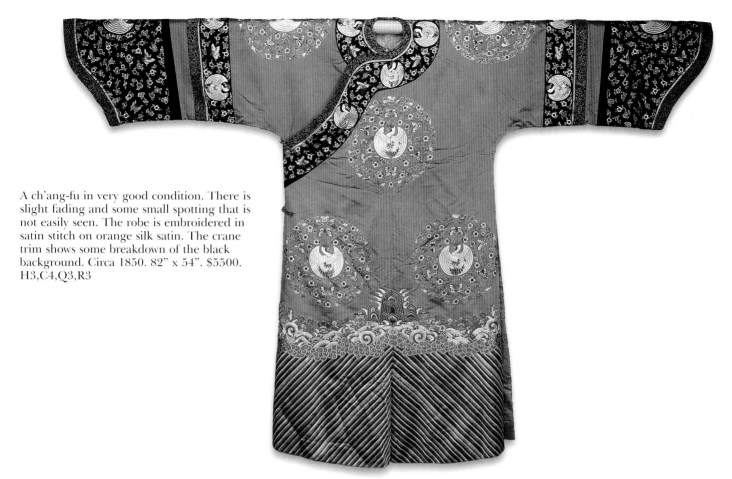

A ch'ang-fu in very good condition. There is slight fading and some small spotting that is not easily seen. The robe is embroidered in satin stitch on orange silk satin. The crane trim shows some breakdown of the black background. Circa 1850. 82" x 54". $5500. H3,C4,Q3,R3

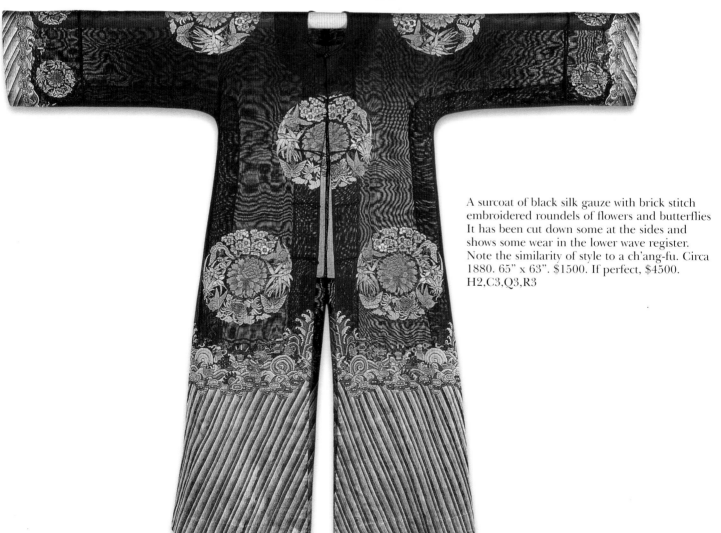

A surcoat of black silk gauze with brick stitch embroidered roundels of flowers and butterflies. It has been cut down some at the sides and shows some wear in the lower wave register. Note the similarity of style to a ch'ang-fu. Circa 1880. 65" x 63". $1500. If perfect, $4500. H2,C3,Q3,R3

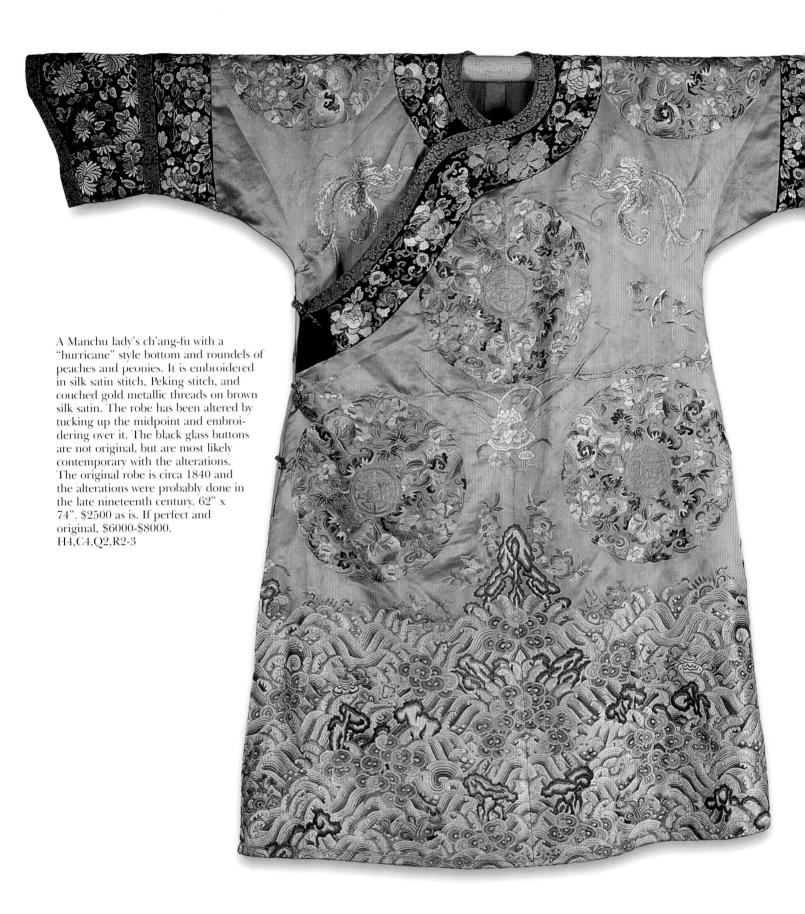

A Manchu lady's ch'ang-fu with a
"hurricane" style bottom and roundels of
peaches and peonies. It is embroidered
in silk satin stitch, Peking stitch, and
couched gold metallic threads on brown
silk satin. The robe has been altered by
tucking up the midpoint and embroi-
dering over it. The black glass buttons
are not original, but are most likely
contemporary with the alterations.
The original robe is circa 1840 and
the alterations were probably done in
the late nineteenth century. 62" x
74". $2500 as is. If perfect and
original, $6000-$8000.
H4,C4,Q2,R2-3

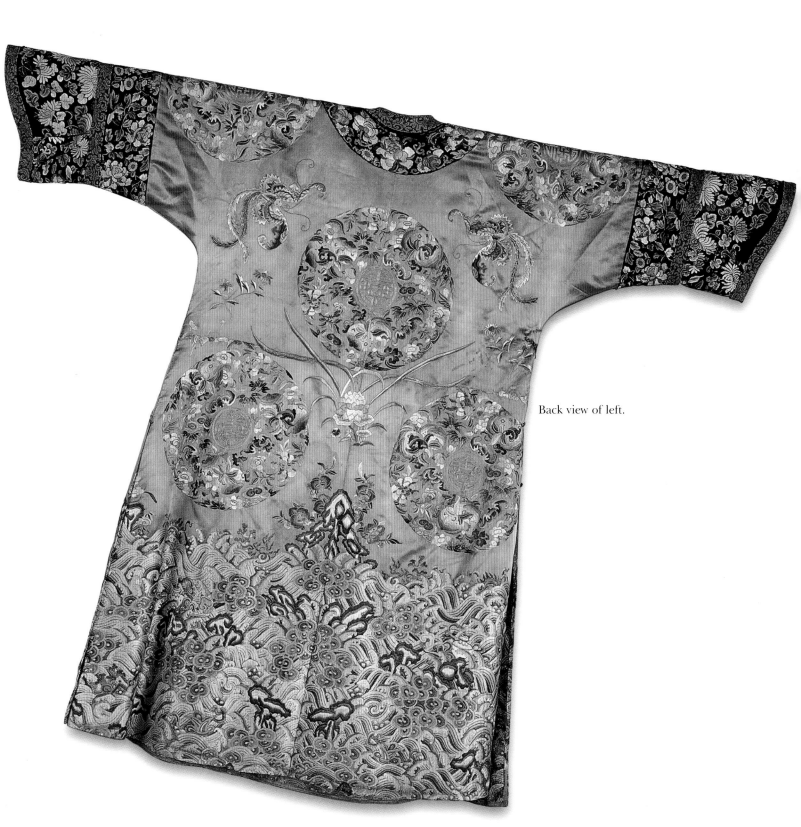

Back view of left.

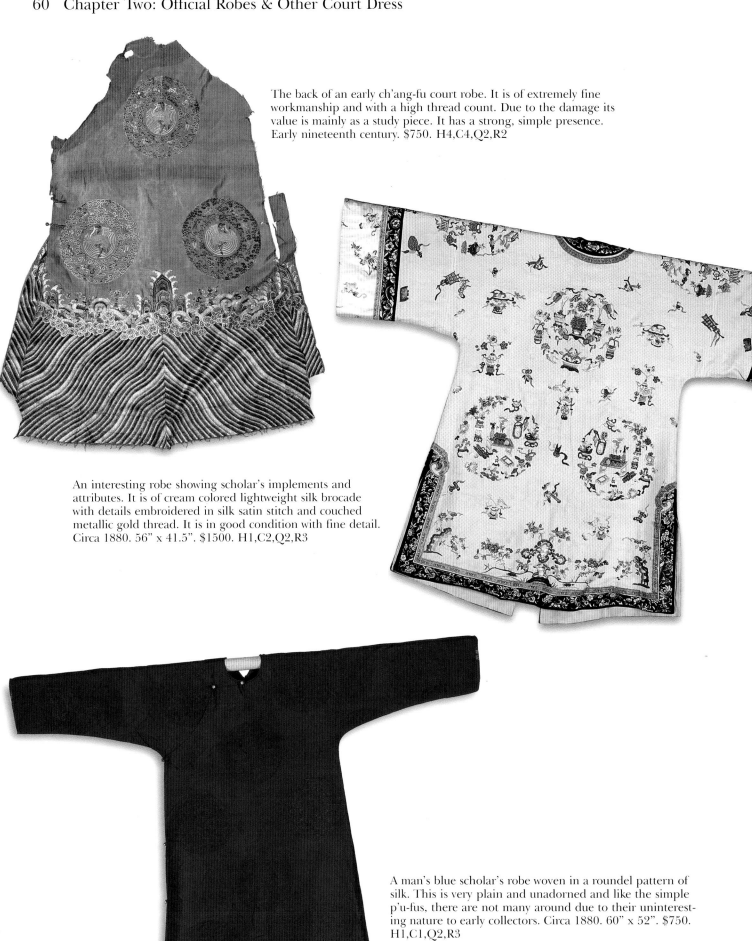

The back of an early ch'ang-fu court robe. It is of extremely fine workmanship and with a high thread count. Due to the damage its value is mainly as a study piece. It has a strong, simple presence. Early nineteenth century. $750. H4,C4,Q2,R2

An interesting robe showing scholar's implements and attributes. It is of cream colored lightweight silk brocade with details embroidered in silk satin stitch and couched metallic gold thread. It is in good condition with fine detail. Circa 1880. 56" x 41.5". $1500. H1,C2,Q2,R3

A man's blue scholar's robe woven in a roundel pattern of silk. This is very plain and unadorned and like the simple p'u-fus, there are not many around due to their uninteresting nature to early collectors. Circa 1880. 60" x 52". $750. H1,C1,Q2,R3

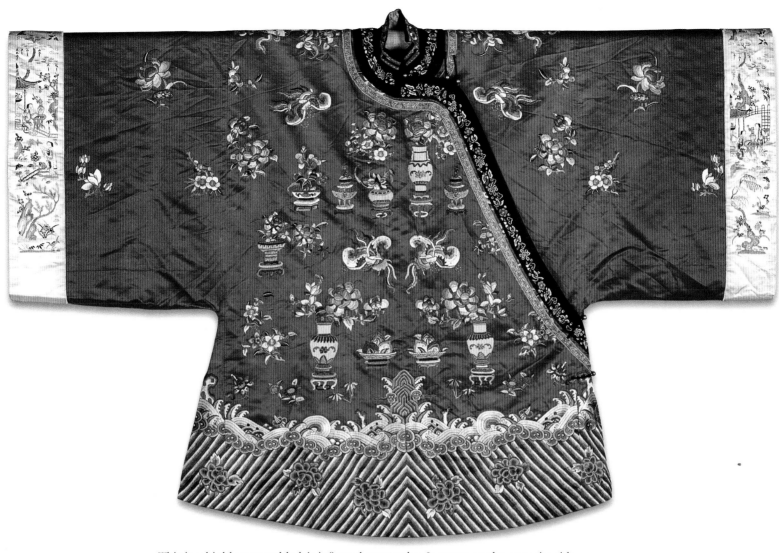

This is a highly unusual lady's informal court robe. It opens on the opposite side, compared to most others, and has an asymmetrical design in the satin and Peking stitch embroidered symbols. As noted in *Chinese Dress* by Verity Wilson: "During the period spanning the eighteenth to twentieth centuries...the only Chinese who reversed this procedure were those who wished to make a political statement against the ruling dynasty at the time of the Taiping rebellion (1850-1864)." It is in excellent condition and shows high quality workmanship. Late nineteenth century. 62" x 39". $2100. H1,C1,Q1,R2

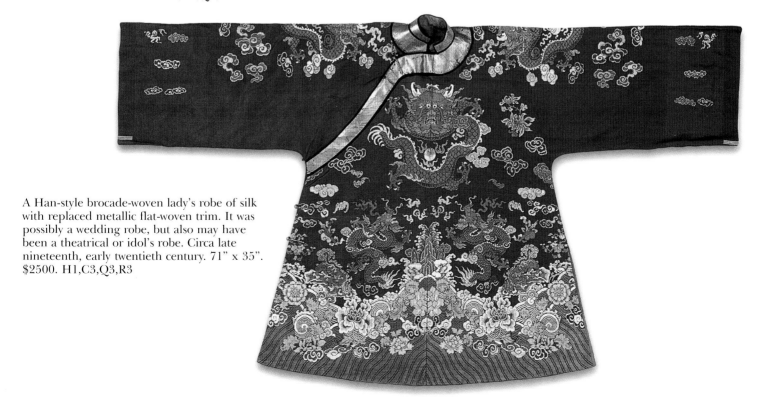

A Han-style brocade-woven lady's robe of silk with replaced metallic flat-woven trim. It was possibly a wedding robe, but also may have been a theatrical or idol's robe. Circa late nineteenth, early twentieth century. 71" x 35". $2500. H1,C3,Q3,R3

This is a circa 1900 chuba, although the dragons are in an earlier style. These fabrics were sent to Tibet as part of the Chinese imperial-sanctioned trade. This trade began during the reigns of the K'ang-hsi emperor (r.1662-1722) and his son, the Yung-cheng emperor (r. 1723-1735). Brocaded court robes continued a Ming-dynasty tradition and were popular in China until the beginning of the eighteenth century. Their continued popularity in Tibet may stem from the fact Tibet received much material from China as tribute.

Most of these ch'i-fu-type coats arrived in Tibet as yardage and were tailored locally into Tibetan-style chuba. Most are patterned with four-clawed mang dragons, not the five clawed lung dragons as in this example, which would suggest a date at the very end of the Ch'ing dynasty or later.

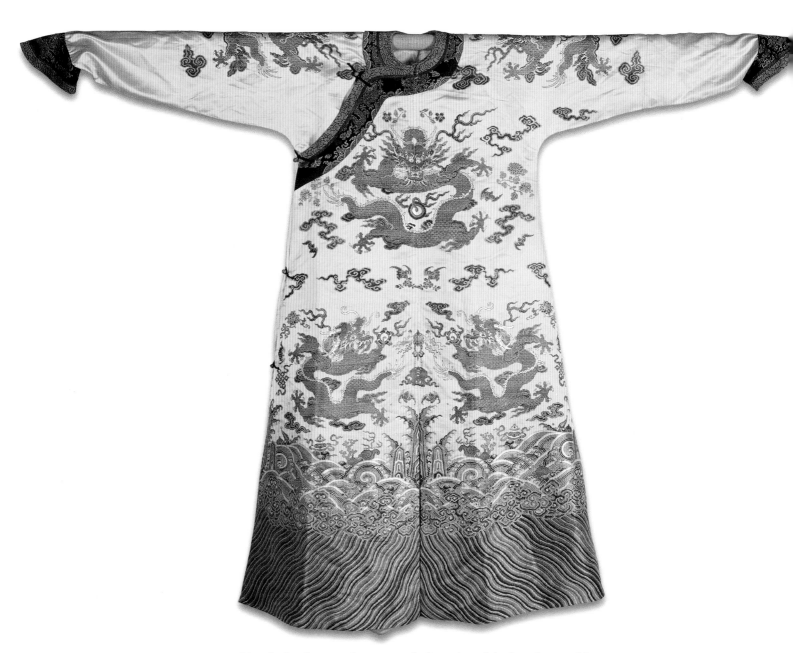

This robe has been made up recently from the original yardage and is lined with a light yellow gauze fabric. 59" x 80". $14,000. From the collection of Gary Wee. H1,C1,Q1,R2

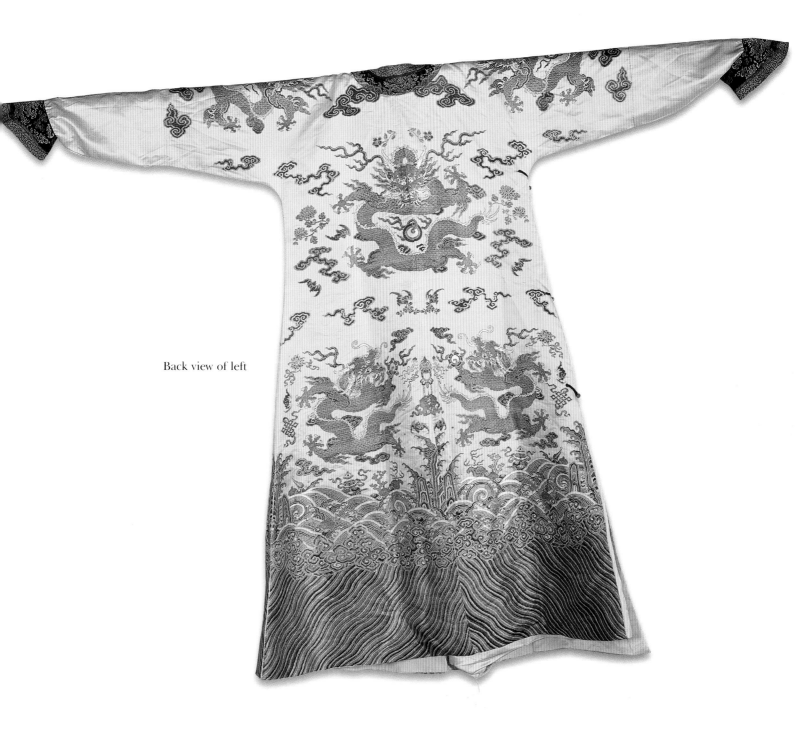

Back view of left

Children's Ch'i-fu Court Robes

Children of high-ranking officials were also accorded the privilege of the dragon robe. Children's robes are rarer than those of adults, due to wear and resizing.

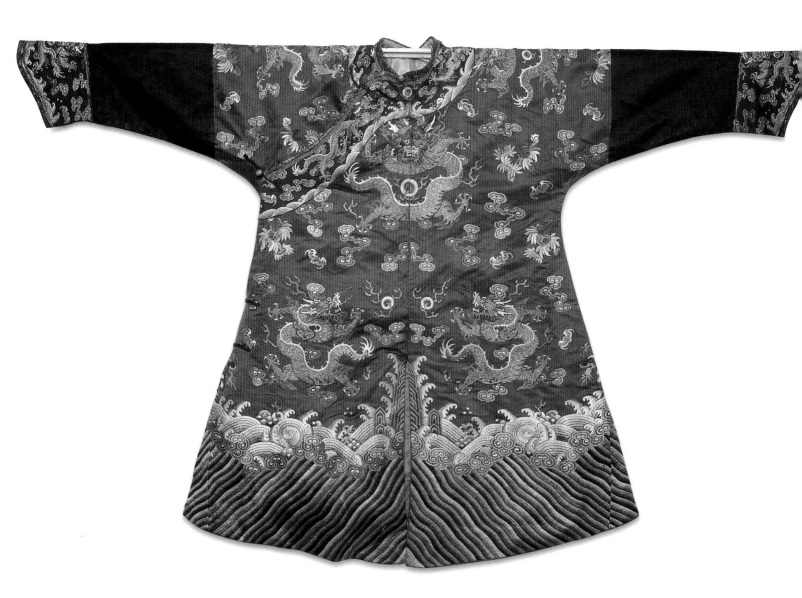

A child's ch'i-fu, most likely belonging to a son of a very high ranking official. It is of brown silk satin embroidered with silk satin stitch and couched metallic gold thread and is a very impressive small robe in good condition. Circa 1850. 54" x 36". $6500. H2,C3,Q2,R2

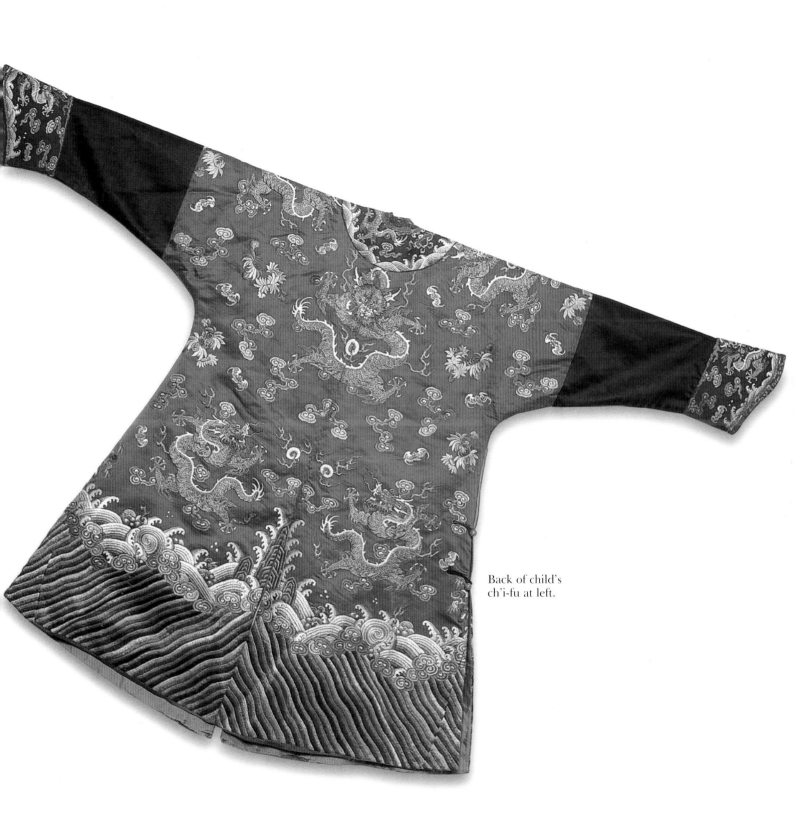

Back of child's
ch'i-fu at left.

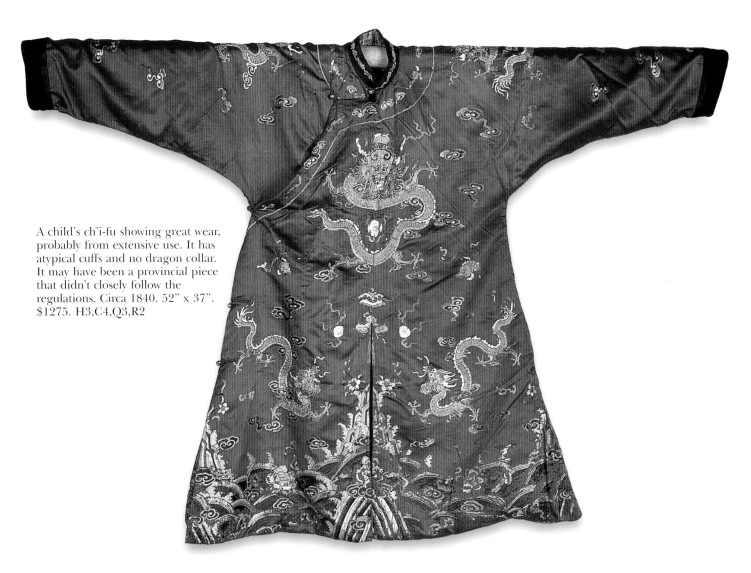

A child's ch'i-fu showing great wear, probably from extensive use. It has atypical cuffs and no dragon collar. It may have been a provincial piece that didn't closely follow the regulations. Circa 1840. 52" x 37". $1275. H3,C4,Q3,R2

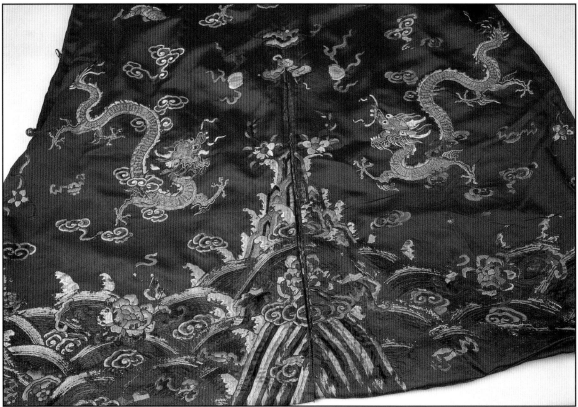

Detail of above showing wear

Chapter 3
Surcoats & Rank Badges

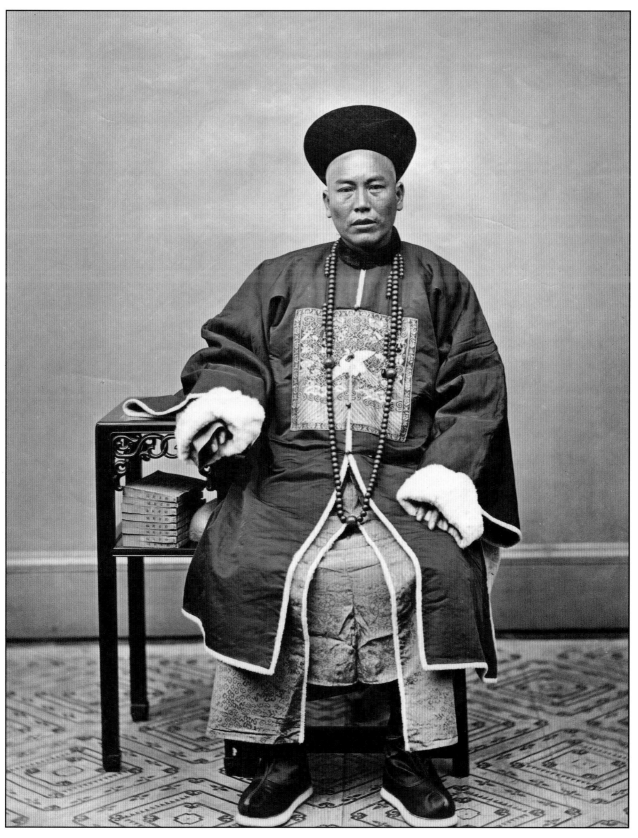

Photographer unknown. Portrait of a man in official robe. Circa 1870s. Vintage albumen print, 10.5" x 8.625".
Courtesy of Throckmorton Fine Arts.

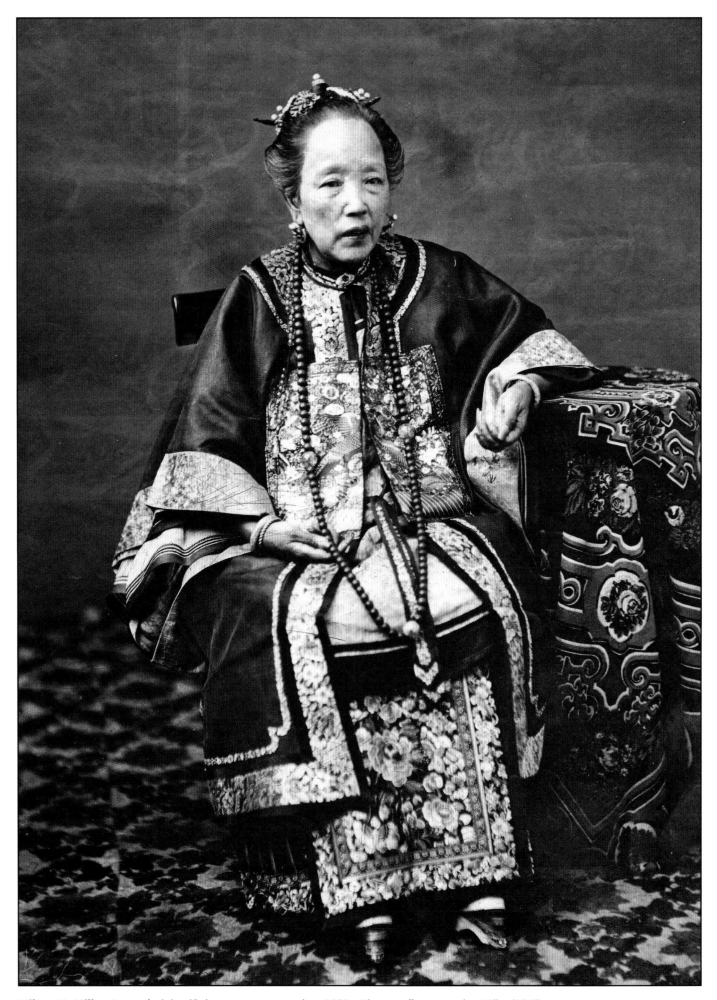

Milton M. Miller. A mandarin's wife in court costume, circa 1860s. Vintage albumen print 10" x 7.75".
Courtesy of Throckmorton Fine Arts.

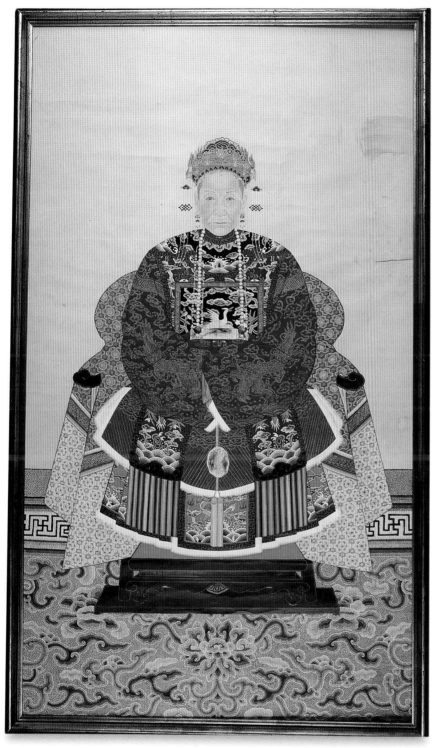

A watercolor ancestor portrait of a woman. It shows how the layers of clothing were worn and includes a court necklace, a rank badge vest with a first rank crane over a red winter fur-lined Han style formal or festival robe and Han style embroidered skirt. Circa second half of the nineteenth century. Picture only, 25" x 43". $1275.

P'u-Fu

At court, a simple dark robe, called a p'u-fu, was worn as an outer garment over the more elaborate robe called a ch'i-fu. It was emblazoned on the front and back with the corresponding pair of rank badges that reflected each wearer's status. A relatively few of these simple garments have survived due to their uninteresting nature. Late in the Ch'ing Dynasty and into the twentieth century we do see p'u-fus that resembled informal robes.

All officials, both civil and military, wore these dark blue or black garments, with the only distinctive difference being the badges. The simplicity equalized the playing field of the status of courtiers or others in attendance to the emperor, whereas the emperor, empress, and other family members wore regal robes.

Both men and women wore p'u-fus at court. Originally the only female allowed to wear the rank was the wife of the official, but as rules relaxed, mothers, daughters, and sons also indulged in the practice. The distinction between a male and a female badge is the position of the sun and of the bird or animal that adorned the badge. On the female badges the sun is on the right, as viewed, causing the bird or animal to also face right since the figure always faces the sun. The men's badges had the sun on the left and, thus, the figure facing toward the left as viewed. When a couple sat together they would position themselves so that the figures would face each other. The official's bird or animal would also face toward the emperor when at court. The civil officials would stand to the left side and the military officials on the emperor's right. The military badges were another issue as when the official was in the presence of the emperor, images on the badges put the official at odds with the placement of his wife, so the military badges often have the sun in the correct position but the animal may face the opposite direction and look over its shoulder.

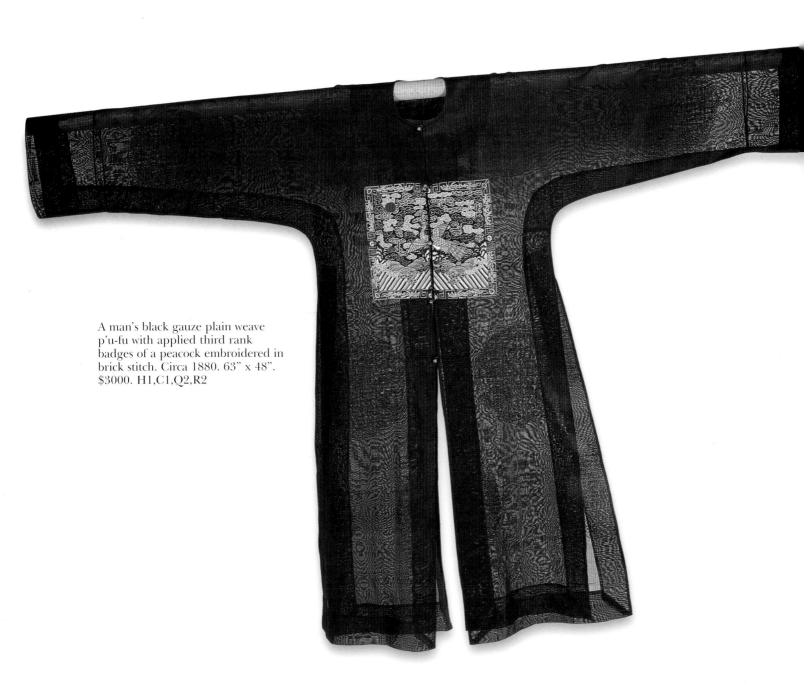

A man's black gauze plain weave
p'u-fu with applied third rank
badges of a peacock embroidered in
brick stitch. Circa 1880. 63" x 48".
$3000. H1,C1,Q2,R2

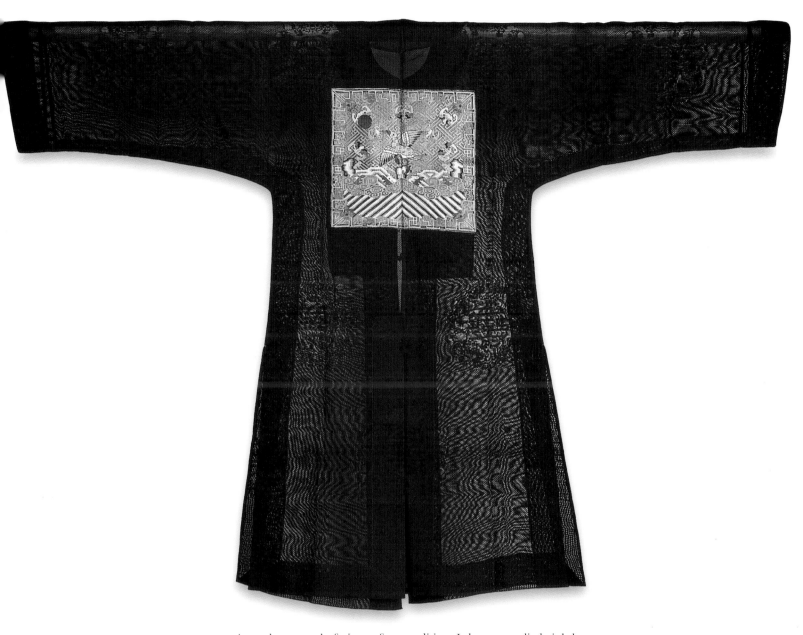

A man's gauze p'u-fu in perfect condition. It has an applied eighth rank quail badges embroidered in brick stitch on gauze. Late 19th century. 66" x 47". $3000. H1,C1,Q2,r3

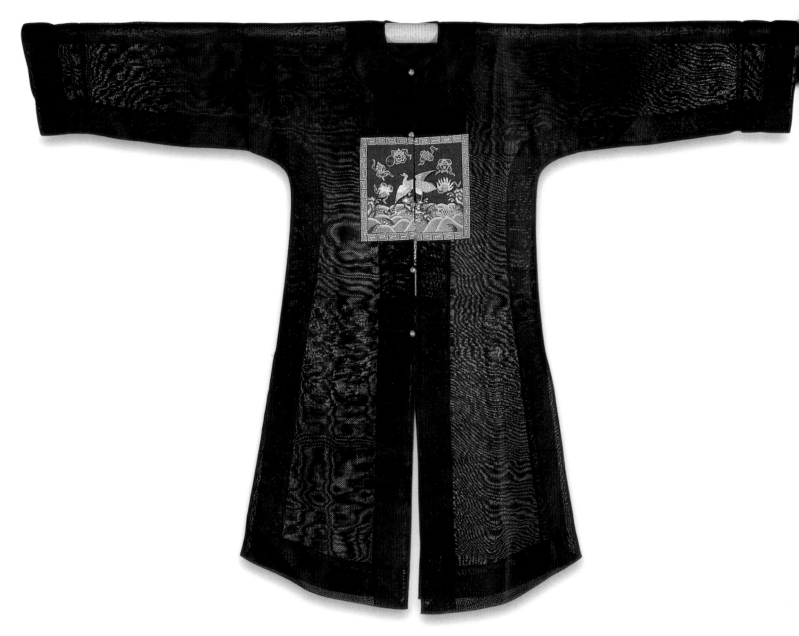

A man's p'u-fu of black gauze woven in a roundel pattern. It has applied rank badges consisting of fine petit point background stitch with an applied fourth rank wild goose embroidered in fine satin stitch on both back and front. Circa 1880. Badges measure 9" x 8.25", p'u-fu measures 64" x 46.75". $2500. H1,C1,Q2,R2

This is a nice, woman's p'u-fu and even though the piece is in fairly rough condition, it is valued with an eye to the beautiful and detailed embroidery. Note the height of the center mountain. This helps in identifying the time frame for the piece. The ninth rank paradise flycatcher badge is embroidered into the robe. Circa 1850. 63" x 46.5". $1500. H2,C3,Q2,R3

Front of above.

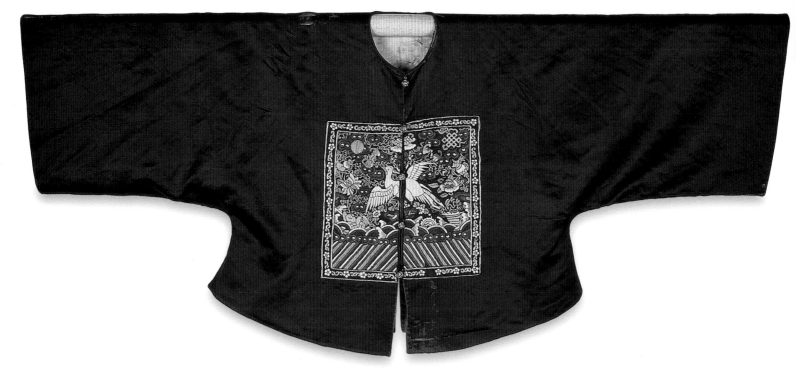

This short style ma-kua riding jacket has been reused as a p'u-fu with the addition
of blue-black silk satin with ninth rank paradise flycatcher badges. This is an
unusual style due to the length of the jacket. The badges are embroidered in
Peking stitch and couched metallic gold thread. There is some wear to the silk and
a small amount of wear to the front badge. Circa 1870. 54.25" x 24.5". $1400.
H2,C3,Q2,R3

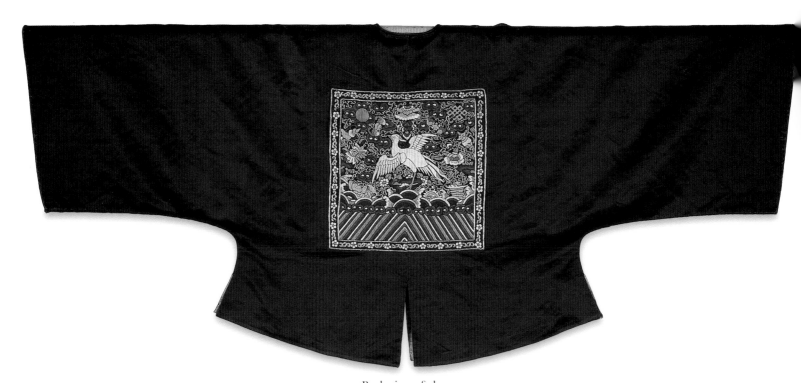

Back view of above.

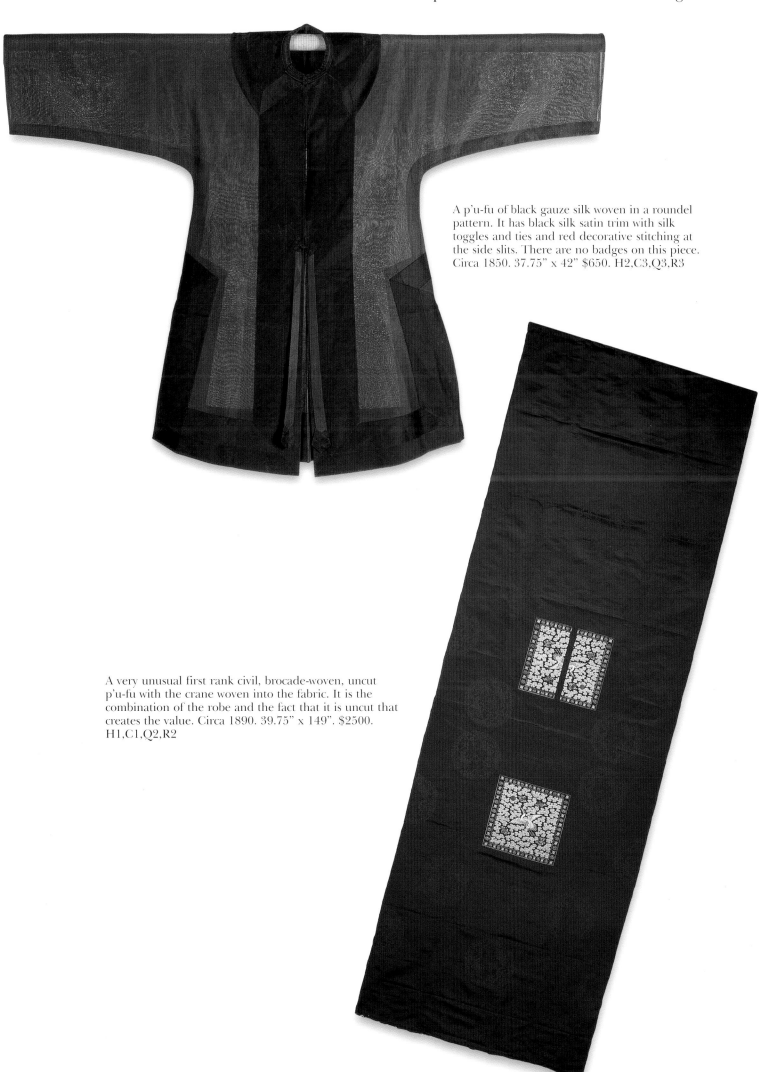

A p'u-fu of black gauze silk woven in a roundel pattern. It has black silk satin trim with silk toggles and ties and red decorative stitching at the side slits. There are no badges on this piece. Circa 1850. 37.75" x 42" $650. H2,C3,Q3,R3

A very unusual first rank civil, brocade-woven, uncut p'u-fu with the crane woven into the fabric. It is the combination of the robe and the fact that it is uncut that creates the value. Circa 1890. 39.75" x 149". $2500. H1,C1,Q2,R2

Rank Badge Vests

The vest is another garment on which the badges of rank could be worn. These were often woven or embroidered with the center areas intentionally left bare to provide space for the badges to be sewn in. There were, however, some that had the rank image created at the same time as the vest, either woven or embroidered. These were most likely made for clients with disposable income, as they could not be changed as the family rose in rank.

These vests were often highly embellished with auspicious symbols, dragons, and the individual birds of rank around the badge area and they often had tasseled fringes along the bottom edge. These were attached with a hand-netted band across the top.

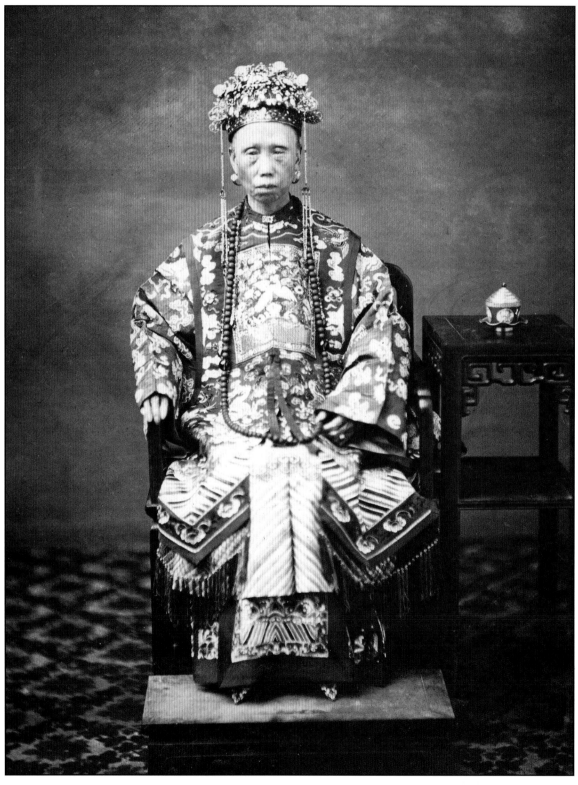

Milton M. Miller. High ranking mandarin's wife in full court robe, circa 1860s. Vintage albumen print. 10.5" x 8.125". Courtesy of Throckmorton Fine Arts

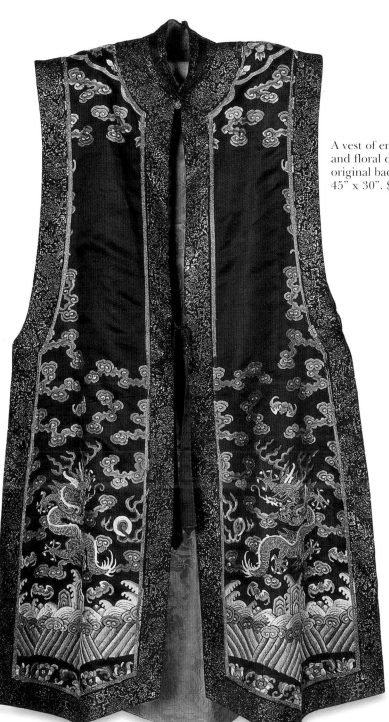

A vest of embroidered silk satin stitched bats and floral designs on dark blue silk satin. The original badges have been removed. Circa 1860. 45" x 30". $1800. H1,C3,Q3,R3

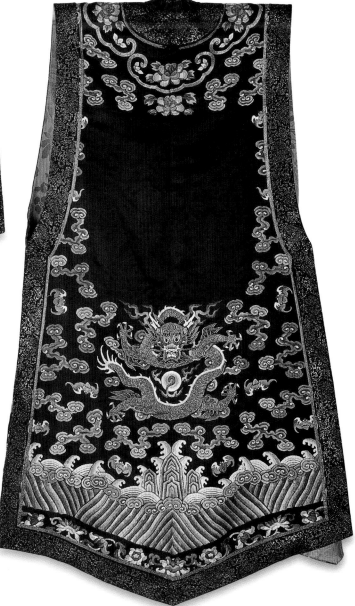

Back view of above.

A k'o-ssu woven vest. This piece would have been worn at court with rank badges attached on the front and back showing the family's rank. This style displays all of the birds of rank woven into the pattern. The netting and tassels at the lower edge were adapted from Han-style clothing. Circa 1850. 49.5" x 64". $1750. H2,C3,Q3,R3

This is an early brocade-woven lady's court vest. The warp threads have broken down and the piece has been completely stabilized. Circa 1820. 46" x 28". $950. H3,C4,Q2,R2

Badges

Rank badges or mandarin squares, as they are often called, were the emblems worn on the front and back of the outer layer of clothing at court showing the civil or military rank.

Civil

The civil rank badge is most commonly encountered. The level it represented was, in theory, attained through rigorous testing, at least in the Ming and earlier years of the Ch'ing dynasties. In later years when the imperial coffers were low, rank was for sale or given in return for special favors. The original testing consisted of huge amounts of memorized information and was so demanding that only a very small percentage of examinees ever passed the first exam. Those who did were allowed to proceed to the next levels where the percentages of those who passed dropped even lower. Cheating was not unheard of, but was greatly frowned upon. If caught, a student's honor and that of his family and possibly his village would be in jeopardy. That being said, there were many forms of "cheat sheets" such as the two shown.

All of the expenses of the schooling and testing were the responsibility of the student, so many were never able to attain their goals for monetary reasons. Often a whole family or even a village would pool their resources for a particularly bright student who, they felt, would bring honor to them.

Although the rank was conferred by the emperor, the badges themselves had to be obtained by the newly hired or promoted official. This helps explain the wide variance of design and workmanship of the squares. Contrary to traditional thinking, the more difficult badges to obtain are the lowest ranking ones, that belonged to poorer officials unable to proceed in their testing due to lack of funds; they probably had only one court costume. Also, it was customary to be buried in one's best garment

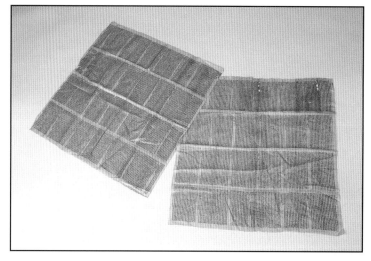

These panels are finely woven silk, with hand-drawn Chinese characters. They were likely made as "cheat sheets" for civil service exams. They are seldom found and difficult to value. 17" x 17.25" each. We are giving them a value of $2500-$3000 each due to their rarity.

so many badges and costumes no longer exist in our world.

The following is a listing of the Ch'ing court civil official's regulations, as these are most commonly seen on the market today. There are other fine publications including *Ladder to the Clouds* by Beverly Jackson and David Hugus that explain the evolution of rank badges over the centuries. The ranks were represented by established bird symbols as follows:

First	Crane
Second	Golden Pheasant
Third	Peacock
Fourth	Wild Goose
Fifth	Silver Pheasant
Sixth	Egret
Seventh	Mandarin Duck
Eighth	Quail
Ninth	Paradise Flycatcher

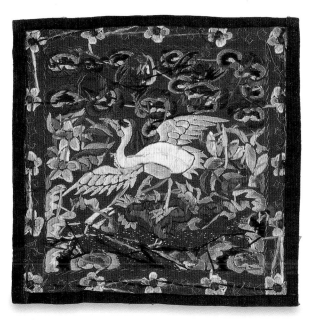

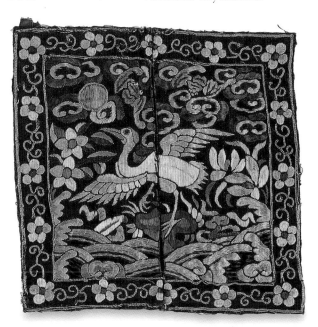

A pair of unusually small rank badges for a male child of first rank. The crane design is embroidered in silk satin stitch with couched gold metallic threads on silk. Circa 1880. Note the reverse side of the back badge, which illustrates the embroidery. Front badge 5.5" x 5.5", back badge 5.75" x 5.5". $1800 for the pair. H2,C3,Q3,R2

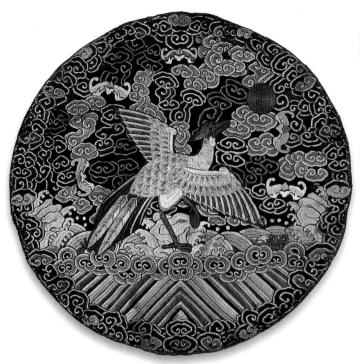

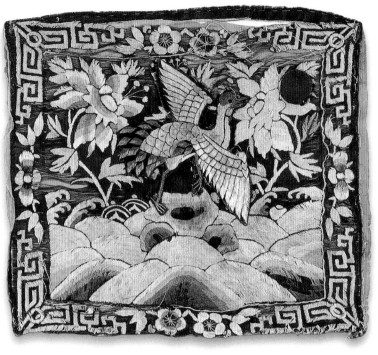

A single back, female roundel badge of a second rank goldcn pheasant. It is embroidered with silk satin stitch on silk. Round badges were originally for members of the imperial family. "Deceptive" round badges were produced primarily in the late Ch'ing period when regulations concerning style and composition were no longer enforced. Circa 1890. 10.5" diameter. $950. H3,C3,Q3,R3

A single back, female rank badge with a first rank crane embroidered in silk satin stitch on silk. This is a good example of a late badge in very poor condition and not economically feasible to restore. The only value is in the bird, c. 1890. 11" x 10". $195. H4,C5,Q3,R4

This badge is a second rank golden pheasant. It is unusual in that the background and appliquéd bird, though contemporary with each other, were produced differently. The black background silk used an iron mordant in the black dye and it is breaking down. The bird, however, has been produced with aniline dyes so it is still in good condition. It is embroidered in silk satin stitch with couched metallic threads and shows the Buddhist eight precious things surrounding the bird. 1870-1890. 11.5" x 11.5". $500. H4,C4,Q3,R3

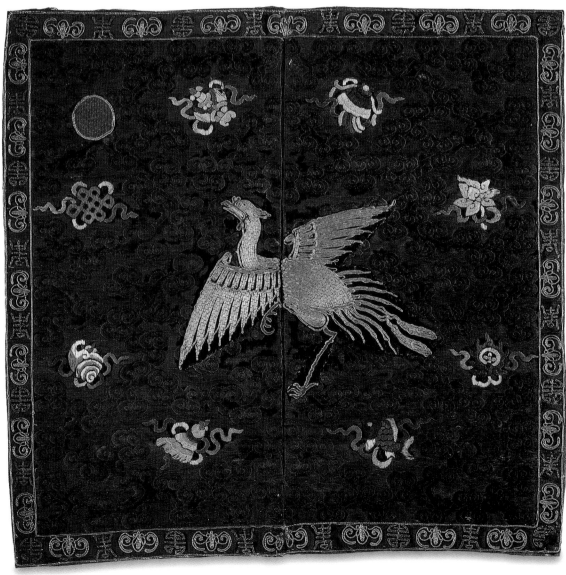

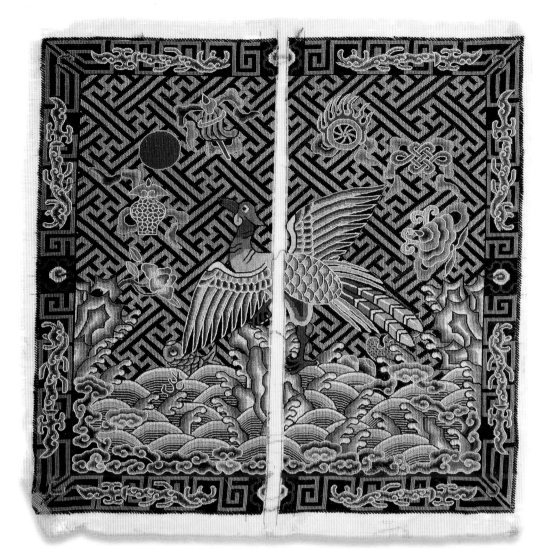

An uncut, unused front male badge of a second rank golden pheasant that was beautifully embroidered in fine silk needlepoint, on silk gauze. Perfect condition. Circa 1890. 10.75" x 11". $950. From the collection of Gary Wee. H1,C1,Q1,R3

A beautiful background of silk satin stitch on black silk satin. The bird, a third rank peacock, is most likely a later addition and is embroidered in silk with long and short stitch and is appliquéd on. The badge shows some breakdown of the silk background and is probably circa 1860. The bird most likely dates to circa 1890. 10.75" x 11.5". $500. H2,C4,Q2,R3

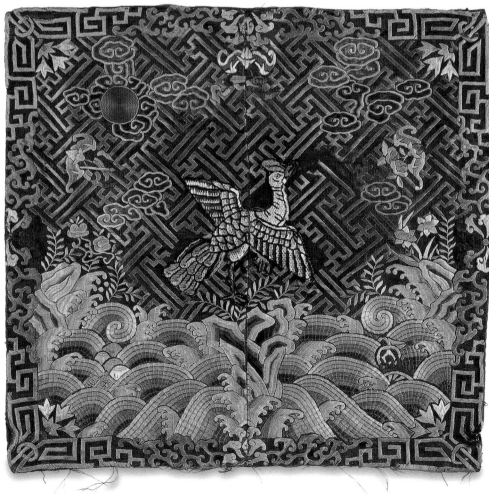

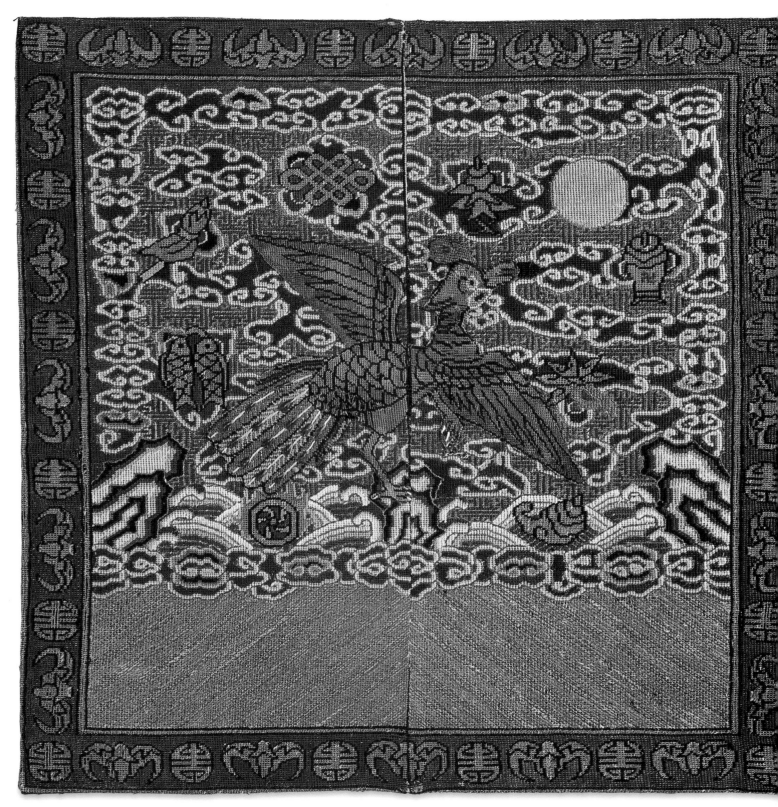

A very finely made lady's third rank peacock front badge. This is embroidered in a combination of silk, and gold and silver metallic threads in fine petit point on silk gauze. Note the fine grid background. The bird is embroidered in the same manner and appliquéd onto the backing. It is in very good condition, showing only a little wear at the edges. Circa 1880. 11.5" x 11.5". $800. H1,C2,Q1,R2

An unusual back rank badge with a third rank peacock, with bamboo and a pine tree embroidered in silk satin stitch on black china silk. The appliquéd peacock is embroidered in silk and couched gold metallic thread. This illustration shows how it was recycled as a cover for a notebook. Circa 1880. 12" x 11.5". $750. H2,C3,Q3,R3

This is the peacock badge after it was removed from the album cover in the photo above.

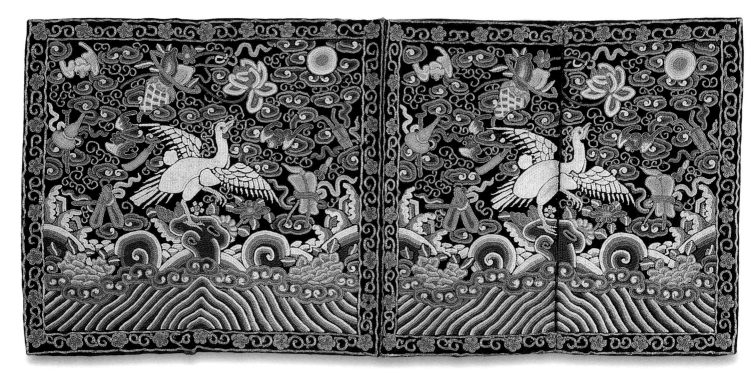

A pair of finely executed, small, fourth rank wild goose lady's badges in perfect condition. Embroidered all over in Peking knot stitch and couched metallic threads. Circa 1870. 9" x 9.1". $3000. H1,C1,Q1,R2

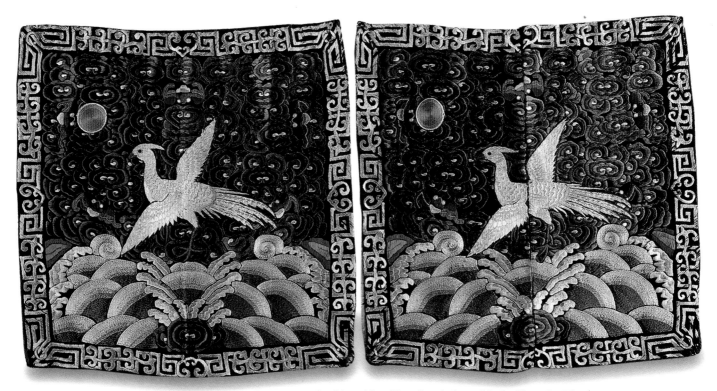

A pair of fifth rank silver pheasants embroidered in silk satin stitch on black silk satin. These are in good condition with just a little wear on the edges. Circa 1880. 12" x 11.5". $1200. H1,C2,Q3,R4

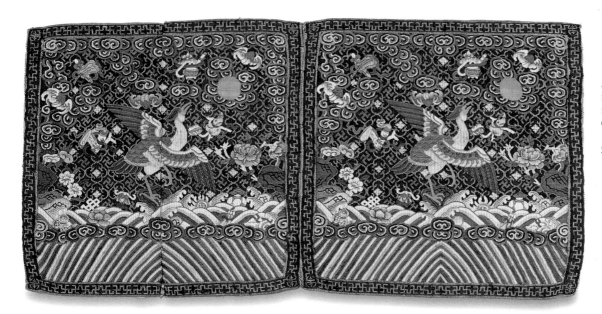

A pair of k'o-ssu woven, female, seventh rank mandarin duck badges. Circa 1850. Back 11.625" x 12.25", front 11.5" x 12.5". $2000. H2,C2,Q2,R3

The back of an early nineteenth century seventh rank mandarin duck rank badge showing the stitch patterns and original colors. It is interesting to see the structure of embroidery and the brighter, unfaded colors. 12.5" x 12.75". $1200. H4,C3,Q2,R3

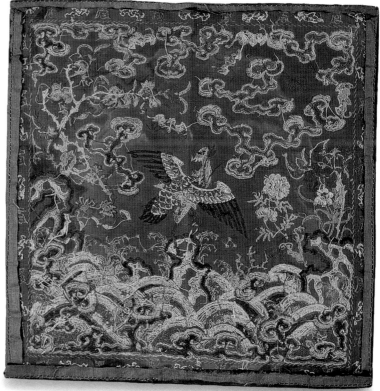

A seventh rank mandarin duck male front badge. It has a background completely done couched metallic gold thread and the bird, symbols, and surroundings are embroidered in silk Pekinese stitch. There is some wear on the gold thread, but is, otherwise, in good condition. It is an interesting reuse of a set of possibly damaged badges, using half of a front and half of a back together. Circa 1840. 12.25" x 11.75". $1275. A complete, original badge would be $2500. H3,C4,Q2,R2

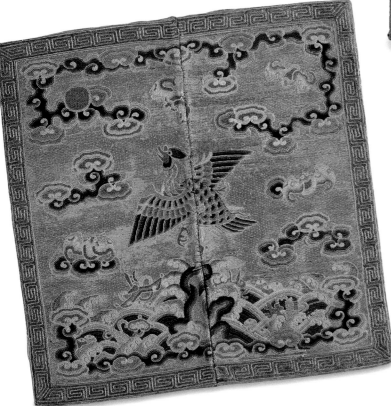

This is a very crudely made seventh rank mandarin duck badge. It is likely an early fake for the tourist trade. It is embroidered in silk satin stitch on gold silk background with couched gold metallic thread around the edges. Circa 1900. 9.5" x 9.5". The value is nominal and only as an early example of a fake. H4,C3,Q4,R4

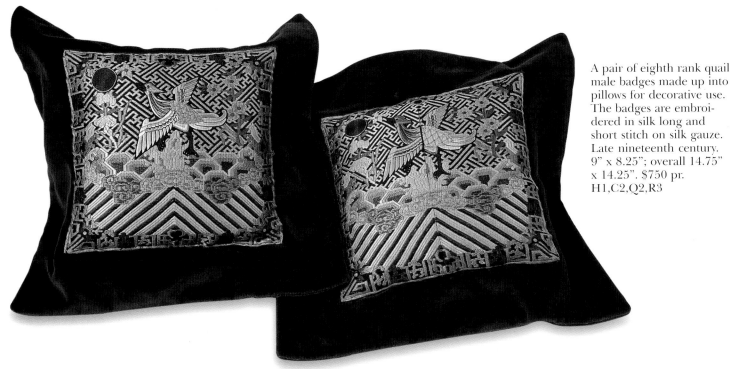

A pair of eighth rank quail male badges made up into pillows for decorative use. The badges are embroidered in silk long and short stitch on silk gauze. Late nineteenth century. 9" x 8.25"; overall 14.75" x 14.25". $750 pr. H1,C2,Q2,R3

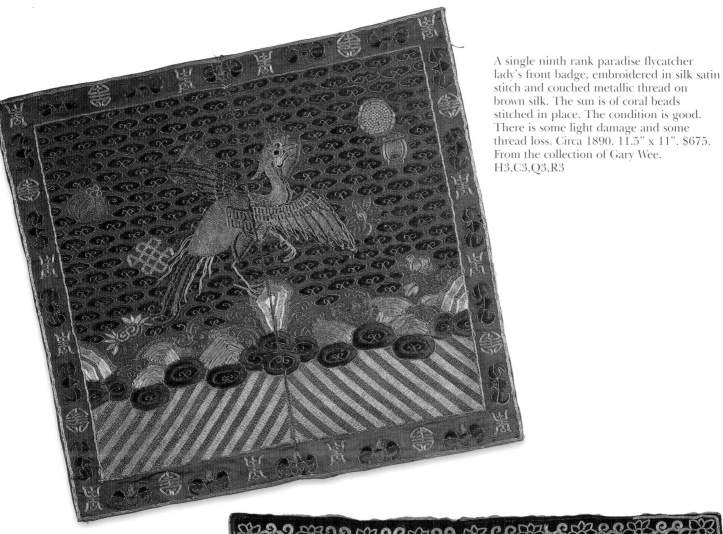

A single ninth rank paradise flycatcher lady's front badge, embroidered in silk satin stitch and couched metallic thread on brown silk. The sun is of coral beads stitched in place. The condition is good. There is some light damage and some thread loss. Circa 1890. 11.5" x 11". $675. From the collection of Gary Wee. H3,C3,Q3,R3

A male, ninth rank civil paradise flycatcher badge, embroidered with couched gold metallic threads on black silk. Circa 1860. 11.75" x 11.25". $475. H2,C3,Q3,R3

Military

Another prominent group of badges were for the military officials. These consisted of the same type of square but with an animal rather than birds. Military officials were not as admired as the civil officials, because the military testing was considered inferior, with tests of strength and accuracy being foremost. Rank was often inherited, also. Towards the end of the Ch'ing dynasty, even as early as around 1800, the Chinese started raising irregular, unofficial military units. By 1850 the Chinese were developing more modern armies that resembled Western style military units. These irregular units, often commanded by local gentry, were still loyal to the emperor, but did not follow older regulations of formal attire. This being said, military badges are more difficult to obtain and, hence, generally of higher value. There are very few low-ranking badges available for some of the same reasons as for the civil. The last three ranks are virtually non-existent.

As stated previously, when the official was in the presence of the emperor and located on his right, the images on the badges put the official at odds with the placement of his wife so the military badges have the sun in the correct position but the animal may face the opposite direction and look over its shoulder.

Again, we will list only the late Ch'ing (1646-1911) animal styles due to availability.

First	Ch'i-lin
Second	Lion
Third	Leopard
Fourth	Tiger
Fifth	Bear
Sixth	Panther
Seventh	Rhinoceros
Eighth	Rhinoceros
Ninth	Sea Horse

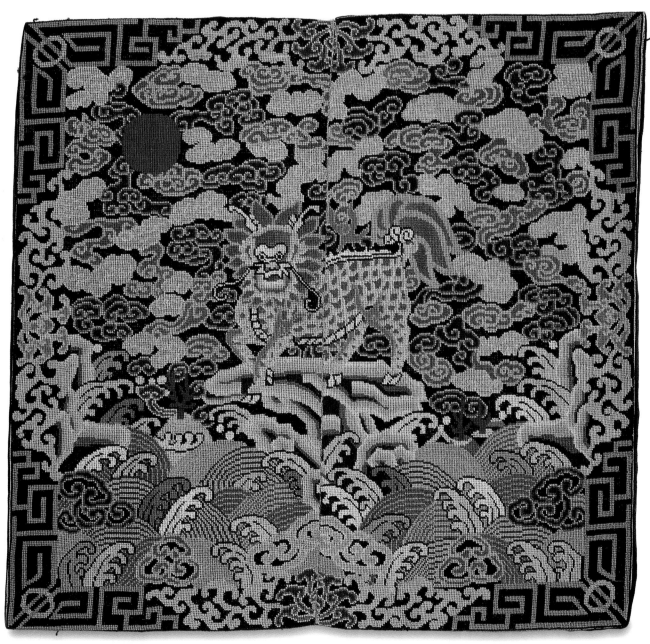

First rank male military ch'i-lin badge. The ch'i-lin is a mythical creature with the head of a dragon, body of a stag, scales of a fish, and tail of a Chinese bear representing felicity, longevity, and wise administration. This one is a front badge in silk needlepoint. Circa 1900. 10" x 10.25". $2000. H1,C1,Q2,R3

A pair of female k'o-ssu woven second rank lion badges in very good condition, with slight staining on the back one. Note the difference of the variegated threads on the bodies. Circa 1870. 11.5" x 11.75". $2500. H3,C3,Q3,R3

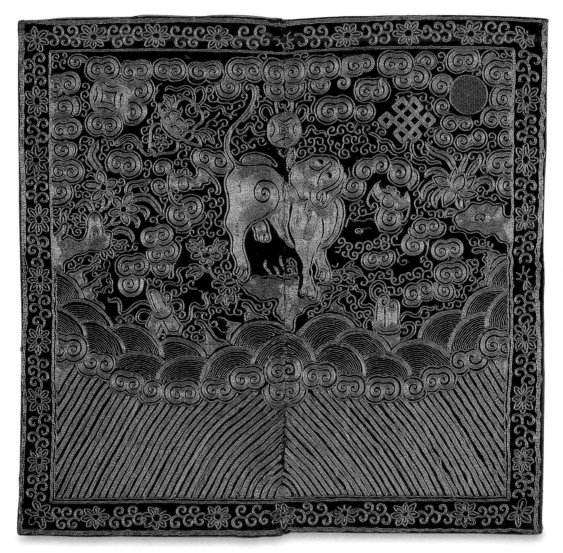

A single front, female second rank military rank badge of a lion. It is embroidered in couched gold metallic threads on black silk. This piece has minor restoration. Circa 1890. 11.375" x 11.875". $995. H2,C2,Q2,R3

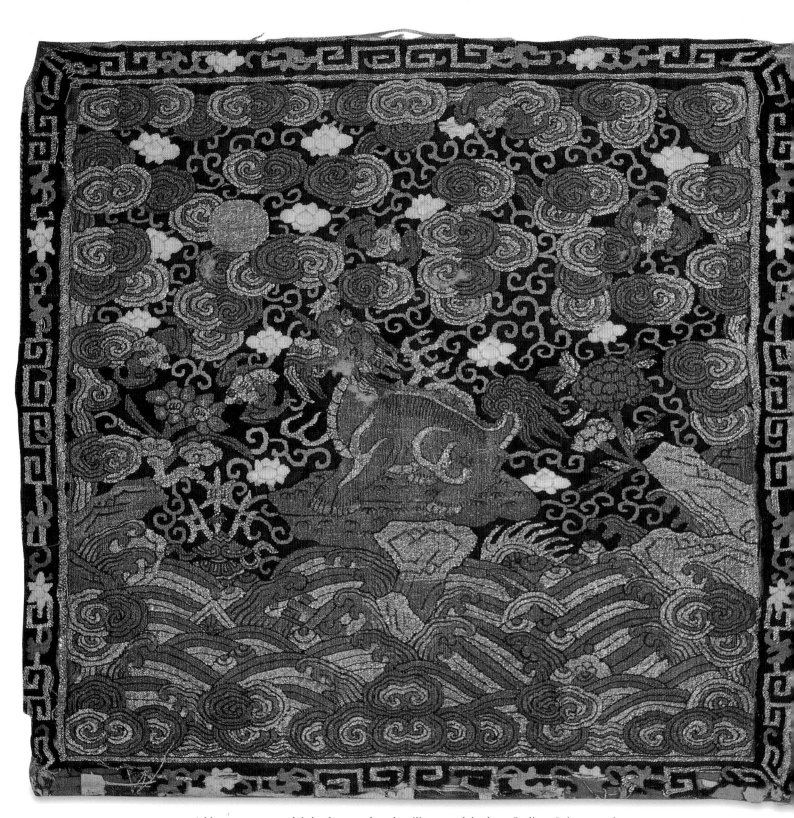

A k'o-ssu woven male's back second rank military rank badge of a lion. It is woven in
gold and bronze metallic thread with blue, black, and white silk threads. Circa 1860.
11.75" x 12.25". $1100. If perfect, $3000 plus. H2,C4,Q1,R2

A pair of military fourth rank male badges each with the figure of a tiger embroidered in couched gold metallic threads and satin stitched silk threads. The background is in an unusual grid pattern. The badges have been completely stabilized and even with the repairs, they show some loss. Circa 1870. Each measures 10.25" x 11.5". $1200 for the pair. If in excellent condition, $2000. H4,C4,Q3,R3

A pair of lady's brick stitch military fourth rank badges with tigers. These are unusual in that their stripes have been over-painted along with being worked in the petit point stitch and, although the tiger bodies are facing left, they are looking over their shoulders at the suns. The work is very fine as shown in the grid background. Circa 1880. 11.75" x 11.75". $2750. H3,C3,Q3,R3

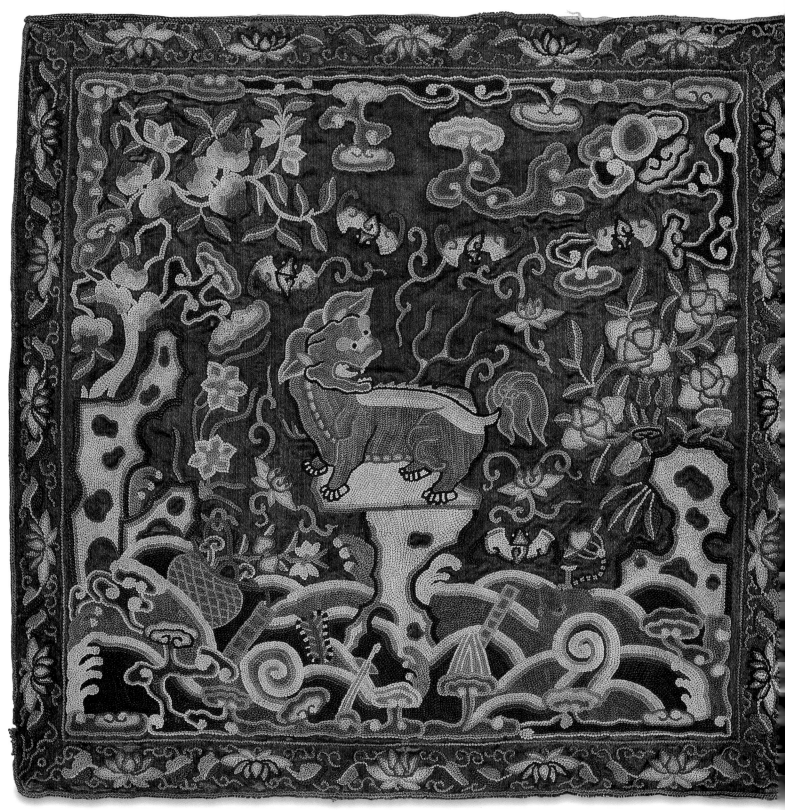

A military fifth rank badge of a bear embroidered in Peking stitch on blue silk satin.
Circa 1820. 12" x 12". $5000. H2,C3,Q1,R2

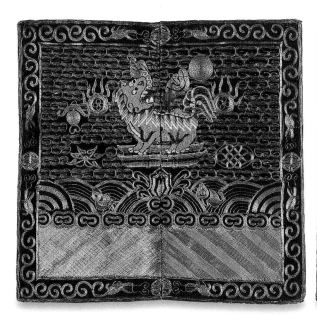
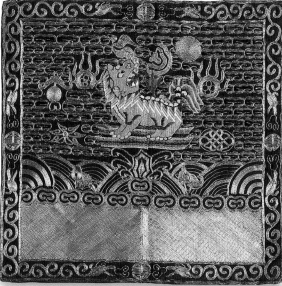

Pair of lady's fifth rank bear military badges embroidered in silk satin stitch and couched metallic gold thread. Circa 1890. 10.5" x 11.5" each. $1800. H2,C2,Q3,R3

A single front, fifth rank military bear badge in silk needlepoint on silk gauze with couched metallic gold edges. Circa 1830. 12.5" x 11.25". $2500. H3,C3,Q2,R2

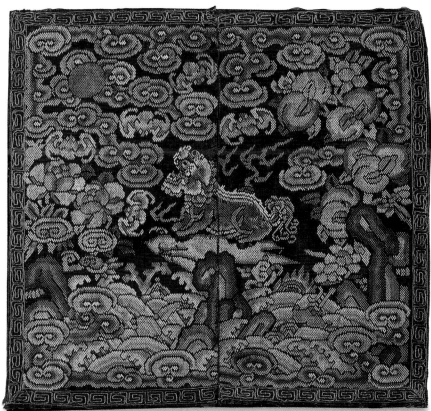

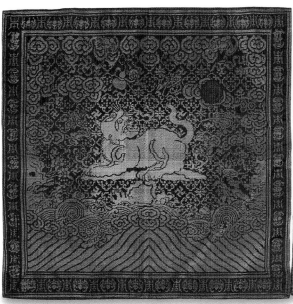
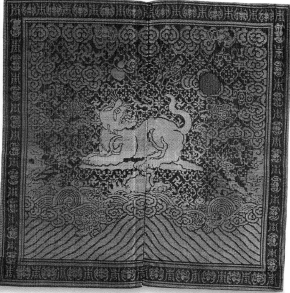

A pair of sixth rank panther military badges for a lady. These are brocade-woven in black and gold colored silk and have a red sun. Circa 1880. Back 11.5" x 11.875", front 11.25" x 11.75". $1800. H1,C1,Q3,R3

Nobility Emblems

The emperor and his extended family wore another form of badge. These were originally square like other badges, but were embellished with a dragon motif; later the shapes were mostly round. The roundels and squares were often woven into the garments and over the years have been removed and presented as stand-alone items. The availability of these is on par with the military badges.

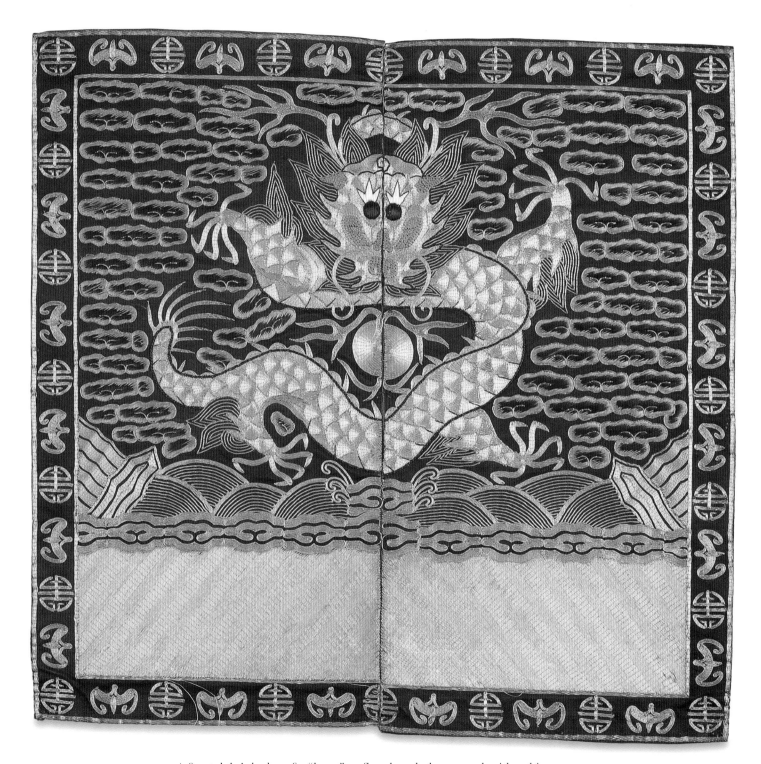

A front duke's badge of a "lung," or five-clawed, dragon embroidered in couched gold threads and silk satin stitch on silk. Circa 1890. 12.25" x 11.75". $1200. H1,C1,Q3R3

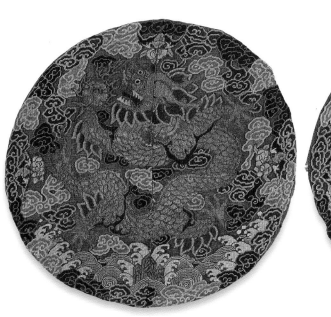
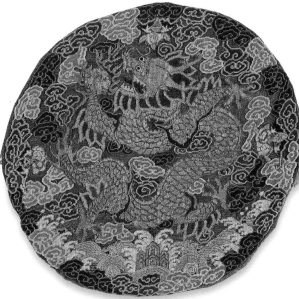

A pair of roundels of silk petit point on silk gauze with striding lung dragons. Circa 1870. The back is 10.25" diameter, front is 10" diameter. $2200. H3,C3,Q2,R3

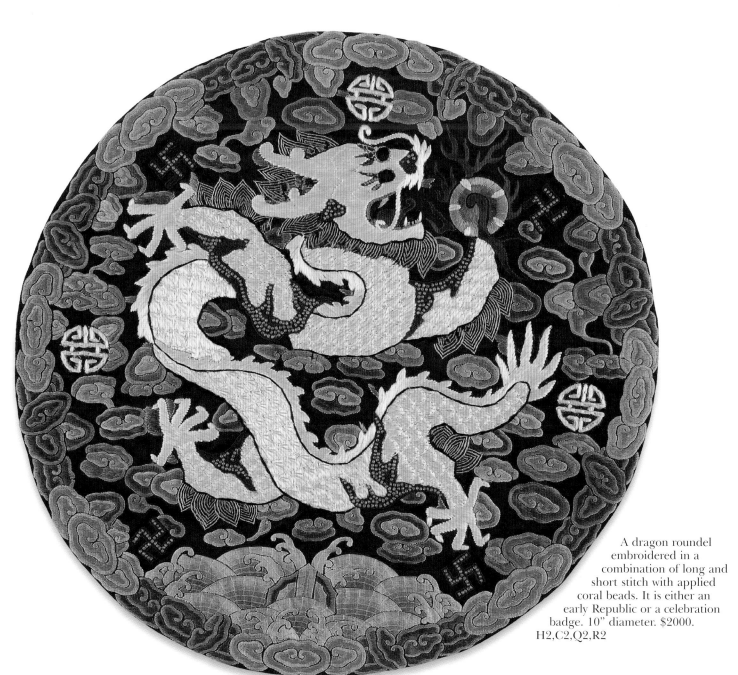

A dragon roundel embroidered in a combination of long and short stitch with applied coral beads. It is either an early Republic or a celebration badge. 10" diameter. $2000. H2,C2,Q2,R2

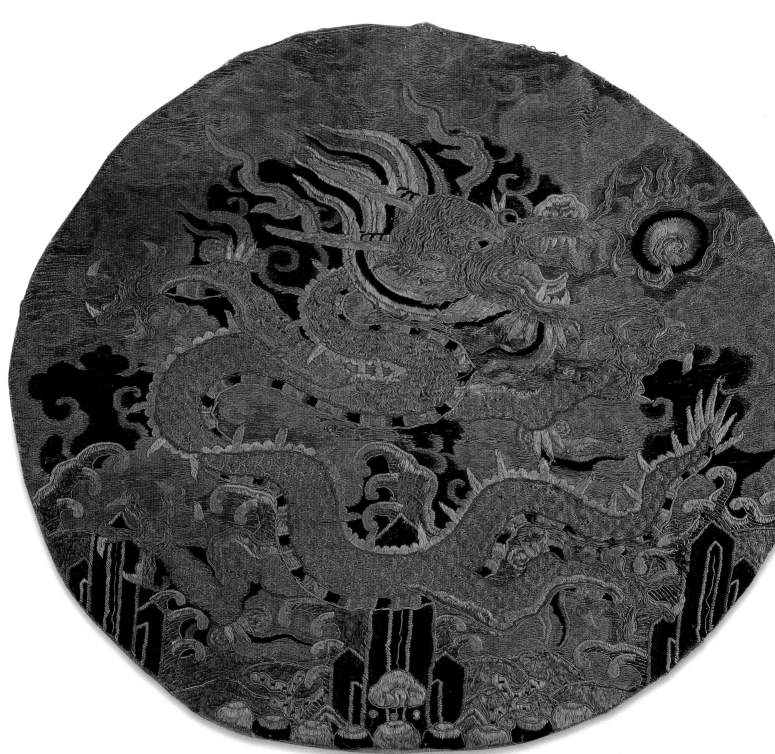

A roundel of a dragon from a late Ming dynasty robe. It is brocade-woven with couched cord details and in poor condition. It has been completely stabilized and is an example of an early ducal badge. 11.5" x 13". $5000. From the collection of Gary Wee. H4,C4,Q1,R2

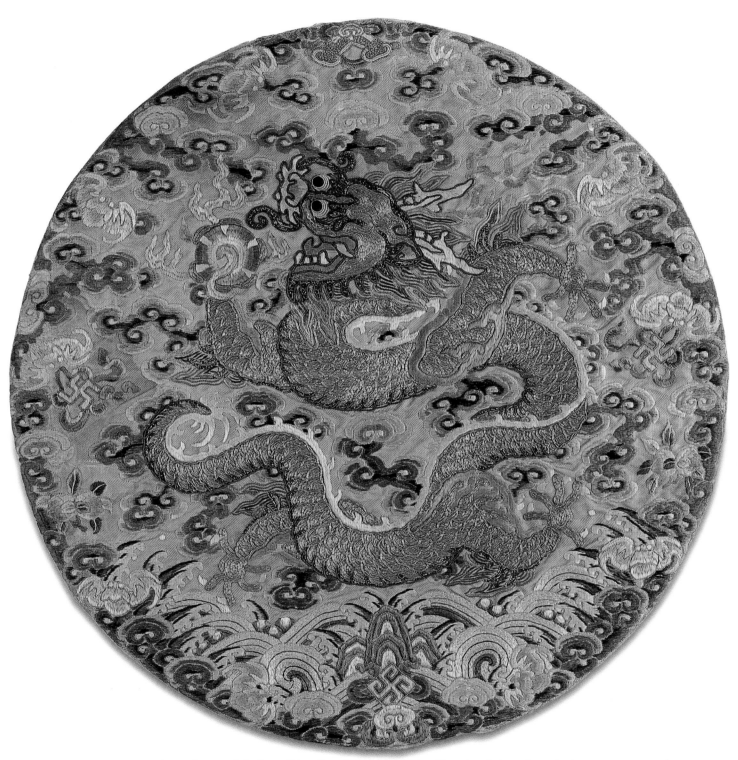

An early roundel of a walking five-clawed dragon in silk satin stitch and couched gold metallic thread on gold silk background. It is a roundel from an important court robe. There is some light damage. Circa 1860. 10.3" diameter. $1700. H4,C3,Q2,R3

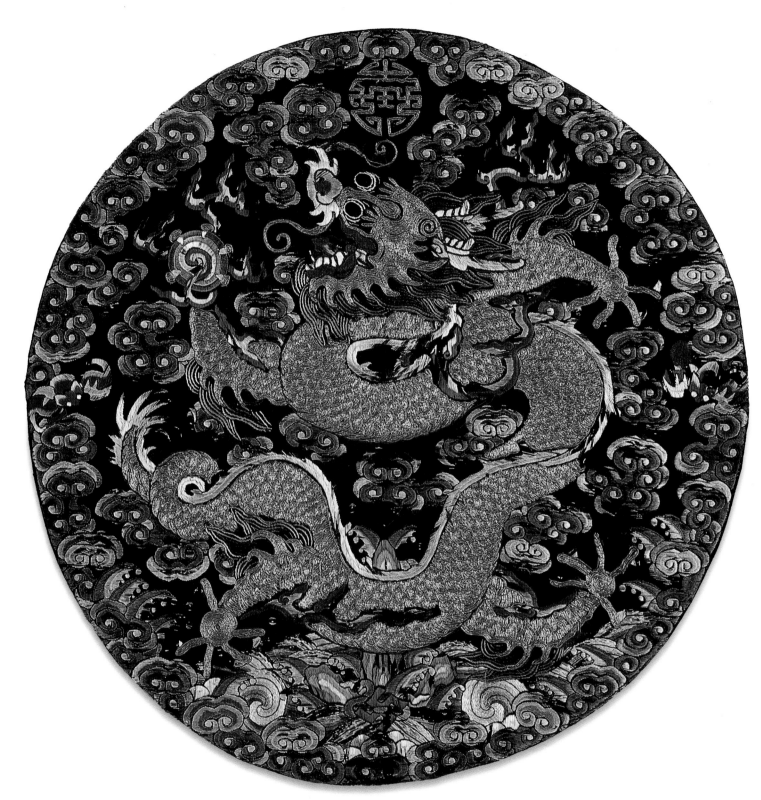

A dragon roundel, with the striding dragon with five claws, is surrounded by bats and clouds. Note the gold symbol at the top. It is embroidered in silk satin stitch and couched gold metallic threads. There is some thread loss. Circa 1880. 11.2" x 11.5". $1500. H2,C4,Q2,R3

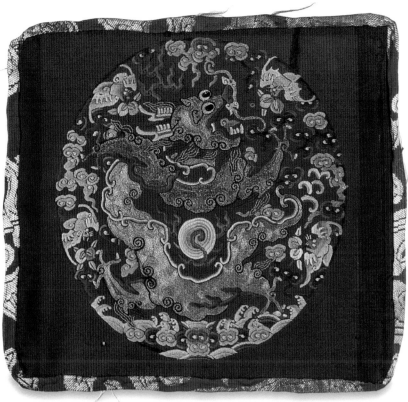
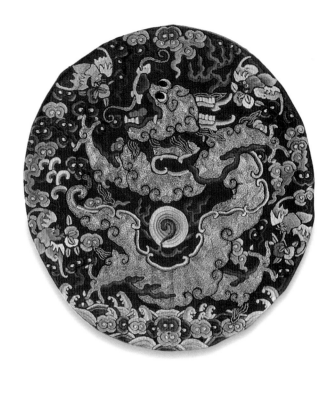

Two roundels from the same robe. The style of the dragons is unusual as they are three-toed and have a curly appearance to their bodies. They are embroidered on burgundy colored silk and are done in silk satin stitch and couched gold metallic threads. Circa 1890. 8.5" each. $1500 for the pair. H3,C3,Q2,R3

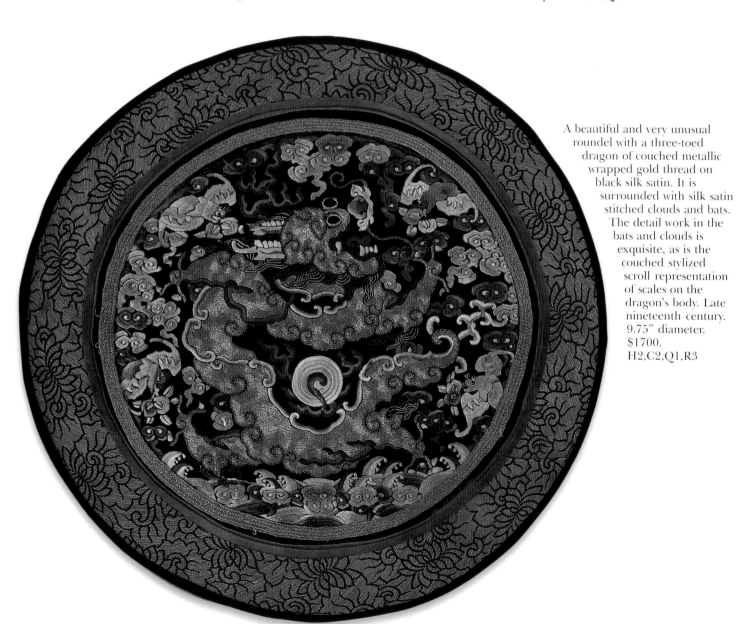

A beautiful and very unusual roundel with a three-toed dragon of couched metallic wrapped gold thread on black silk satin. It is surrounded with silk satin stitched clouds and bats. The detail work in the bats and clouds is exquisite, as is the couched stylized scroll representation of scales on the dragon's body. Late nineteenth century. 9.75" diameter. $1700. H2,C2,Q1,R3

Censorate

Within the imperial court, a special group, called the censorate, was picked from the highest levels of civil bureaucracy to investigate and regulate the actions of the general bureaucracy, including mismanagement and corruption. Among positions they took were viceroys and governors, and in the late Ch'ing dynasty many judges and magistrates wore the censor's badge. The censor's badge depicted a mythological animal with a white body, dragon head, a single horn, a bushy tail, and paws. This mythical animal, the hsieh-chi, was reputed to be able to distinguish good from evil.

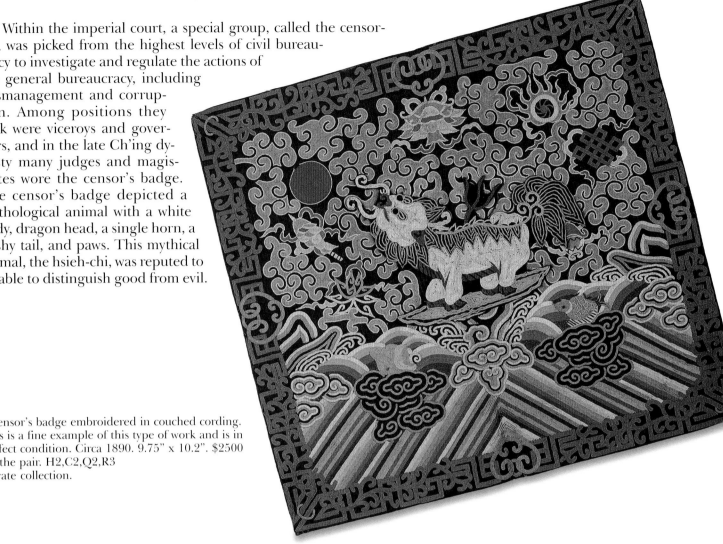

A censor's badge embroidered in couched cording. This is a fine example of this type of work and is in perfect condition. Circa 1890. 9.75" x 10.2". $2500 for the pair. H2,C2,Q2,R3
Private collection.

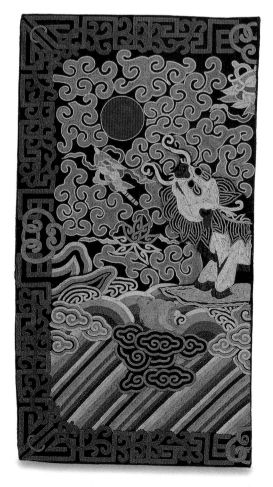

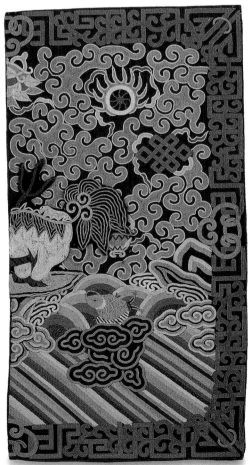

Front badge, mate to above.

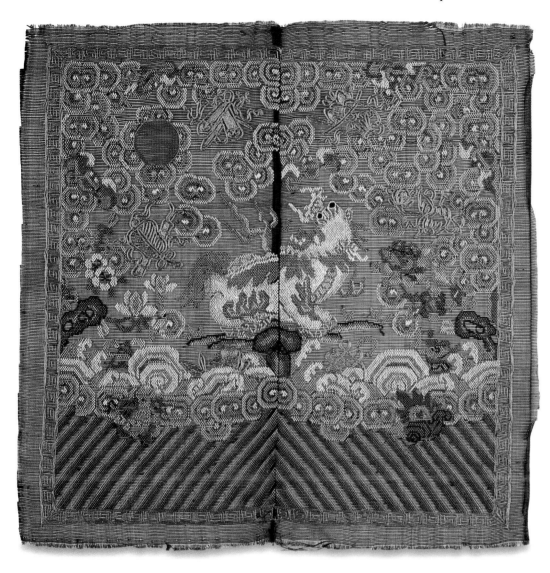

A single front, male censor's badge. It has silk embroidery on silk gauze with couched gold metallic threads. It was possibly embroidered directly on a p'u-fu and then cut away. Circa 1880. 12" x 11.5". $3000. H1,C1,Q1,R2

A metallic k'o-ssu woven censor's front badge in silver and shades of gold with black background. This badge is of high quality manufacture, but unfortunately shows much loss. Circa 1850. 12.6" x 11.7". As is, $1200. If complete, $4000. H3,C4,Q1,R2

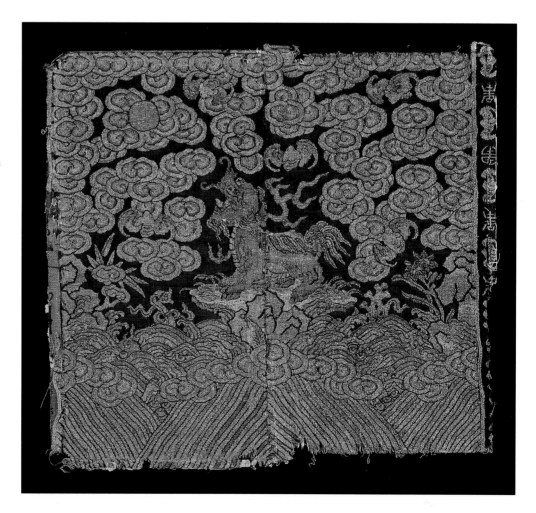

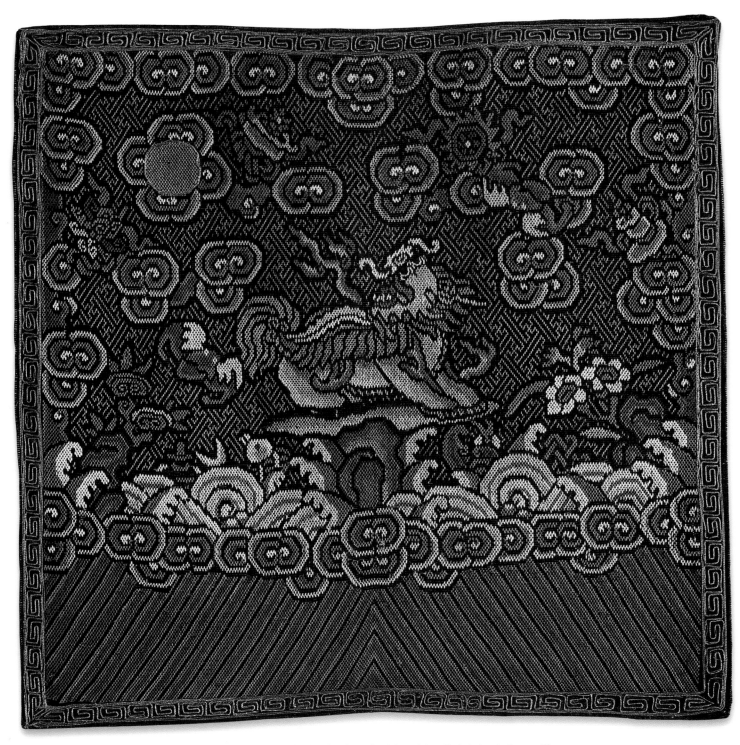

A single male censor's rank badge back embroidered in silk brick stitch on silk gauze
and is in good condition. Circa 1875. 11.2" x 12.5". $2500. H2,C2,Q2,R2

Others That Fall Out of the
Realm of Normal

The following are a group of badges found on the market showing different styles, ages, and influences. After the 1911 revolution, badges and garments of state were no longer used, but not completely done away with. The first president of the Republic of China, Yuan Shih-k'ai, attempted to continue the tradition in a different form. This was not a popular practice after the overthrow of the imperial system and was shortly discontinued. These badges are fairly rare.

Other items shown are a Korean badge and Chinese badge panels without any bird or animal attached. These were made in workshops and the animal or bird indicating rank could be attached and changed as the officer attained higher rank.

A pair of unused early Republic badges dating from 1911-1915, the period when Yuan Shih-k'ai was in power. These are five-character badges of silk embroidery on black silk that were "conferred" by official grace, or as gifts. The value of these stems from their fine overall condition and in the fact that they are a pair. One is 9" in diameter; the other is 8.875" in diameter. $2500 for the pair. Individual values, $1000. H1,C1,Q3,R2

This is a Korean rank badge. Although this is not technically a Chinese textile, many collectors of Chinese rank badges have these in their collections. They are not as prevalent as the Chinese ones and are very distinct in their style. They generally show two animals or birds, depending on rank, embroidered on a brocade background, and were also originally in pairs. Circa 1830. 6" x 7.5". $2400. H2,C2,Q2,R2

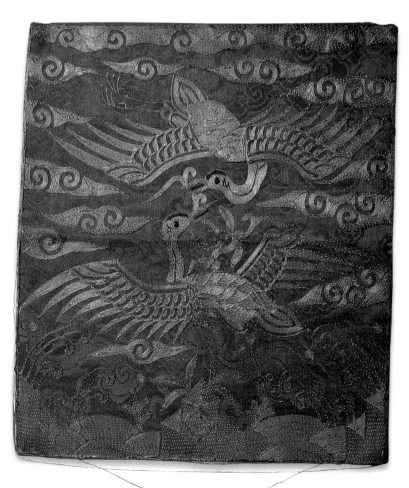

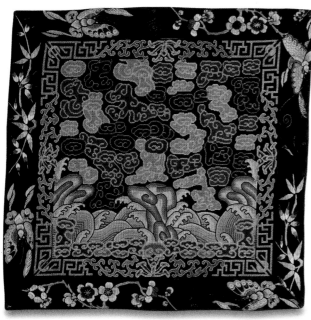

A rank badge background of fine petit point stitching on black silk gauze. Circa 1860. 11.875" x 11.625. $135. H2,C2,Q2,R3

Back of left showing relining with Japanese obi fabric.

A rank badge background, finely embroidered in silk satin stitch and couched gold thread. This is a late reform style badge with no waves and only bats carrying "wan" symbols, which mean "ten thousand times happiness," around the area where the bird or animal would have been appliquéd. Circa 1895. 12." x 11.75". $375. With a rank figure, bird or animal, the badge would take on a higher value. H1,C1,Q3,R3

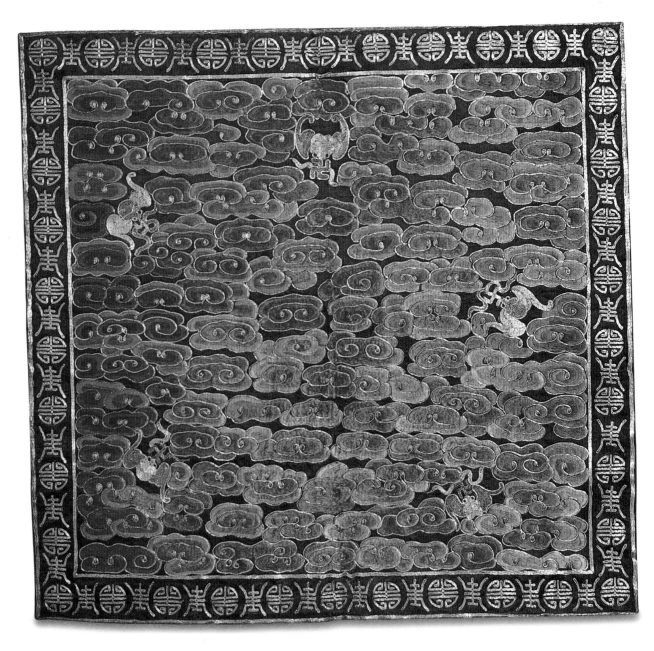

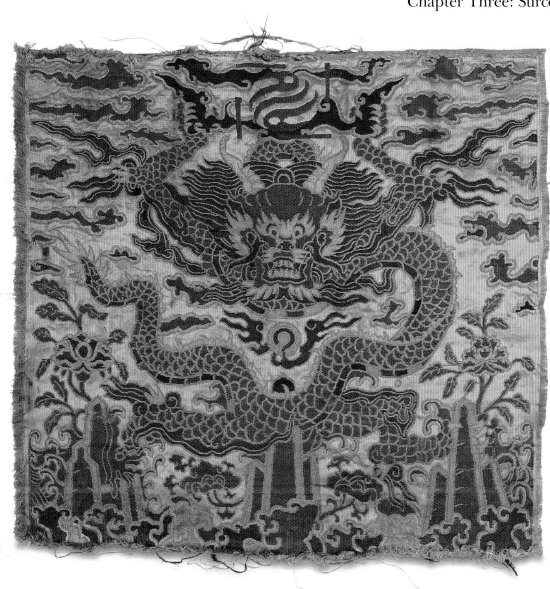

A brocade-woven panel of a fake ducal or imperial badge. Twentieth century manufacture. 14" x 16.5"

These are pieces cut from an early mandarin duck rank badge and applied to a paper backing for safe keeping. They are of silk satin stitch and couched cording and gold metallic wrapped thread on silk. Circa 1810. 7" x 10". $650. H2,C5,Q2,R2

An early Ming dynasty k'o-ssu woven rank badge. Note the double bird image, in this case a peacock, which was a common motif at this time. There was very little definition about how the badges were to appear, but the early Ming designs had both birds in flight and mid- and late Ming badges had one bird grounded and one in flight. The colors have faded to blues and oranges. 15.5" x 15.5". $5500. From the collection of Gary Wee. H3,C4,Q2,R1

This is probably an old fake rank badge. It is fairly crudely embroidered, but an interesting study piece. It dates to the first half of the twentieth century. 9.5" x 9.5". $50. H4,C3,Q4,R4

Two pair of fake badges currently available on the market. Note the designs are almost exactly alike except for the colors and the imagery does not follow traditional designs. They are very crudely rendered. Approximately 12" x 12".

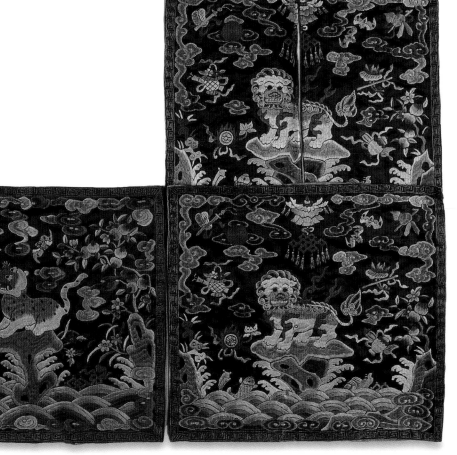

Three more fake badges, the same as previous examples. These appear to have been made in the same workshop and utilize gross characterizations of the figures and style. Modern. Value is minimal as decorator items only. Approximately 12" x 12". $25 each.

A Comparison

The following is a series of one civil rank, the fifth rank silver pheasant, showing the differences of styles and manufacture through time and interpretation. This group illustrates well, the problems of valuing Chinese textiles based on verbal descriptions alone.

The fifth rank is one of the most common badges available because middle ranking civil servants were granted their rank. This rank included instructors and librarians at various institutes, salt inspectors, sub-prefects and assistant directors for boards and courts. The birds face left toward the sun located on the left side. The official's wife was also allowed to wear the badge of rank of her husband and hers had the bird facing right with the sun on the right. The front badges are split down the center to conform to the opening of the p'u-fu and the back badges are uncut.

The manufacture of these was varied and may have occurred in workshops with many embroiderers and weavers, in cottage industries, or even by the official's family members.

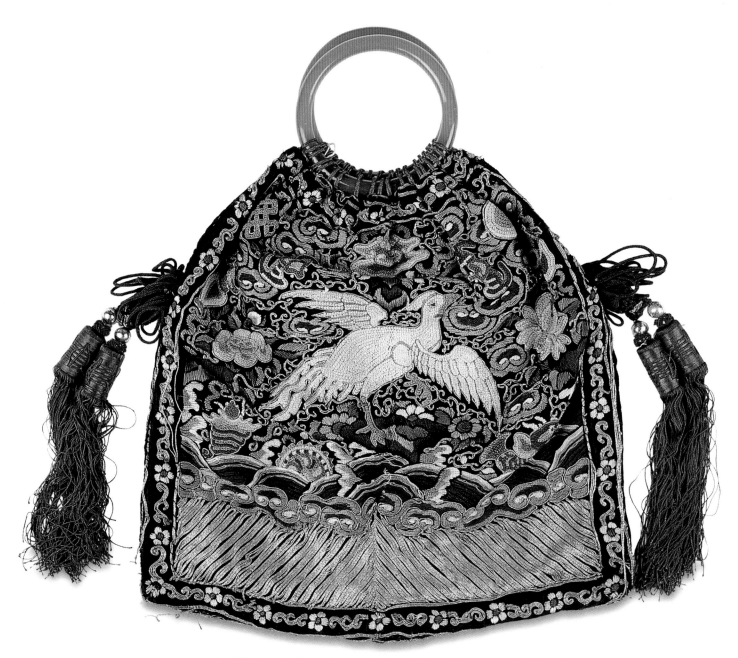

A purse made of fifth rank silver pheasant badges. The badges are embroidered in silk satin stitch and couched gold metallic threads and are in restorable condition. The purse has green glass bangle- style handles and tassels at the sides. Badges circa 1890; purse form circa 1920. 12" x 13". $750. H3,C3,Q4,R4

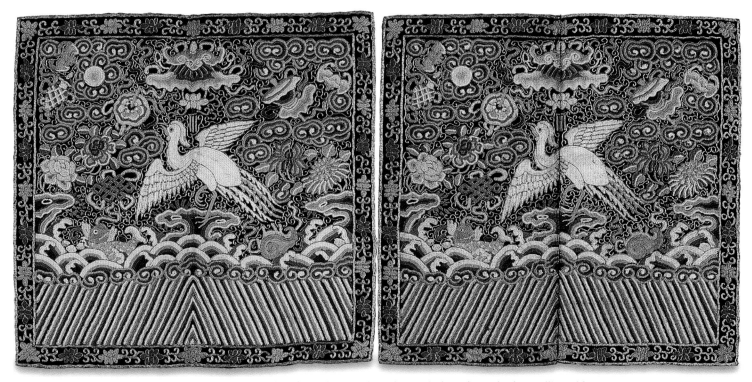

A pair of badges embroidered in allover Peking knot stitch and couched metallic gold
thread on black silk background. Circa 1890. 11.75" x 12.5". $2500. H2,C2,Q1,R1

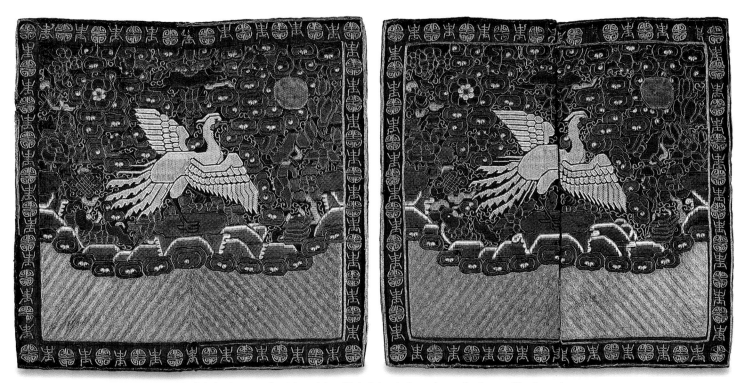

A pair of lady's badges embroidered in silk brick stitch and couched metallic threads on
brown silk. There is some thread loss and some restoration. Circa 1870. 12" x 11.5". $1700.
If perfect, $2500. H2,C3,Q3,R4

A pair of lady's roundels, k'o-ssu woven with a decorative grid background. These have the eight precious things around the birds, are unused, and in perfect condition. Circa 1890. 12.5" x 11.75". $1500. These are a good example of late badges using an unregulated round form. H1,C1,Q3,R4

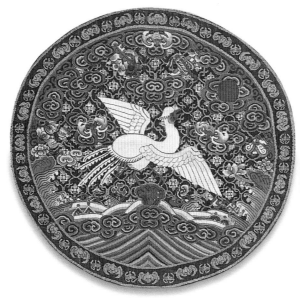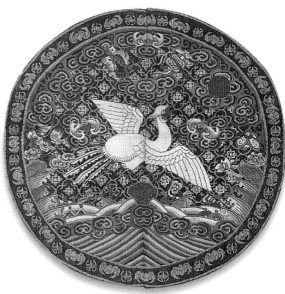

A pair of reform badges. These are embroidered with silk satin stitch and couched metallic gold threads. Their condition is good with some loose threads that can be easily stabilized. After 1898. 12" x 11". $900. When restored, $1200. H2,C3,Q3,R4

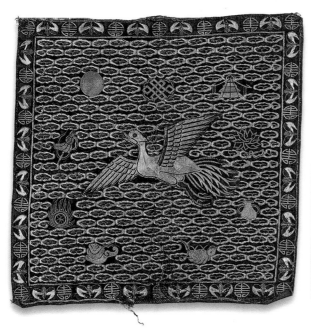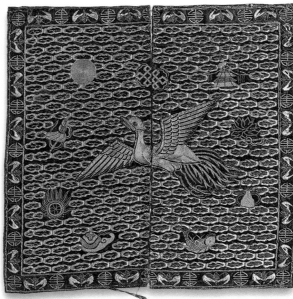

This pair of lady's badges are completely couched in gold metallic thread. The difference in color on the edges may be due to different thread lots or it may possibly be a workshop piece done by different embroiders. Circa 1880. Front badge 11.25" x 12.25"; back badge 11.25" x 12.5". $1200. H2,C2,Q3,R4

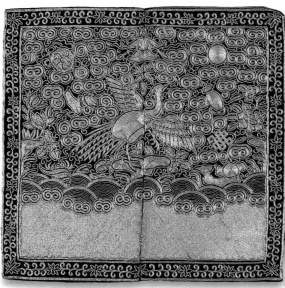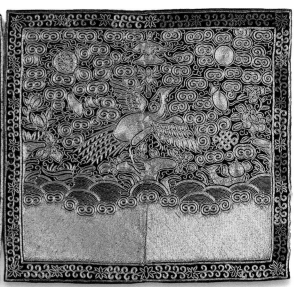

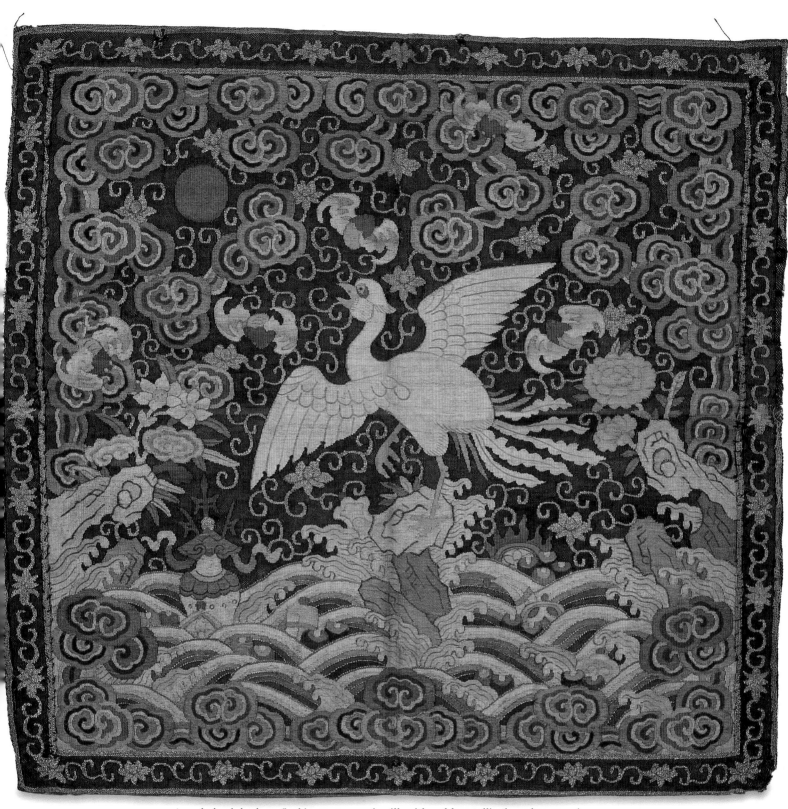

A male back badge of a k'o-ssu woven in silk with gold metallic threads woven in.
Very finely done and in good condition. Circa 1850. 12.5" x 12". $1500. If a pair,
$4500. H2,C2,Q1,R2

A single unused male back badge. It is embroidered with silk in brick stitch on silk gauze. The bird is embroidered in the same manner and appliquéd to the backing. It is still in the original protective paper. Circa 1890.12.5" x 12". $ 750. The additional value of this compared to the one opposite is due to its unused condition and that it is still in its protective paper. H1,C1,Q2,R3

A back rank badge with gold metallic background of clouds. It is embroidered in silk satin stitch and stem stitch. This would have been, most likely, worn by the wife or daughter of an official. It has very wavy tail feathers compared to others of its type. The edges need repair but it is in good condition otherwise. Circa 1870. 11.5" x 12". $750. Its value comes from its elegance of design, fine quality craftsmanship, and artistic composition. If perfect $1200. From the collection of Gary Wee. H2,C4,Q2,R3

A badge embroidered with silk in brick stitch on silk gauze. The bird is also of brick stitch and appliquéd to the background; it is somewhat unusual because it has a topknot. As time progressed and laws relaxed the images on the badges tended to change somewhat and blur the lines between the ranks so it would appear higher and become what is referred to as a "deceptive" badge. It is in excellent condition. Circa 1890. 11.5" x 11". $650. H1,C1,Q2,R3

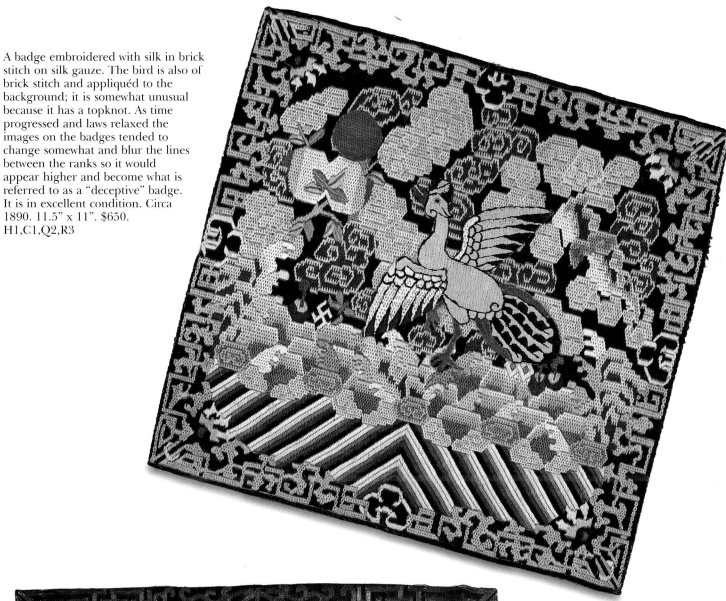

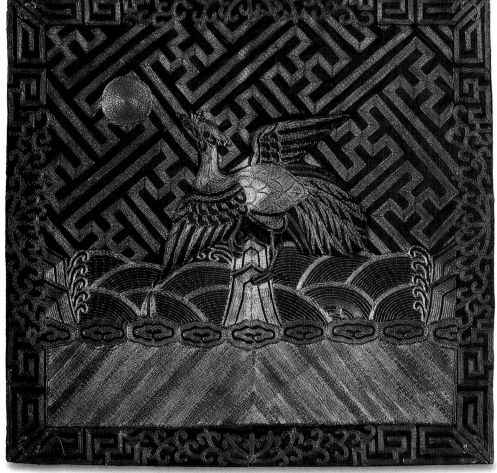

A single, male back badge embroidered in couched metallic threads. The colors are created by different colored silk couching threads over gold and silver wrapped metallic threads. The bird is in the same technique and appliquéd onto the backing. The badge is in good condition with some staining. Circa 1890. 11.25" x 10.75". $475. If perfect, $525. H2,C3,Q3,R4

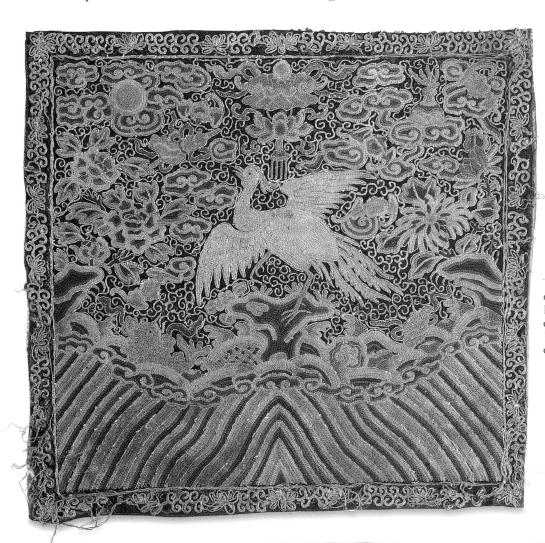

This silver pheasant is embroidered in an allover pattern of Peking knot stitch. It is in poor condition. Circa 1880. 12.5" x 11.5". $450 as is. In good condition, $1200. H4,C4,Q1,R3

This badge is embroidered in silk satin stitch and couched metallic threads on brown silk background. Circa 1880. 12.1" x 11.25". $450. There is some discoloration. If perfect, it would be in the $650 range. H2,C3,Q3,R4

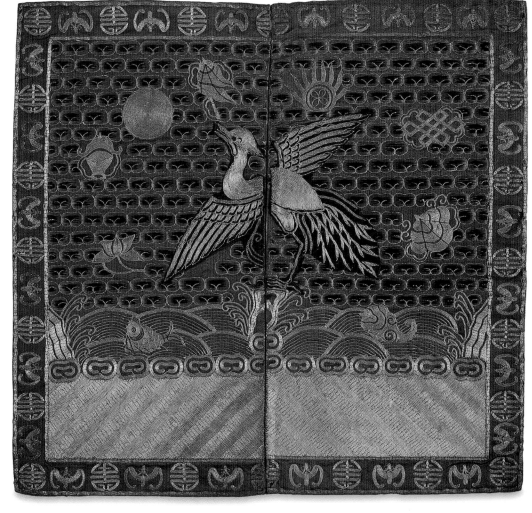

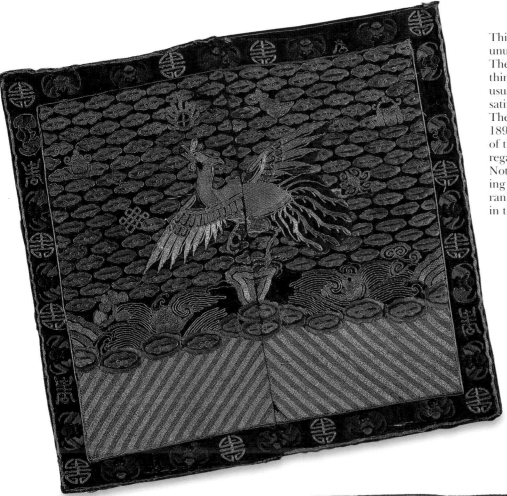

This is a later badge and somewhat unusual in that there is no sun on it. There are symbols of Buddhist precious things around the bird instead of the usual landscape. It is embroidered in silk satin stitch and couched metallic threads. There is some damage to the piece. Circa 1890. 12.25" x 12". $450. It is an example of the late practice of "deception" regarding the actual rank of the wearer. Note the topknot and the waddle denoting both a fourth rank goose and a third rank peacock. If it were perfect it would be in the $750 range. H3,C2,Q3,R4

This is a smaller size female badge, possibly a child's. Towards the end of the nineteenth century, when the laws were relaxed, children of officials were also allowed to wear the badges of their father's rank. This piece is embroidered in silk satin stitch and couched metallic threads, and the bird is appliquéd to the backing. Circa 1900. 9" x 9.25". $350. If perfect, $450. H2.C3.Q3,R4

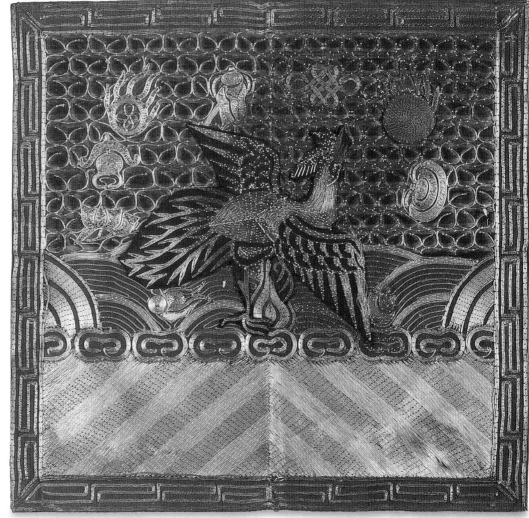

This is a late reform period fifth rank silver pheasant front badge with a simple overall cloud design. It is k'o-ssu woven and there is some damage. There are no auspicious items around the bird and no wave forms below. Circa 1890. 11.5" x 11.5". $275. If restored it would be in the $475 range. H3,C4,Q3,R4

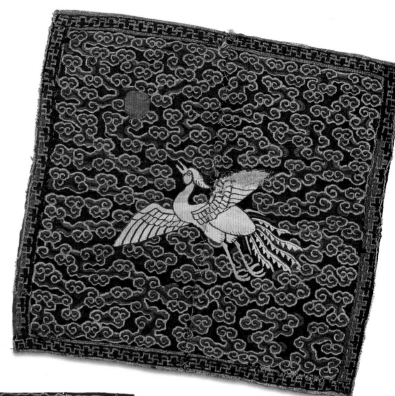

These may not be genuine badges as they were embroidered in this manner and made into a purse. Both are backs and are of exactly the same poor quality. Circa 1910. 12" x 22". $250. H2,C3,Q4,R5

A male front badge, k'o-ssu woven with a gold metallic background. Circa 1890. 11.2" x 10.75". $150 due to its poor condition. Even if perfect it would only be in the $250 range due to its crude workmanship. H2,C3,Q3,R4

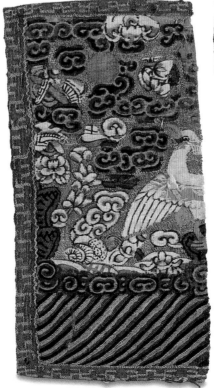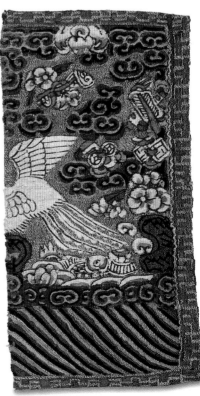

Chapter 4
Religious Costume

The two major religions in the Ming and Ch'ing dynasties were Buddhism and Taoism and each had their own types of vestments. The Buddhist vestment was the simple robe, called the kashaya. It was a horizontal, roughly rectangular, expanse of cloth that was draped over the left shoulder and under the right arm of the wearer and fastened in the front in a variety of manners. This type of garment was often fabricated from small squares sewn together. The traditional explanation for this was that they were made from discarded or donated cloth fragments. Buddha had renounced wealth and a kashaya honored the concept by using fragments. It was, in actuality, a show of false piety. These garments were usually of expensive materials donated or commissioned by wealthy patrons of the court. Often incorporated within the bodies of these garments was symbolic and even imperial imagery.

Priest's Robes

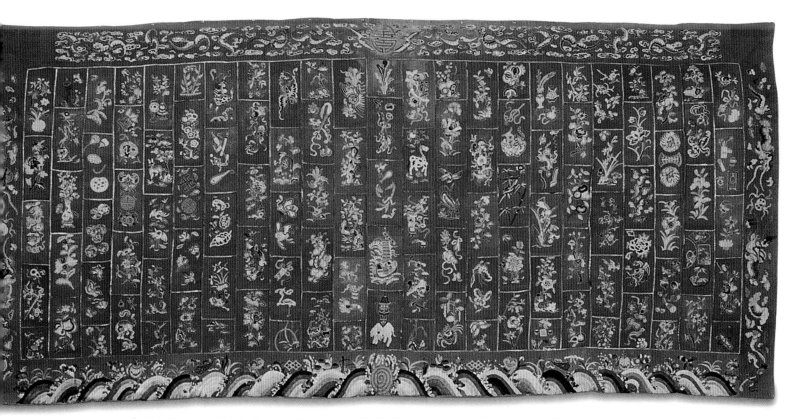

A priest's robe comprised of twenty-three rows of red silk crepe rectangular patches. All the figures on this piece are embroidered in Peking stitch, couched metallic gold threads, and couched cording. They represent the precious objects, mythical beasts, scholar's implements, and other motifs. The waves along the bottom are executed in satin stitch. There is loss of both black and brown colors due to the metal salts used in the dye mordants of these earlier pieces. There is some staining and general wear. The robe is very finely embroidered, is highly stylized and has a great overall presence. Circa 1820. 106" x 49". $25,000. If it were perfect it could bring as much as $40,000. H3,C3,Q1,R1,

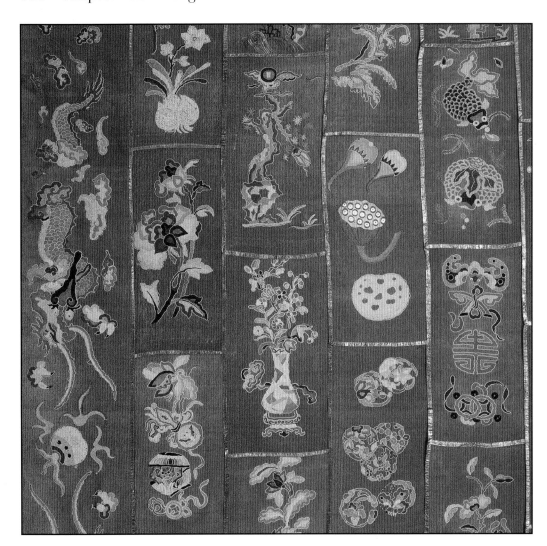

Detail of priest's robe (shown on page 117) showing left side.

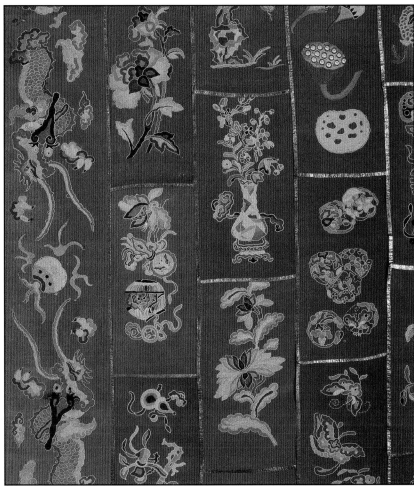

Detail of the priest's robe (shown on page 117), left side showing dragons.

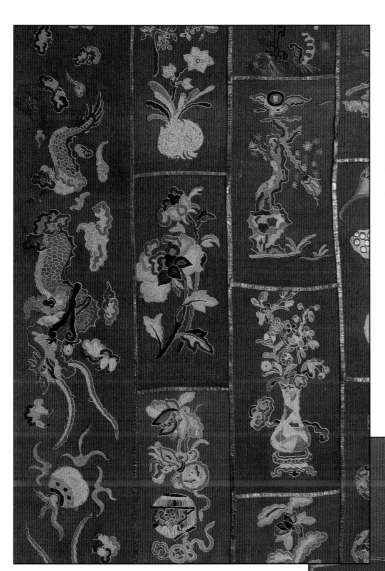

Detail of the priest's robe (shown on page 117), left side showing dragons, close up.

Upper left corner detail of the priest's robe (shown on page 117) showing stylized bats of Peking stitch and upper register.

Lower right corner detail of the priest's robe (shown on page 117) showing the wave detail and lower register.

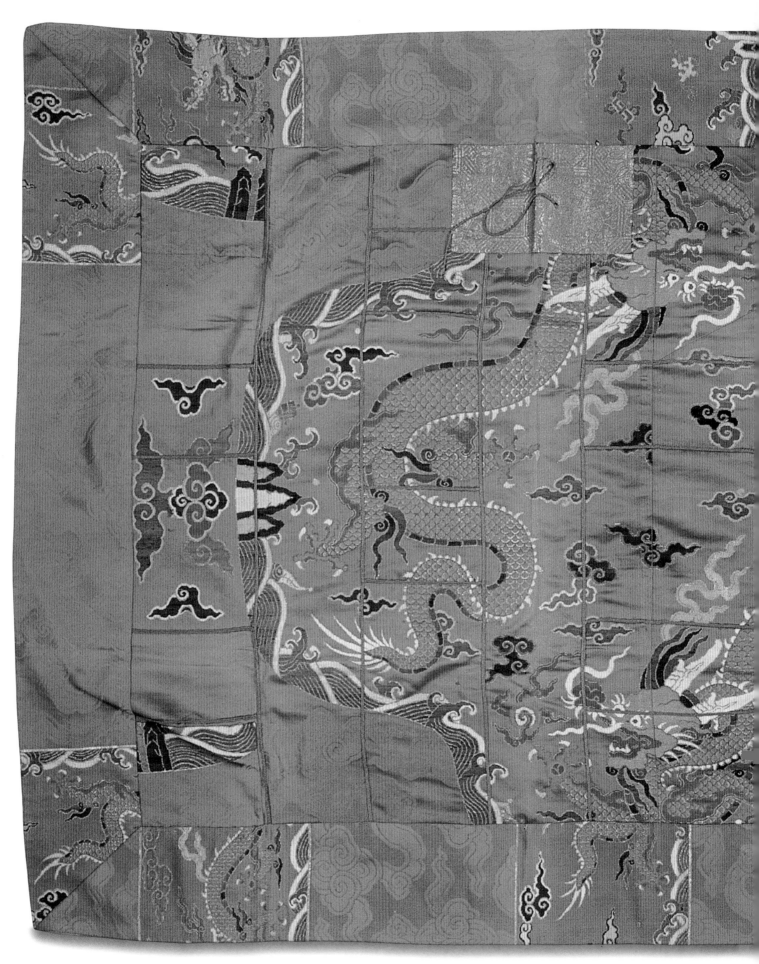

This is actually a Japanese Buddhist priest's robe made from uncut yardage intended for a
Chinese ch'ao-pao. This followed roughly the same form as the kashaya and shows the
quality of the type of fabrics donated as offerings to the temples. It is reddish orange in
color. Circa first half of the nineteenth century. 80" x 46". $6000. H1,C1,Q2,R2

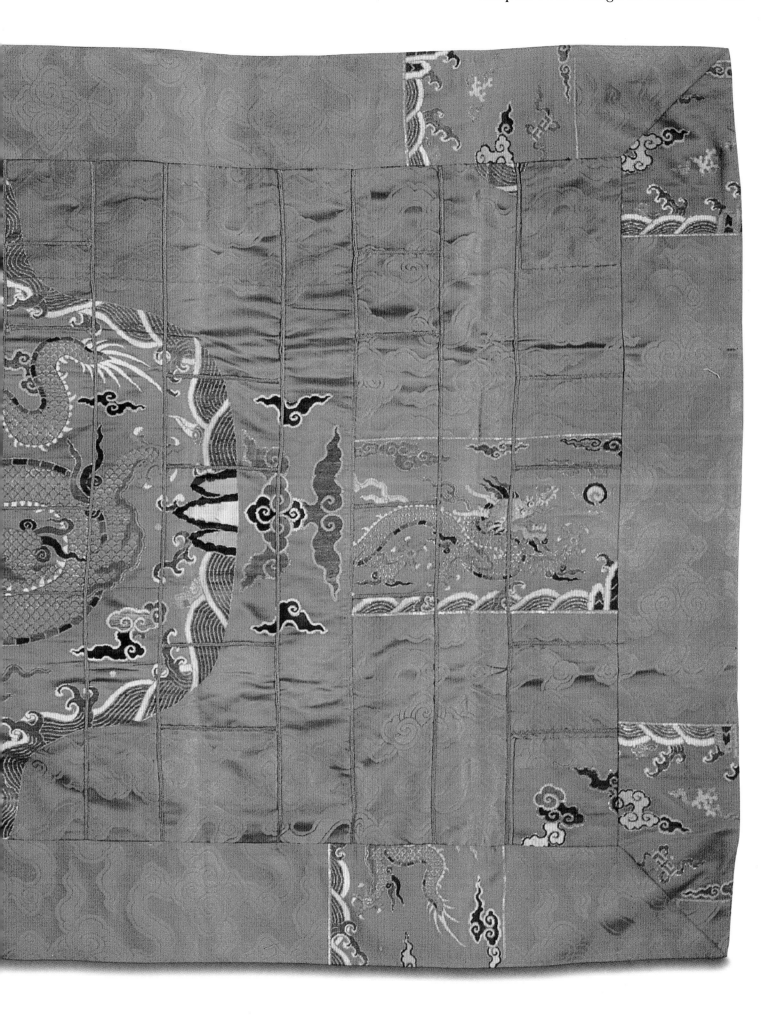

Taoist priest's robes followed the style of the Han robe.

The poncho-like form, called a chiang-i, had a central front opening and ties with a vertical seam down the back. The lower sides were sewn together with openings for the arms and wide borders along sides and hems and an attached collar.

The other type of Taoist religious robe, a tao-pao, is a full-cut long robe in a basic Han-style, with very wide sleeves and border designs. This robe has a vertical opening down the front and is fastened by ties.

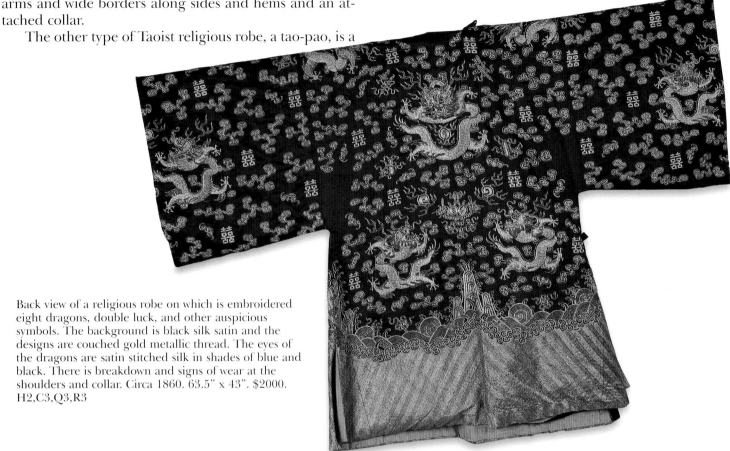

Back view of a religious robe on which is embroidered eight dragons, double luck, and other auspicious symbols. The background is black silk satin and the designs are couched gold metallic thread. The eyes of the dragons are satin stitched silk in shades of blue and black. There is breakdown and signs of wear at the shoulders and collar. Circa 1860. 63.5" x 43". $2000. H2,C3,Q3,R3

Front of robe above.

Detail of the back of the religious robe above.

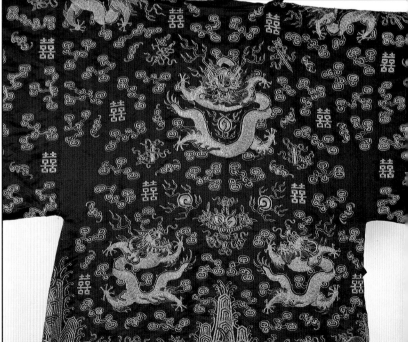

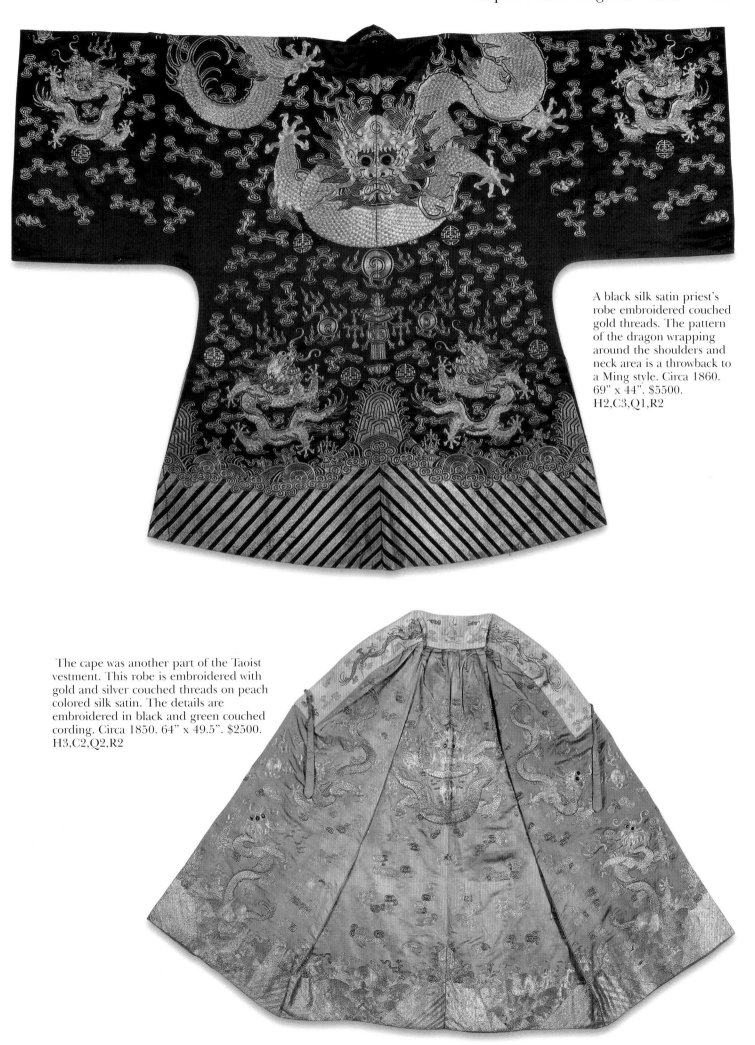

A black silk satin priest's robe embroidered couched gold threads. The pattern of the dragon wrapping around the shoulders and neck area is a throwback to a Ming style. Circa 1860. 69" x 44". $5500. H2,C3,Q1,R2

The cape was another part of the Taoist vestment. This robe is embroidered with gold and silver couched threads on peach colored silk satin. The details are embroidered in black and green couched cording. Circa 1850. 64" x 49.5". $2500. H3,C2,Q2,R2

Idols' Robes

Another type of robe was used for festivals and other special occasions in the temples, where they were placed on the idols. They were variations of the tao-pao design with very full body and sleeves. Most of these religious vestments incorporated bold designs as they were made to be seen from a distance.

Taoist robes followed a standard design; the center upper back had a cosmic diagram that integrated several symbols, including a central pagoda surrounded by various star, cloud, and flower patterns, together with other Buddhist and Taoist symbols, which generally reflected the image of universal order and paradise. They can be compared to the symbols on a dragon robe, which also represented a complete universe in harmony. Values of nineteenth century and earlier religious garments are often high due to their rarity and their usually good to fine condition, as they were used only for special occasions.

The following robe is unique. It is in a bright imperial yellow, though faded, and includes all 12 symbols of imperial authority. The symbols have an unusual placement so that most can be viewed from the front when it was placed on a statue. This robe can be compared with two 17th century robe fragments in the Victoria and Albert museum in London. There are likely more unidentified ex-amples in other private and public collections. When inspecting the robe an inscription was found on the inside lining. It was divided and reversed, perhaps an indication the robe was taken apart, cleaned, and reconstructed. In the process the lining was reversed possibly to present a cleaner side. The inscription was able to be reconstructed and translated and is as follows:

Fourth year if the Kuang-hsu reign, cyclical year mouyi *[1879]*
auspicious day of the second month *[of the lunar year]*
Sacred robe of the T'ien-hou sheng-mu *[Queen of the Heavens, Divine Mother-Patron of Seafarers]*
Respectfully contributed by Ju Tung-hao, zi: Shunheng *[ones "zi" name is usually the name one used on a seal]*

The following is an excerpt from a letter of authentication from John Vollmer: "Most image robes are decorated with imperial imagery (dragons) and resemble court robes. However it is exceedingly rare to find one with the 12 symbols of imperial authority. The use of these motifs was largely reserved for the emperor and his immediate family. The best known examples with these symbols on an image robe are two 17th century robe fragments in the Victoria and Albert Museum *(see,* Verity Wilson, *Chinese Dress,* 1986, p.83)".

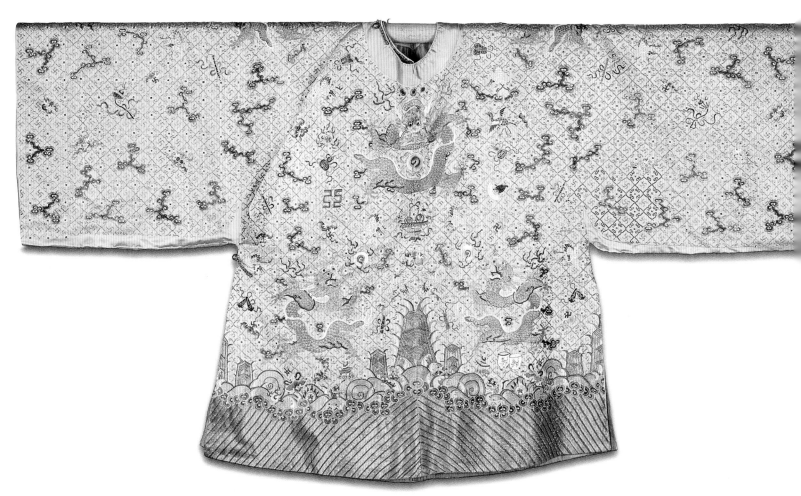

Front view of the above. Overall size 67" wide x 38" high.
$75,000. From the collection of Gary Wee. H3,C2,Q1,R1

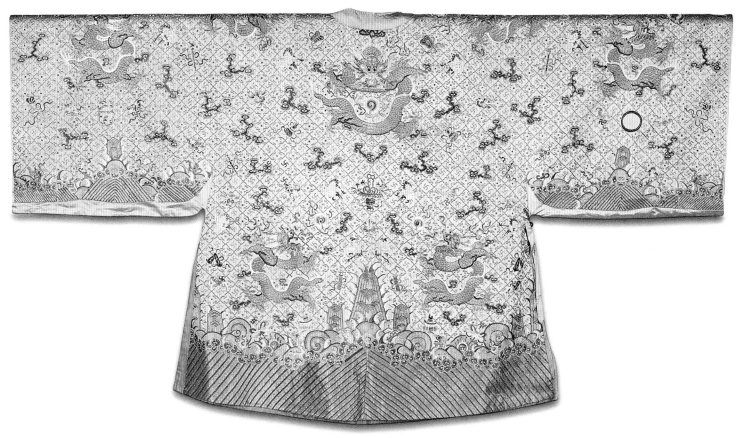

Back view of opposing page.

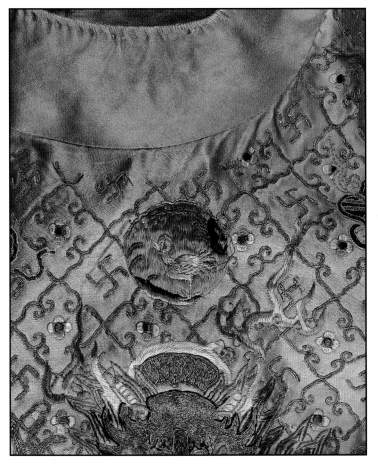

A detail of the cockerel symbol from the imperial image robe.

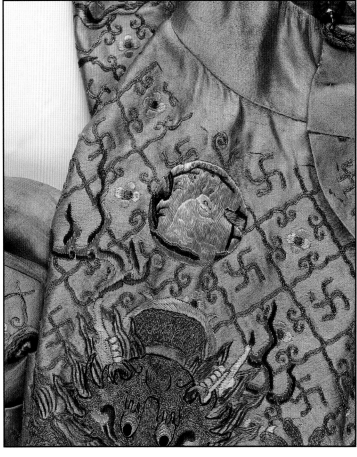

A detail of the rabbit mixing the elixir of life symbol from the imperial image robe.

A detail of the ax of authority symbol from the imperial image robe.

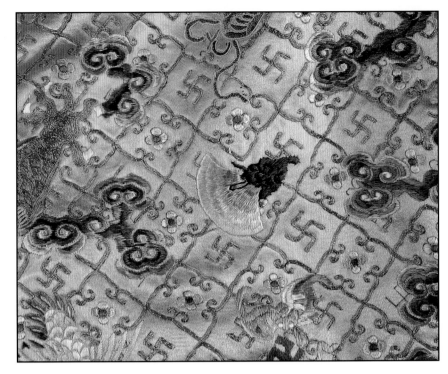

A detail of the "fu" symbol from the imperial image robe.

A detail of the constellation symbol from the imperial image robe.

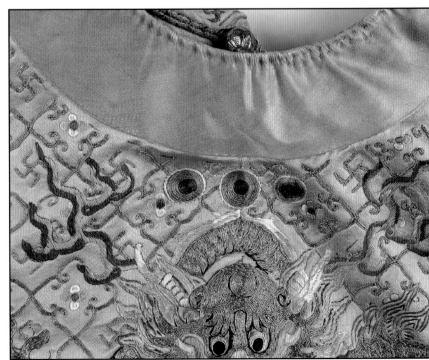

A detail of the tiger cups symbol from the imperial image robe.

A detail of the pair of dragons symbol from the imperial image robe.

A detail of the bowl of millet symbol from the imperial image robe.

A detail of the water weed symbol from the imperial image robe.

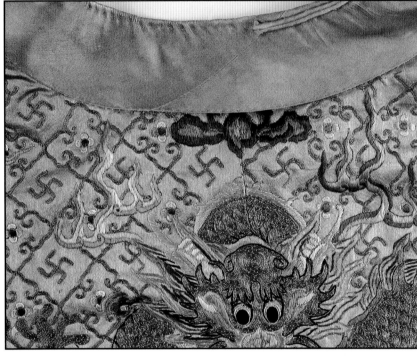

A detail of the mountain symbol from the imperial image robe.

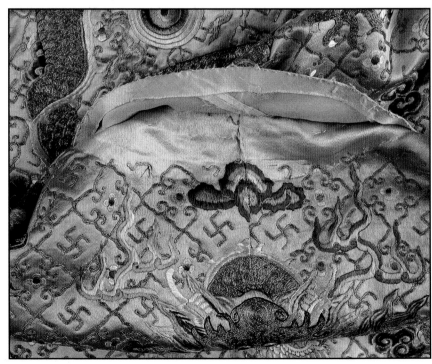

A detail of the imperial image robe showing the mountain and the original bright imperial yellow color of the silk.

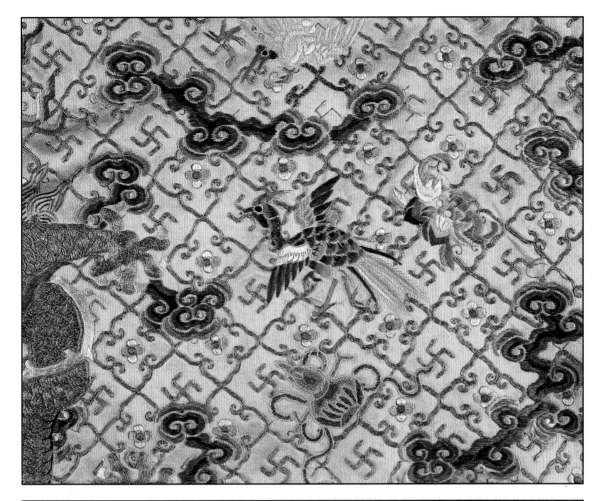

A detail of the pheasant symbol from the imperial image robe.

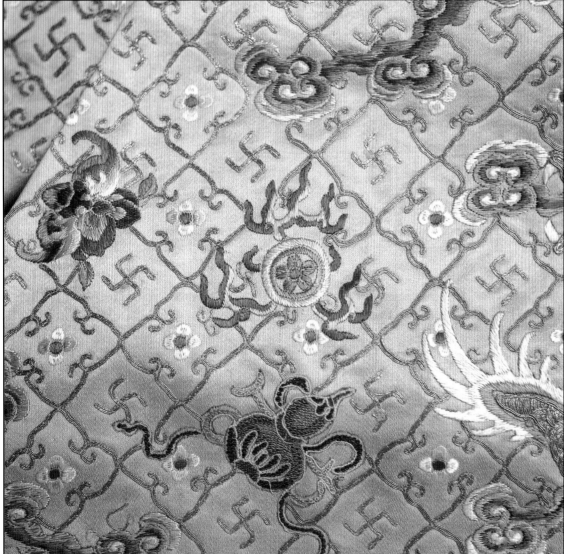

A detail of the flames from the imperial image robe.

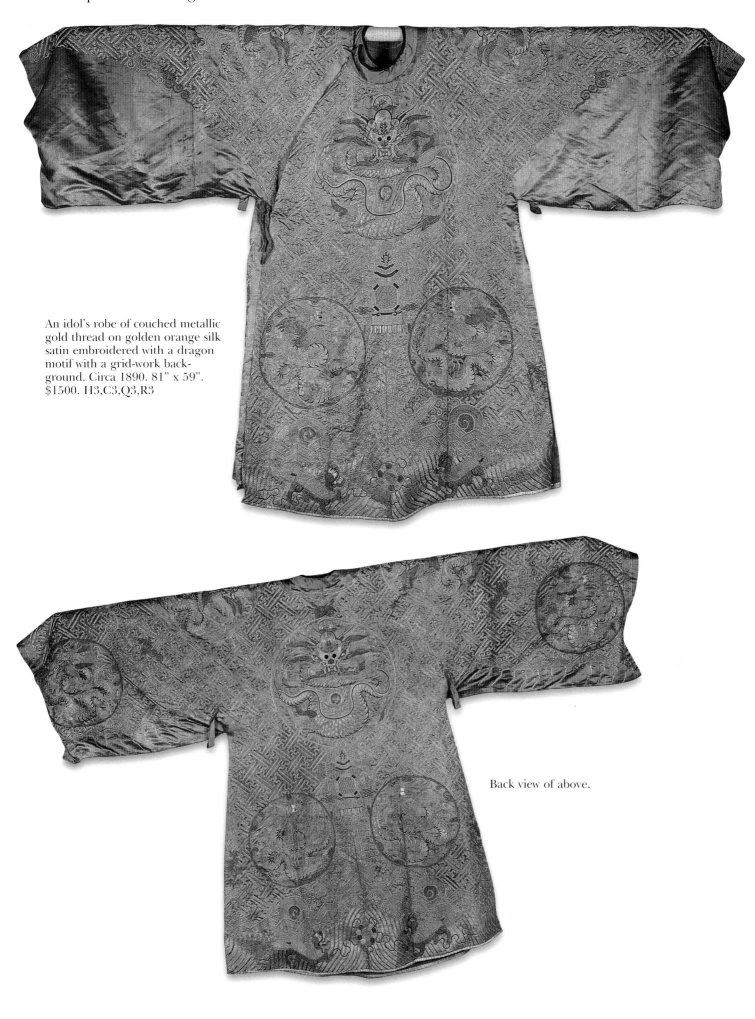

An idol's robe of couched metallic gold thread on golden orange silk satin embroidered with a dragon motif with a grid-work background. Circa 1890. 81" x 59". $1500. H3,C3,Q3,R3

Back view of above.

Chapter 5
Unofficial Dress Attire

Unofficial wear can be loosely defined as clothes not controlled by government regulations. Unofficial or informal wear, however, sometimes communicated age and status. Certain colors were appropriate to seasons, age of the wearer, and occasion, and further, the imagery and combinations of symbols express a language reflecting the aspects of its wearer. Thousands of years of history and customs are reflected in Chinese costume.

Han vs. Manchu

The Han are the largest cultural/ethnic group of China and their clothing is varied in design as to func-tion. In 1644, when the nomadic Manchus conquered China and set up the Ch'ing dynasty, they set them-selves apart from the other peoples they ruled and brought their nomadic style of dress. They also regu-lated and codified all clothing appropriate to official occasions.

Ladies' Han-style jackets were generally very full cut with wide sleeves. The jackets were often quite plain, but they almost always had decorative sleevebands. They were made using various techniques including brocade, k'o-ssu, embroidery, or even painting. The designs could tell stories or be good luck symbols, religious symbols, flora, or fauna.

Jackets
Han-Style & Manchu-Style

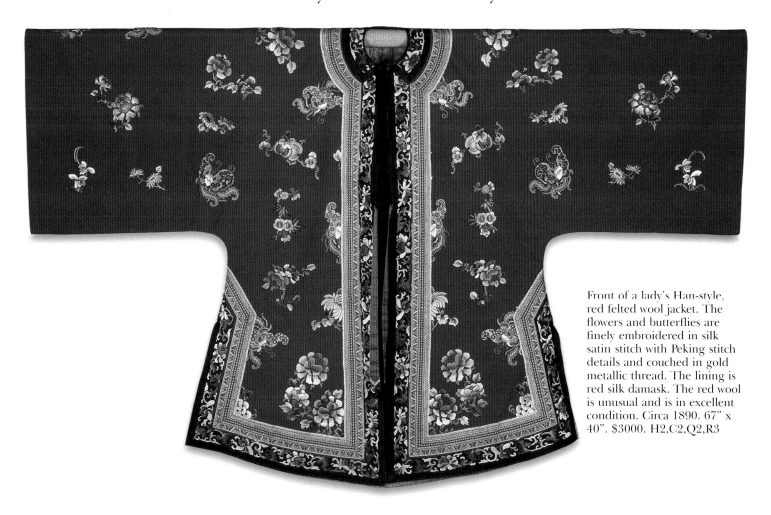

Front of a lady's Han-style, red felted wool jacket. The flowers and butterflies are finely embroidered in silk satin stitch with Peking stitch details and couched in gold metallic thread. The lining is red silk damask. The red wool is unusual and is in excellent condition. Circa 1890. 67" x 40". $3000. H2,C2,Q2,R3

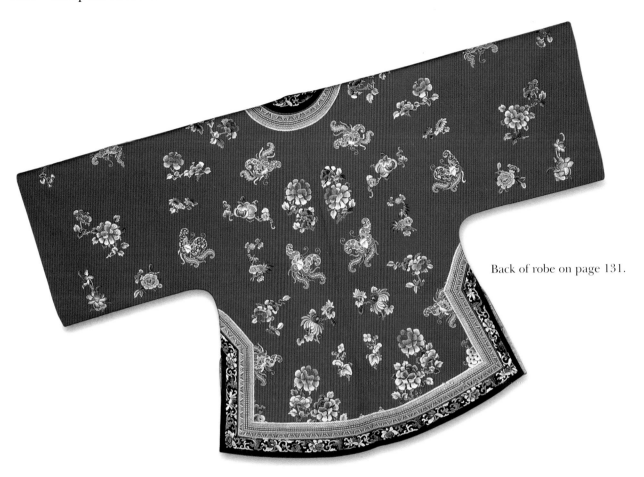

Back of robe on page 131.

Detail of lining of
robe on page 131.

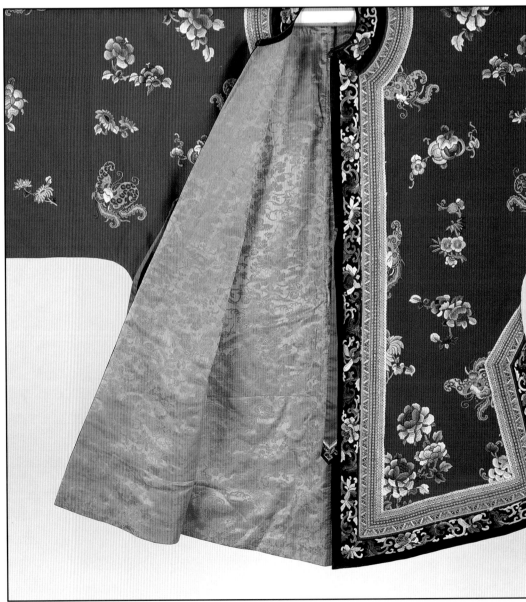

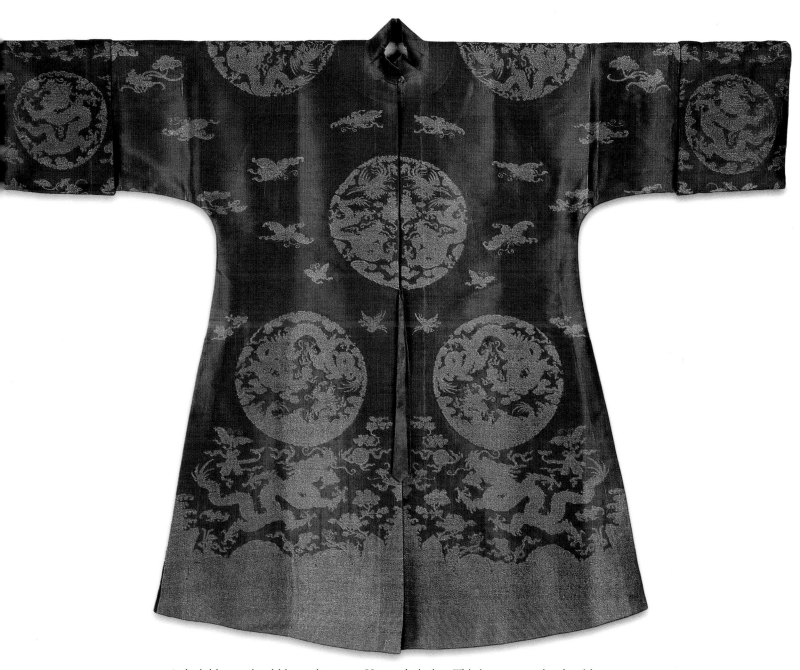

A dark blue and gold brocade-woven Han-style jacket. This is an unusual style with dragon motifs woven into the eight roundels in the bodice and also along the lower register. The sleeve bands are very wide and also have a dragon roundel on both front and back. Circa 1880. 57" x 45". $2500. H2,C2,Q2,R3

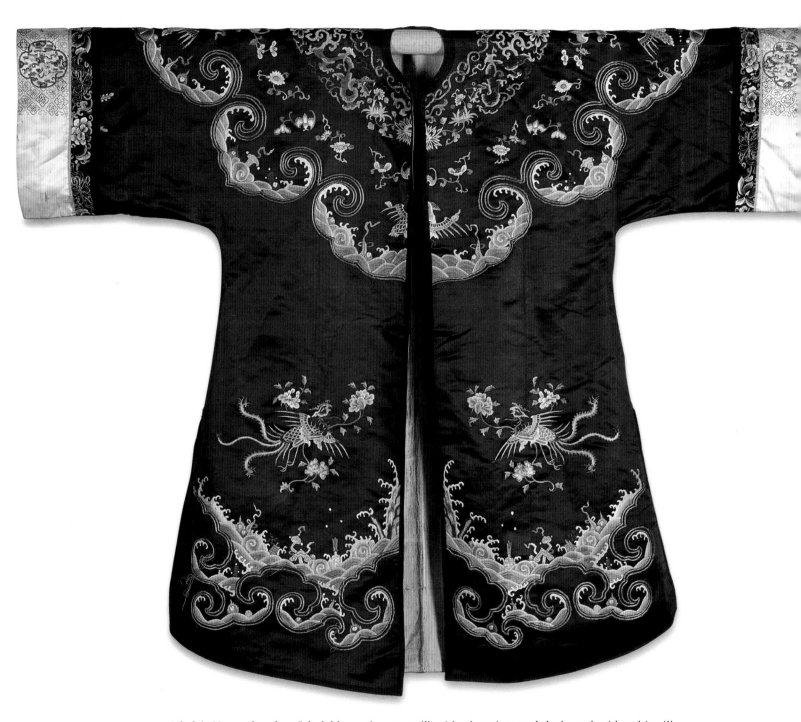

A lady's Han-style robe of dark blue satin weave silk with phoenixes and ducks embroidered in silk satin stitch with details in couched metallic gold threads. The sleeve bands are embroidered in extremely fine satin and Peking stitch with fish, sages, and a figure floating in the clouds. The robe may have been remodeled later, as the sleeves appear smaller and the bands do not form the usual cuff. Circa 1880. 43.25" x 55". $1700. H2,C2,Q2,R3

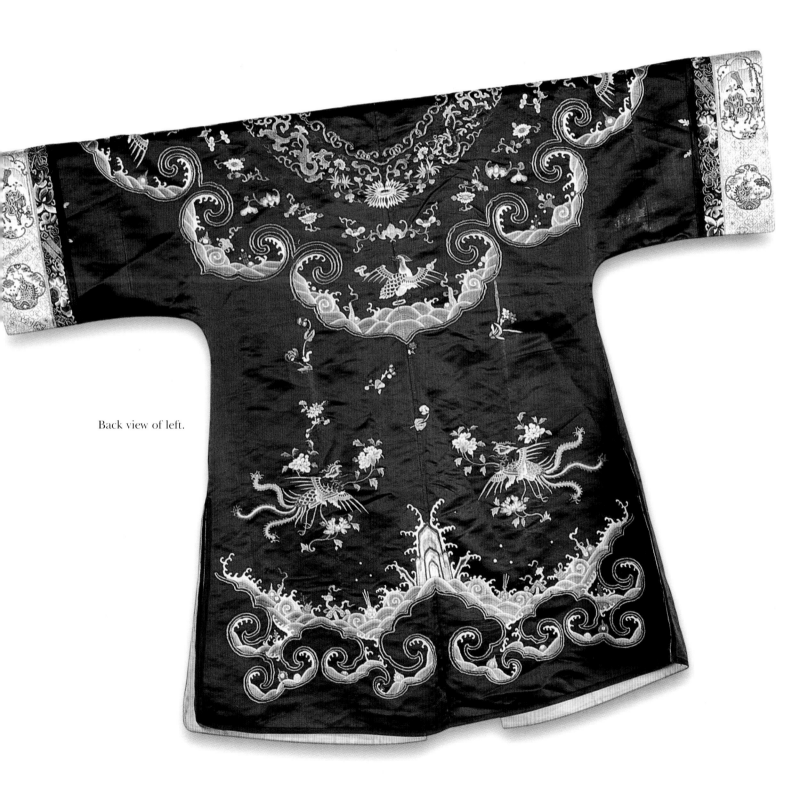

Back view of left.

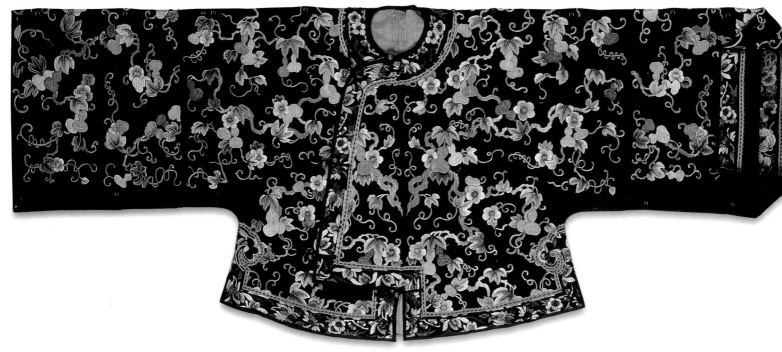

An unusual lady's, possibly manchu, wool winter jacket embroidered with flowers and gourds in silk satin stitch. The sleeve bands are embroidered in silk Peking stitch and satin stitch on black silk, with metal buttons. The piece is in average condition with slight staining and some moth holes. It is a very strong design with high quality workmanship. Circa 1870. 65" x 26". $1200. If perfect, $3000. H2,C3,Q2,R2

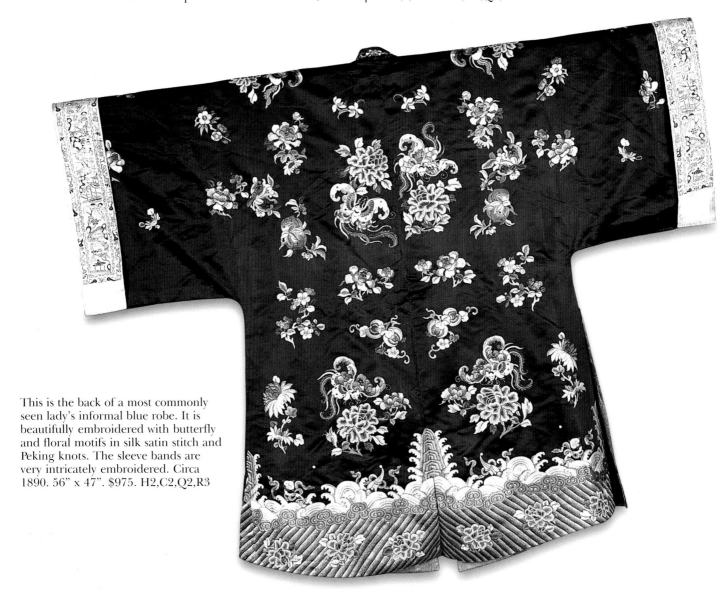

This is the back of a most commonly seen lady's informal blue robe. It is beautifully embroidered with butterfly and floral motifs in silk satin stitch and Peking knots. The sleeve bands are very intricately embroidered. Circa 1890. 56" x 47". $975. H2,C2,Q2,R3

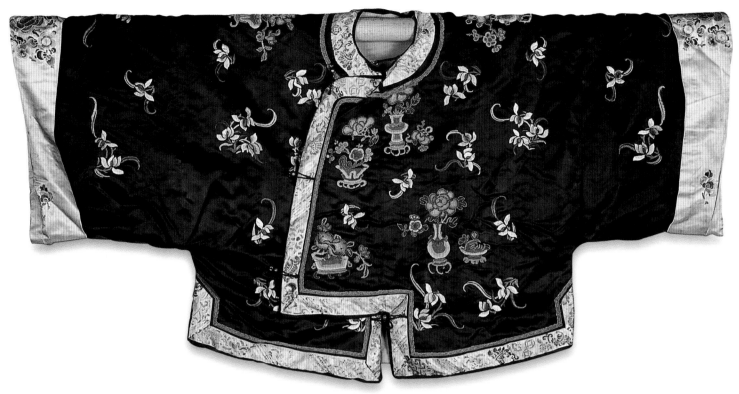

A lady's informal winter-weight jacket, possibly manchu. It is of dark blue-black silk satin, with silk batting and embroidered with silk satin and Peking stitch. It is a short style, being waist length, and the bottom is accented with woven ribbon. Late nineteenth century. 49" x 25". $975. H2,C2,Q2,R3

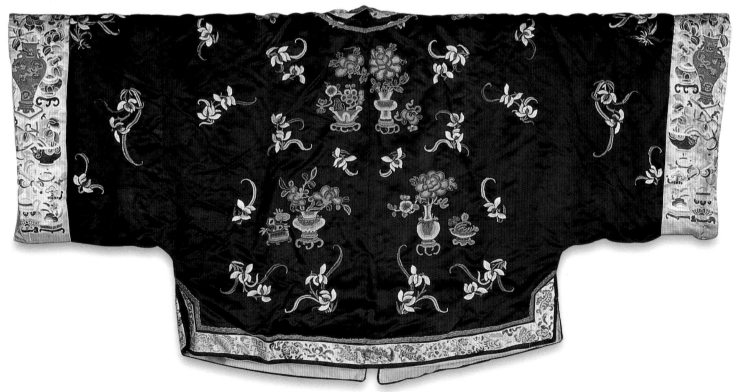

Back view of above.

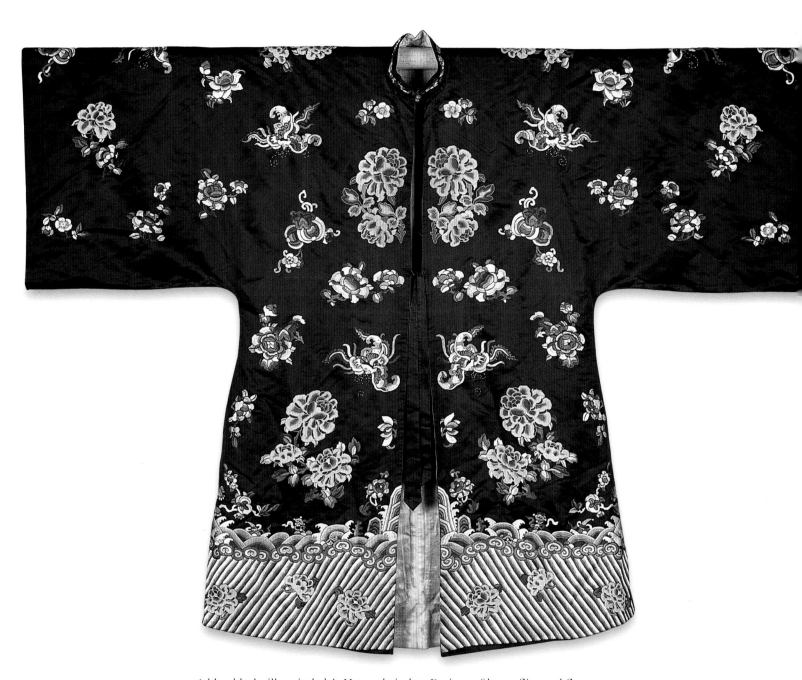

A blue-black silk satin lady's Han style jacket. Designs of butterflies and flowers are embroidered in shades of blue satin stitch and Peking stitch. It is very nicely detailed and in good condition. Circa 1890. 59" x 46". $975. H2,C3,Q3,R4

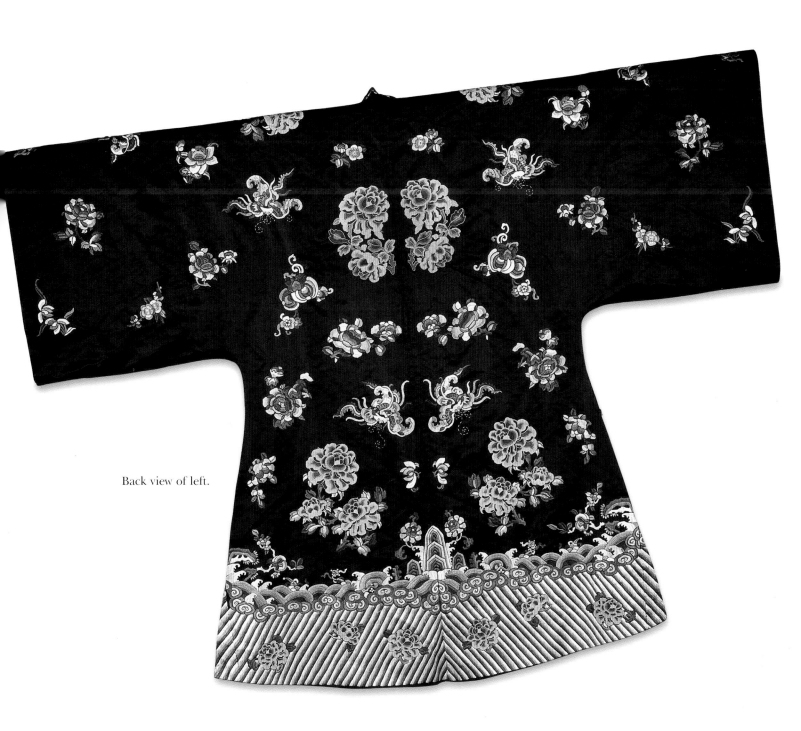

Back view of left.

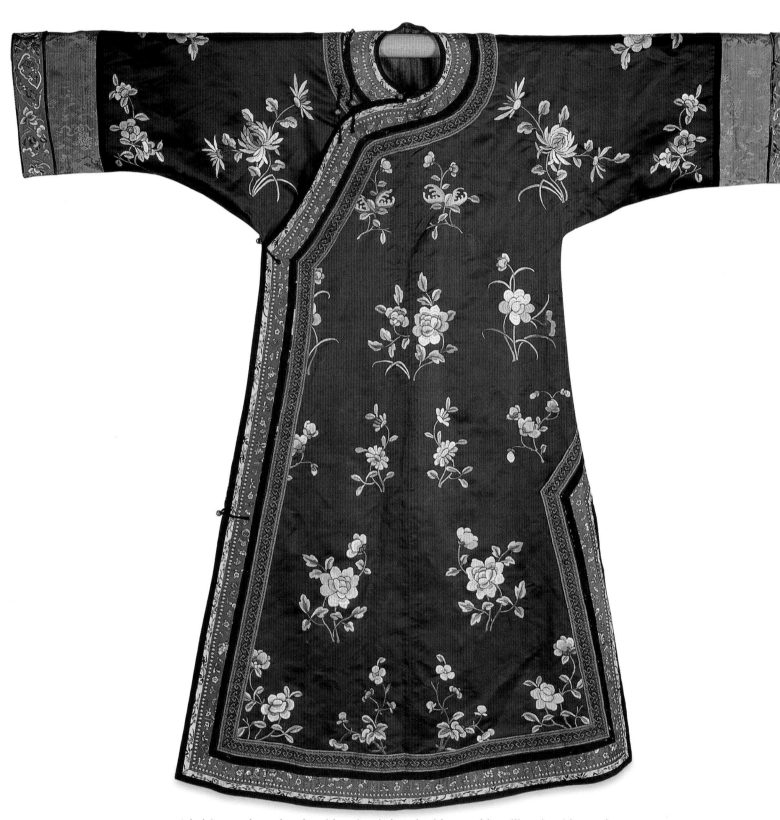

A lady's manchu style robe with satin stitch embroidery on blue silk satin with metal buttons. The sleeve bands do not appear original to the piece, but are contemporary with it. Circa 1870. 52" x 54.5". $750. H2,C2,Q3,R3

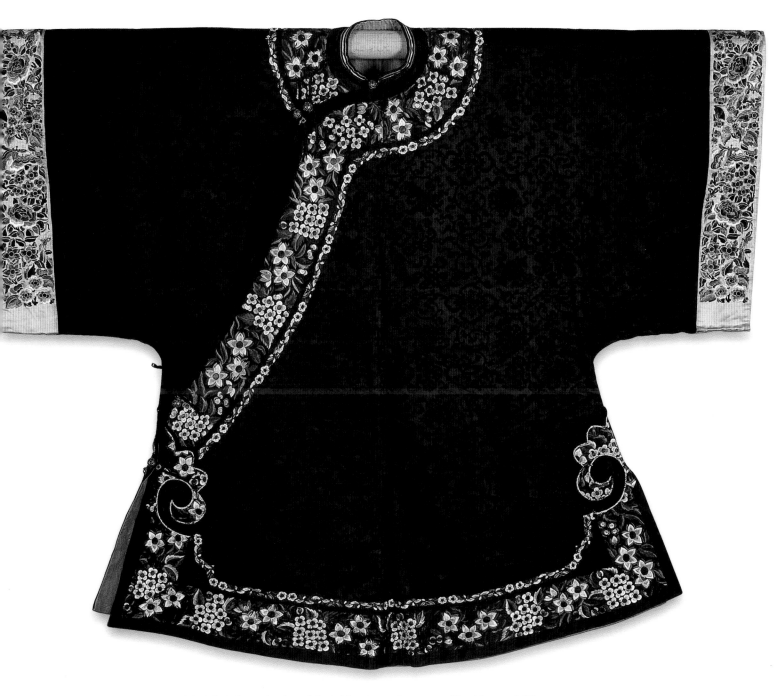

A lady's informal robe of dark blue brocade-woven silk with metal filigree buttons. The sleeve bands are of yellow silk satin with satin stitch embroidery of flowers and butterflies. The sleeve bands have been repositioned and are most likely not original to the piece, though contemporary with it. The trim is of blue and white satin stitch on black silk. Circa 1860. 44" x 36". $650. H2,C3,Q3,R4

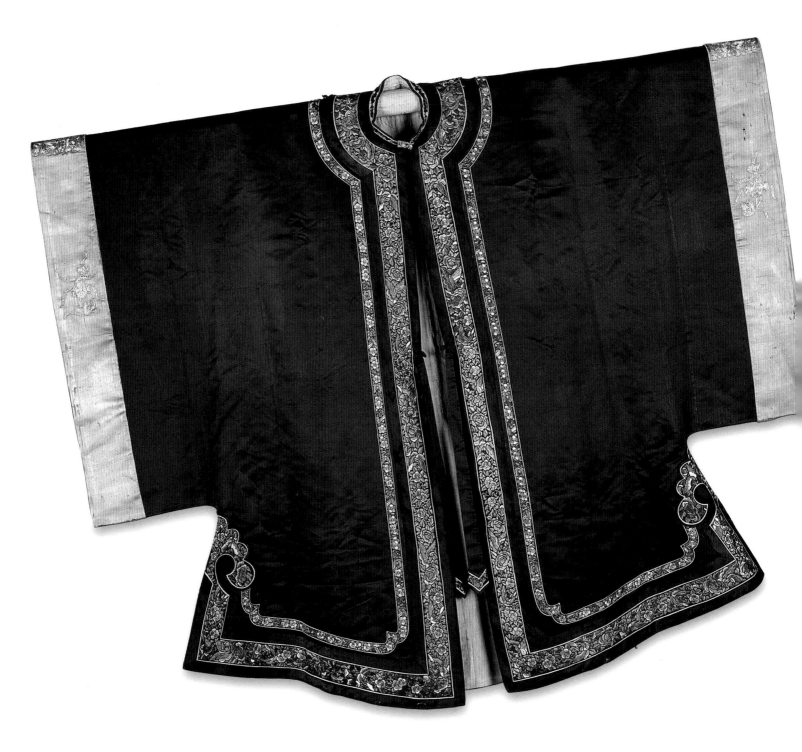

A lady's Han style jacket in a blue-black damask floral pattern silk. It has elaborately embroidered sleeve bands of light blue silk couched with gold metallic thread. The jacket is trimmed with embroidered bands of blue floral motifs on black silk. There is significant wear and breakdown along the shoulders and collar. Circa 1890. 48" x 37.5". $500 due to simple design and condition. H2,C3,Q3,R4

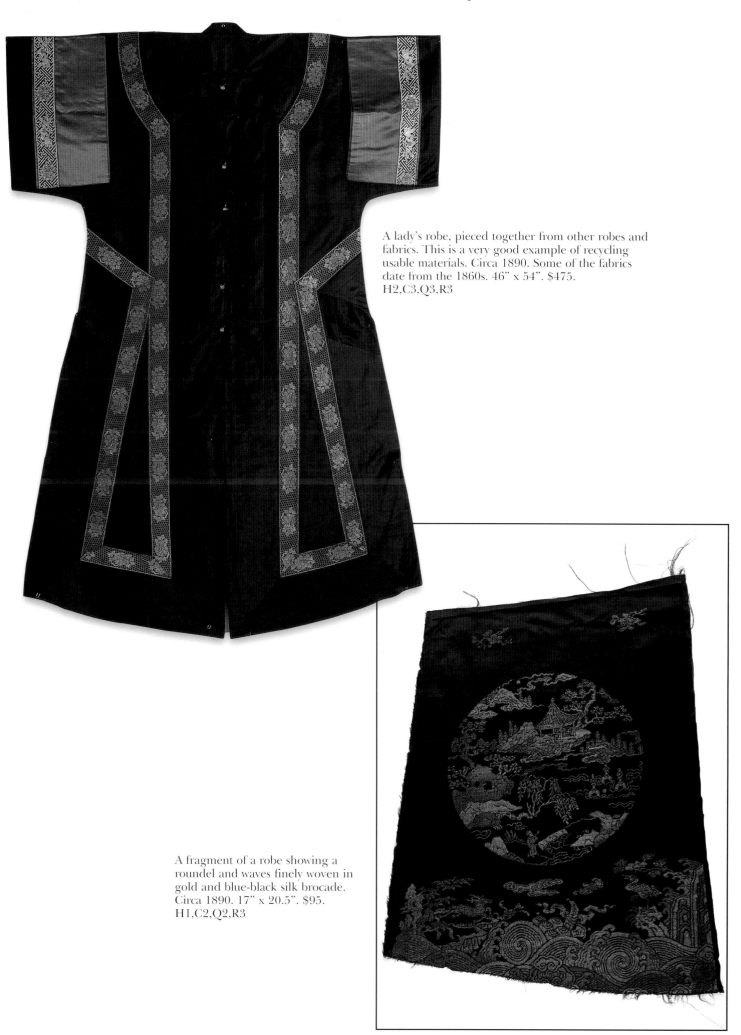

A lady's robe, pieced together from other robes and fabrics. This is a very good example of recycling usable materials. Circa 1890. Some of the fabrics date from the 1860s. 46" x 54". $475. H2,C3,Q3,R3

A fragment of a robe showing a roundel and waves finely woven in gold and blue-black silk brocade. Circa 1890. 17" x 20.5". $95. H1,C2,Q2,R3

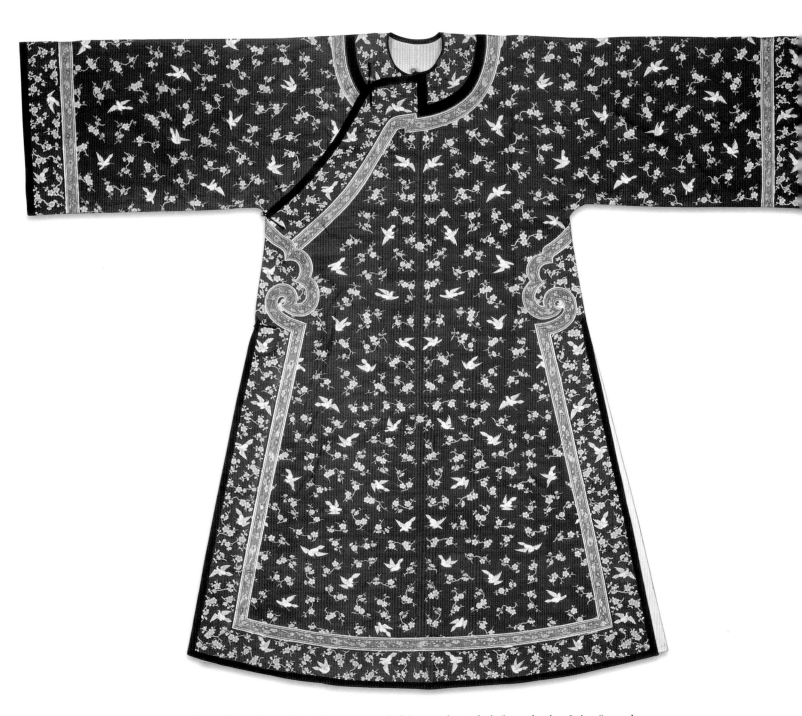

A beautiful and very fine k'o-ssu woven lady's manchu style informal robe. It is of purple background with very detailed white birds and gold metallic flowers. The trim is an exact pattern match but with black background, as are the white colored sleeve linings. It is lined in traditional aqua blue silk and is in very good condition. Circa 1880. 61.75" x 59.5". $9500. H2,C2,Q1,R2

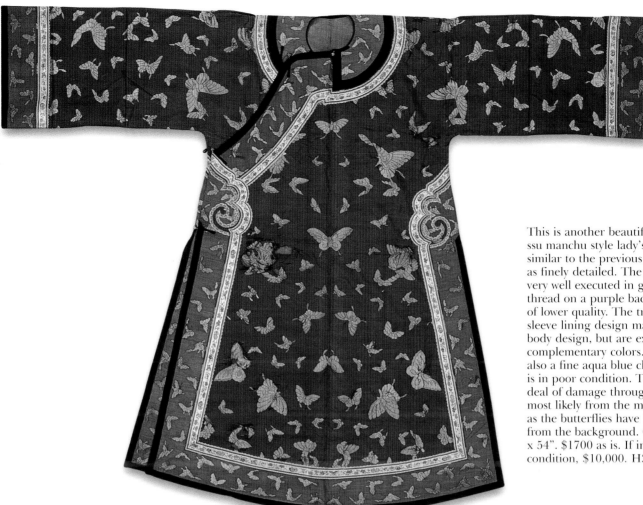

This is another beautifully woven k'o-ssu manchu style lady's robe. It is similar to the previous robe but is not as finely detailed. The butterflies are very well executed in gold metallic thread on a purple background, but of lower quality. The trim and inner sleeve lining design match the main body design, but are executed in complementary colors. The lining is also a fine aqua blue china silk, but it is in poor condition. There is a great deal of damage throughout the piece, most likely from the metallic thread, as the butterflies have broken away from the background. Circa 1880. 72" x 54". $1700 as is. If in perfect condition, $10,000. H3,C5,Q2,R3

This is a very simple style of robe woven in a light weight silk damask. The unusual feature here is the painted sleeve bands. They are woven in the corresponding lightweight silk damask and have no embroidery at all. Circa 1890. 49" x 38". $750. H4,C3,Q3,R3.

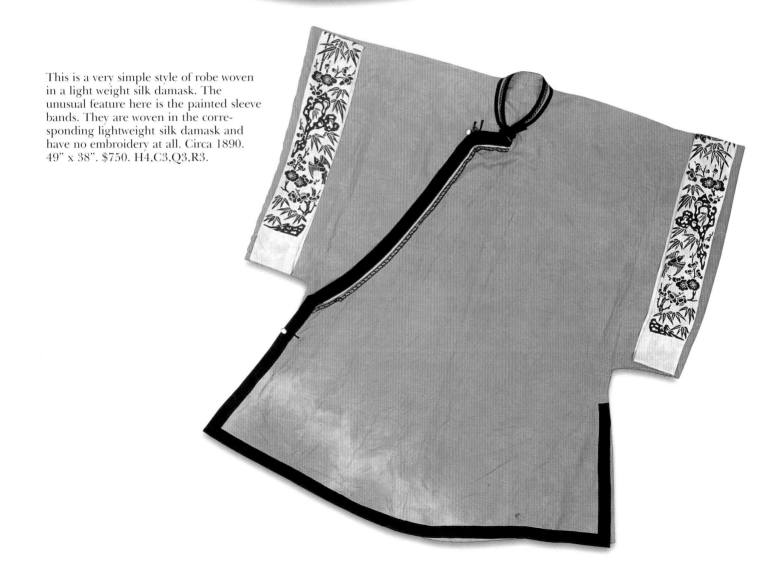

Sleevebands

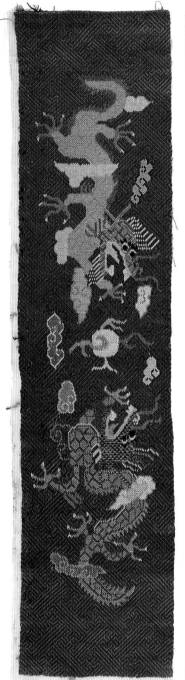
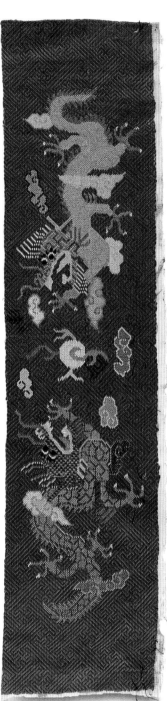

A pair of sleeve panels with silk brick stitch embroidered dragons on red silk. Circa 1900. 3" x 12.5". $295.

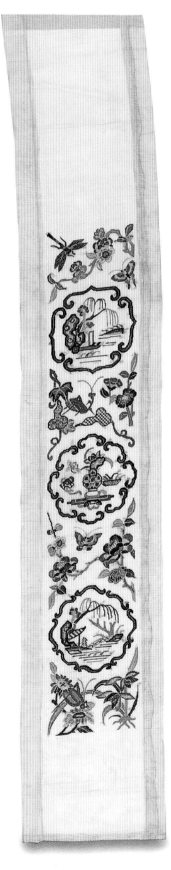
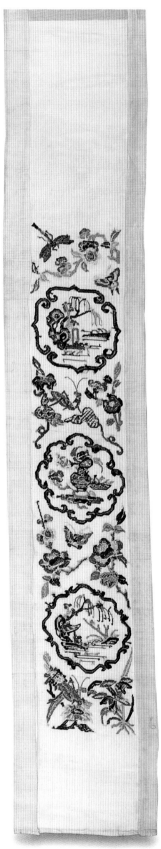

A pair of lady's sleeve bands embroidered in silk satin stitch with couched details and Peking stitch on white silk of scenes in medallions. Circa 1880. Each 3" x 36.5". $275. H1,C1,Q2,R3

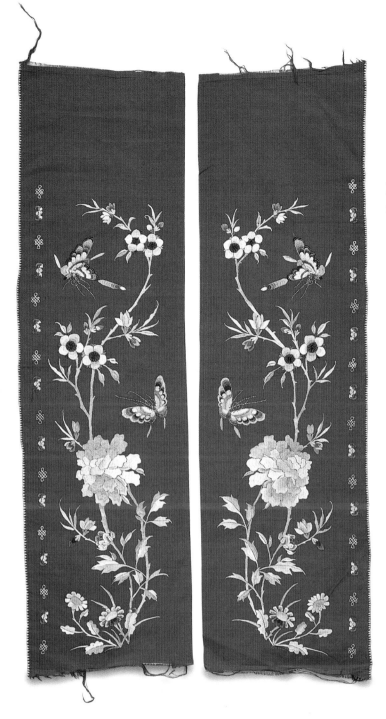

A portion of a pair of sleeve panels of very fine quality. They are embroidered in silk satin stitch on blue silk. Circa 1890. 3.5" x 12". $195. H1,C1,Q3,R4

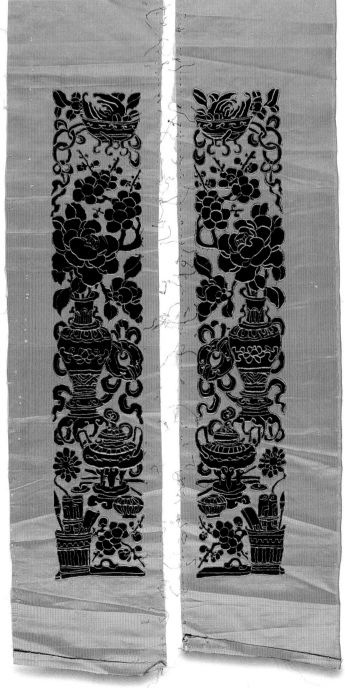

A pair of lady's sleeve bands embroidered with black silk Peking stitch and couched gold metallic threads on dark yellow silk satin. Circa 1900. Each measures 6" x 39.5". $195. H1,C1,Q2,R3

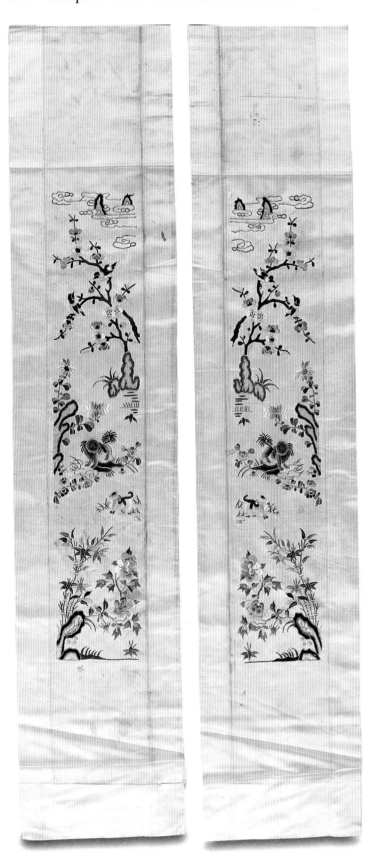

A pair of sleeve panels of silk satin embroidery on white finely woven satin brocade. Circa 1890. 6.5" x 44" each. $175. H1,C1,Q2,R3

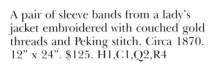

A pair of sleeve bands from a lady's jacket embroidered with couched gold threads and Peking stitch. Circa 1870. 12" x 24". $125. H1,C1,Q2,R4

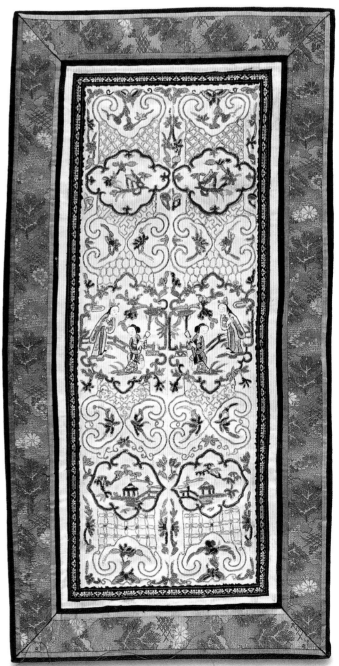

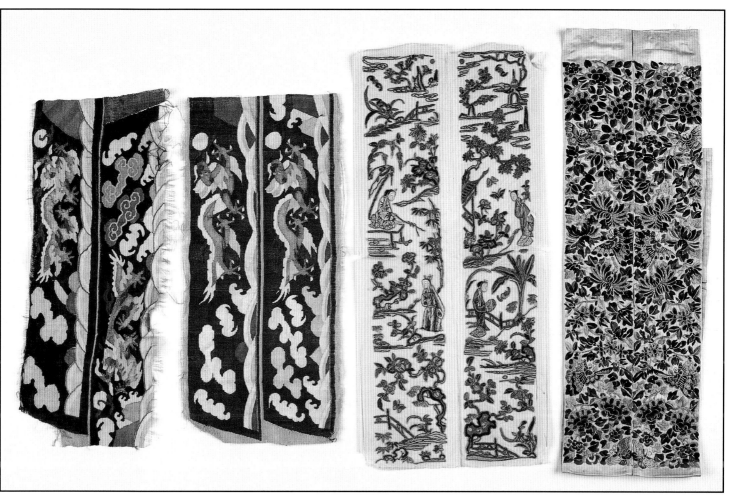

Left: uncut sleeve bands of loosely woven k'o-ssu with dragons, clouds and waves. Circa 1900. 18.5" x 6". $45. H1,C1,Q4,R3
Second: uncut sleeve bands of loosely woven k'o-ssu, with dragons, clouds and waves. The painted details are missing on this pair. This is a good example of an unfinished piece. Circa 1890. 15.5" x 7". $45. H1,C1,Q4,R3
Third: a pair of lady's sleeve bands embroidered with silk threads on silk fabric and applied to paper. The details are highlighted with couched, spun peacock feathers and metallic gold threads. Circa 1850. 18" x 8". $175. H1,C1,Q2,R4
Right: silk embroidered sleeve bands from a lady's jacket embroidered in Peking stitch with couched metallic gold threads. Circa 1890. Size 19" x 7".$150. H1,C1,Q3,R4

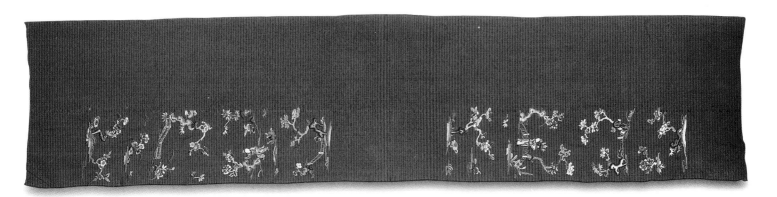

A small pair of uncut sleeve panels with silk satin stitch embroidery on red silk brocade. Circa 1880. 19" x 85". $95. H1,C1,Q4,R3

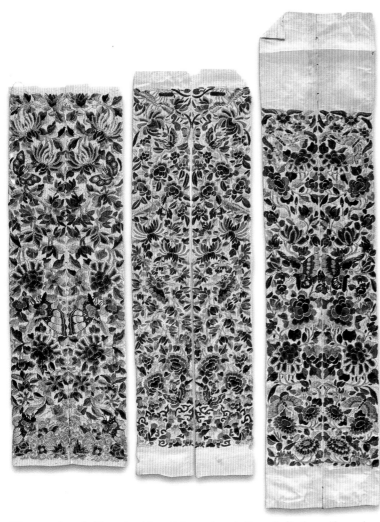

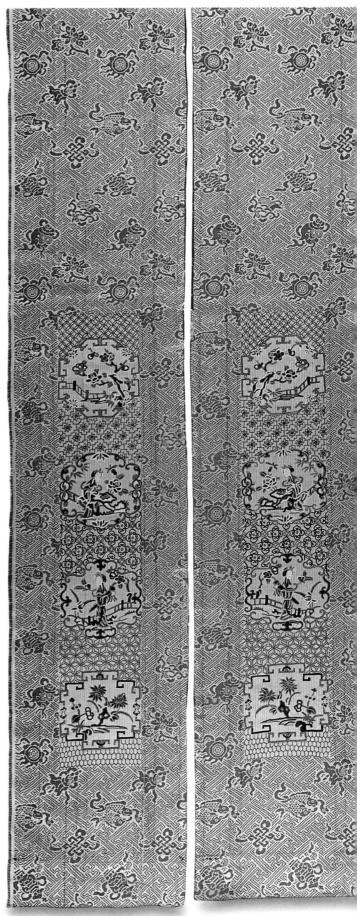

Three pairs of silk embroidered sleeve bands from ladies' semiformal jackets. The left set is embroidered in Peking stitch and couched metallic threads on a gauze brocade-woven silk with cloud design. Circa 1890. 24" x 3" each. $80 for the pair.
The center set is embroidered in silk satin stitch with couched metallic threads. Circa 1890. 19" x 3" each. $80 for the pair.
The right set is embroidered in Peking stitch, satin stitch and with couched gold metallic threads. Circa 1890. 24" x 3" each. $80 for the pair. All rated at H1,C1,Q3,R4

A pair of sleeve panels with extremely fine embroidery on silk damask. They are embroidered in a medallion style with many different stitches in silk, creating almost a sampler effect. Circa 1880. 7.5" x 43" each. $450. H1,C1,Q2,R3

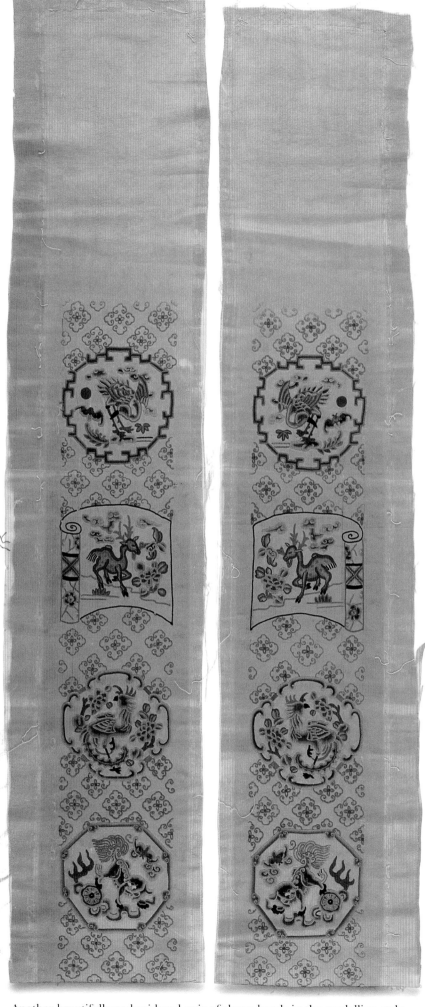

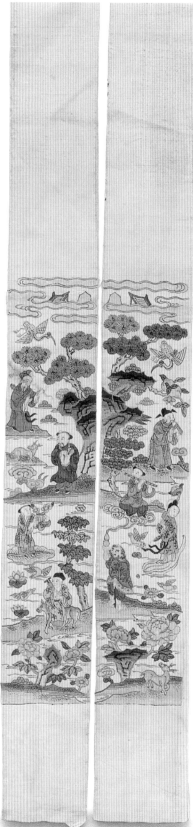

A pair of very fine k'o-ssu woven sleeve panels depicting a Chinese myth, with painted details that are designed in such a manner as to make almost a complete scene across the two panels. Circa 1870. 4" x 45". $950. H2,C3,Q1,R1

Another beautifully embroidered pair of sleeve bands in the medallion style. They are stitched with silk thread in Peking stitch on gold silk satin. Note the unusual scroll shaped medallion. Circa 1870. 5.5" x 40" each. $500. H3,C3,Q2,R3

Ladies Han Style Skirts
Full skirts

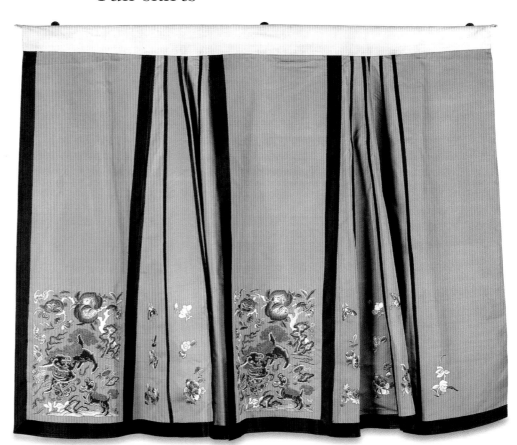

A lady's Han style skirt of light green silk with an unusual design of fu-lions with peaches, bats, and various floral motifs embroidered in satin stitch, Peking stitch, and couched gold metallic threads. It is edged in black bias silk and is in excellent condition. Circa 1880. 34" long, 43" wide at the waist, 86" at the bottom. $975. H1,C1,Q2,R3

Below:
An unusual skirt of heavy blue-black silk satin with only bats as the motif. It is edged with a fine ribbon with woven gold metallic trim and black silk bias edging. A modern skirt top has been added. It has simplicity of design and good quality workmanship. Circa 1880. 89" x 39.5". $850. H2,C2,Q2,R3

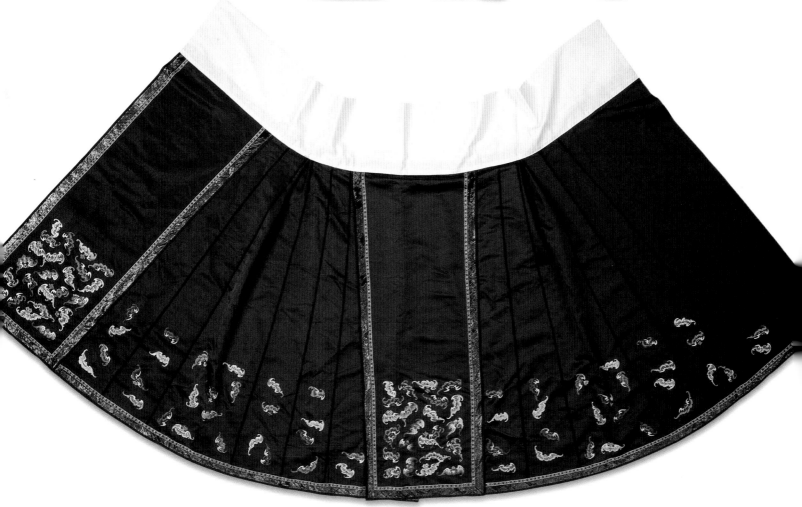

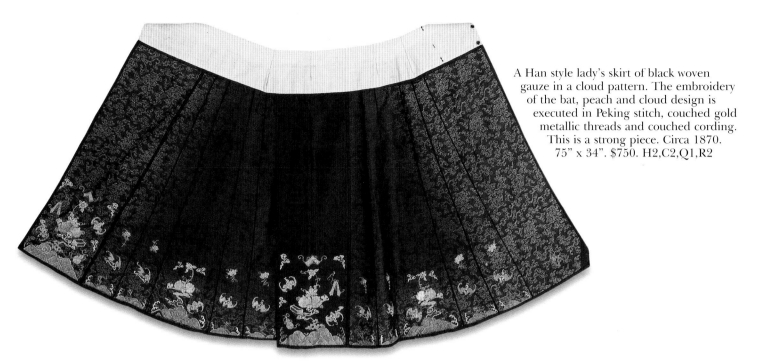

A Han style lady's skirt of black woven gauze in a cloud pattern. The embroidery of the bat, peach and cloud design is executed in Peking stitch, couched gold metallic threads and couched cording. This is a strong piece. Circa 1870. 75" x 34". $750. H2,C2,Q1,R2

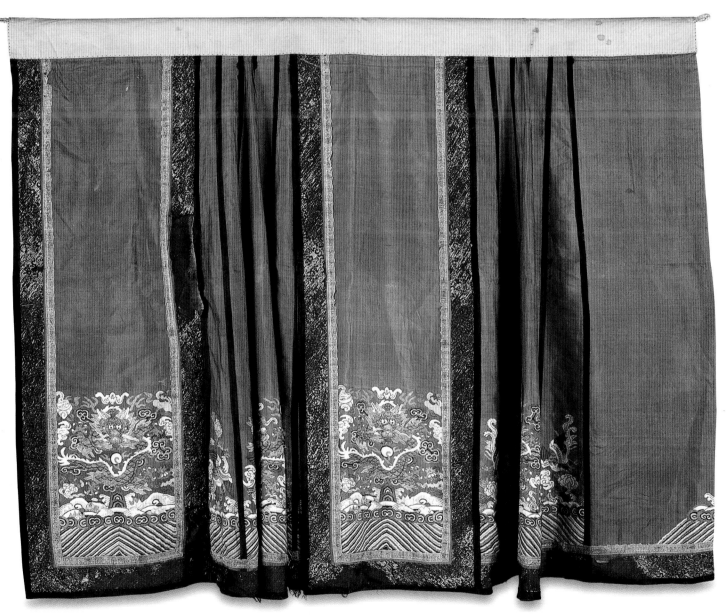

A lady's Han style k'o-ssu woven skirt with a colorful dragon motif in the manner of a dragon robe. Its orange color denotes its use as either for wedding or festival occasion. Circa 1880. 38.5" long, 43" at the waist, 85" across the bottom. The edging has broken down due to the mordants in the dyes. $750. H3,C3,Q3,R4

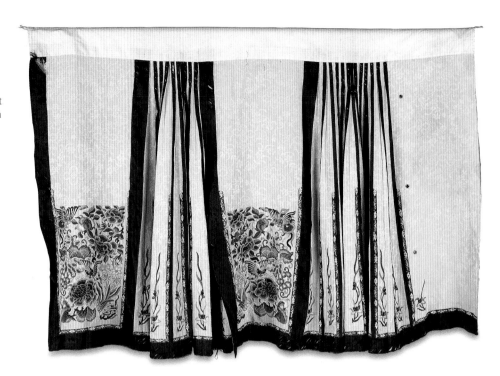

A beautiful yellow double apron skirt embroidered in Peking and silk satin stitch on a delicate brocade background. The black bias silk edging has broken down with time. Circa 1860. 84.5" x 37.5". $750. H2,C3,Q3,R4

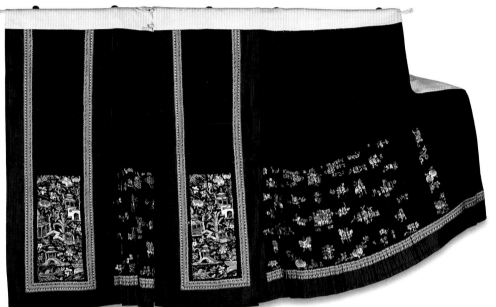

A finely pleated blue-black skirt embroidered with a village scene in silk satin stitch and couched gold metallic thread. Very good condition. Circa 1880. 38" x 86.5". $750. H2,C2,Q2,R4

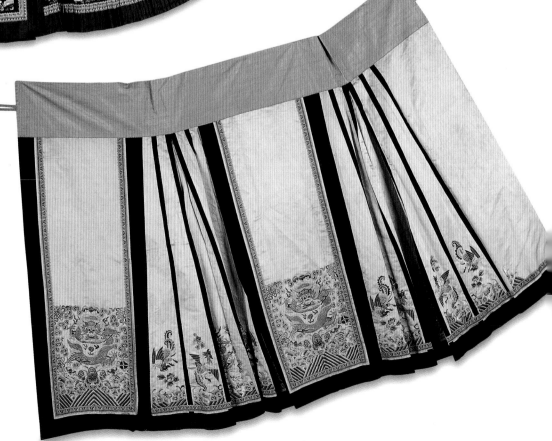

A lavender skirt with a couched metallic gold dragon and phoenix on the front and back panels. Satin stitch waves and birds in shades of blue and black complete the design. Circa 1880. 82" x 39". $650. H3,C3,Q3,R4

Skirt Panels

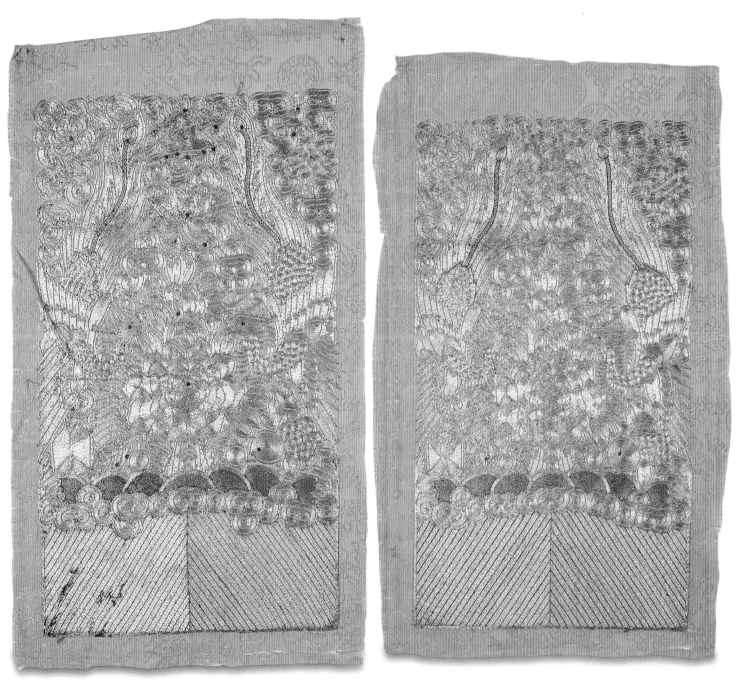

A pair of panels from a skirt finely embroidered with peacocks and flowers in couched gold and purple threads on brocade-woven gauze fabric. These are extremely well done and have tiny gold colored sequin details. Circa 1880. 9" x 16" each. $195. H3,C3,Q1,R3

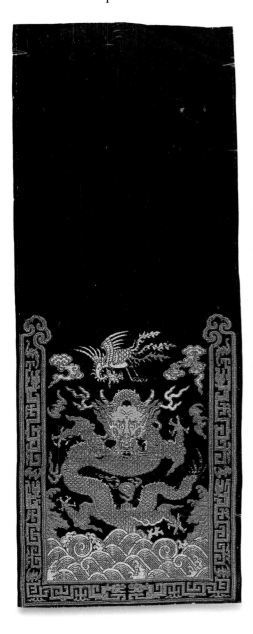

One of a group of three brocade-woven skirt panels with dragon and phoenix motifs. These are interesting as a study for comparisons. This one is black with metallic gold and cream colored patterns. Circa 1900. 10" x 33.75". $195. H1,C1,Q3,R3

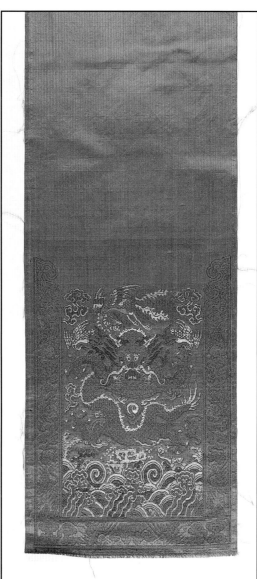

Another of the group of three woven skirt panels, this one with green silk background woven with metallic gold and white and yellow silk. Circa 1900. 9.75" x 34". $195. H1,C1,Q3,R3

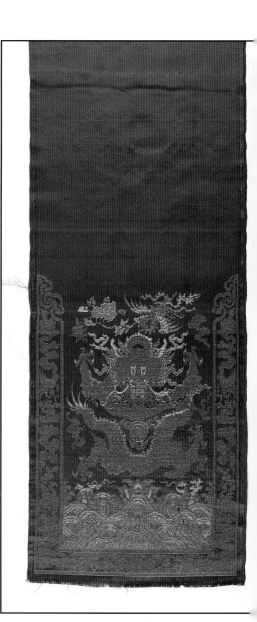

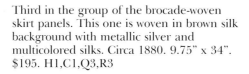

Third in the group of the brocade-woven skirt panels. This one is woven in brown silk background with metallic silver and multicolored silks. Circa 1880. 9.75" x 34". $195. H1,C1,Q3,R3

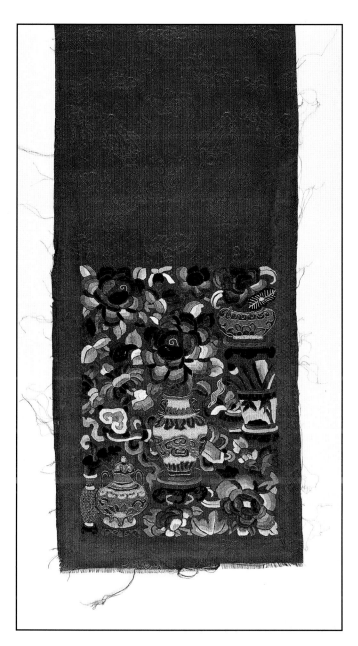

A fragment of a brown silk damask weave summer skirt. It is embroidered in silk satin stitch and Peking knots with couched gold metallic threads. Circa 1880. 10.5" x 32". $140. H2,C3,Q3,R4

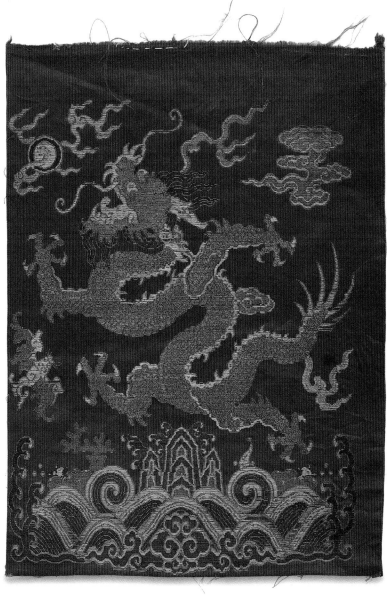

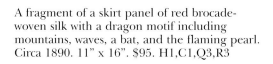

A fragment of a skirt panel of red brocade-woven silk with a dragon motif including mountains, waves, a bat, and the flaming pearl. Circa 1890. 11" x 16". $95. H1,C1,Q3,R3

Wedding Attire

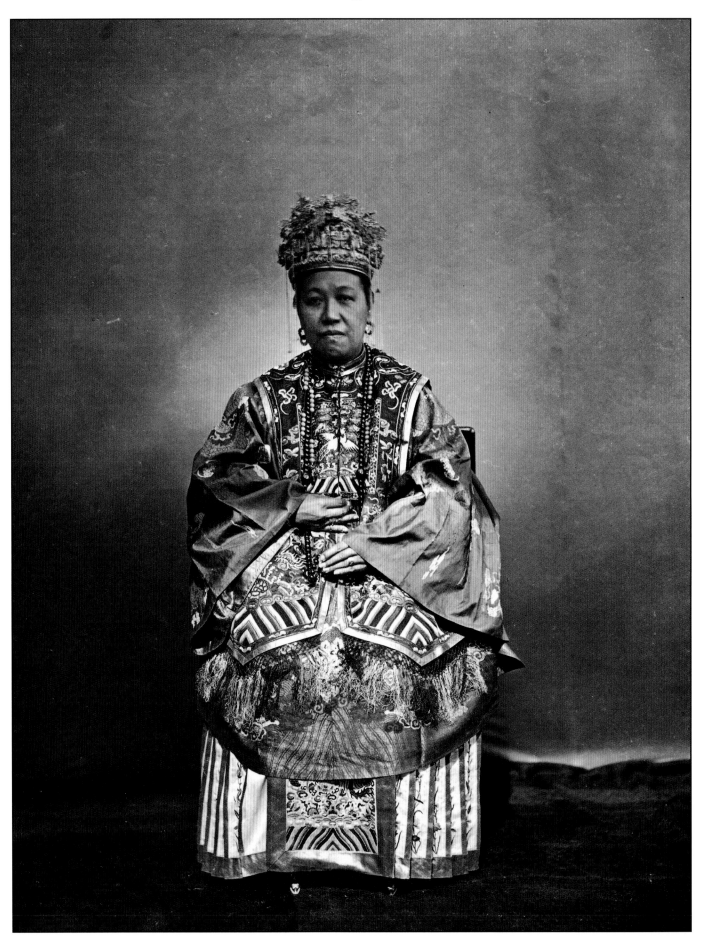

Milton M. Miller. The wife of an official in her "bridal" dress circa 1860s. Vintage albumen print. 9" x 7".
Courtesy of Throckmorton Fine Arts.

In China, the color red is associated with festive occasions. Red or dark orange wedding attire, with dragon and phoenix motifs, were commonly worn by brides, who were dressed as "empresses" for the occasion. These wedding attires often doubled as attire for other formal occasions including birthdays, anniversaries, festivals, and official events. They generally followed the styles of the formal jacket with closures on the side and were worn with a Han style skirt with embroidered front and rear panels and side pleats.

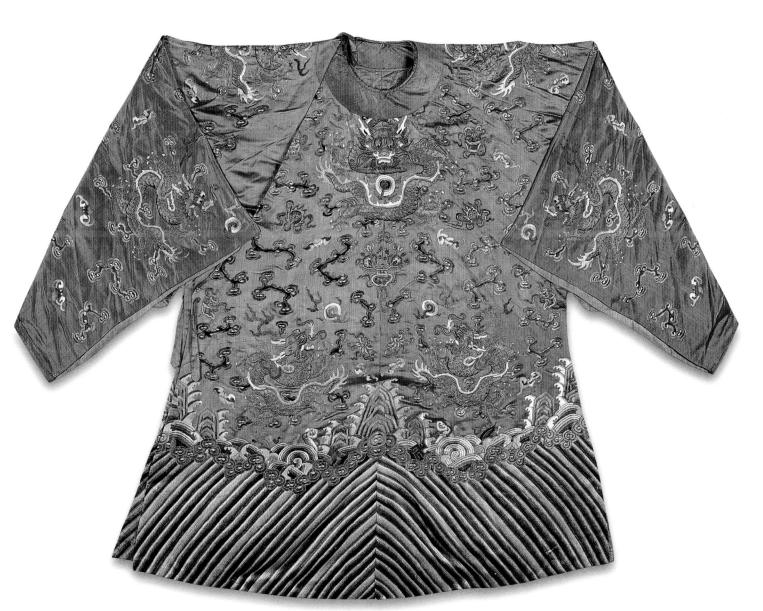

An orange wedding robe of silk satin embroidered with satin stitch, Peking stitch and couched gold metallic threads and cording. It is missing the original collar and appears to have been cut down at the front side opening. Circa 1850. 67" x 44". $1075. H3,C3,Q3,R4

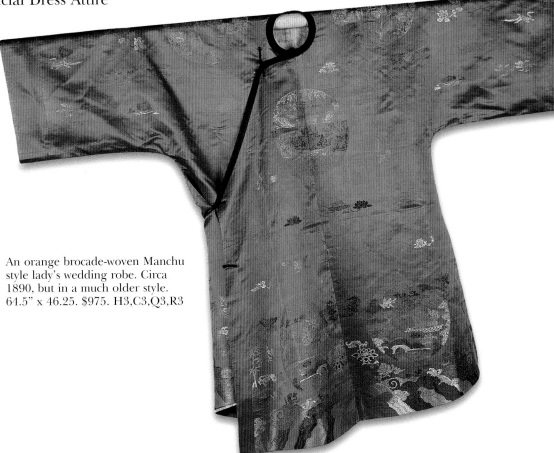

An orange brocade-woven Manchu style lady's wedding robe. Circa 1890, but in a much older style. 64.5" x 46.25. $975. H3,C3,Q3,R3

An orange silk satin wedding robe. It has dragons embroidered with gold couched metallic threads, the center motif embroidered in Peking stitch while the other motifs are executed in silk satin stitch. There is heavy damage in the shoulder area significantly lowering its value. Circa 1870. 60" x 45". $900. H3,C4,Q3,R4

Detail of damaged shoulder of robe above.

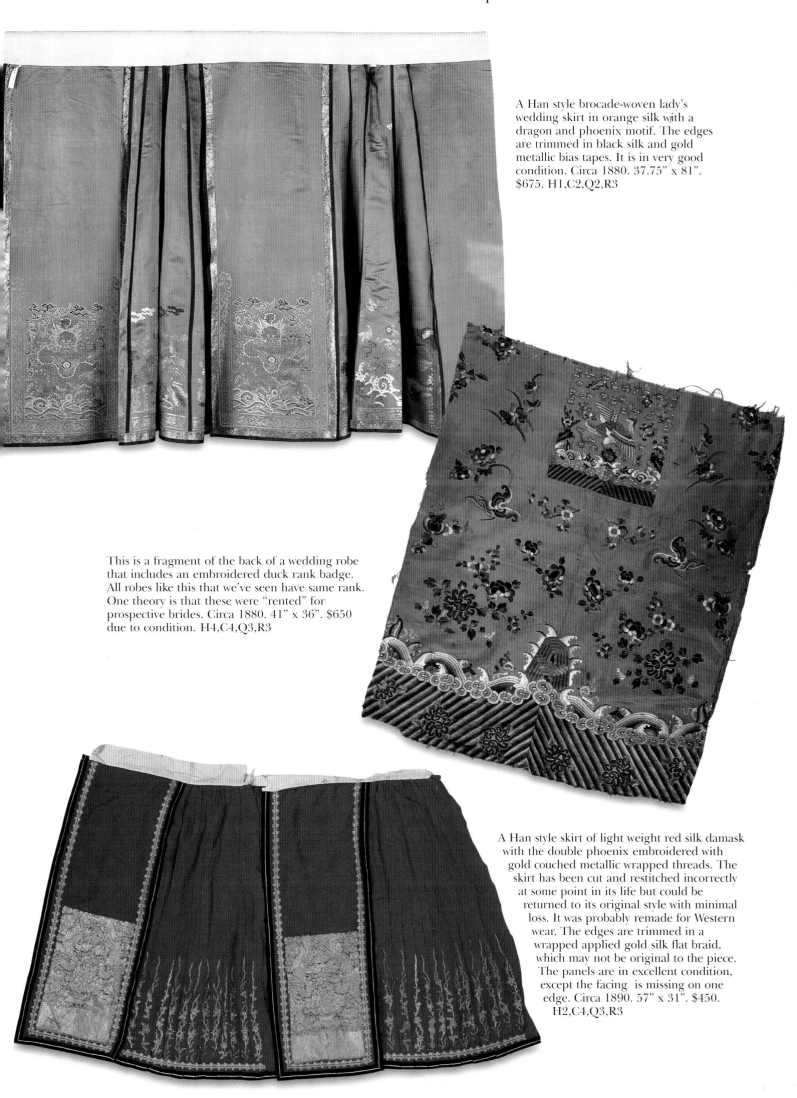

A Han style brocade-woven lady's wedding skirt in orange silk with a dragon and phoenix motif. The edges are trimmed in black silk and gold metallic bias tapes. It is in very good condition. Circa 1880. 37.75" x 81". $675. H1,C2,Q2,R3

This is a fragment of the back of a wedding robe that includes an embroidered duck rank badge. All robes like this that we've seen have same rank. One theory is that these were "rented" for prospective brides. Circa 1880. 41" x 36". $650 due to condition. H4,C4,Q3,R3

A Han style skirt of light weight red silk damask with the double phoenix embroidered with gold couched metallic wrapped threads. The skirt has been cut and restitched incorrectly at some point in its life but could be returned to its original style with minimal loss. It was probably remade for Western wear. The edges are trimmed in a wrapped applied gold silk flat braid, which may not be original to the piece. The panels are in excellent condition, except the facing is missing on one edge. Circa 1890. 57" x 31". $450. H2,C4,Q3,R3

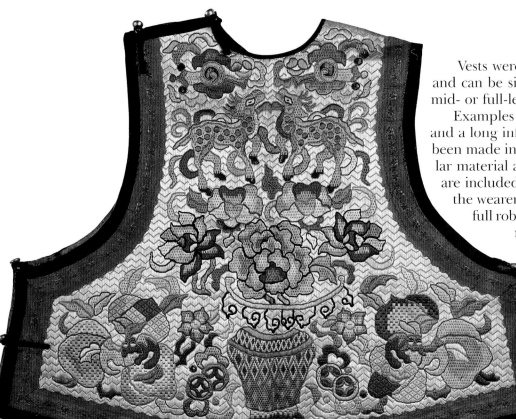

Vests

Vests were widely used in every level of attire and can be side-opening or front-opening, short, mid- or full-length.

Examples in this section include a child's vest and a long informal vest (which, interestingly, had been made into a robe by adding sleeves of a similar material at a later date). Court vests, however, are included in a previous chapter. Vests allowed the wearer more freedom of movement than a full robe and could be used to extend a wardrobe.

A beautiful child's vest embroidered in needlepoint stitches in silk thread on silk gauze and outlined in couched gold metallic thread. There is some staining from use. Circa 1890. 14" x 11". $695. H3,C4,Q3,R3

A lady's manchu style vest of dark blue silk satin embroidered with butterflies and flowers done in silk satin stitch. The trim is also dark blue with embroidered butterflies. It has champlevé-accented buttons, three of which have been replaced. Circa 1870. 44.25" x 53". $1200. This piece came from a collection of theatrical garments and was altered to a robe. We were able to remove all the alterations to bring it back to original. H2,C2,Q3,R3

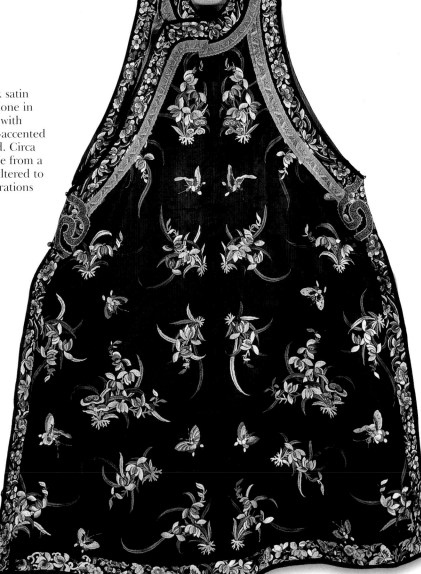

Children

Children's styles mimicked those of their elders, especially at court and with the imperial family. There are small versions of the dragon robe or Ch'i-fu, little girls' skirts and tops, and other informal jackets.

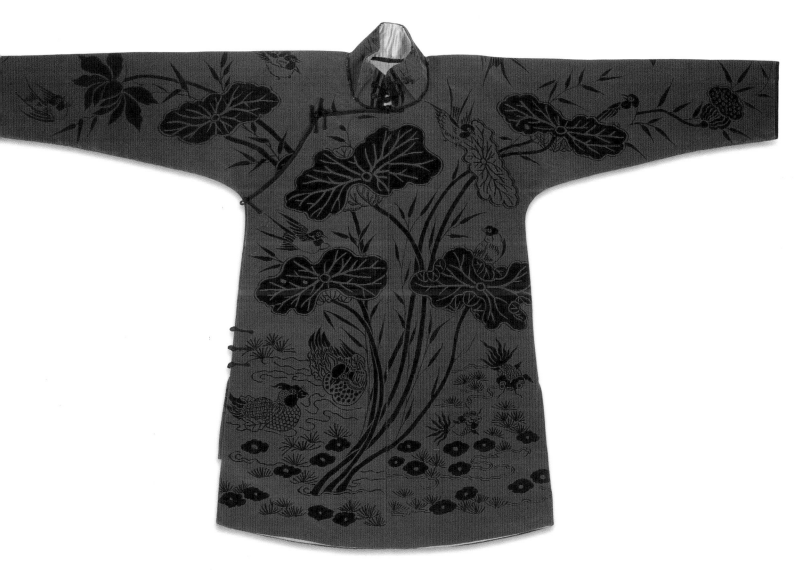

Child's jacket of charcoal grey cut velvet in beautiful condition with a lotus, bird and goldfish motif. It is lined with turquoise blue silk, has black silk toggles, and is a great example of this type of garment. The tailored style and pictorial scene was popular in the early twentieth century. It is in good condition with little wear and a few small stains. 50" x 34". $1700, if perfect $2200.

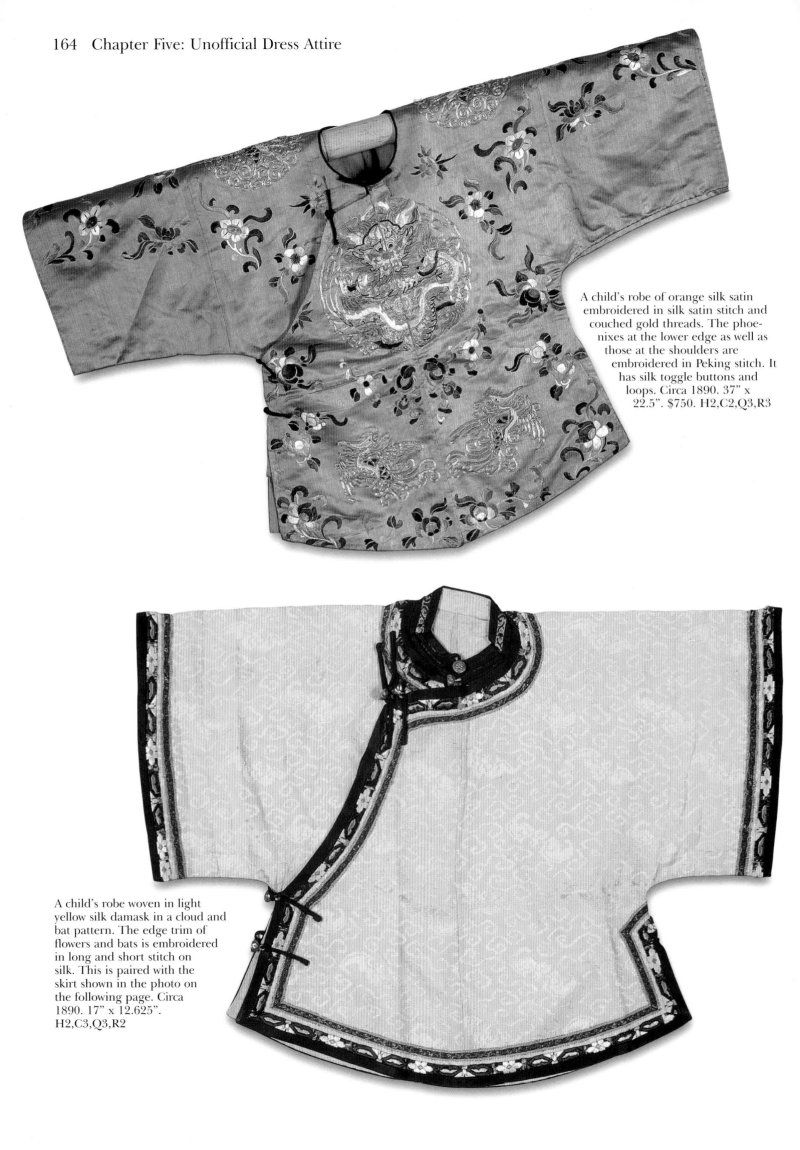

A child's robe of orange silk satin embroidered in silk satin stitch and couched gold threads. The phoenixes at the lower edge as well as those at the shoulders are embroidered in Peking stitch. It has silk toggle buttons and loops. Circa 1890. 37" x 22.5". $750. H2,C2,Q3,R3

A child's robe woven in light yellow silk damask in a cloud and bat pattern. The edge trim of flowers and bats is embroidered in long and short stitch on silk. This is paired with the skirt shown in the photo on the following page. Circa 1890. 17" x 12.625". H2,C3,Q3,R2

A child's skirt of peach colored damask silk woven in a flower pattern. The front and back panels have satin stitch flowers with couched metallic gold thread detail. The edge trim of flowers and bats is embroidered in long and short stitch on silk. Circa 1890. 15" x 16.5". H2,C3,Q3,R2. Paired with the robe on the previous page, $750 for the set.

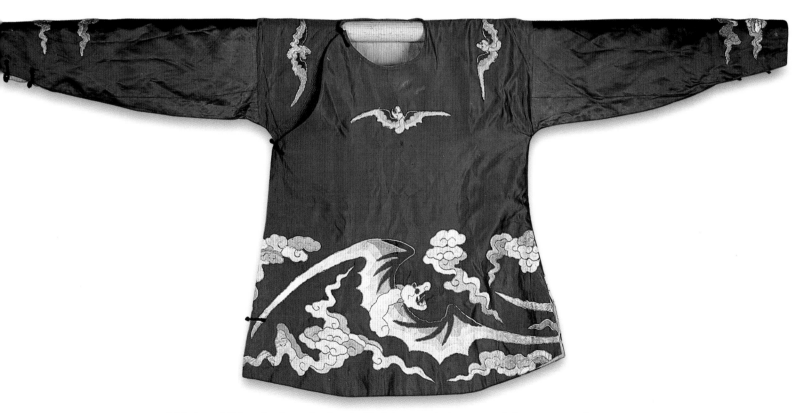

This is a child's robe from the first half of the twentieth century. It has an unusual design of boldly executed bats. There is some damage and staining on the silk fabric. A portion of the design is embroidered directly on to the background fabric of silk and the other is appliquéd. 63" x 29.5". $450. H4,C4,Q3,R3

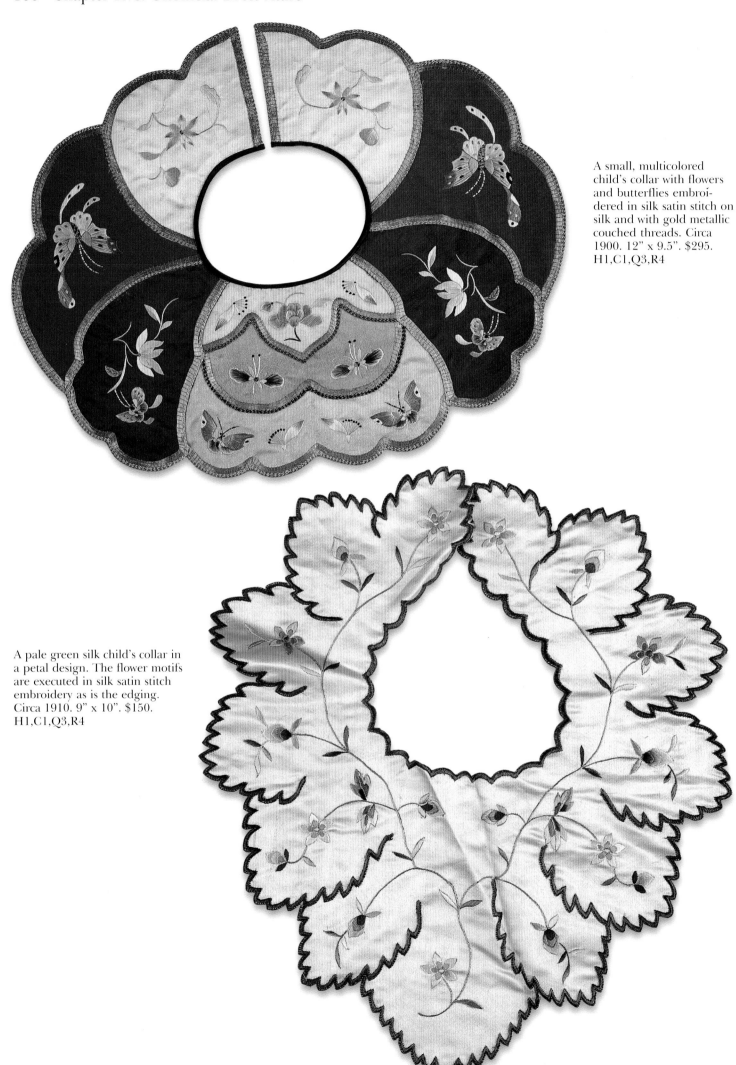

A small, multicolored child's collar with flowers and butterflies embroidered in silk satin stitch on silk and with gold metallic couched threads. Circa 1900. 12" x 9.5". $295. H1,C1,Q3,R4

A pale green silk child's collar in a petal design. The flower motifs are executed in silk satin stitch embroidery as is the edging. Circa 1910. 9" x 10". $150. H1,C1,Q3,R4

Chapter 6
Theatrical Costume

Theater was one of the most popular forms of entertainment for all levels of society. Performers ranked from simple street actors to sumptuous court troupes. Theater costumes were exaggerated to be visible from a distance and were made to fit loosely to facilitate quick changes. Most of the themes of Chinese theater or opera, as it is often called, are based on historical events that portray the court, military, and civil characters. Both female and male parts were played by all male or all female troupes and costumes were standardized.

The materials used in the costumes were sturdy and usually had a cotton or bast fiber lining with padding. The outer part of the garment was generally silk and boldly embellished with large symbols and imagery. The designs are embroidered with heavy threads and further embellished with mirrored studs and gilt-thin armor accents. Chinese theater costumes were not regulated and many pieces we see in collections show flamboyant interpretations of classic dress.

Many of the finely made, boldly designed robes and outfits offered at antique shows and auctions are theater robes, though not properly identified as such. Theater costumes can range from very ornate and valuable to simple and inexpensive. Many are inventive and gaudy. The prices of theater costume range from one hundred to many thousands of dollars. There are imperial theatrical garments that rival the finest formal court robes in their materials and manufacture. Many theater pieces are also misidentified as Tibetan due to their rich, bold appearances.

Robes

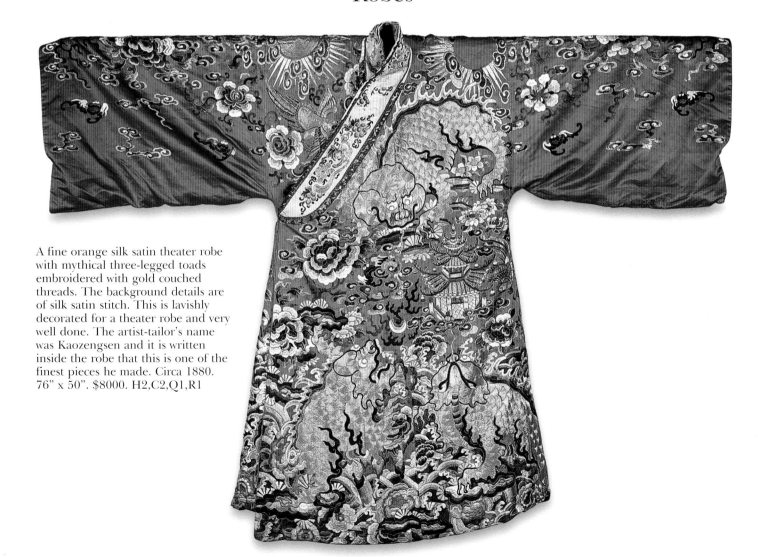

A fine orange silk satin theater robe with mythical three-legged toads embroidered with gold couched threads. The background details are of silk satin stitch. This is lavishly decorated for a theater robe and very well done. The artist-tailor's name was Kaozengsen and it is written inside the robe that this is one of the finest pieces he made. Circa 1880. 76" x 50". $8000. H2,C2,Q1,R1

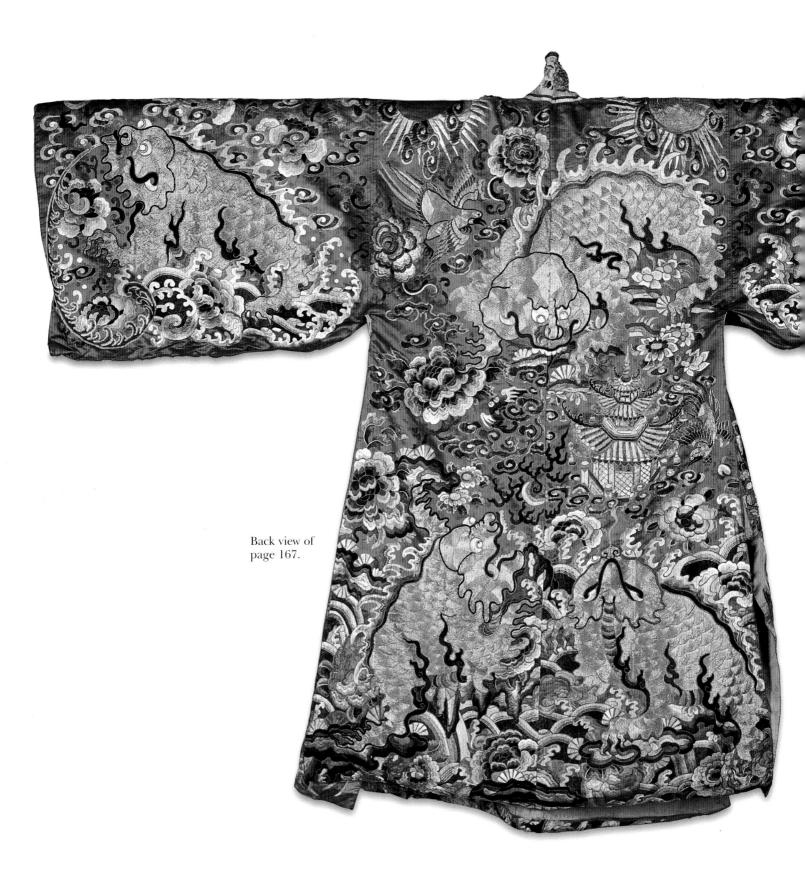

Back view of
page 167.

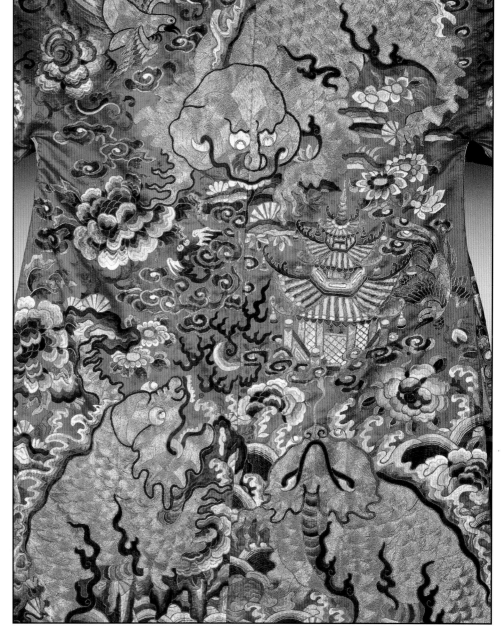

Detail of back
view of left.

Signature detail
for robe at left.

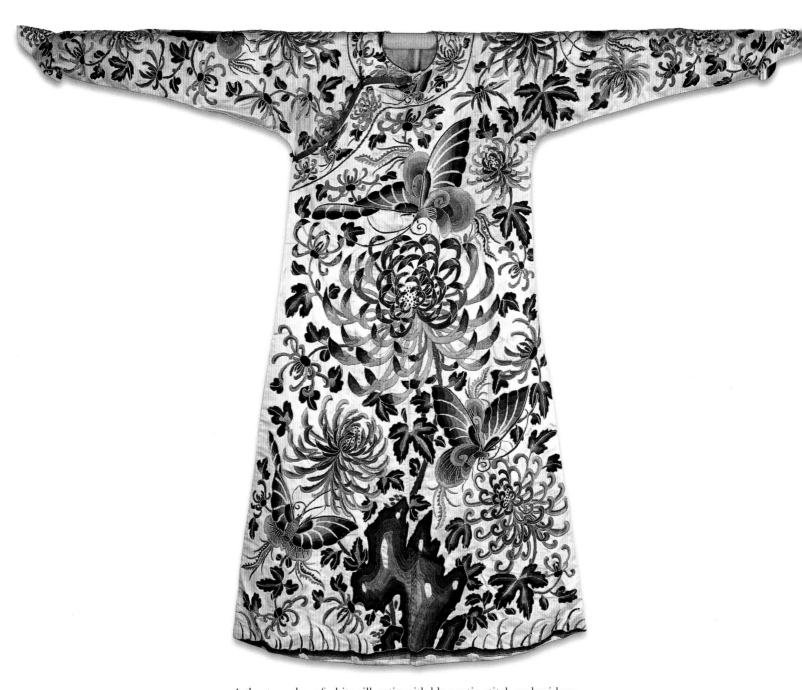

A theater robe of white silk satin with blue satin stitch embroidery and gold couched threads. Theater robes traditionally do not have much value. Circa 1880. 80" x 52". $1800. H3,C3,Q3,R3

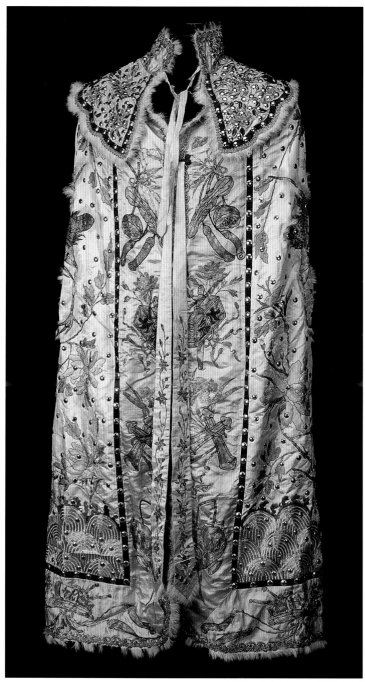

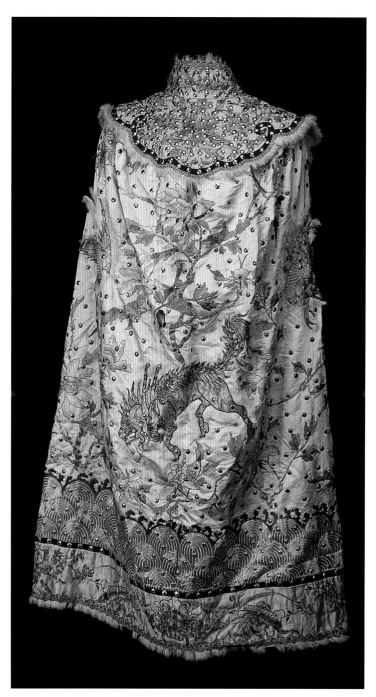

A cape of white silk satin for a theater costume. It is embroidered in silk satin stitch and couched metallic threads and studded in silver colored metal buttons to catch the light. It is edged in rabbit fur and lined in pink silk. There are some small tears on the side and a hole in the center back. It is a strong, decorative piece. Second half of the nineteenth century. 63.5" x 50". $600 in its current condition; when restored it will be worth $1200. H2,C4,Q3,R3

Back view.

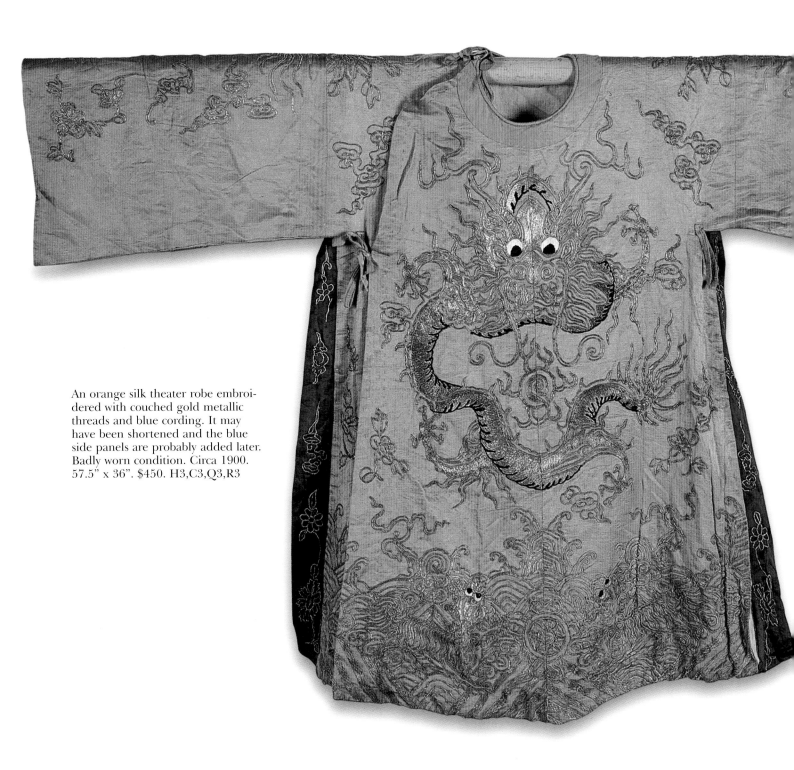

An orange silk theater robe embroidered with couched gold metallic threads and blue cording. It may have been shortened and the blue side panels are probably added later. Badly worn condition. Circa 1900. 57.5" x 36". $450. H3,C3,Q3,R3

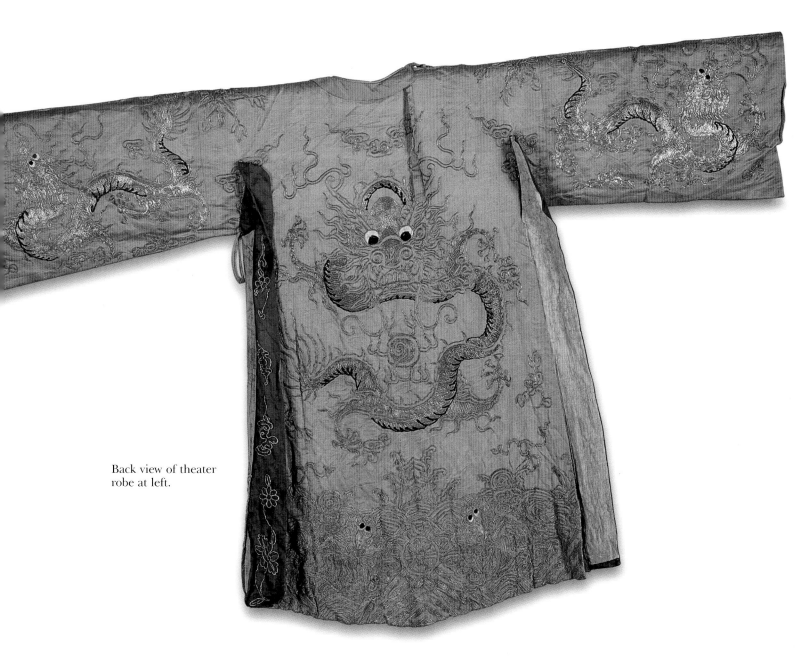

Back view of theater
robe at left.

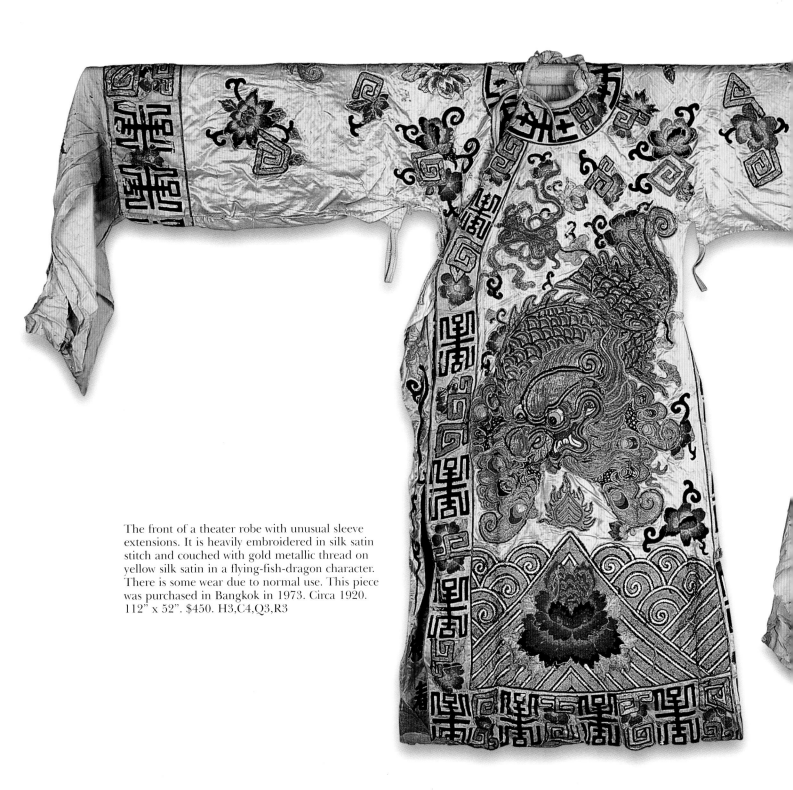

The front of a theater robe with unusual sleeve extensions. It is heavily embroidered in silk satin stitch and couched with gold metallic thread on yellow silk satin in a flying-fish-dragon character. There is some wear due to normal use. This piece was purchased in Bangkok in 1973. Circa 1920. 112" x 52". $450. H3,C4,Q3,R3

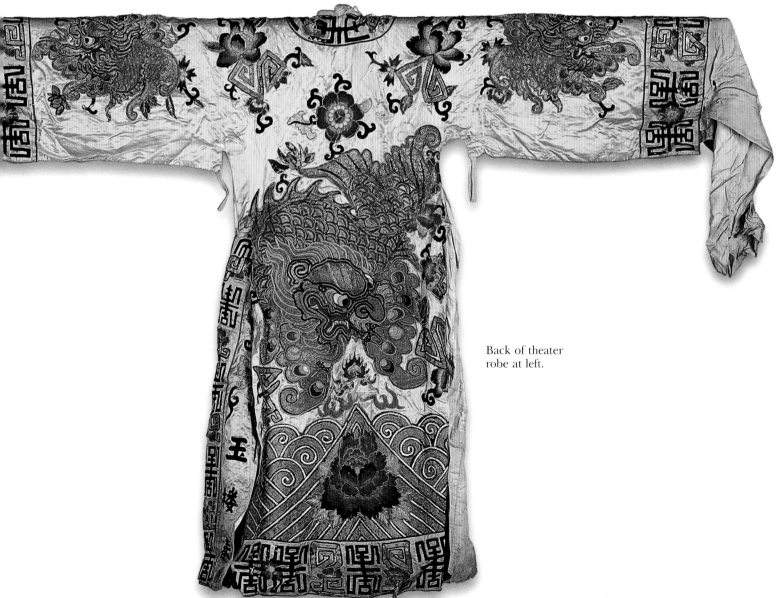

Back of theater
robe at left.

A Chinese theater or opera backdrop showing three main figures embroidered with wool thread in mat stitch on a bast fiber backing. Even in its extremely worn condition and with much thread loss, it still has great presence as a piece of art. 112" x 59" Circa 1870. In its current condition it is the $900 range; if it were in top condition it would command $4000 to $6000. H4,C4,Q2,R3

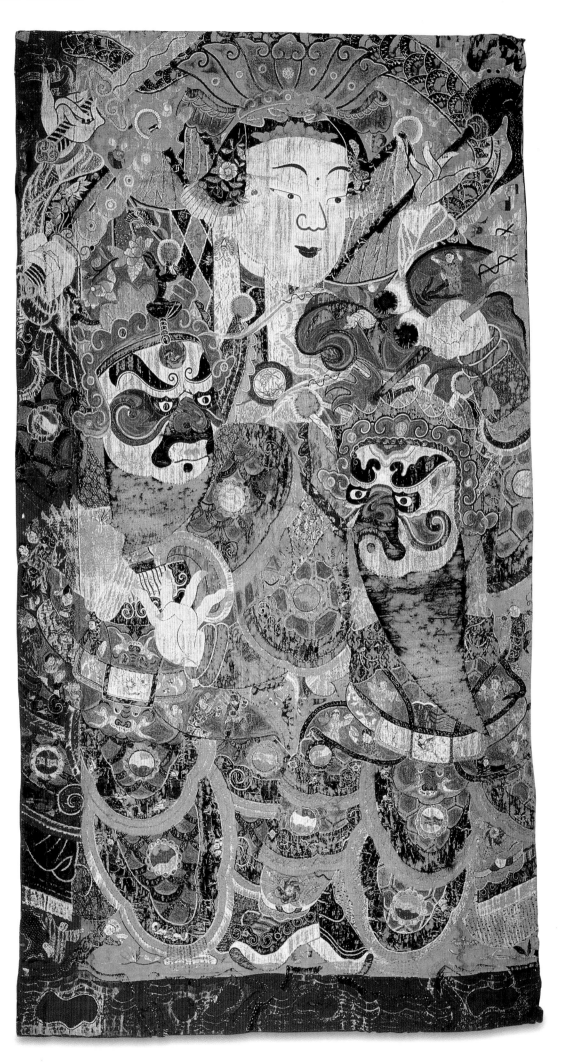

Chapter 7
Accessories

Hats

Official hats served as indicators of rank. The shapes and materials allowed in each rank were regulated. There were two forms of court hats in the Ch'ing dynasty. The summer "ratta" hats were conical and made of woven wicker often covered with fine silk and had a fabric rim and fabric liner. The top of the cone had a red twisted silk tassel topped with a round bead set in metal. The color and/or material of the bead denoted the rank of the wearer.

The winter version was a close fitting cap of either black wool or black silk over a cardboard form with an external brim, again, with the red tassel and rank bead on top. Both of these court hats could be fitted with a tubular plume holder called a linzghi, made of Peking glass or stone such as jade, into which feathers could have been bundled and inserted. Most often these were peacock feathers and the number of those with eyes, either one, two, or three had significance and were presented by the throne for meritorious service.

There are many forms of informal hats from simple black caps or caps with artificial queues for men, to many fanciful hats for children and some for women. There are, also, a group of hats worn to protect one from the elements in inclement weather that resembled shoulder length hoods.

There are many other forms of military and dress styles, but as to textile head covers, classified as hats, the aforementioned are the most prominent.

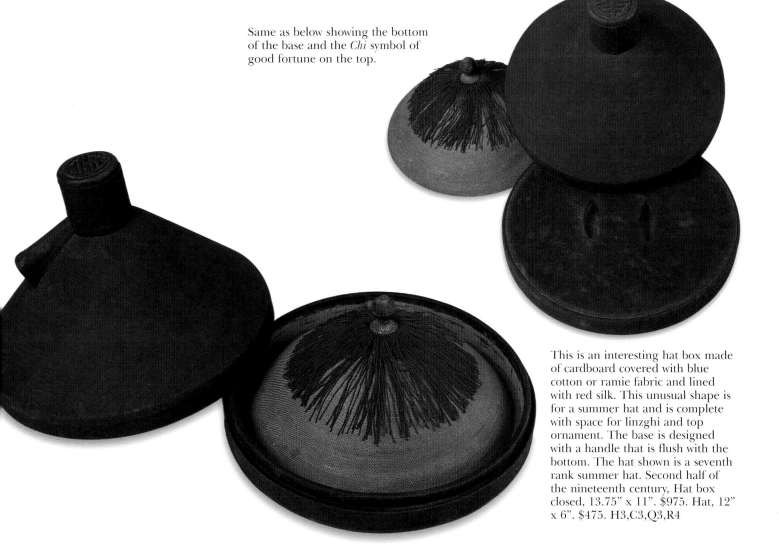

Same as below showing the bottom of the base and the *Chi* symbol of good fortune on the top.

This is an interesting hat box made of cardboard covered with blue cotton or ramie fabric and lined with red silk. This unusual shape is for a summer hat and is complete with space for linzghi and top ornament. The base is designed with a handle that is flush with the bottom. The hat shown is a seventh rank summer hat. Second half of the nineteenth century, Hat box closed, 13.75" x 11". $975. Hat, 12" x 6". $475. H3,C3,Q3,R4

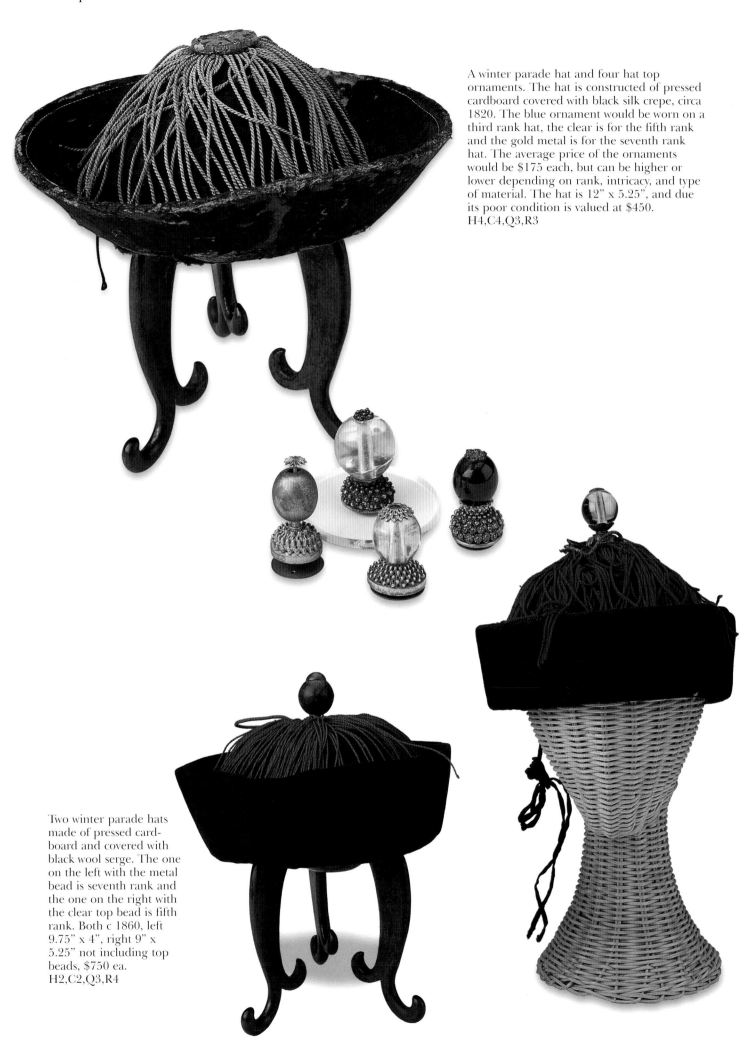

A winter parade hat and four hat top ornaments. The hat is constructed of pressed cardboard covered with black silk crepe, circa 1820. The blue ornament would be worn on a third rank hat, the clear is for the fifth rank and the gold metal is for the seventh rank hat. The average price of the ornaments would be $175 each, but can be higher or lower depending on rank, intricacy, and type of material. The hat is 12" x 5.25", and due its poor condition is valued at $450. H4,C4,Q3,R3

Two winter parade hats made of pressed cardboard and covered with black wool serge. The one on the left with the metal bead is seventh rank and the one on the right with the clear top bead is fifth rank. Both c 1860, left 9.75" x 4", right 9" x 5.25" not including top beads, $750 ea. H2,C2,Q3,R4

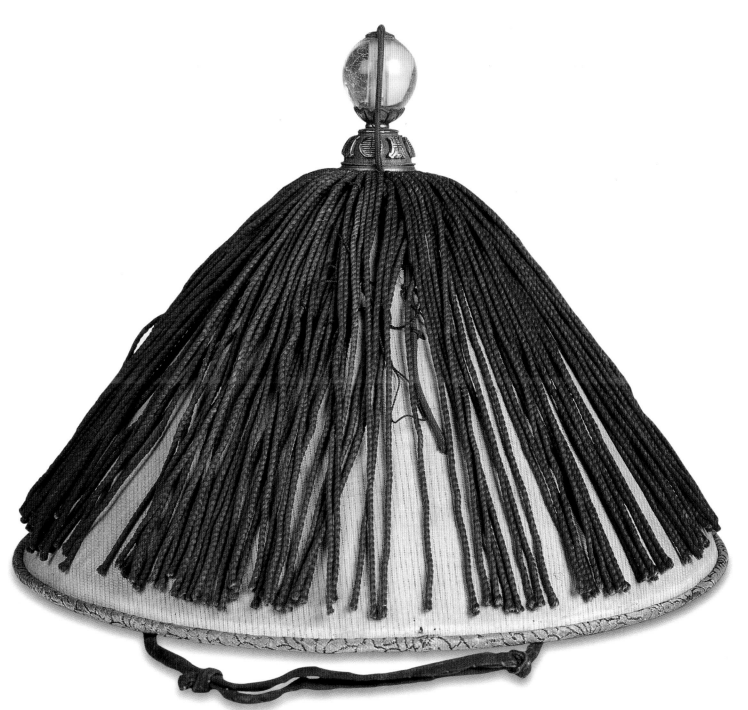

A summer court hat with tassel-style decoration and glass and brass
finial of fifth rank in perfect condition. Circa 1870. 12" x 8.5". $1400.
H1,C1,Q1,R3

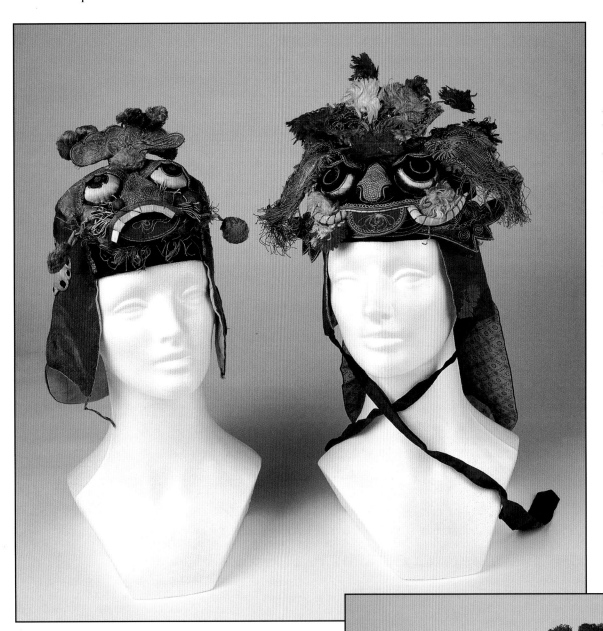

Two nice children's hats. These were collected in the 1940s and are backed with thin leather. They are quite well made and very cute. There are similar reproductions made today, but not of this quality and detail. Early twentieth century. 16" x 12" and 15" x 13" folded flat. $600 each. Both: H2,C3,Q2,R3

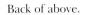

Back of above.

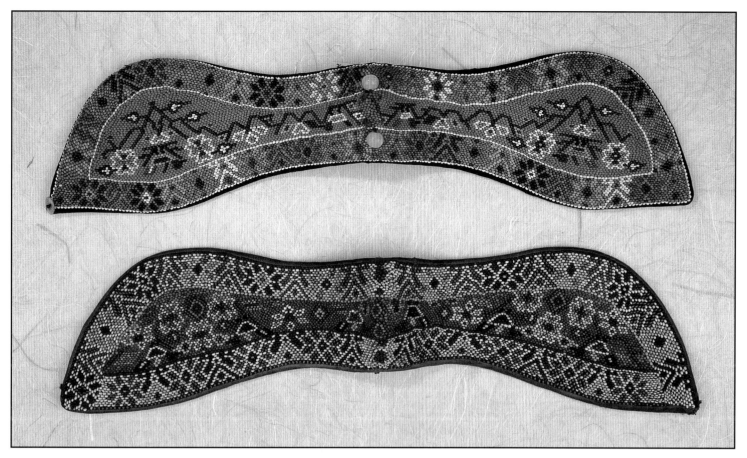

Two beaded headpieces made in the southern Hunan province, an area known for its beadwork. 16 x 3.5. $275 ea. H2,C2,Q2,R4

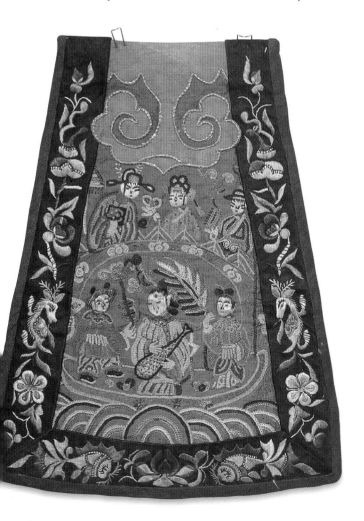 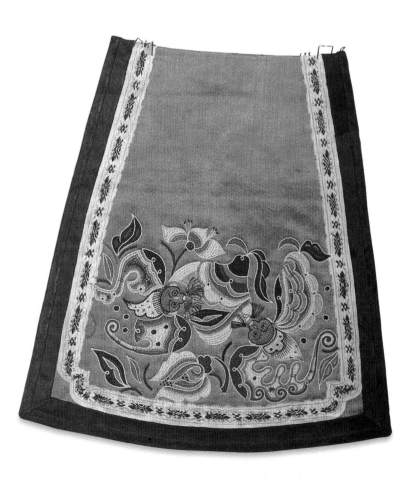

Two back panels from children's hats, embroidered on orange silk satin in silk satin stitch, Peking stitch and couched gold thread. Circa 1880. The larger one, on the left 7.25" x 9", $150. The smaller one, on the right, 8" x 8", $75 each. Both: H3,C3,Q3,R4

Footwear

The most often collected types of footwear that we see are the infamous lily-foot shoes. These tiny shoes speak of a cruel practice that was considered a sign of beauty for women. At about age five, a young girl's feet were wrapped tightly or "bound," forever sentencing this person to be crippled as walking was very difficult. These shoes range in size from a few inches long to four or five inches and are quite intricate in their design. They were often decorated with auspicious symbols. There were stockings and ankle covers that completed the footwear. This practice ended in the late nineteenth and early twentieth century.

Other styles of embroidered slippers for ladies were more common. There were also high platform shoes that became popular for Manchu ladies. These protected the hems of the skirts while walking, as well as giving the person more height. The soles were of carved wood or laminated leather and they usually had silk uppers.

Official footwear for men were boots of padded and quilted fabric. These were usually made with a cotton base and a silk cover. The soles were many layers of fabric and or leather laminated together. Shorter shoes or slippers of this style were also worn by women and children.

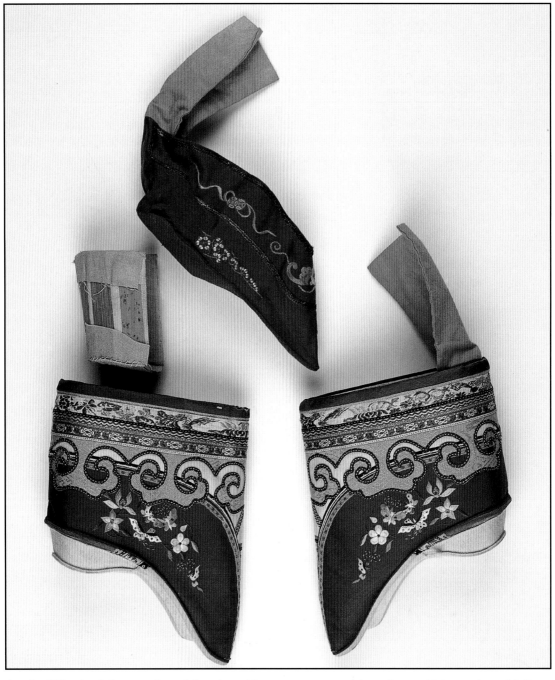

A pair of lily, cloud, lotus, or bound feet shoes (the names were used interchangeably) complete with liner inserts and stiffened heel counters. They are embroidered with silk satin stitch flower motifs on red silk satin. They also have appliqué work, couched gold threads, and woven ribbon trim. They have never been worn and are in excellent condition. The inside slipper and outside are made of the same material and are a matched set. Circa 1890. Each approximately 5" long. $750. Private collection. H1,C1,Q1,R2

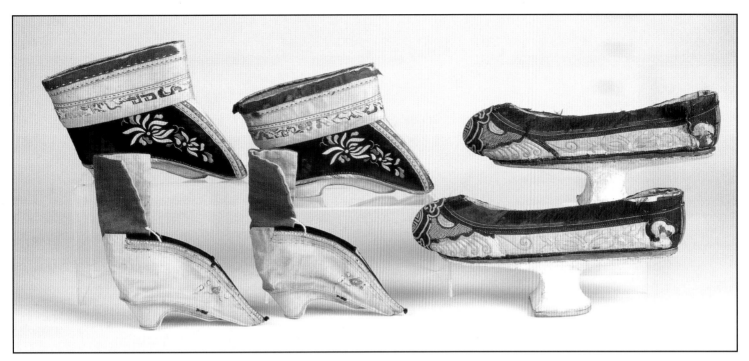

Three different styles of Chinese shoes. The two pairs on the left are for bound feet with fine silk embroidery on silk and have layered cotton soles and would be for a Han lady. The pair on the right consists of normal size platform shoes worn to protect the garments of the wearer from the dirty streets and are for a Manchu lady. Circa 1880s. They all have some condition problems. The platform shoes $495. H4,C4,Q3,R4. The fancy bound feet pair, $395. H3,C4,Q3,R2. The smaller bound feet pair, $295. H3,C4,Q4,R3

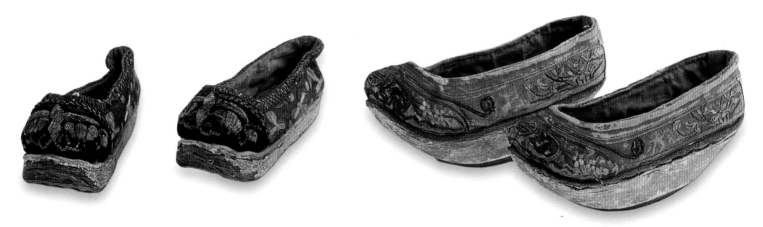

Two pairs of more modern shoes with wood soles and silk tops in a normal size. They are embroidered with silk threads on silk, and show extensive wear. On left, 6.5" long, $75. On the right 5.25" long, $50. Both: H4,C4,Q4,R4

Side views of above.

Purses, Pouches, Plaques & Other Belt Hangings

Scent purses, pouches, and pockets were worn by both men and women. These largely ornamental items were accessories, as traditional robes had no pockets.

Scent purses, perfume enhanced, were worn to help dispel body odor and to perfume the wearer's presence. They were produced in many levels of quality and complexity. Other accessories included are fan cases, spectacle cases, and pockets for holding sewing items.

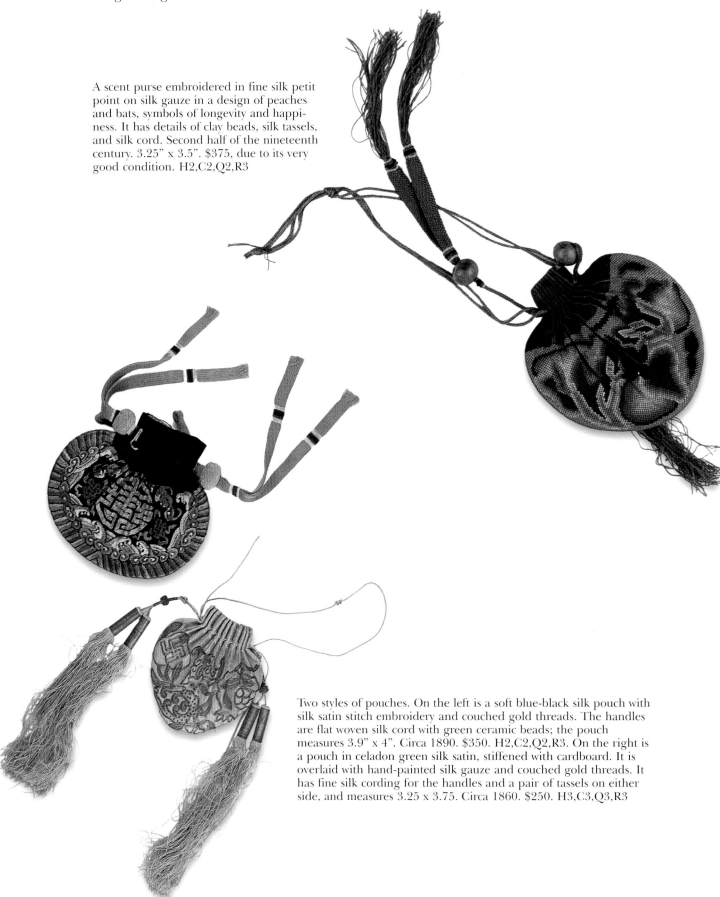

A scent purse embroidered in fine silk petit point on silk gauze in a design of peaches and bats, symbols of longevity and happiness. It has details of clay beads, silk tassels, and silk cord. Second half of the nineteenth century. 3.25" x 3.5". $375, due to its very good condition. H2,C2,Q2,R3

Two styles of pouches. On the left is a soft blue-black silk pouch with silk satin stitch embroidery and couched gold threads. The handles are flat woven silk cord with green ceramic beads; the pouch measures 3.9" x 4". Circa 1890. $350. H2,C2,Q2,R3. On the right is a pouch in celadon green silk satin, stiffened with cardboard. It is overlaid with hand-painted silk gauze and couched gold threads. It has fine silk cording for the handles and a pair of tassels on either side, and measures 3.25 x 3.75. Circa 1860. $250. H3,C3,Q3,R3

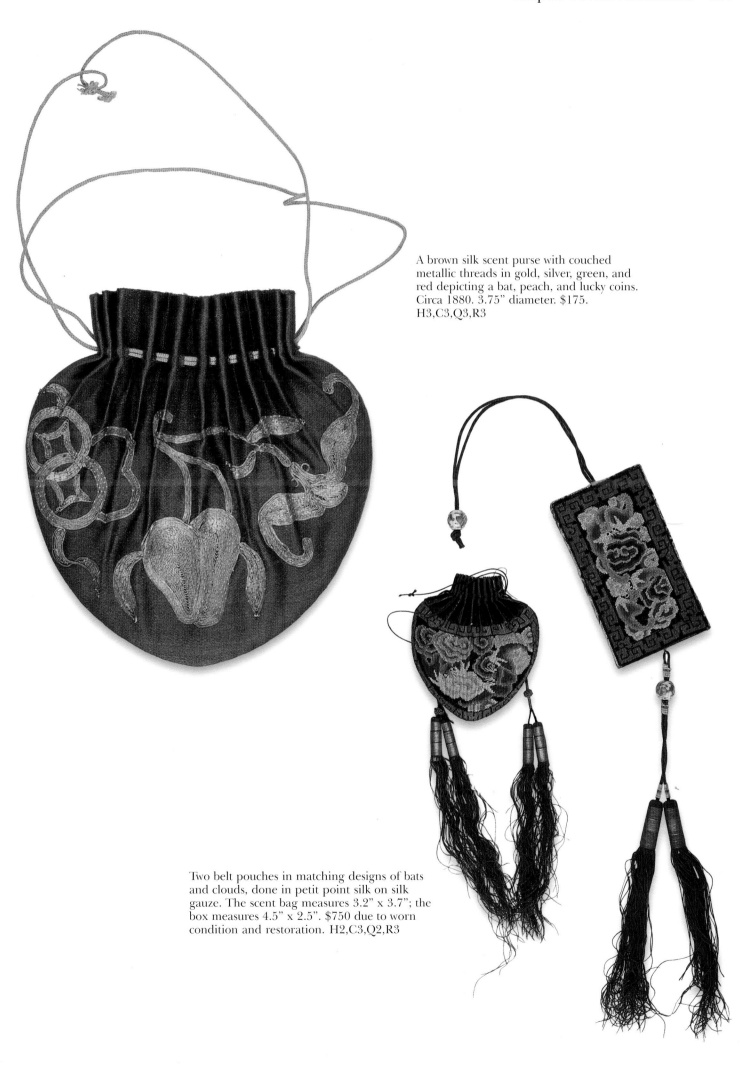

A brown silk scent purse with couched metallic threads in gold, silver, green, and red depicting a bat, peach, and lucky coins. Circa 1880. 3.75" diameter. $175. H3,C3,Q3,R3

Two belt pouches in matching designs of bats and clouds, done in petit point silk on silk gauze. The scent bag measures 3.2" x 3.7"; the box measures 4.5" x 2.5". $750 due to worn condition and restoration. H2,C3,Q2,R3

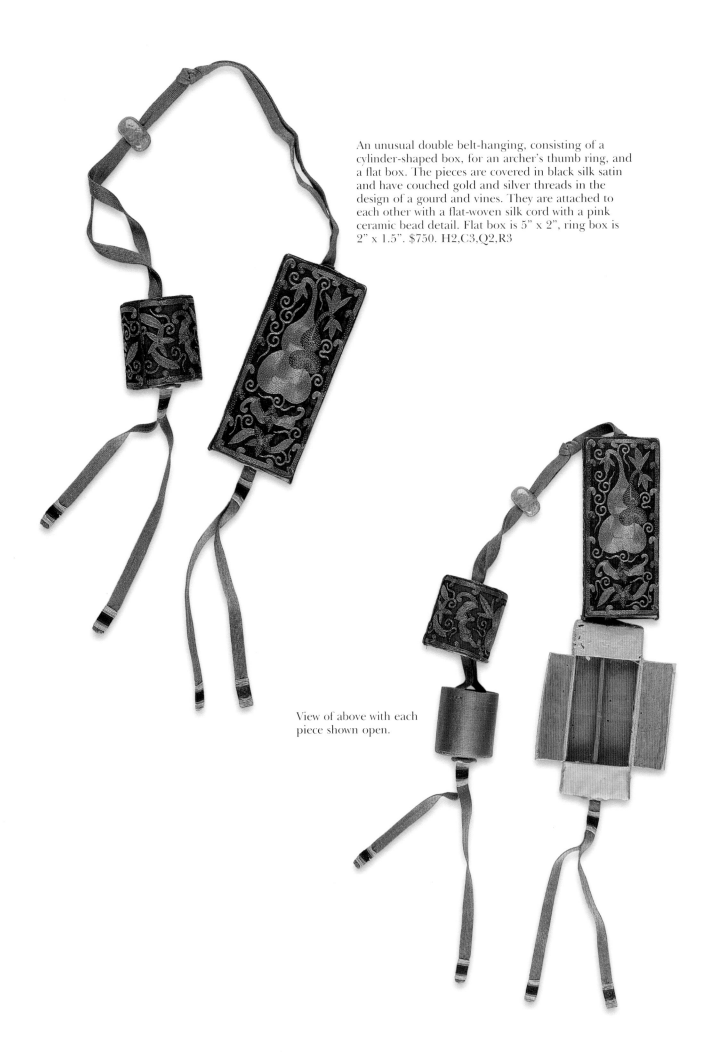

An unusual double belt-hanging, consisting of a cylinder-shaped box, for an archer's thumb ring, and a flat box. The pieces are covered in black silk satin and have couched gold and silver threads in the design of a gourd and vines. They are attached to each other with a flat-woven silk cord with a pink ceramic bead detail. Flat box is 5" x 2", ring box is 2" x 1.5". $750. H2,C3,Q2,R3

View of above with each piece shown open.

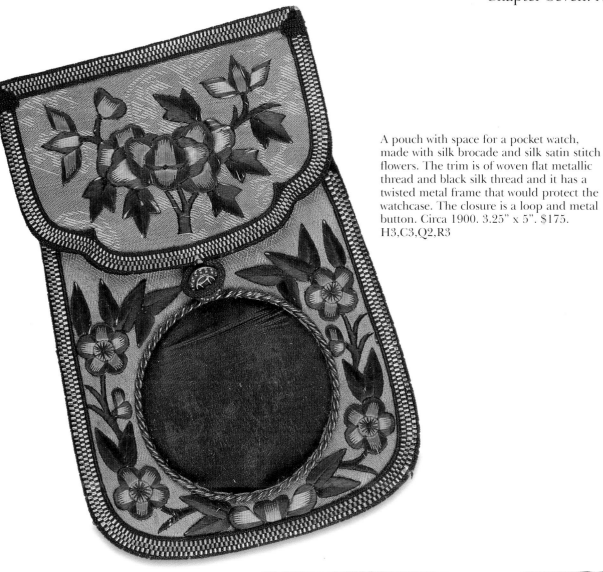

A pouch with space for a pocket watch, made with silk brocade and silk satin stitch flowers. The trim is of woven flat metallic thread and black silk thread and it has a twisted metal frame that would protect the watchcase. The closure is a loop and metal button. Circa 1900. 3.25" x 5". $175. H3,C3,Q2,R3

A double-sided purse or pouch with the pattern embroidered in brick stitch on gauze. The outer edges are needle woven in four distinct patterns. Circa 1890. 4.5" x 4.375". $175. H2,C2,Q3,R4

A pocket-style belt purse of bast fiber base with fine silk embroidery in satin stitch and Pekinese stitch on the front, showing a peacock and golden pheasant. The edge is needle woven in blue and white silk threads and it has a metal button for closure. It is in poor condition. Circa 1880. 3.5" x 5". $125. H3,C3,Q3,R4

A bi-fold pouch of silk and bast fibers embroidered with a floral motif in the Pekinese stitch with details of natural seed pearls and green glass beads. 3.25" x 8". $750 due to condition. H3,C3,Q2,R2

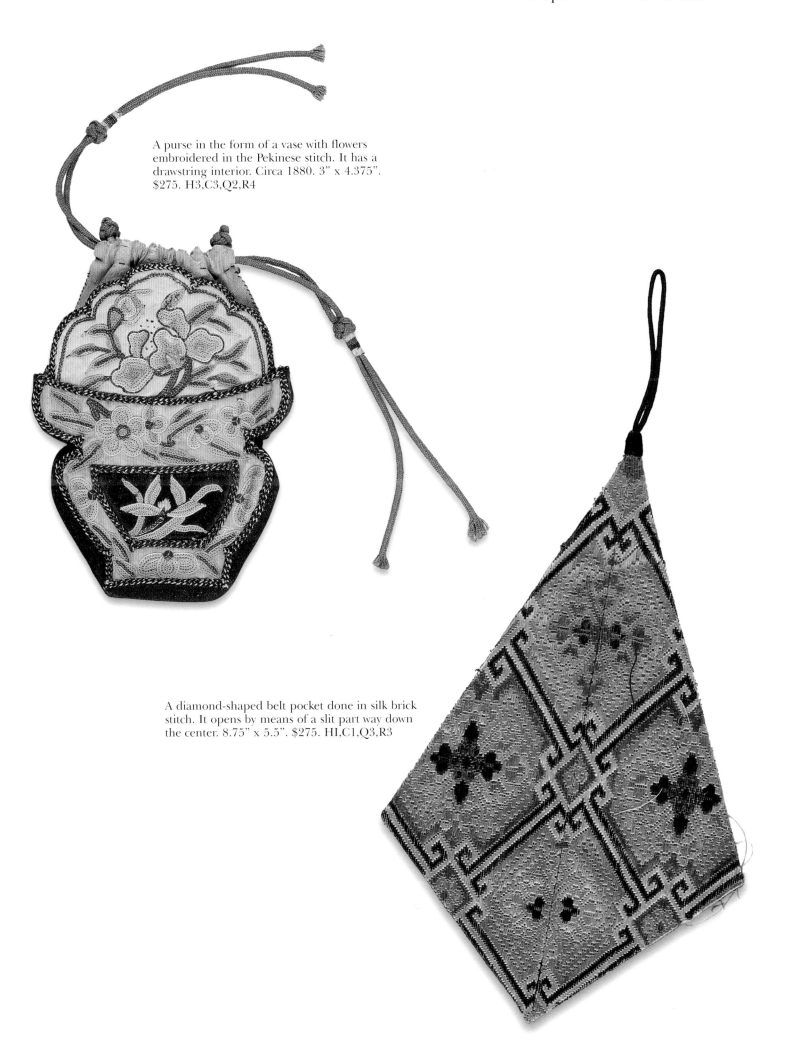

A purse in the form of a vase with flowers embroidered in the Pekinese stitch. It has a drawstring interior. Circa 1880. 3" x 4.375". $275. H3,C3,Q2,R4

A diamond-shaped belt pocket done in silk brick stitch. It opens by means of a slit part way down the center. 8.75" x 5.5". $275. HI,C1,Q3,R3

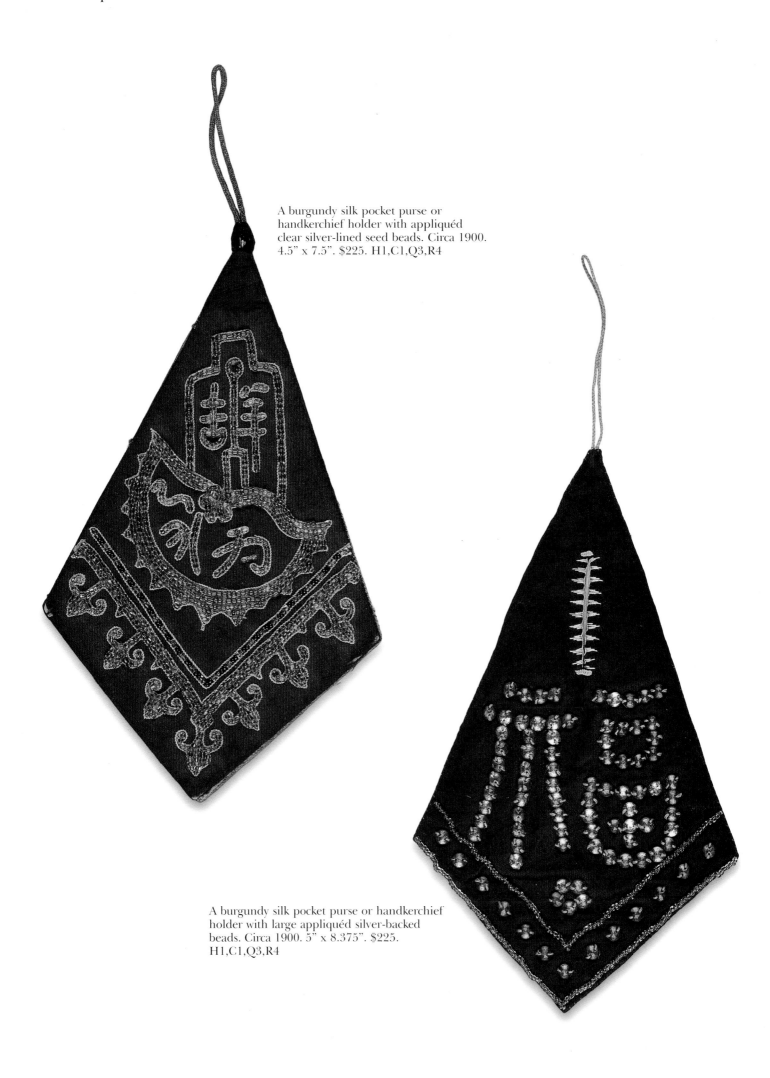

A burgundy silk pocket purse or handkerchief holder with appliquéd clear silver-lined seed beads. Circa 1900. 4.5" x 7.5". $225. H1,C1,Q3,R4

A burgundy silk pocket purse or handkerchief holder with large appliquéd silver-backed beads. Circa 1900. 5" x 8.375". $225. H1,C1,Q3,R4

A tri-fold wallet of dark red silk embroidered with couched twisted threads in various colors forming an abstract design of Chinese characters. Circa 1910. 3.5" x 10". $195. H1,C1,Q3,R4

A tri-fold wallet of maroon silk, embroidered with couched twisted threads in various colors in a floral motif. Circa 1910. 3.5" x 10". $95. H1,C1,Q3,R4

A tri-fold wallet of dark red silk embroidered with couched twisted threads in various colors forming an abstract design of Chinese characters. Circa 1910. 3.5" x 10". $195. This is a mate to the one at its left. H1,C1,Q3,R4

A small tri-fold pouch of pink and purple satin with clear beads in a grape motif. A nice piece, but it lacks subtlety and is bold and somewhat garish with only decorative value. Twentieth century. 3.25" x 7". $75. H1,C1,Q3,R4

A pocket or pouch of silk with silk satin stitch and couched gold metallic threads. It closes at the top with a metal snap. Circa 1900. 6.25" x 3.75". $195. H1,C1,Q3,R4

A pair of embroidered silk satin panels sewn back to back to create a pouch. Both have silk satin stitch floral motifs and woven ribbon trim, and are quite unusual. Circa 1900. 4.5" x 5". $195. H1,C1,Q3,R4

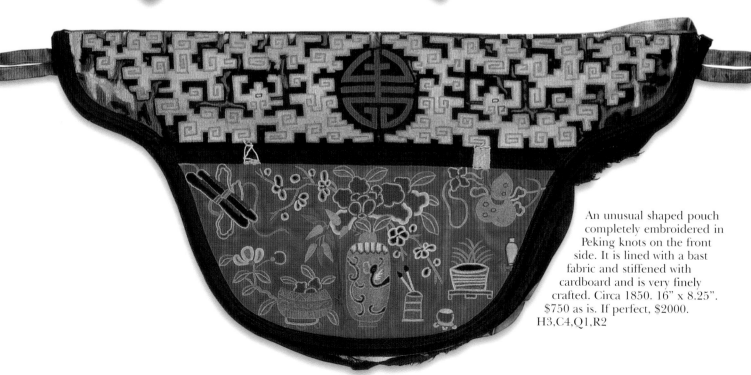

An unusual shaped pouch completely embroidered in Peking knots on the front side. It is lined with a bast fabric and stiffened with cardboard and is very finely crafted. Circa 1850. 16" x 8.25". $750 as is. If perfect, $2000. H3,C4,Q1,R2

A fan case of pink china silk with satin stitch embroidery on one side and purple china silk with satin stitch embroidery on the reverse. Circa 1870. 2.125" x 11.125". $175 due to its worn condition. H3,C3,Q3,R4

Three fan cases of silk over cardboard. All three are embroidered with couched twisted cording and couched gold metallic threads. Circa 1900. They range in size from 9.5" to 10.25" long. $125-225 based on complexity and condition. All: H1,C1,Q3,R4

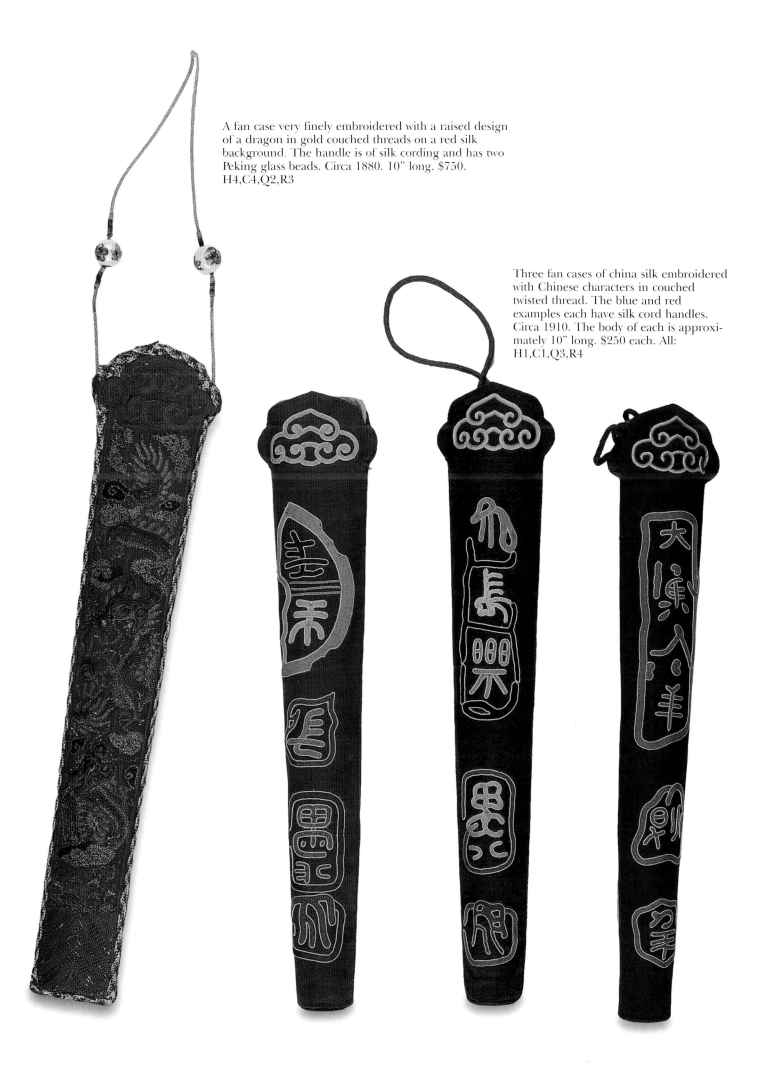

A fan case very finely embroidered with a raised design of a dragon in gold couched threads on a red silk background. The handle is of silk cording and has two Peking glass beads. Circa 1880. 10" long. $750. H4,C4,Q2,R3

Three fan cases of china silk embroidered with Chinese characters in couched twisted thread. The blue and red examples each have silk cord handles. Circa 1910. The body of each is approximately 10" long. $250 each. All: H1,C1,Q3,R4

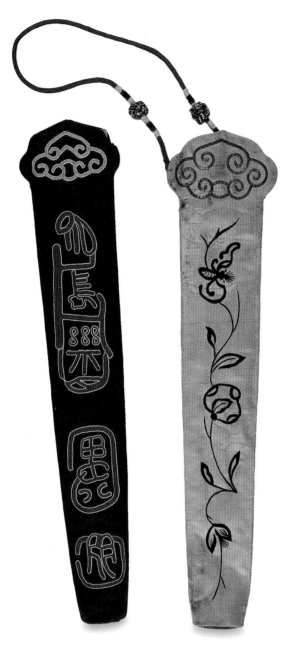

Two fan cases. The dark red case is made of silk and embroidered with Chinese characters in couched twisted thread. Circa 1910. The light blue case is satin weave silk with a black silk satin stitch floral motif. It also has a handle of blue silk cord and glass beads. Circa 1890. Each is approximately 10" long. Light blue: $125; Red: $250. Both: H1,C1,Q3,R4

Three fan cases of china silk embroidered with Chinese characters in couched twisted thread. Circa 1910. The body of each is approximately 10" long. $250 each. All: H1,C1,Q3,R4

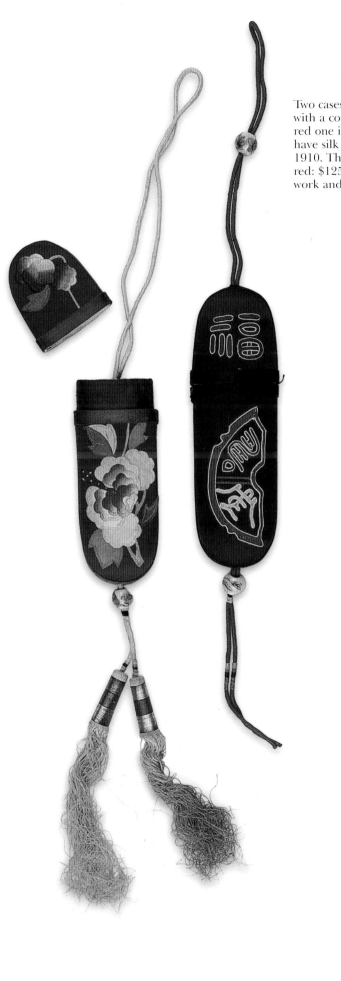

Two cases for eyeglasses. The dark red case is of silk with a couched twisted thread design. The lighter red one is also silk with a satin stitch appliqué. Both have silk cords and tassels and glass beads. Circa 1910. The bodies measure 6" x 2" x .75". Lighter red: $125; dark red $200, based on the complexity of work and condition. Both: H1,C1,Q3,R4

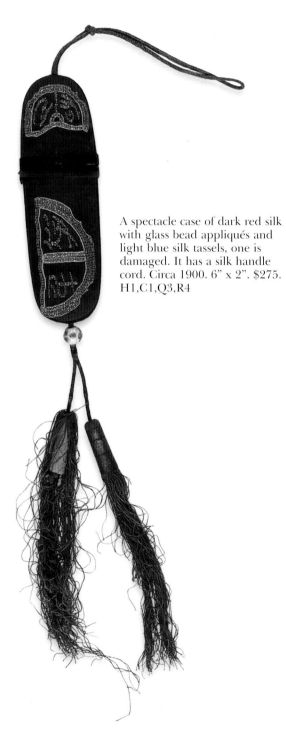

A spectacle case of dark red silk with glass bead appliqués and light blue silk tassels, one is damaged. It has a silk handle cord. Circa 1900. 6" x 2". $275. H1,C1,Q3,R4

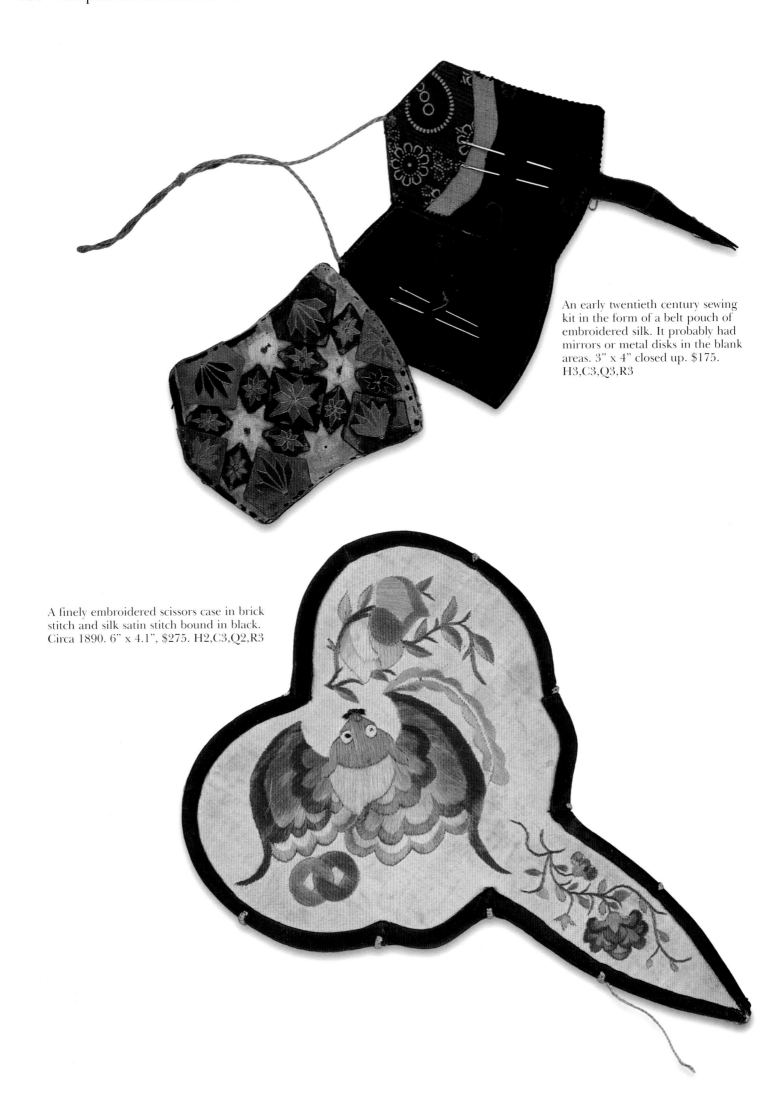

An early twentieth century sewing kit in the form of a belt pouch of embroidered silk. It probably had mirrors or metal disks in the blank areas. 3" x 4" closed up. $175. H3,C3,Q3,R3

A finely embroidered scissors case in brick stitch and silk satin stitch bound in black. Circa 1890. 6" x 4.1", $275. H2,C3,Q2,R3

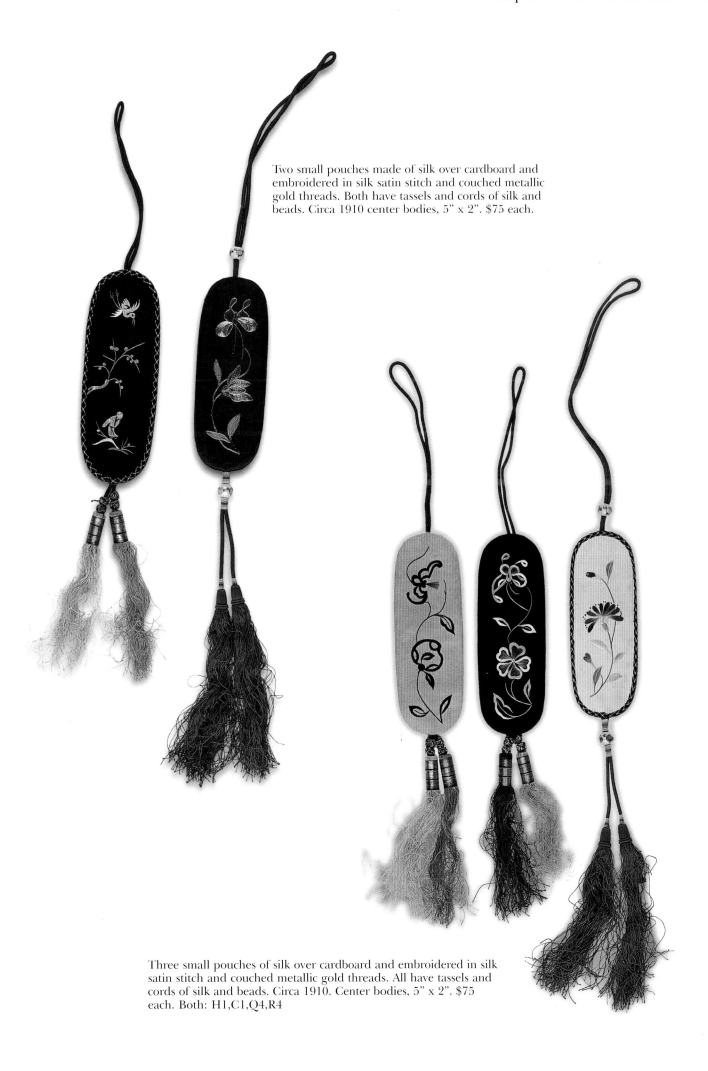

Two small pouches made of silk over cardboard and embroidered in silk satin stitch and couched metallic gold threads. Both have tassels and cords of silk and beads. Circa 1910 center bodies, 5" x 2". $75 each.

Three small pouches of silk over cardboard and embroidered in silk satin stitch and couched metallic gold threads. All have tassels and cords of silk and beads. Circa 1910. Center bodies, 5" x 2". $75 each. Both: H1,C1,Q4,R4

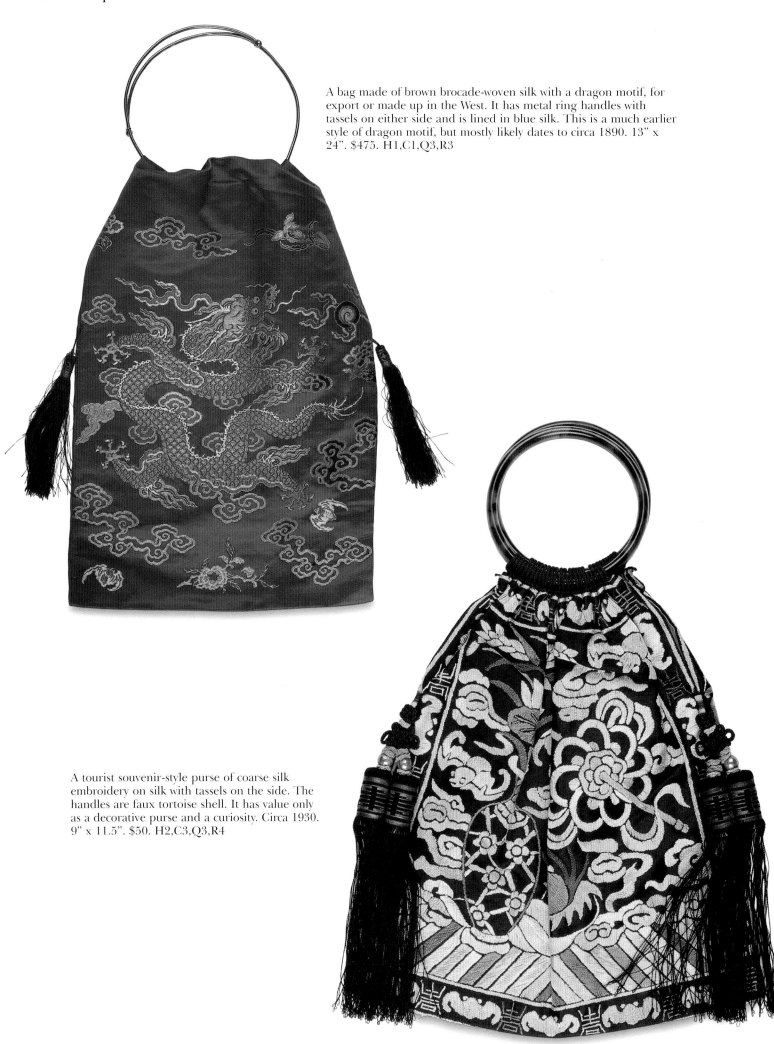

A bag made of brown brocade-woven silk with a dragon motif, for export or made up in the West. It has metal ring handles with tassels on either side and is lined in blue silk. This is a much earlier style of dragon motif, but mostly likely dates to circa 1890. 13" x 24". $475. H1,C1,Q3,R3

A tourist souvenir-style purse of coarse silk embroidery on silk with tassels on the side. The handles are faux tortoise shell. It has value only as a decorative purse and a curiosity. Circa 1930. 9" x 11.5". $50. H2,C3,Q3,R4

Collars

Separate collars were worn by people as part of their wardrobe. Formal court collars, or pi-ling, were somewhat standard in form and were roughly a triangular wing shape, stiffened to add volume to the overall costume.

There were other styles of collars used on less formal occasions. These range from a simple one inch band to ornate collars that trail to the waist. Detachable collars were an accessory that could be used with different garments, much in the same way we use different scarves as fashion accents to augment a woman's wardrobe. People also used accessories such as belt hangings, overskirts, neck pendants, purses, and so forth, as a practical method of extending their wardrobe.

There are many examples of informal collars in Chapter 9 that are unfinished and uncut.

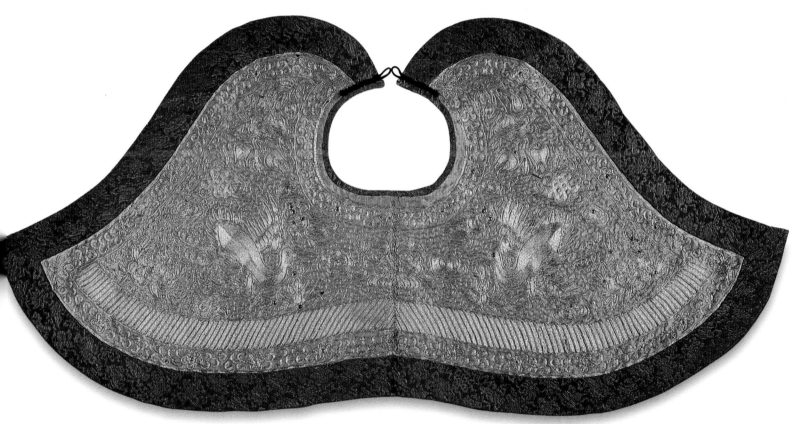

A court collar of cranes embroidered in couched metallic gold threads with fine gold sequin details. Circa 1870. 31" x 15". $475. H2,C2,Q2,R3

A court collar of black and gold brocade-woven dragons edged in a gold and black floral brocade. This piece has highlights of randomly placed metal sequins. Circa 1870. 32" x 15.5". $475. H3,C3,Q2,R3

Two children's collars in the form of a lion. These were worn as good luck symbols to protect the children from "evil spirits." Early twentieth century. Upper one 9.25" x 6", lower one 8.75" x 6". $450 each. Both: H3,C3,Q3,R4

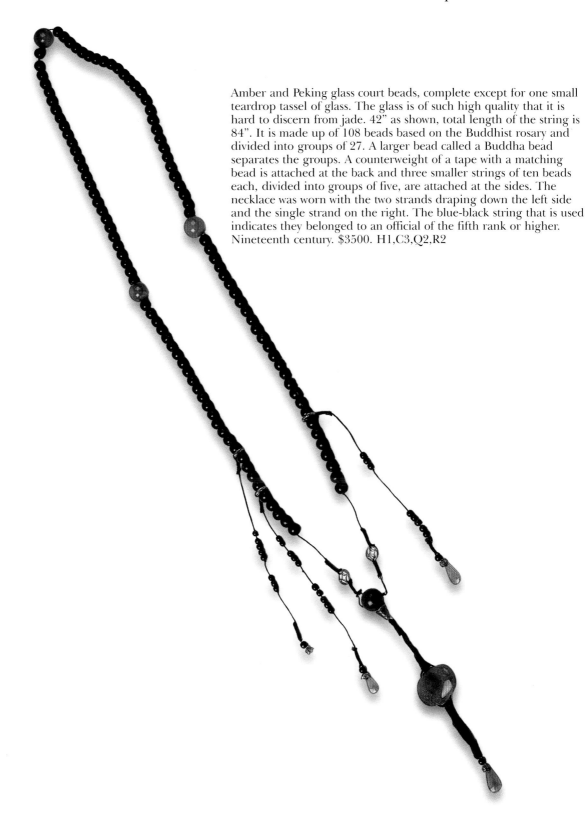

Amber and Peking glass court beads, complete except for one small teardrop tassel of glass. The glass is of such high quality that it is hard to discern from jade. 42" as shown, total length of the string is 84". It is made up of 108 beads based on the Buddhist rosary and divided into groups of 27. A larger bead called a Buddha bead separates the groups. A counterweight of a tape with a matching bead is attached at the back and three smaller strings of ten beads each, divided into groups of five, are attached at the sides. The necklace was worn with the two strands draping down the left side and the single strand on the right. The blue-black string that is used indicates they belonged to an official of the fifth rank or higher. Nineteenth century. $3500. H1,C3,Q2,R2

Other Accessories

Bamboo undergarments have been worn since the fifteenth century. These garments were made of small hollow sections of bamboo strung on plied cotton cording in a netting fashion and edged with cotton tabby. They were worn next to the skin during hot weather to help keep the wearer cool and more importantly to keep the expensive silk garments from being damaged by perspiration and body oils.

These pieces were in the form of jackets and vests and made in various qualities. The one shown here is a simple one. Some are more finely woven from smaller sections of bamboo and even have design bands worked in.

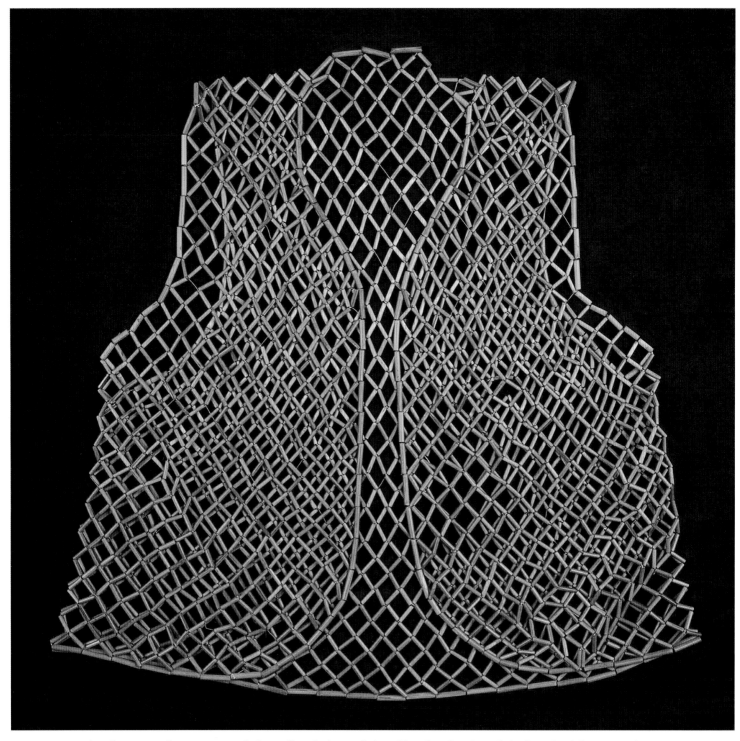

A bamboo vest. These vary greatly in quality, design and size of bamboo beads and the length of the vest and some can be valued up to $1000. This particular one is in the $450 range. Circa second half of the nineteenth century. 24" x 25". H1,C3,Q3,R3

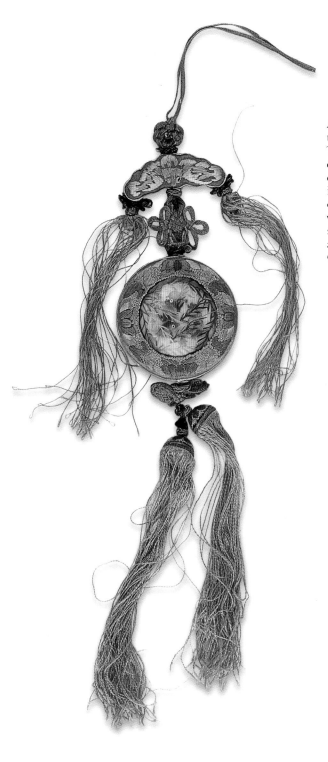

A tassel made as an ornament to hang on a bed, consisting of two three-dimensional stuffed elements separated by a Chinese knot. The top piece is a crescent shape of silk satin embroidery on cream-colored silk satin with a silk tassel on either end. The second element is a Chinese knot in orange silk cording. The third element is of spherical shape covered with red silk satin on the back, embroidered in silk satin stitch. The front has a clear glass dome with carved wooden fish and seaweed and it is surrounded by white silk satin embroidered with a floral design. The fourth element is also a Chinese knot in orange silk cord and it has two silk tassels. Central area, 2" x 2". $225. H2,C2,Q2,R3

Back view of above.

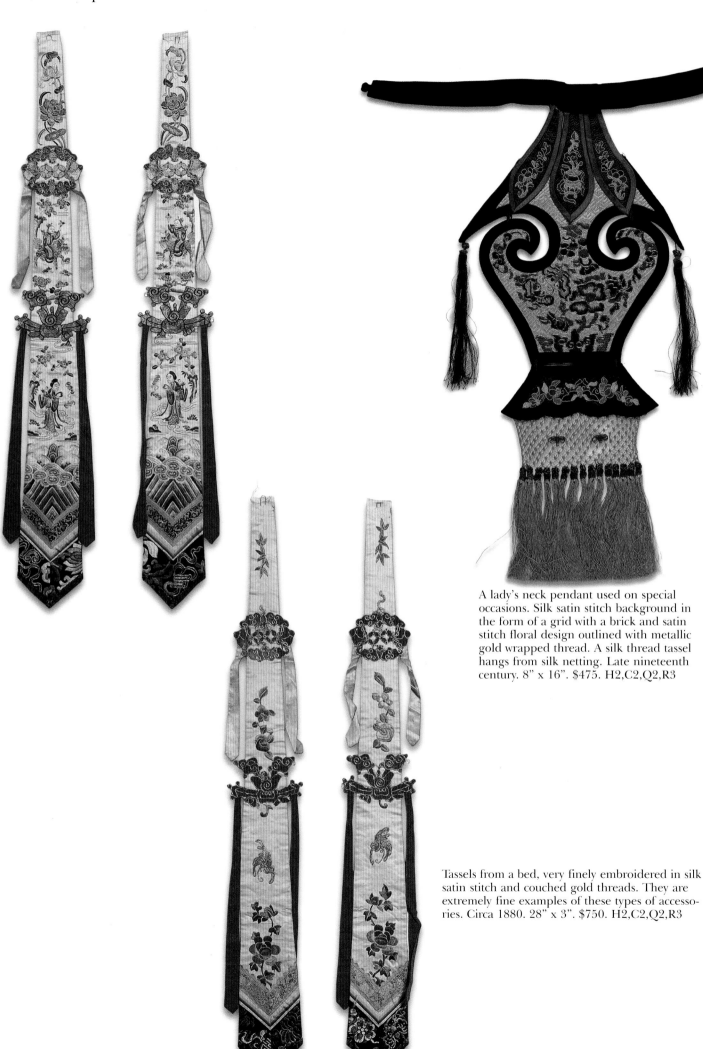

A lady's neck pendant used on special occasions. Silk satin stitch background in the form of a grid with a brick and satin stitch floral design outlined with metallic gold wrapped thread. A silk thread tassel hangs from silk netting. Late nineteenth century. 8" x 16". $475. H2,C2,Q2,R3

Tassels from a bed, very finely embroidered in silk satin stitch and couched gold threads. They are extremely fine examples of these types of accessories. Circa 1880. 28" x 3". $750. H2,C2,Q2,R3

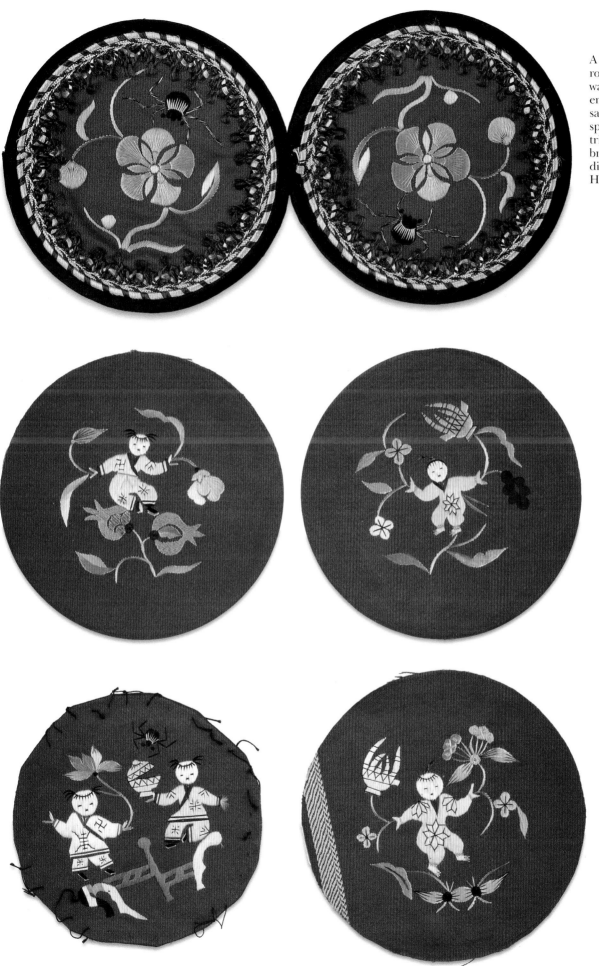

A pair of red silk satin roundels used as ear warmers. They are embroidered with a silk satin stitch floral and spider motif and trimmed in twisted silk braid. Circa 1900. 3" dia. $40-$60. H1,C1,Q4,R4

Two pair of red silk satin roundels used as ear warmers. The motifs of children playing are embroidered with silk satin stitch. Circa 1900. 3" dia. $40 to $60 per pair. Both: H1,C1,Q4,R4

Two sets of silk satin roundels used as ear warmers. The pale green set is embroidered in silk satin stitch in a simple floral design. The dark green pair have appliquéd flowers and couched gold metallic threads, trimmed with black bias silk. Circa 1900. 3" dia. $40 to $60 per pair. Both: H1,C1,Q4,R4

Two sets of red silk satin roundels used as ear warmers. The bottom set with a motif of children playing is embroidered in a silk satin stitch. The top set is also embroidered in a silk satin stitch, but of a floral motif. Each set is bound with a blue silk bias strip. Circa 1900. 3" dia. $40 to $60 per pair. Both: H1,C1,Q4,R4

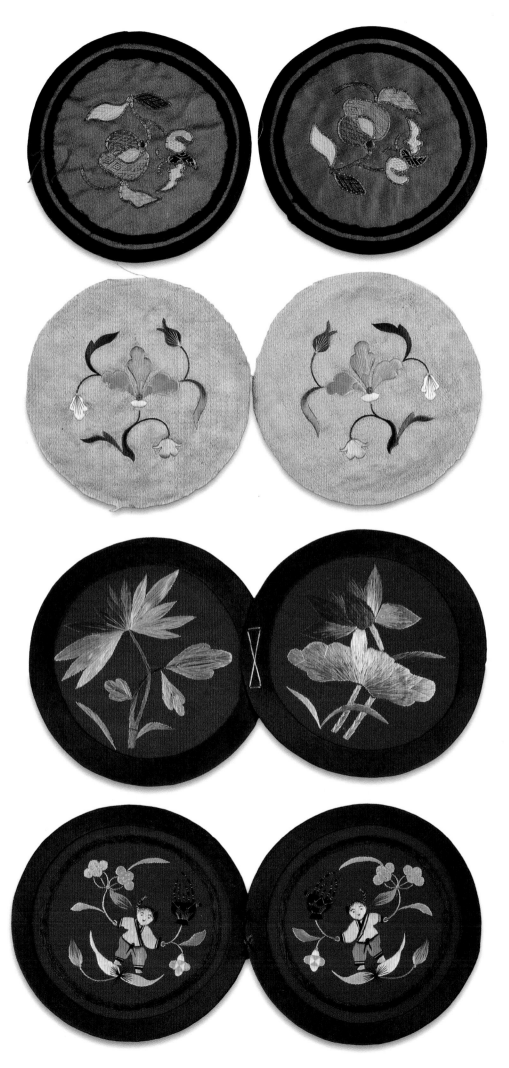

Chapter 8
Hangings, Frontals, Covers, & Export Textiles

Decorative Table Skirts or Frontals

Tables, whether used as altars or for dining, writing, etc., often have front valences and skirts for decoration. These can be a single panel or tiered for beauty and to cover the legs, feet, and structure of the table.

In temples and court settings these covers would also set the tone and purpose of the room, conveying religious, imperial, or festive messages through the use of related imagery in the decorative scheme of the frontals. Skirts and frontals come in all sizes and complexities. Most have a plain cotton or bast fiber top band that would go on the top of the table under the table top cover, to hold it in position in the front. Most of the frontals are of silk and are lined in silk, cotton or bast fiber.

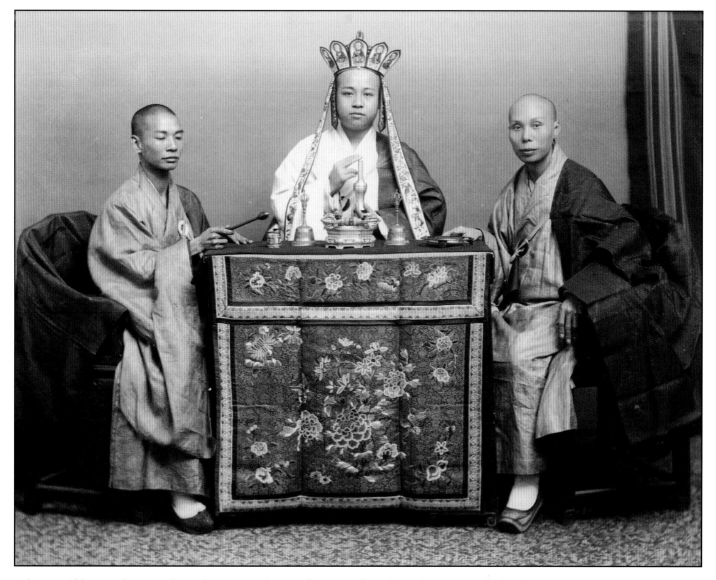

Lai Fong. Chinese Priests praying. Circa 1880. Vintage albumen print, 9" x 11". Courtesy of Throckmorton Fine Arts.

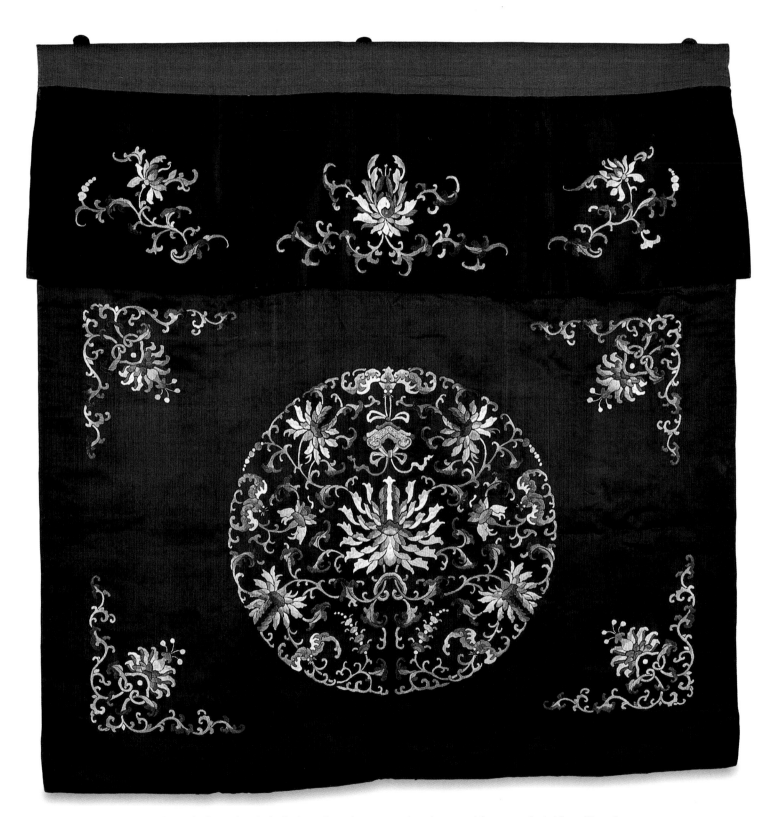

A frontal of a satin stitch design of curving vegetation, bats, and lotus on dark blue silk satin.
There is a small hole but it is, otherwise, in good condition. Circa 1880. 34.5" x 31.25".
$475. H2,C3,Q2,R3

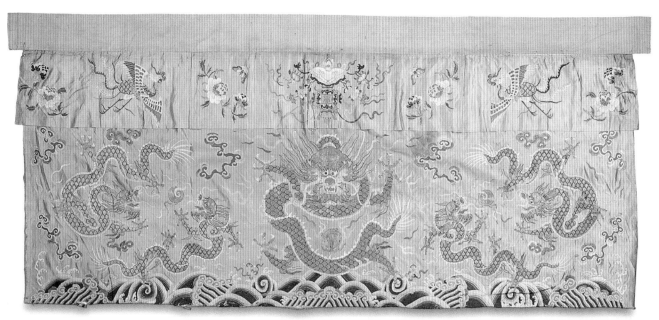

An early frontal of gold silk satin with a dragon and phoenix motif. The dragons are embroidered in couched gold metallic threads and the other motifs are in silk satin stitch and Peking stitch. This piece has numerous problems including stains, burn holes, and thread loss. Circa 1800. 96" x 45". $2500 as is. In better condition it would be in the $4000-$6000 range. Private collection. H3,C3,Q2,R2

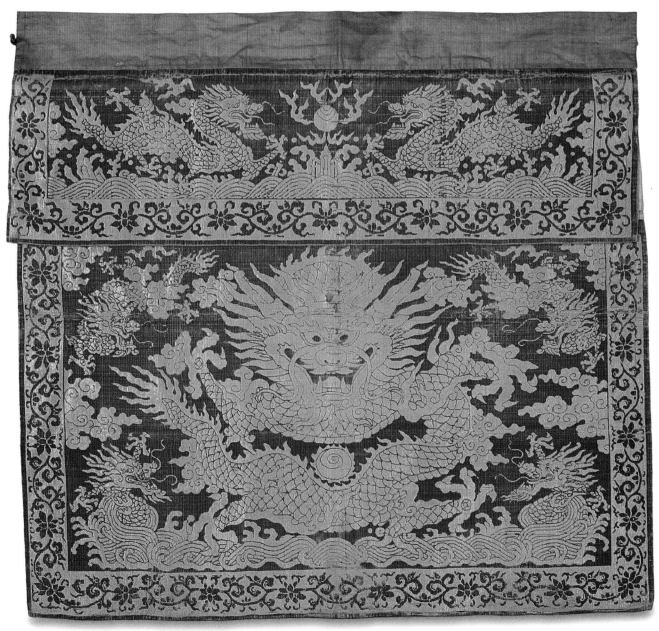

A beautiful example of a nineteenth century cut velvet frontal. It has some breakdown, which is reflected in the price of $975. 36 x 28". If perfect, $1500. H3,C3,Q2,R3

A fine cut velvet frontal in the design of a dragon. This is a fairly early piece and is in poor condition due to wear and breakdown. It dates from the early nineteenth century and is valued at $600 due to its condition. 35" x 34.5". If perfect, $3000 range. H4,C4,Q2,R3

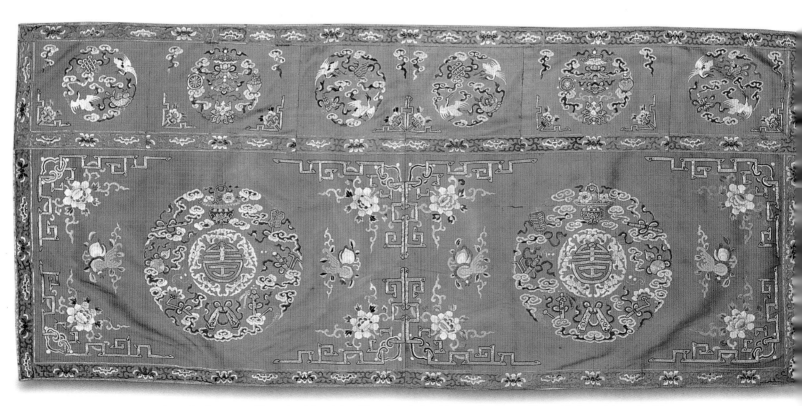

A frontal of orange silk embroidered in silk satin stitch with couched metallic gold thread in a double shou, or long life symbol, surrounded by a floral motif. The top edge is embroidered with cranes and the eight Buddhist auspicious symbols. There is slight splitting of the background silk but restoration would be difficult as only the surface is light damaged. The under threads would not align properly for good viewing. Frontals of this size and quality are quite rare. Circa 1850. 74" x 37.5". $1200. If perfect, $5000. H3,C3,Q2,R2

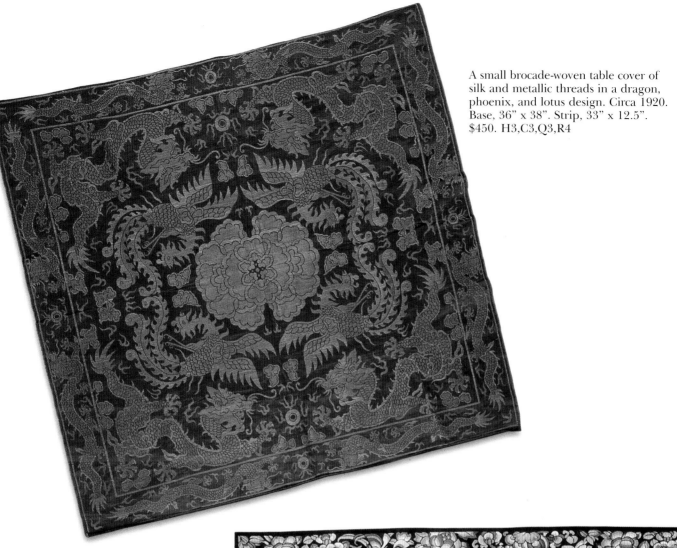

A small brocade-woven table cover of silk and metallic threads in a dragon, phoenix, and lotus design. Circa 1920. Base, 36" x 38". Strip, 33" x 12.5". $450. H3,C3,Q3,R4

A table frontal panel remounted with later decorative trim. This beautifully executed panel is quite bold and decorative and presents very well with one exception. The Chinese/Buddhist good luck symbol "wan," which means 10,000. This ancient symbol was unfortunately borrowed by Hitler and the Nazis and used in the mirror image of the Chinese symbol. The infamy and atrocities which have become associated with this symbol genuinely affect the value of this textile in the market. This piece's value is in the range of $300, but without the symbol, or with it smaller and more stylized or incorporated in background fretwork design so as to appear less obvious, would probably double its value. Circa 1880. 30" x 31". H2,C3,Q2,R3

Valances, Panels, & Other Embellished Hangings

This large group includes curtains, pictorial hangings, door hangings, and banners. The Chinese make extensive use of textiles as coverings for surfaces, including walls, windows, doors and furniture. Special pieces are made to commemorate occasions such as birthdays, festivals, weddings, etc. These textiles are specific to their settings and, through the use of combined imagery and colors, can convey many levels of information, much more so than the use of textiles in the Western world.

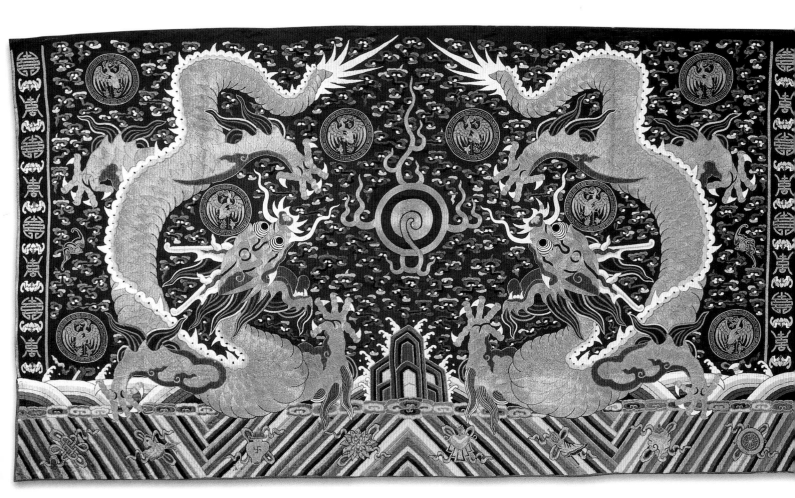

A large temple hanging depicting two dragons chasing the pearl of heaven with the eight Buddhist auspicious symbols below in the waves and crane roundels. The piece has damage in the form of three or four tears. The unfinished top points to the fact that it probably had a secondary smaller valance decorated with a series of smaller mang dragons as in the example on pages 227 & 228. Circa 1880. 108" x 58.5". $2000. In original condition, $4000. H2,C3,Q3,R3

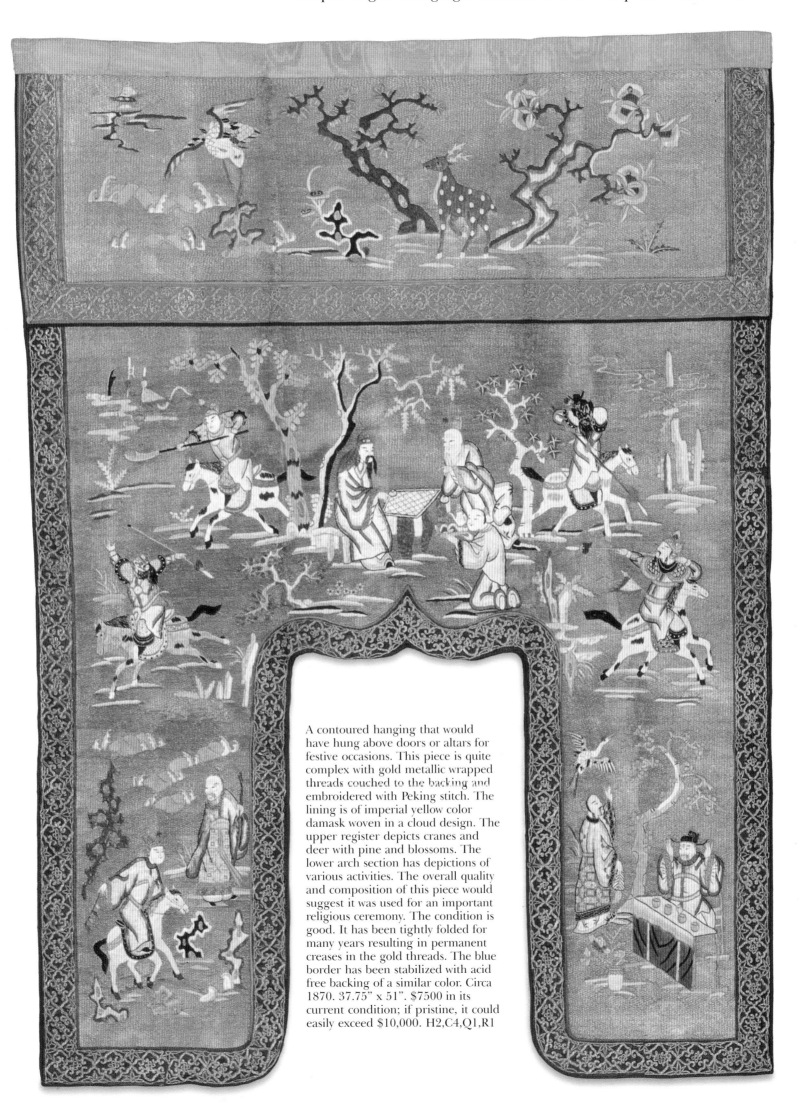

A contoured hanging that would have hung above doors or altars for festive occasions. This piece is quite complex with gold metallic wrapped threads couched to the backing and embroidered with Peking stitch. The lining is of imperial yellow color damask woven in a cloud design. The upper register depicts cranes and deer with pine and blossoms. The lower arch section has depictions of various activities. The overall quality and composition of this piece would suggest it was used for an important religious ceremony. The condition is good. It has been tightly folded for many years resulting in permanent creases in the gold threads. The blue border has been stabilized with acid free backing of a similar color. Circa 1870. 37.75" x 51". $7500 in its current condition; if pristine, it could easily exceed $10,000. H2,C4,Q1,R1

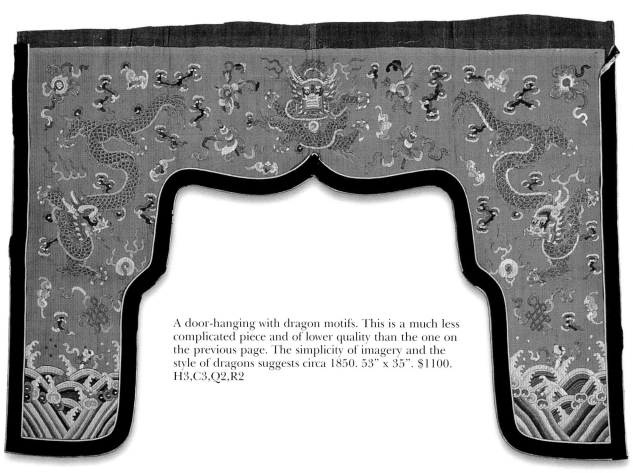

A door-hanging with dragon motifs. This is a much less complicated piece and of lower quality than the one on the previous page. The simplicity of imagery and the style of dragons suggests circa 1850. 53" x 35". $1100. H3,C3,Q2,R2

A very finely embroidered panel in a phoenix motif, done in silk satin stitch and stem stitch on white silk satin. It is somewhat faded, which detracts from its value. Circa first half of the twentieth century. 52.5" x 64" $750. H3,C3,Q2,R3

One of a pair of hangings for a baby's bed, in light beige silk satin with metallic woven trim. This one has a peacock embroidered in silk satin stitch. The other panel has a fu-lion. They are from the collection of a missionary priest in China, who also sold Singer sewing machines there between 1895 and 1910. Both show the use of aniline dyes and are whimsically done for Chinese use. Circa 1900. 15.5" x 43" each. $400 for the pair. H2,C2,Q3,R3

A valance of lotus blossoms embroidered in silk satin stitch on red silk, highlighted with couched gold metallic threads. Circa 1870. 18" x 109". $1500. Private collection. H3,C3,Q2,R2

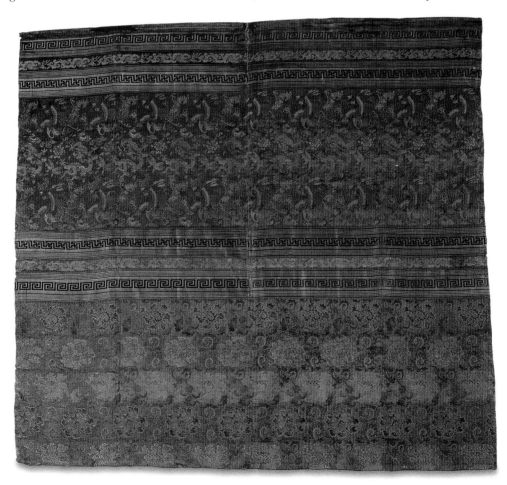

A finely woven brocade panel, possibly used as drapery fabric. This piece has been cut down and completely stabilized due to its poor condition. It was originally woven as two long panels and stitched together down the center. Circa 1820. 47" x 50". $450. H4,C4,Q2,R3

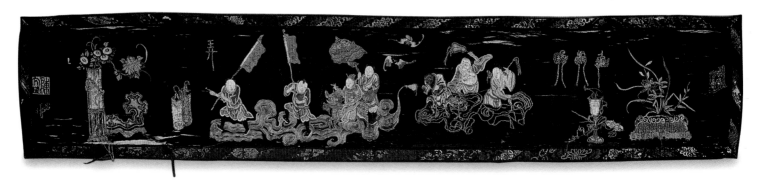

An early panel depicting immortals. Possibly from an altar frontal, it is embroidered in couched gold metallic threads, satin stitch, and Peking stitch on black silk. The black silk background is badly disintegrated and the piece has had many repairs. It is in poor condition and not easily restorable. The edging is early, but later than the panel. Circa 1800. 69" x 13.5". $195 due to its condition. If in good condition it would be in the $2000 range. H4,C4,Q2,R2

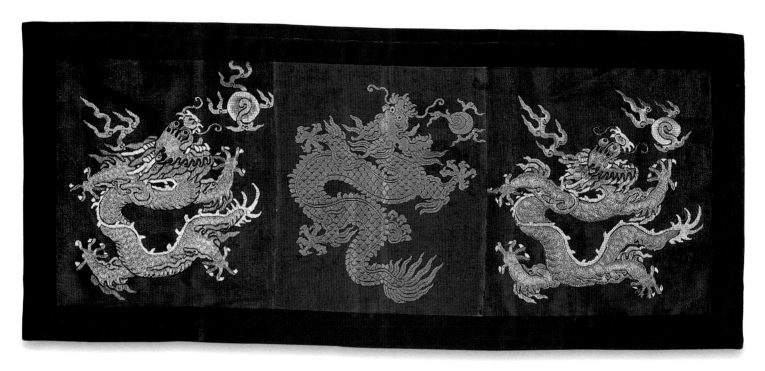

A panel made up of three dragons from three different pieces, all three possibly the ninth dragon from the inside flaps of ch'i-fus. The two outer ones are embroidered with couched gold threads and long and short stitch. The center panel is brocade-woven with both silk and metallic threads. It is bound in two courses of black silk satin. Circa 1860. 35" x 15.25". $450. H2,C1,Q3,R4

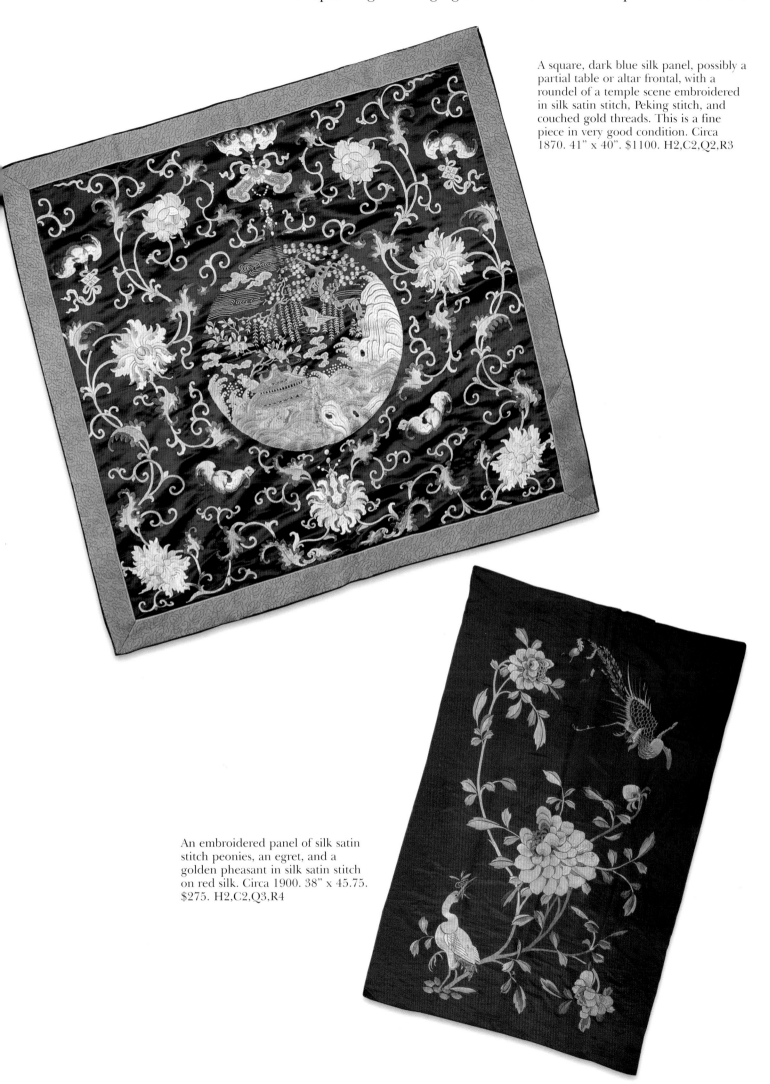

A square, dark blue silk panel, possibly a partial table or altar frontal, with a roundel of a temple scene embroidered in silk satin stitch, Peking stitch, and couched gold threads. This is a fine piece in very good condition. Circa 1870. 41" x 40". $1100. H2,C2,Q2,R3

An embroidered panel of silk satin stitch peonies, an egret, and a golden pheasant in silk satin stitch on red silk. Circa 1900. 38" x 45.75. $275. H2,C2,Q3,R4

A heavily embroidered silk panel with dragons and clouds in silk satin stitch and couched gold metallic threads. There is some light damage. Circa 1850. 26.5" x 29.75". $550. H4,C3,Q1,R2

A silk embroidery that may have been used as a table cover. It is embroidered in silk satin stitch on fine china silk with a motif of a dragon and phoenix. The back appears the same as the front showing the high quality of the embroidery. Circa 1920. 28" x 27.25". $50. H2,C2,Q2.R3

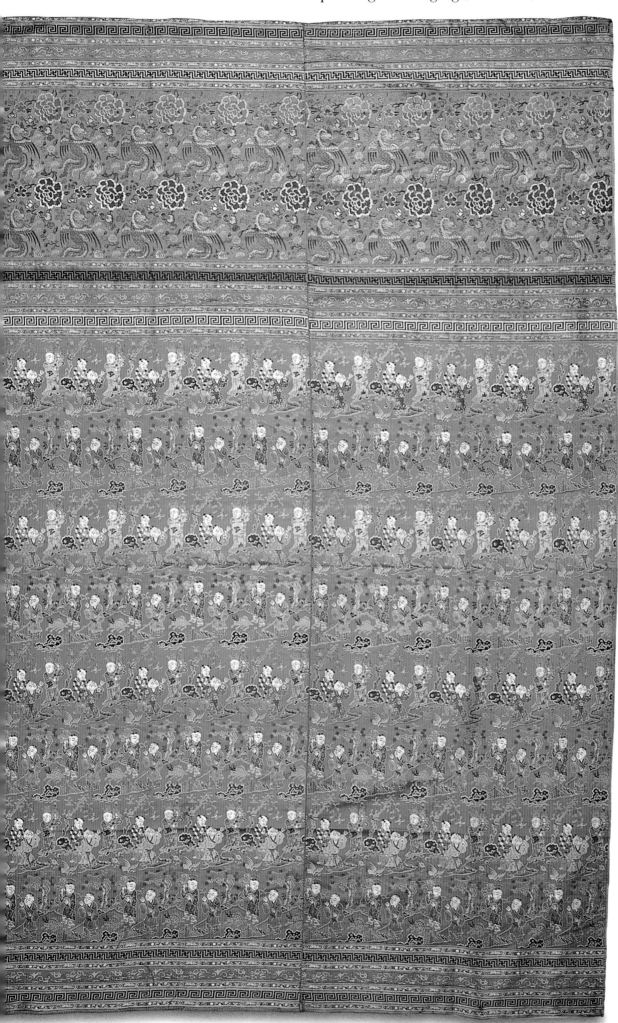

A brocade-woven panel with the "Hundred Boys" motif. It is in good condition. Circa 1880. 56" x 87". $1500.
H2,C3,Q2,R4

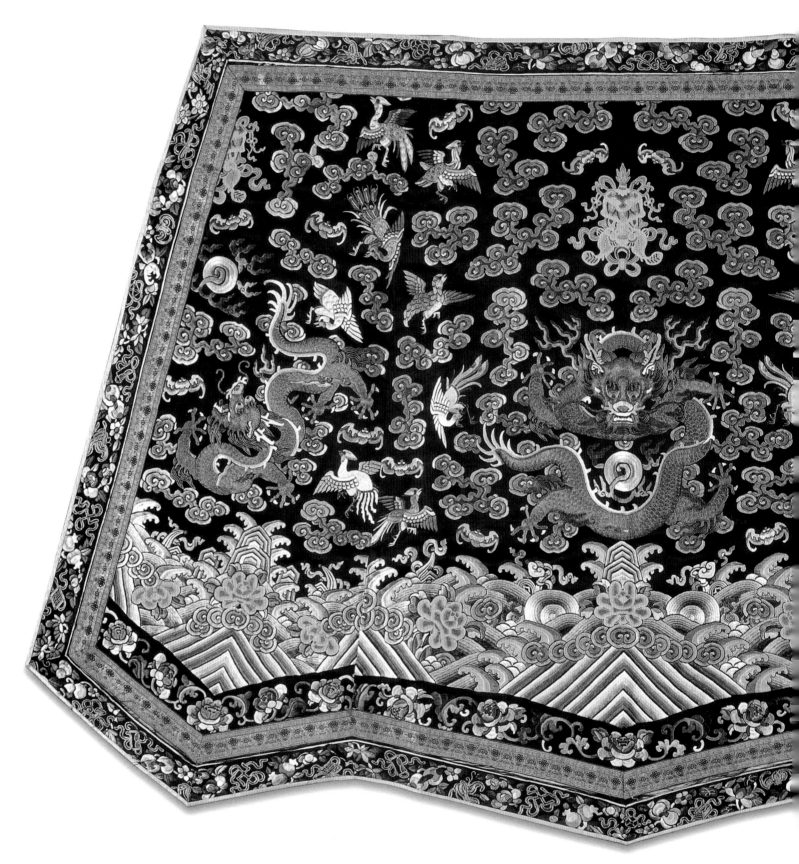

A panel made from the lower portion of a Chinese vest showing dragons and birds of rank. It is of silk satin stitch embroidery on blue-black silk satin with Peking stitch detail on flowers. Circa 1870. 50" x 32.5". $975. H2,C2,Q2,R3

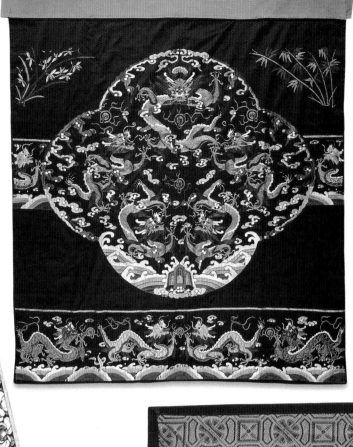

A very brightly colored wall hanging from the first quarter of the twentieth century. It is embroidered in silk satin stitch and couched threads on blue-black silk satin. This piece is adapted from the design of an uncut formal ch'ao-pao (refer to page 93 of *Ruling from the Dragon Throne* by John Vollmer) with a distinctive lobed yoke upper body section and lower dragon skirt band. 69" x 57". $650. H2,C2,Q3,R3

A dark blue silk robe fragment embroidered with silk satin stitch flowers and trimmed with woven ribbon. The robe fragment is circa 1850 and probably mounted circa 1900. Many fragments of fine Ch'ing textiles have come to the West in sections and were framed later for decorative purposes. Overall size 9" x 12.5". $120. H2,C3,Q1,R3

Back view of right

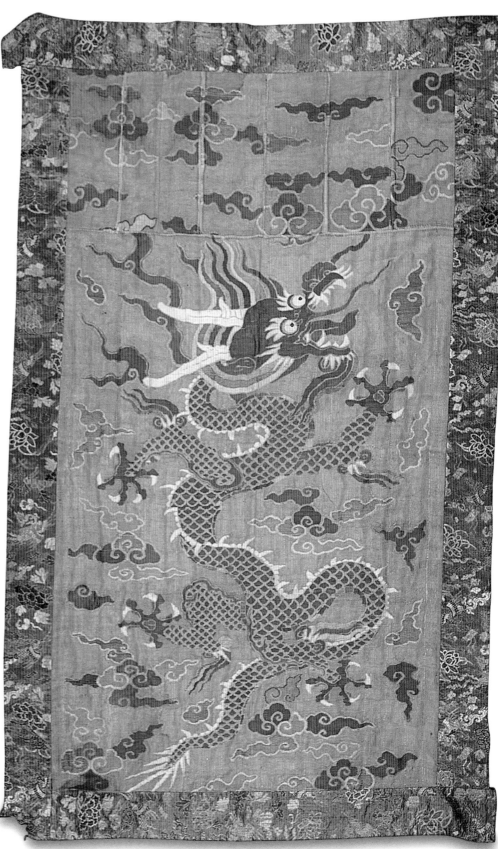

A k'o-ssu panel depicting a dragon among clouds, assembled from 17th century Ming textile fragments. Recolored more recently. 38" x 62". $3500. H4,C3,Q1,R1

A beautiful k'o-ssu woven panel of a phoenix on a rock. It is very finely woven and detailed in light neutral colors, there is some staining in the lower corner. Circa 1860. Textile size 21" x 21". $900 due to condition. H3,C2,Q1,R3

Another example of a very finely woven k'o-ssu panel. This one is so well executed that the back appears almost as perfect as the front. Circa 1860. Textile size 19.5" x 19.5" $1200. H3,C2,Q1,R3

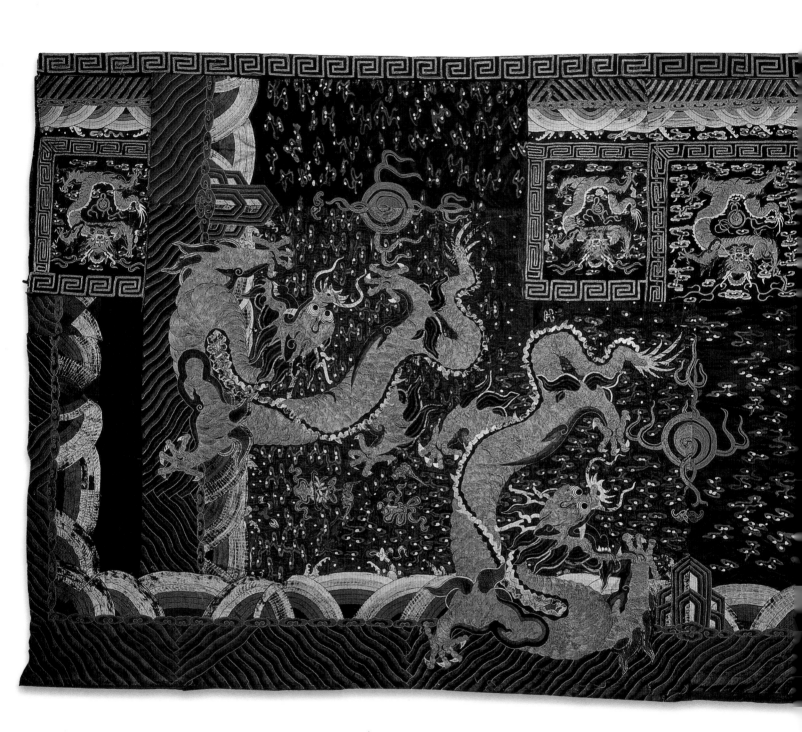

This is an extremely large panel and was used in the movie "The Last Emperor" as a background hanging in the Forbidden City. It was originally a smaller temple panel made of a blue silk embroidered with dragons and dates to the late nineteenth century. The piece was greatly enlarged by the addition of silk satin panels with embroidery, coarsely executed. We attempted to return the piece to its original form but were unable to do so because some areas have been cut away and are missing. 193" x 85". $2000. H2,C4,Q2,R

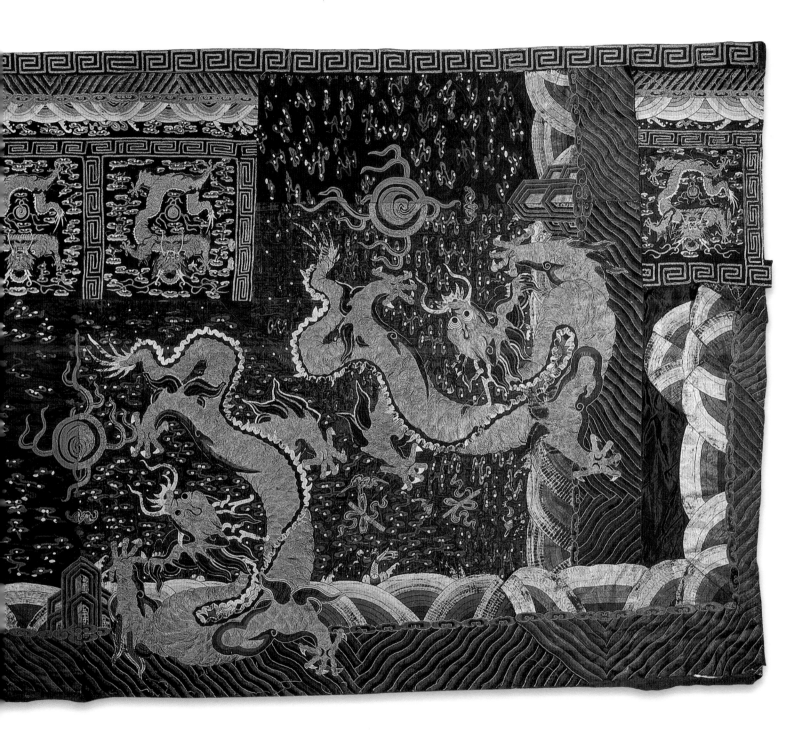

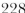

A nicely embroidered, very large panel of peacocks and other birds and flowers. It is in poor condition with loss and degradation. It has value as a study piece only, as there is loss of both warp and weft threads in the background due to unstable dyes and metal salt mordants that were used pre-1860. It is a ghost of a masterpiece and to save it would require too much restoration. With so many other good pieces on the market it would be impractical to do such extensive work. From the first half of the nineteenth century. 47" x 130". $575. H4,C5,Q2,R3

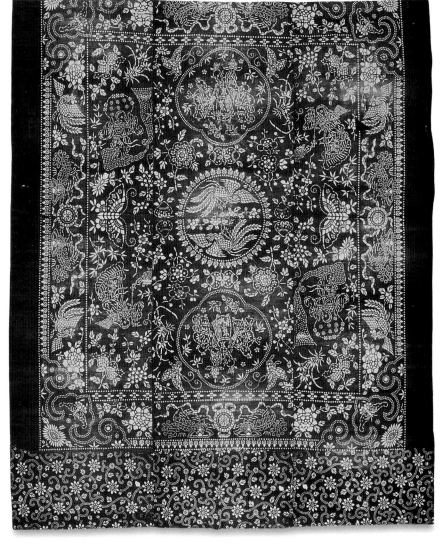

A panel of Indigo-dyed paste resist cotton utilizing stencils from the Kiangsu Province north of Shanghai. It is stenciled with phoenix and auspicious symbols. This district is famous for its resist dye techniques on hand woven cotton. Late nineteenth century. It was collected in the province in 1970 by a visiting artist. 56" x 68". $500-600. Private collection. H2,C2,Q3,R3

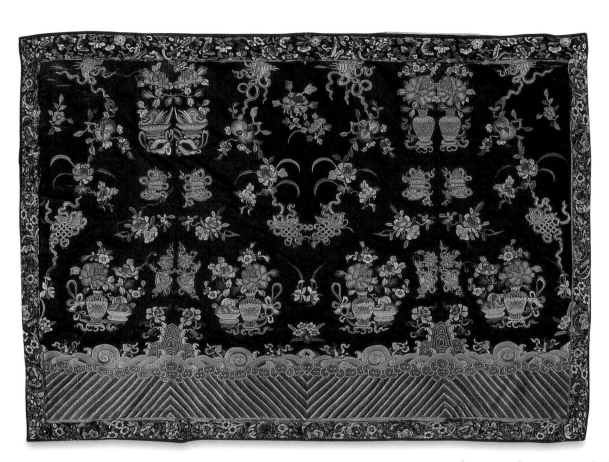

Left:
A panel made up from a woman's robe. It is of good quality craftsmanship, but the background is broken down due to the dye mordants. Circa 1850. 36.2" x 55.75". It presents well as a decorative piece and if restored properly it would be valued at $900-$1200. As is, $450. H3,C4,Q2,R3

Bottom left:
A silk hanging embroidered with peonies in silk satin stitch and trimmed with ribbon and a floral bias edging. Circa 1880. 14" x 22". $175. H3,C3,Q3,R4

Bottom right:
An early k'o-ssu woven panel depicting a female deity. There is discoloration from time and the condition is somewhat fragile. Early nineteenth century. 22.5" x 41.5". $475. H4,C4,Q2,R3

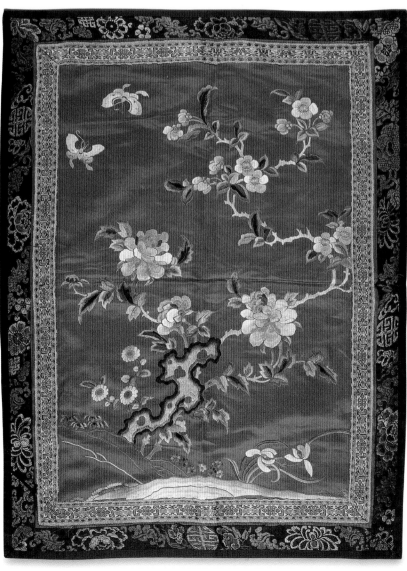

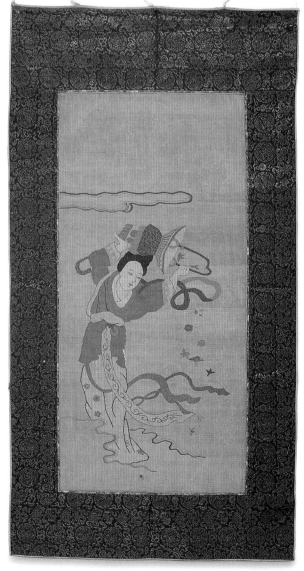

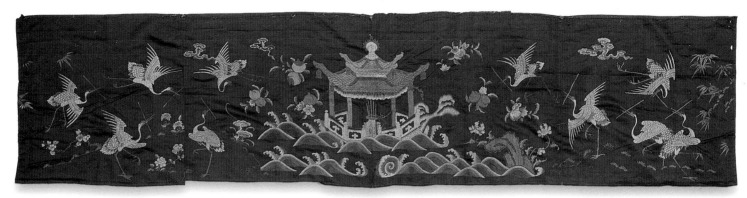

A long banner or valance embroidered with a temple surrounded by flying cranes, in silk satin stitch on blue-black silk satin. This was originally the top of a large temple piece that has been disassembled as there was extensive damage to portions. There is a good amount of thread loss and loose threads. Early nineteenth century. 109" x 25.5". $600 as is. Restored and with period edging in the $1800 range. H3,C3,Q3,R3

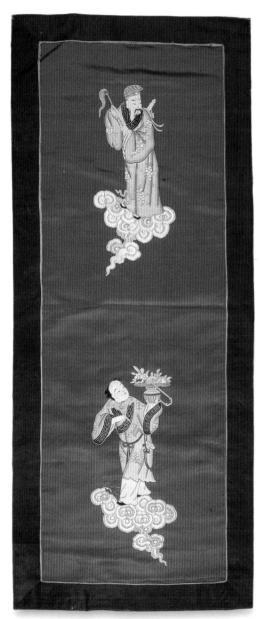

A beautiful temple hanging showing two immortals. It is finely embroidered in silk satin stitch with couched gold metallic wrapped thread and black twisted cord details. It is a very nice example of this style. Circa 1850. 21" x 51". $375. H2,C2,Q3,R4

This is an early Korean temple hanging. It shows both Korean and Chinese influences in the embroidery work and design. It is comprised of two dragon motifs on the sides embroidered on black silk (note the "tiger" appearance of the one on the left), a center panel of orange silk with auspicious imperial symbols embroidered in silk satin stitch and couched gold metallic wrapped threads. There is a center medallion of silk and silk brocade which matches the bottom border. The piece is most likely made from elements of several pieces. Nineteenth century. 23" x 30". $900. H3,C4,Q2,R2

An embroidered panel of cream silk gauze with a brick stitch and needlepoint landscape of rocks, grass, and flowers. It has an unusually large border of woven gold metallic trim and may have been a scholar's scroll converted to a hanging with the added edging. Eighteenth century. 20" x 67". $3700. H3,C3,Q1,R1

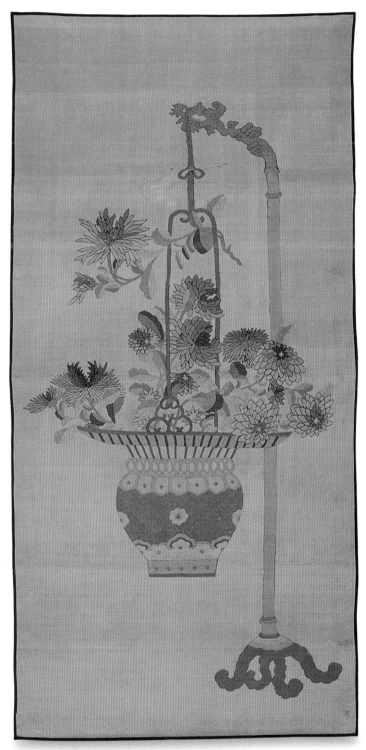

A k'o-ssu woven panel showing a hanging pot of chrysanthemums. Very finely woven but discolored over time. This is another scholar's piece. Circa 1840. 17" x 35". $1450. H4,C3,Q1,R3

A Tibetan canopy cover made from an uncut brocade dragon robe section with very interesting imagery that includes a three-legged money toad with head tilted back, a cloud flowing from it's mouth and coins resting on the cloud, spotted deer and ships laden with treasures. It is edged in fine damask silk with the same fretwork pattern in three colors and backed with a bast fiber lining. It has ties on the corners and a Tibetan script dedication. It is in good condition for its age but there is some staining. Circa 1780. 136" x 70", $2200.

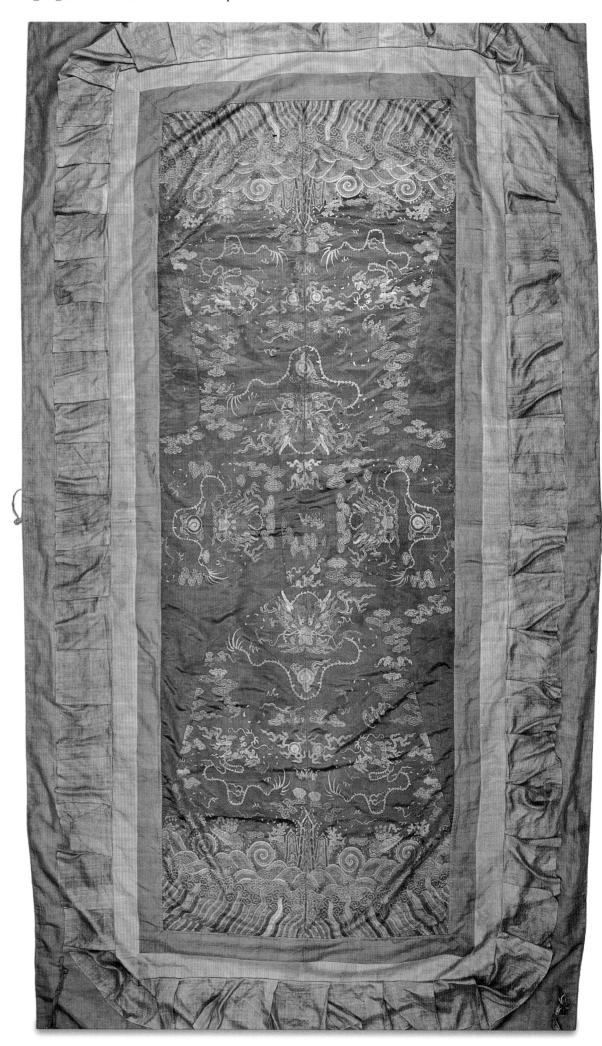

Detail of the previous page showing a three-legged money toad with a coin and clouds emanating from its mouth.

Detail of the previous page showing a deer incorporated into the motif.

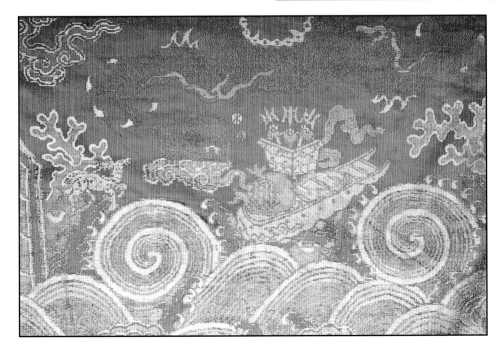

Detail of the previous page showing a ship overflowing with treasure.

An intricately embroidered scholar's panel in Peking stitch and couched cording on brown silk satin. There is some breakdown of the background silk. Circa 1830. $750 due to condition. H4,C4,Q3,R3

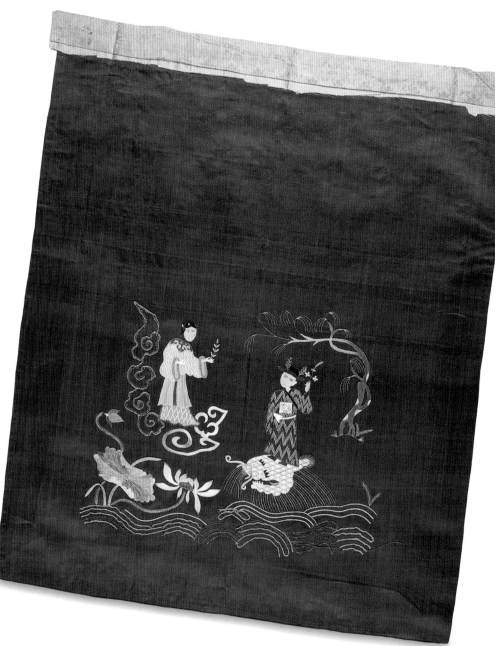

A hanging scholar's panel embroidered in silk satin and stem stitch with couched gold metallic threads on blue silk satin. The waves are executed in couched, twisted peacock feathers. The theme of a carp changing to a dragon denotes success in the examinations. This has probably been remade in the past. Circa 1880. 14" x 20". $475. H2,C2,Q3,R3

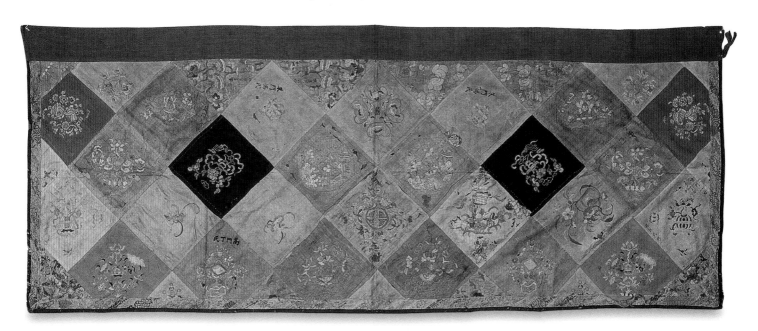

A nice frontal or valance of pieced woven damask and lampas embroidered
with symbols and other motifs. Circa 1750. 18" x 40.5". $600. H4,C4,Q2,R2

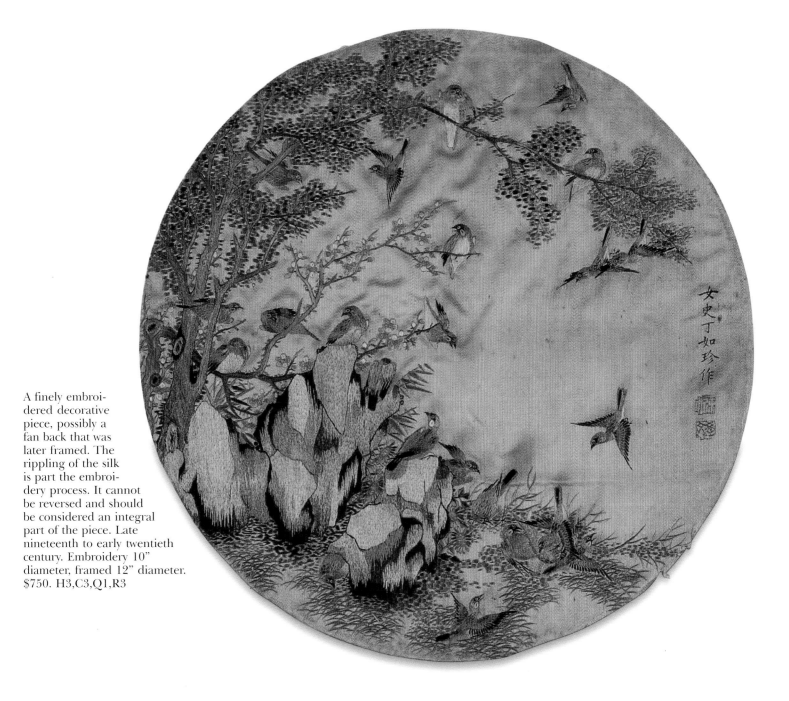

A finely embroi-
dered decorative
piece, possibly a
fan back that was
later framed. The
rippling of the silk
is part the embroi-
dery process. It cannot
be reversed and should
be considered an integral
part of the piece. Late
nineteenth to early twentieth
century. Embroidery 10"
diameter, framed 12" diameter.
$750. H3,C3,Q1,R3

A roundel with bats and flowers embroidered in silk brick stitch on silk gauze with natural dyes. Circa 1860. 11.5" diameter. $175.

Three roundels. The ones on the right and lower center are made from fragments of larger pieces. The one on the left was originally part of the back of a robe, circa 1830, and has severe condition problems. $175. Nominal value on the other two

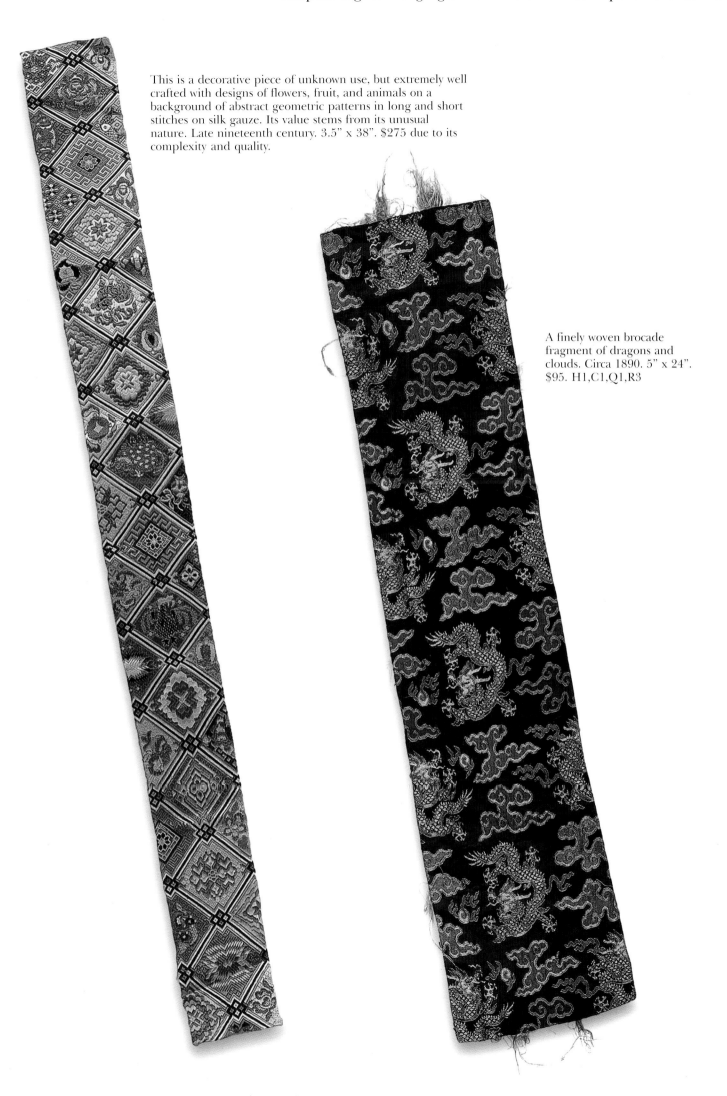

This is a decorative piece of unknown use, but extremely well crafted with designs of flowers, fruit, and animals on a background of abstract geometric patterns in long and short stitches on silk gauze. Its value stems from its unusual nature. Late nineteenth century. 3.5" x 38". $275 due to its complexity and quality.

A finely woven brocade fragment of dragons and clouds. Circa 1890. 5" x 24". $95. H1,C1,Q1,R3

Throne, Kang, & Chair Covers

Cushions were often produced for the hardwood couches and thrones, and were used for comfort as well as for decoration. Throne cushions were extensively used in the imperial palaces and other ceremonial buildings but not all throne cushions are imperial.

The textiles used to cover the heated brick platforms, or kangs, varied in size and were square or rectangular shaped with a wide border and large center field filled with curvilinear floral and tendril designs and sometimes combined with grid design elements.

Cushions for throne backs and seats followed the contours of the particular throne they were made for and varied in basic shapes and sizes.

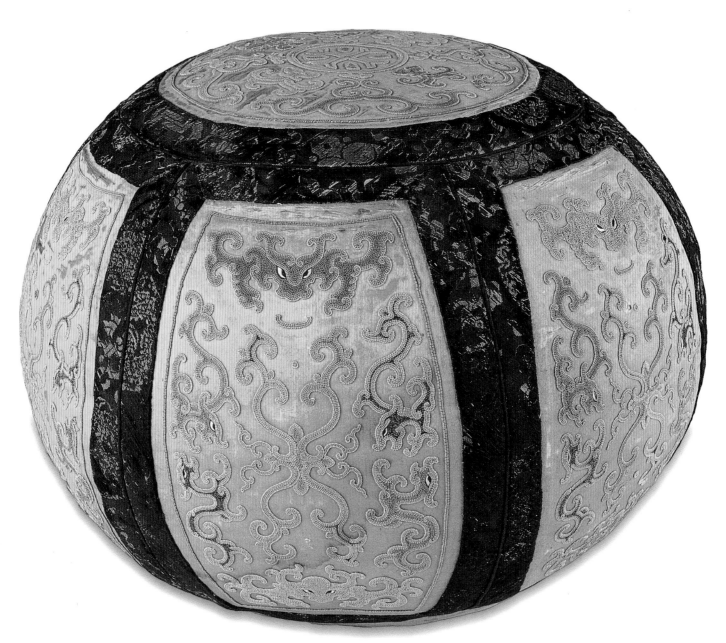

An arm cushion for the throne, embroidered in Peking stitch on imperial yellow silk satin. The panels are separated by black and gold brocade-woven strips and decorated with stylized dragons and bats in alternating colors on yellow panels. There are some loose threads. Circa eighteenth century. 14" x 11". $3500. H4,C3,Q1,R1

An imperial kang or cushion cover of silk satin stitched floral designs on imperial yellow damask background. This piece is in perfect and unused condition. Circa 1890. 59.25" x 29.5". $4500. From the collection of Gary Wee. H1,C1,Q1,R2

A throne back cushion cover with roundels in a theme of lotus, bats, tendrils, double fish symbolizing plenty, a Ju-i scepter symbolizing wishes fulfilled, and the "wan" or reverse swastika symbolizing ten thousand. It is the front face piece only. The back and side panels have been detached and lost and the piece shows a good amount of wear. There is loss at the edges from being cut down but ninety-nine percent of the cover is intact. Early nineteenth century. 24" x 24". $4500. H2,C3,Q1,R1

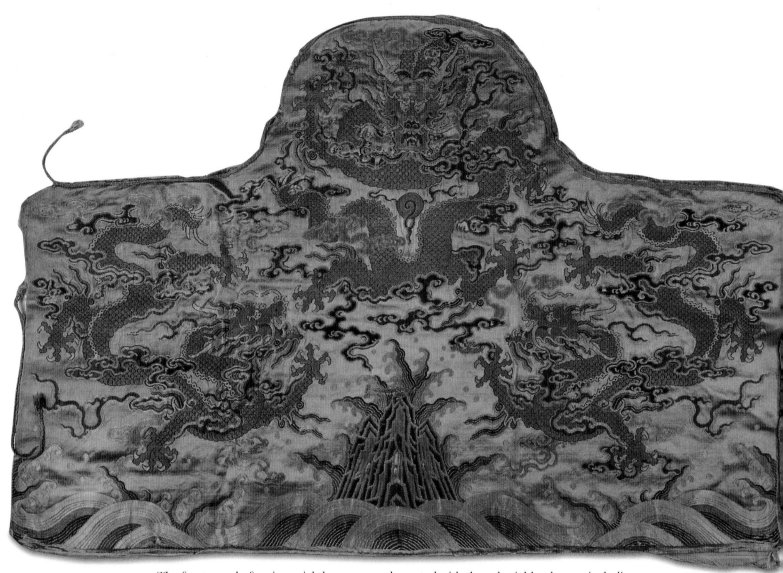

The front panel of an imperial throne cover decorated with the celestial landscape, including three lung dragons with mountains and waves. The brocade material is woven with multicolored silk and gold wrapped threads on gold ground. The condition is fair with some loss and damaged threads. The side pieces and back are missing and the lining may not be original to the piece. Late eighteenth, early nineteenth century. 21.5" x 32". $7500. H3,C3,Q1,R1

A kang cover embroidered in silk brick stitch on silk gauze. The border is embroidered with dragons on a cream-colored background with lotus, peach, and peony motifs. The high quality of this piece suggests it was made for a high ranking person. Circa 1880. 35.5" x 36.5". $5500. H1,C1,Q1,R2

Chinese wood chairs were draped with covers for special occasions. The covers that fit over the top rail of the chair show a design on the back, and drape down over the front with a design for the inner back, the seat area, and from the seat to floor area. There could be four areas of design or use depending on the composition. Some pieces had a back flap design and one continual design for the front. They were produced in all textile techniques. They were usually made in sets and are worth more as such.

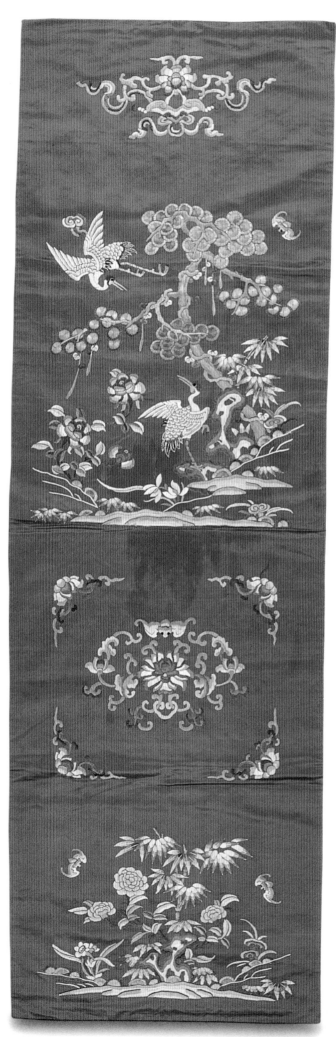

A chair cover of red embroidered silk. The imagery suggests it was used for a wedding or other festive occasion. The red background color and the paired cranes with the various vegetal rebuses's convey a message of good luck, long life, and good fortunes. The condition of this is good with slight staining. Circa 1880. 19.5" x 70". $600. If pristine, $1200. H2,C4,Q2,R3

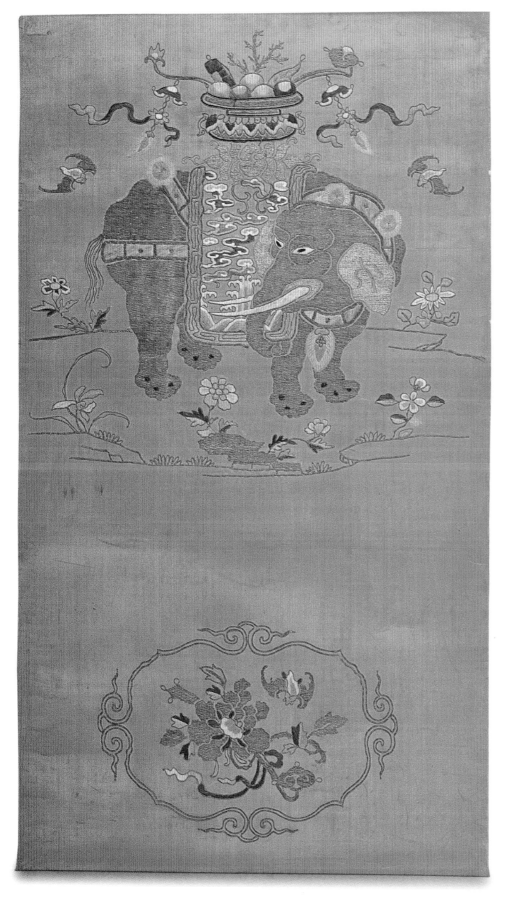

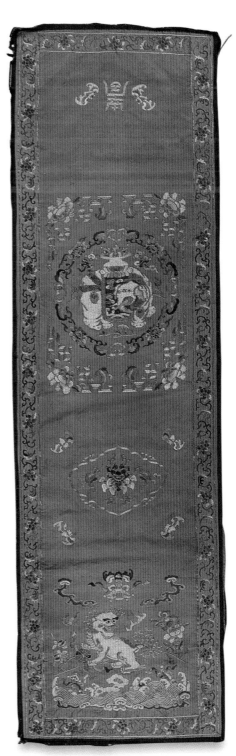

An early panel with an elephant design embroidered in couched gold metallic thread and silk satin stitch on orange plain weave silk. It is a chair back section cut down and later applied to a paper backing and used in a Japanese screen. Very fragile. Circa 1830. 35.5" x 19.5". $875. H4,C4,Q2,R3

A chair cover of orange silk embroidered in couched gold threads and satin stitch embroidery on plain weave with an elephant, fu-lion, and bats. There is slight staining and some fading and wear. Circa 1830. 19.5" x 65.25". $1200. H3,C3,Q2,R3

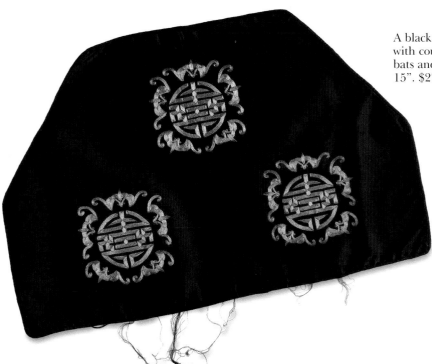

A black silk satin chair back cover embroidered with couched gold metallic threads in a motif of bats and good fortune symbols. Circa 1890. 23" x 15". $275. H2,C2,Q2,R3

A chair cover of red wool completely embroidered with loosely spun silk split or mat stitch in a crane and cloud design. Circa 1880. 22" X 69". $850. H1,C1,Q1,R3

Far left:
An unusual chair cover of brocade-woven silk with geometric floral and animal designs. This may have been intended for a palace setting, because there are dragons woven in around the edges. Circa 1890. 21.5" x 70". $1500. H1,C1,Q1,R3

Left:
An early, multicolored brocade chair cover woven in silk. Excessive use and light damage has caused the fabric to break down. Although the piece was stabilized, it is still quite fragile. Circa 1820. 21" x 68". $1200. H4,C4,Q2,R2

A chair cover, completely hand-stitched in loosely spun silk thread in a running backstitch. The images of the fu-lions, phoenix, and floral motifs are satin stitched in loosely spun silk to create a very soft and fluid look. There is extensive thread loss to the fu-lion corresponding to the position of a person's back rubbing against it. This piece merits restoration for decorative purposes and to bring back the dramatic presence and showy design. Late eighteenth to early nineteenth century. 21" x 64". Unrestored $1200-1500. Restored properly, $3000 range. H3,C4,Q2,R3

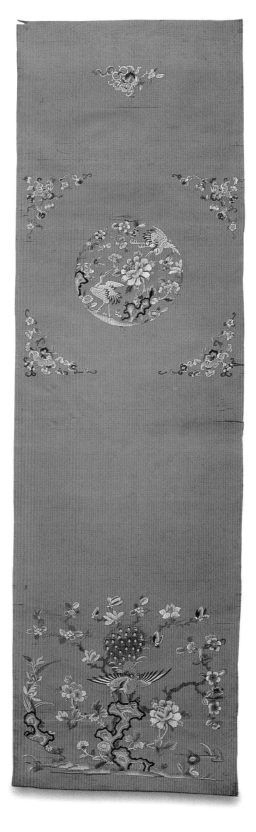

An extremely finely woven silk chair cover embroidered with cranes and peacocks amid floral motifs in silk satin stitch and couched gold metallic threads. Its condition is not good as the silks have broken down over time causing splitting in the background. Circa 1820. 21" x 69". $900 due to its condition; if near pristine, even with slight light damage, $2500-3500. H4,C4,Q2,R2

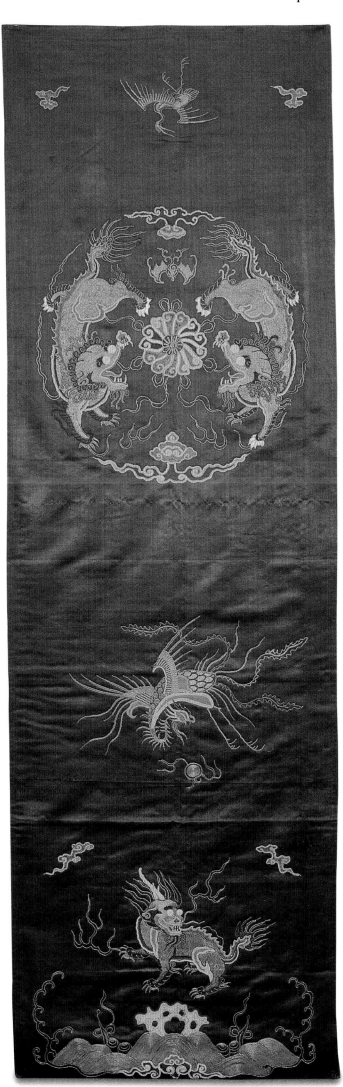

An early chair cover of olive colored silk satin embroidered with birds in silk satin stitch and couched gold thread. There are many loose threads that need retacking. Circa 1800. 19.5" x 60". $1000 as is. $1700 after restoration. H4,C4,Q1,R2

Detail of the chair cover above showing loose gold threads and damage before restoration.

A chair cover of brown silk satin with couched gold metallic thread and Peking stitch in a design of fu-lions. The piece is in good condition with some restoration. From the first half of the eighteenth century. 21" x 62" . $2400. H3,C3,Q1,R2

Detail of throne back below.

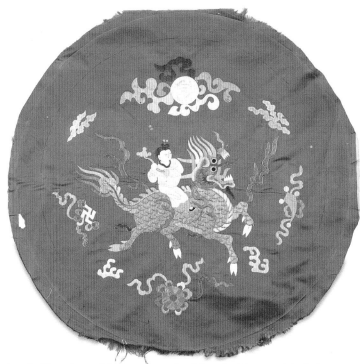

A red silk satin cushion cover embroidered with a mythical character in silk satin stitch on red silk satin. Circa 1890. 21.5" x 20". $50. H3,C3,Q3,R4

An uncut throne back cover of blue silk satin. It is embroidered in silk satin stitch and very fine couched gold thread. Circa 1890. 32" x 36". $3500. H2,C1,Q3,R3

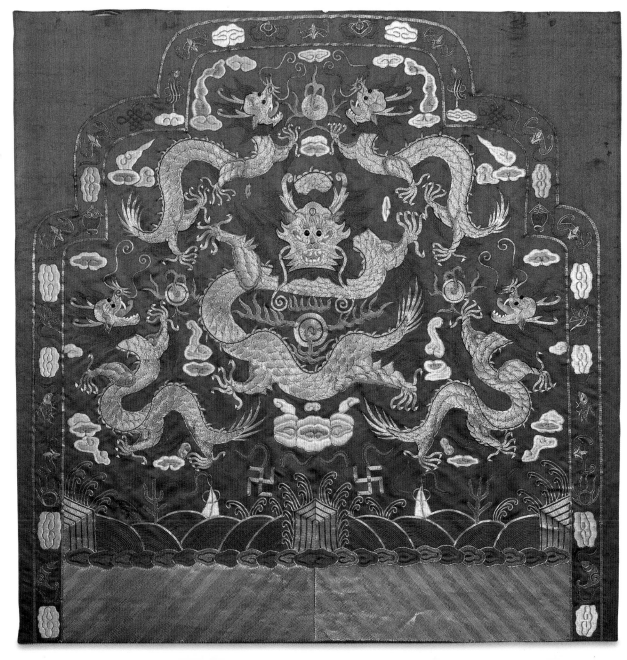

Presentation & Tribute Banners

Presentation and tribute banners were used as interior decorative accents in homes, palaces, and temples. They were hung to celebrate a special events or carried on poles in a procession.

The banner to the right is identical to one in illustrated in *Imperial Silks: Chinese Textiles in the Minneapolis Arts Institute*, Volume Two, page 993.

A very long palace banner that is a composite of many banners. This piece was, most likely, a covering for a pillar or in a large interior space of the palace or temple for special events. It is brocade-woven of dark blue silk with gold, green and coral dragons and is identical on the reverse side. Mid-nineteenth century. 205" x 20.5". Set of three $6500. H3,C3,Q2,R2

Two long yellow silk temple or palace hangings, exquisitely embroidered in silk satin stitch with phoenix birds and flowers. The yellow bands are separated by black silk bands, which are embroidered with cranes and butterflies. There is white silk netting across the bottom of each, ending with the blue silk tassel fringe. Circa 1890. Each 171" x 40".$6500 for the pair. H1,C1,Q2,R2

A red silk satin festival or temple banner with three sages embroidered in silk satin stitch and couched metallic threads. The piece is very faded and in poor condition. Circa 1870. 33" x 82". $750. H4,C4,Q3,R4

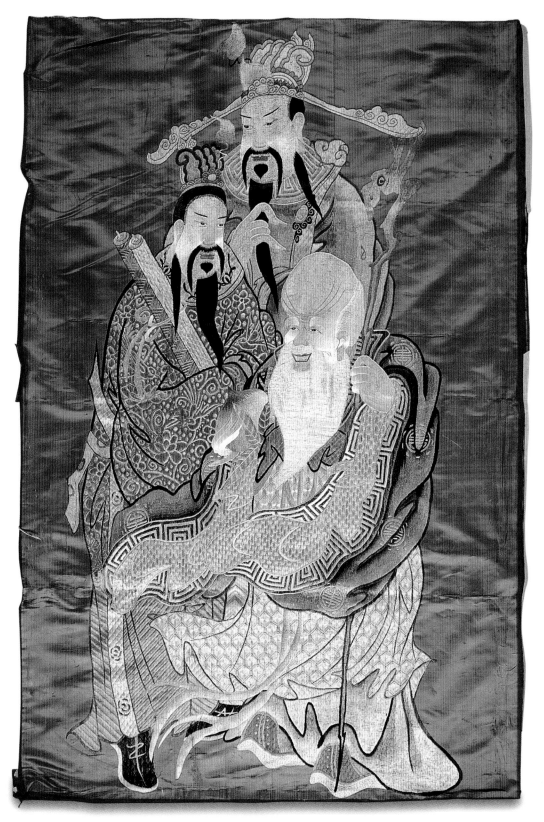

A large banner or valance with various embroidered, repeating motifs appliquéd on green silk damask with a flocked black cut out edging. The piece has considerable staining. Circa 1890. 92" x 18". $450. H4,C5,Q3,R3

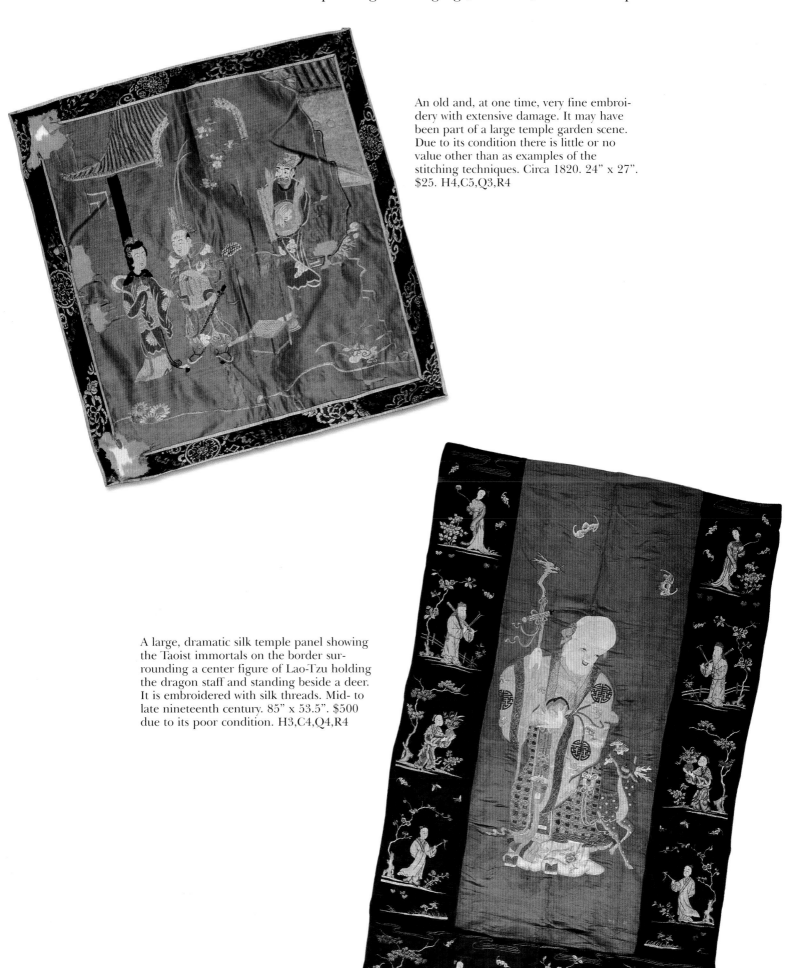

An old and, at one time, very fine embroidery with extensive damage. It may have been part of a large temple garden scene. Due to its condition there is little or no value other than as examples of the stitching techniques. Circa 1820. 24" x 27". $25. H4,C5,Q3,R4

A large, dramatic silk temple panel showing the Taoist immortals on the border surrounding a center figure of Lao-Tzu holding the dragon staff and standing beside a deer. It is embroidered with silk threads. Mid- to late nineteenth century. 85" x 53.5". $500 due to its poor condition. H3,C4,Q4,R4

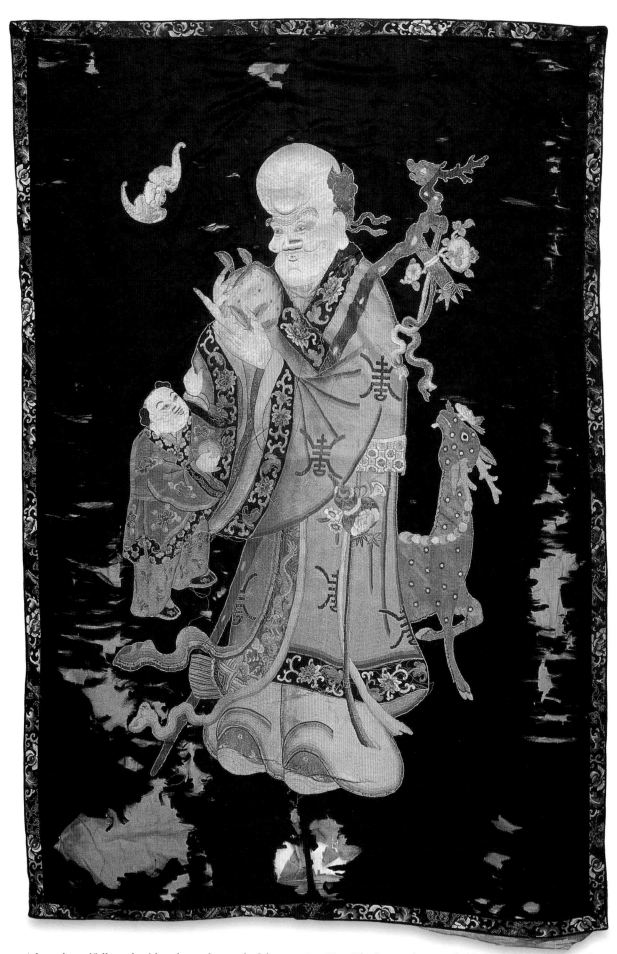

A large beautifully embroidered temple panel of the sage Lao-Tzu. The image dates probably from the early to mid-eighteenth century and was reappliquéd onto the black silk background in the early to mid-nineteenth century. The black has disintegrated due to the iron mordants in the dying process and the piece should be reappliquéd once again. 79" x 53". As it is, the value would be $1000, and if it were restored, $2000. H3,C3,Q2,R3. Compare the quality of this piece with the previous panel. This one is much finer and more detailed.

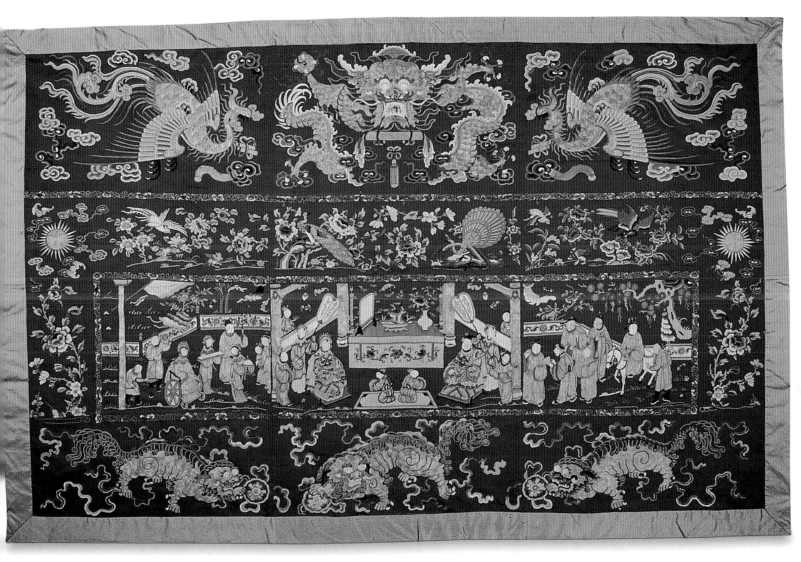

A tremendously large red satin birthday banner finely embroidered with a village scene. It is in satin stitch and couched metallic gold threads. It has been fully stabilized and the edging has been replaced. This piece was originally much larger with dedications, greetings, and well wishes similar to one in Verity Wilson's book *Chinese Textiles*, page 62. Circa 1840. 119" x 76". $4700. In excellent condition it could bring in excess of $10,000. H3,C3,Q2,R2

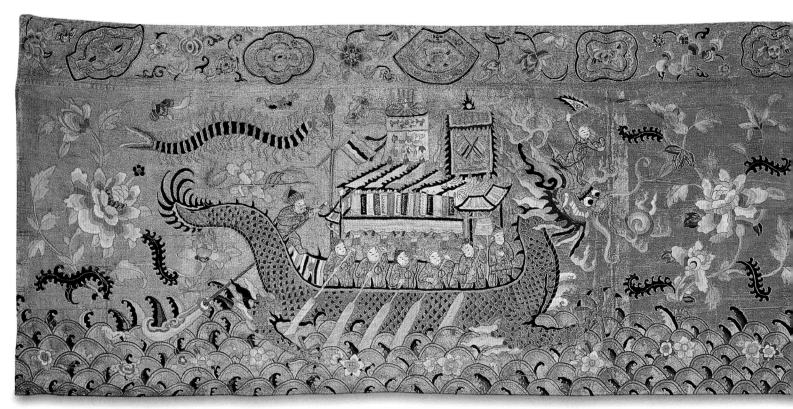

A festival banner embroidered in silk satin stitch with couched metallic gold thread. The background is completely covered with the metallic gold thread and the details are satin stitched in bright colors of silk. The piece has some wear and loose threads. Circa 1850. Probably representing dragon boat races. 92" x 43.5", $950 as is; restored the piece could bring as much as $2500. H3,C4,Q4,R3

Detail of the large panel above showing the wear.

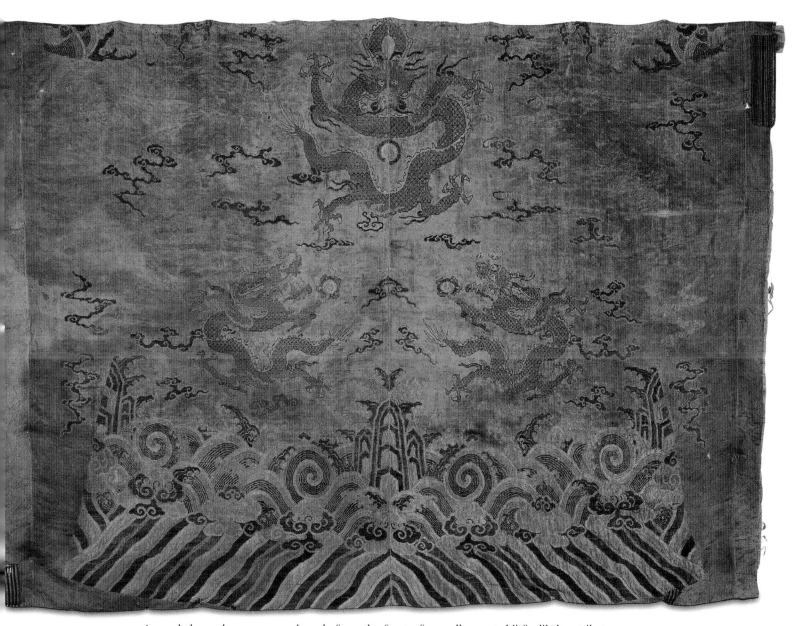

An early brocade-woven panel made from the front of a small, uncut ch'i-fu, likely a tribute gift made into a tribute cloth and used as a column cover by either the Tibetan or Nepalese people. There is a fair amount of staining and some early repairs in the form of patches on the edges. There are also areas showing breakdown of fibers and wear. The piece was disassembled from a vertical hanging and realigned to show the full front of the robe design. Late Ming Dynasty to early Ch'ing Dynasty. 59" x 43". $2500. H4,C4,Q2,R2

An interesting bright yellow silk satin embroidered panel with a bird that has a cartoon-like appearance with its large eyes and stylized tail. It is embroidered with a varied array of stitches. Circa 1900. 29" x 29.5". $1175. H2,C3,Q2,R2

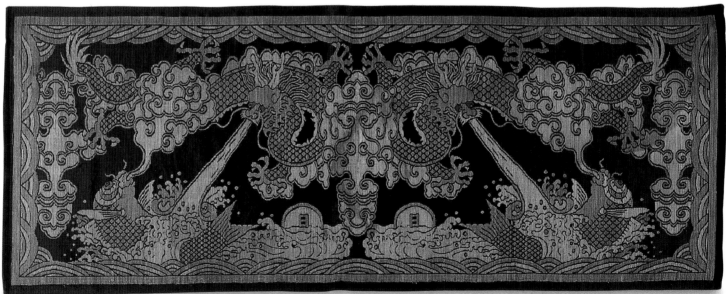

A black, gold, and white silk brocade-woven panel, depicting a pair of carp ascending to become dragons and symbolizing success. There is some staining, but the fibers are in good condition. Circa 1900. 11" x 25.25".$450.

Exports

Chinese textiles have been exported for thousands of years. The term "Silk Road," the most famous early trade route from China to Rome, takes its name from the silk that China exported. Export textiles were often made to client specifications but most retain their Chinese identity through their design and techniques.

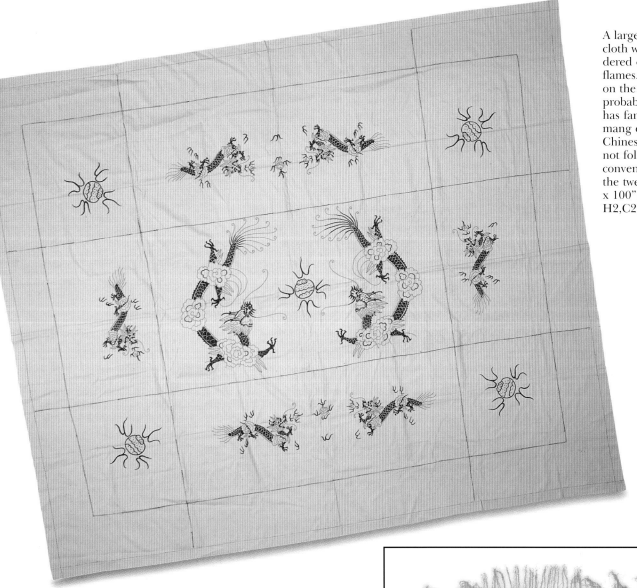

A large white silk table cloth with blue embroidered dragons and flames. It is hemstitched on the edges and was probably for export. It has fanciful four-clawed, mang dragons that are Chinese in style, but do not follow Chinese design conventions. First half of the twentieth century. 82" x 100". $250. H2,C2,Q3,R4

A fine silk white crepe shawl, hand-embroidered in a white on white technique with flowers, birds, and butterflies. Circa 1920. 60" x 58" not including fringe. $160. H2,C2,Q3,R4

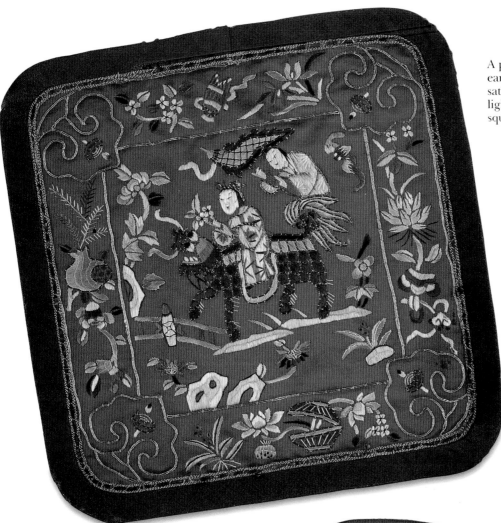

A pot holder for the tourist trade from the early twentieth century. It is embroidered in satin stitch on a red silk background, and is lightly padded, and edged in blue silk. 8.5" square. $60. H2,C3,Q3,R4

A pot holder for the tourist trade from the early twentieth century. It is embroidered in satin stitch on a red silk background and lightly padded. 8.5" square. $60. H2,C3,Q3,R4

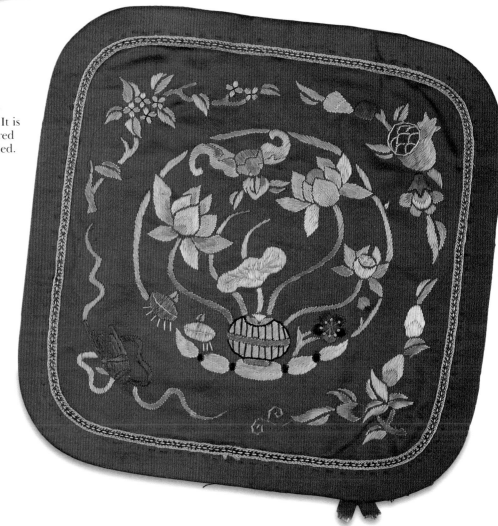

Household

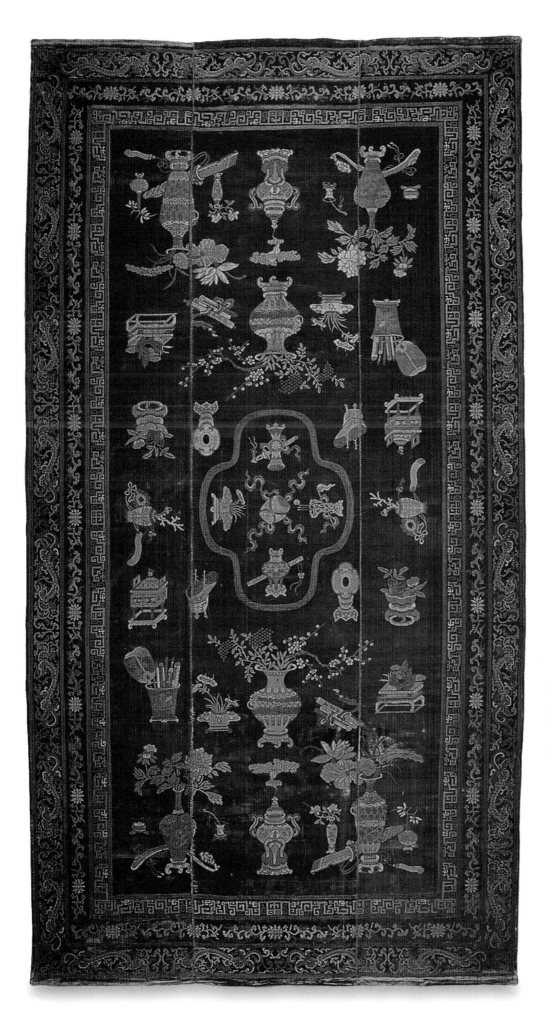

A large golden brown cut velvet carpet woven in three panels with metallic gold and green threads. This may have been used in the Forbidden City. It has had slight restoration, but is in good condition over all. Circa 1800. 75" x 139". $12,500. H2,C3,Q1,R1

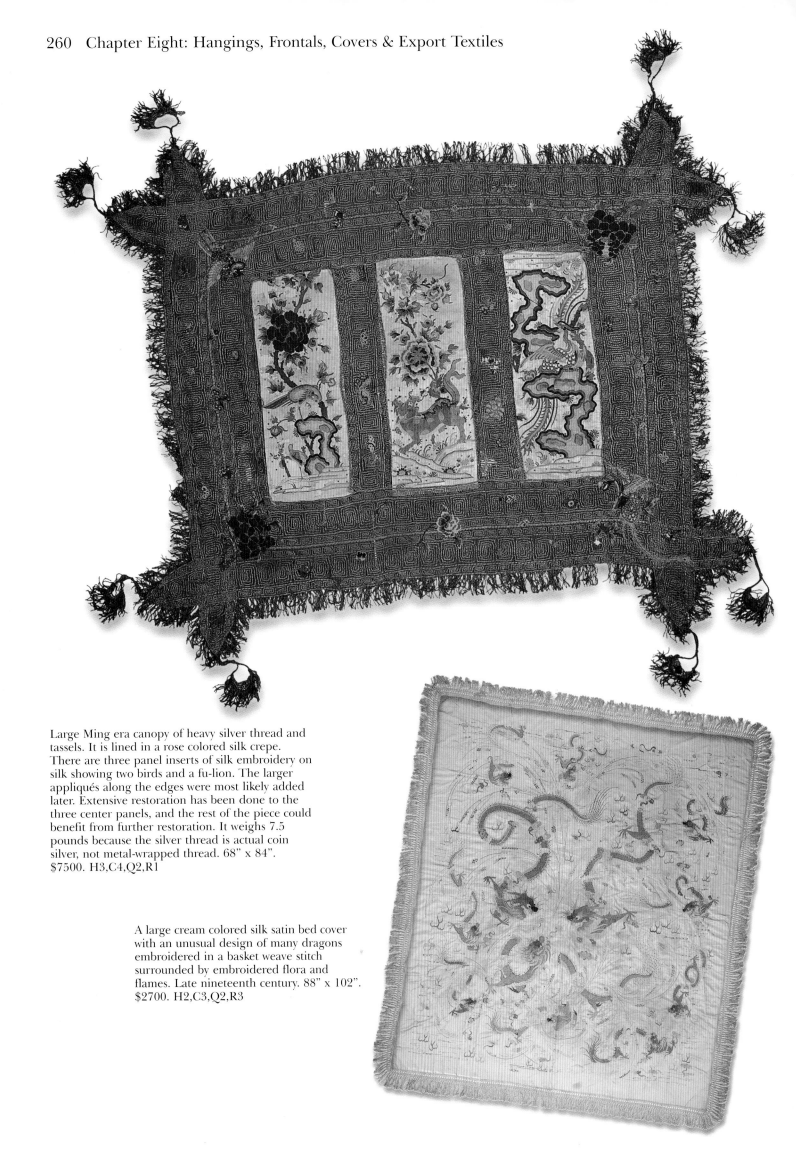

Large Ming era canopy of heavy silver thread and
tassels. It is lined in a rose colored silk crepe.
There are three panel inserts of silk embroidery on
silk showing two birds and a fu-lion. The larger
appliqués along the edges were most likely added
later. Extensive restoration has been done to the
three center panels, and the rest of the piece could
benefit from further restoration. It weighs 7.5
pounds because the silver thread is actual coin
silver, not metal-wrapped thread. 68" x 84".
$7500. H3,C4,Q2,R1

A large cream colored silk satin bed cover
with an unusual design of many dragons
embroidered in a basket weave stitch
surrounded by embroidered flora and
flames. Late nineteenth century. 88" x 102".
$2700. H2,C3,Q2,R3

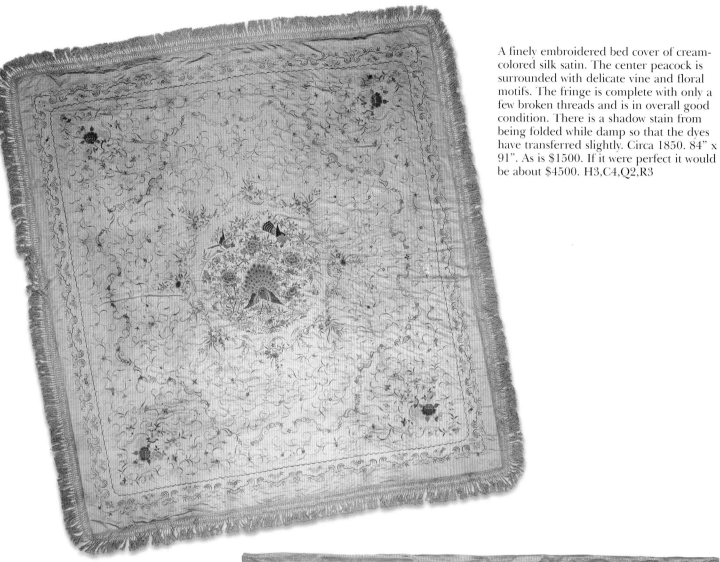

A finely embroidered bed cover of cream-colored silk satin. The center peacock is surrounded with delicate vine and floral motifs. The fringe is complete with only a few broken threads and is in overall good condition. There is a shadow stain from being folded while damp so that the dyes have transferred slightly. Circa 1850. 84" x 91". As is $1500. If it were perfect it would be about $4500. H3,C4,Q2,R3

A small table cover nicely embroidered with a peacock and floral design. It is in poor condition with fiber breakdown and light damage. 52" x 52". $375 due to condition. H3,C4,Q3,R4

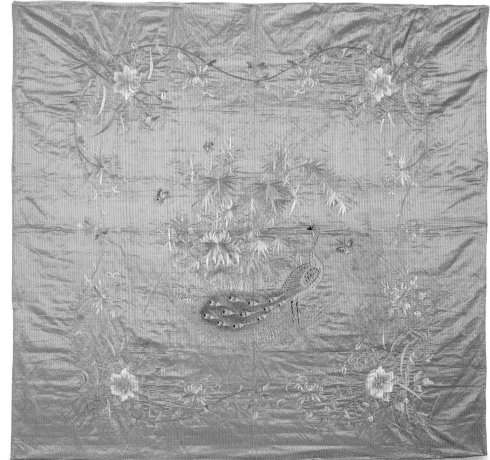

One of a pair of pillow shams embroidered in silk satin stitch on white silk satin and trimmed with a white twisted cording stitched to the edges. Circa 1920. 17.5" x 17'5". $60 for the pair. H1,C1,Q3,R5

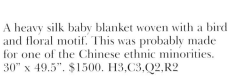

A heavy silk baby blanket woven with a bird and floral motif. This was probably made for one of the Chinese ethnic minorities. 30" x 49.5". $1500. H3,C3,Q2,R2

Chapter 9
Unfinished & Otherwise

The value of many of these items is derived from their unique nature in that they are unused and in pristine condition, a major factor to a collector. Many pieces that come on the market are made in more recent times from unused yardage produced in workshops but were never finished for various reasons, including the disruption of normal life during the uprisings and the fall of the Ch'ing dynasty. Other yardages were given as tribute for service to the court and as presentation gifts to dignitaries and honored guests of the court to be made up at a later time.

A finely woven uncut panel of chartreuse silk brocade. Circa 1890. 49.5" x 30". $475. H2,C2,Q2,R3

Uncut panels for a Chinese purse embroidered in silk petit point on silk gauze. Circa 1890. 7" x 7". $75. H1,C1,Q3,R3

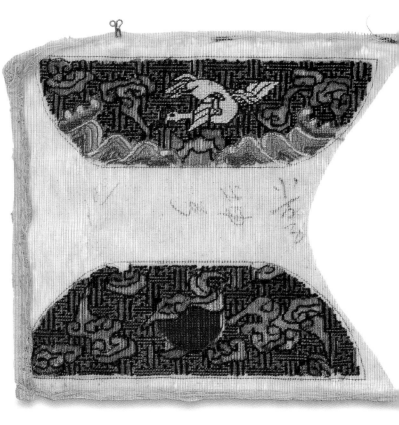

An uncut panel of trim for a robe embroidered with satin stitches and couched metallic threads, and spun peacock feathers couched to white silk satin. Circa 1850. 35" x 29.5". $475. H1,C1,Q2,R4

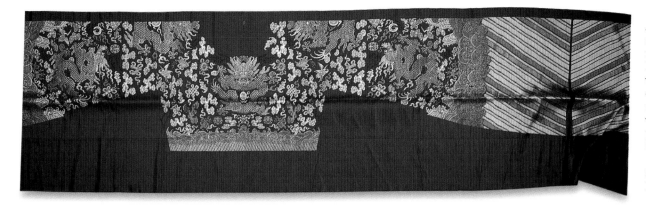

A section of a blue silk brocade uncut robe length. It is a high quality weaving and in excellent condition. Such pieces were often presented as tribute cloths. Circa 1900. 31" x 280". $750.
H1,C1,Q3,R3,

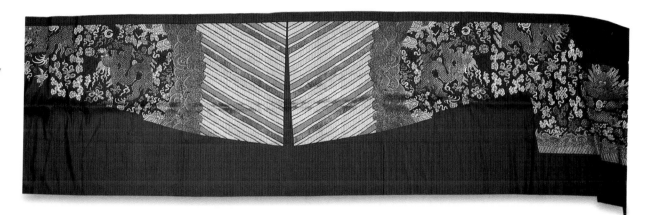

Another view of above.

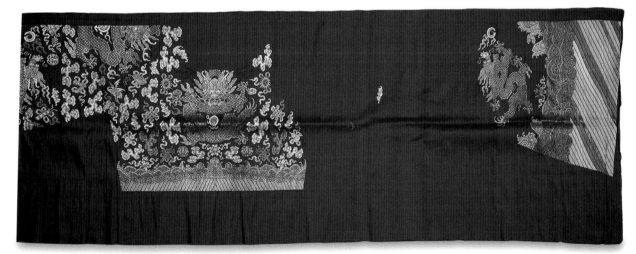

Another view of above.

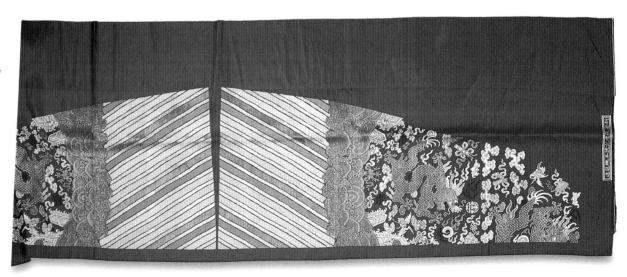

Another view of above.

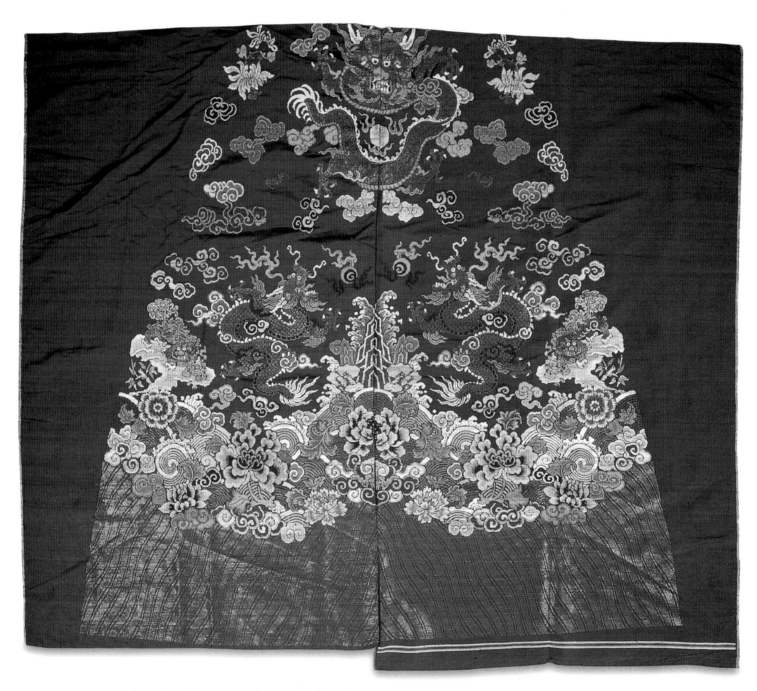

A portion of an uncut robe panel in loosely woven brocade with silk and metallic gold threads.
Circa 1900. 55.5" x 47". $750. H1,C1,Q3,R3

A black silk gauze back panel from an uncut lady's robe. The flowers and butterflies are embroidered with silk in the brick stitch technique. Circa 1880. 40" x 60". $450. H2,C2,Q3,R3

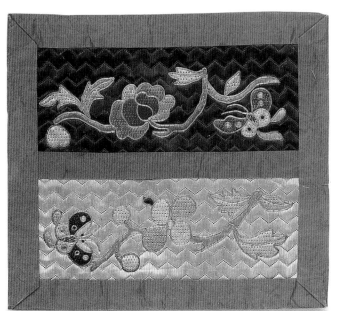

Uncut panels possibly for a pouch, handkerchief holder, or purse, embroidered in long and short stitch in silk thread on silk gauze. They were most likely made for the Western market. Circa 1900. 6.5" x 7". $95 each. H1,C1,Q3,R4

Uncut panels of silk satin stitch on silk background in their original paper surround, possibly for a wallet or handkerchief holder. Circa 1910. 8" x 8". $50. H1,C1,Q3,R4

A portion of an uncut collar and trim panel of brocade, woven with bright silk figures on a black silk background. Circa 1900. 16" 20". $125. H1,C1,Q3,R4

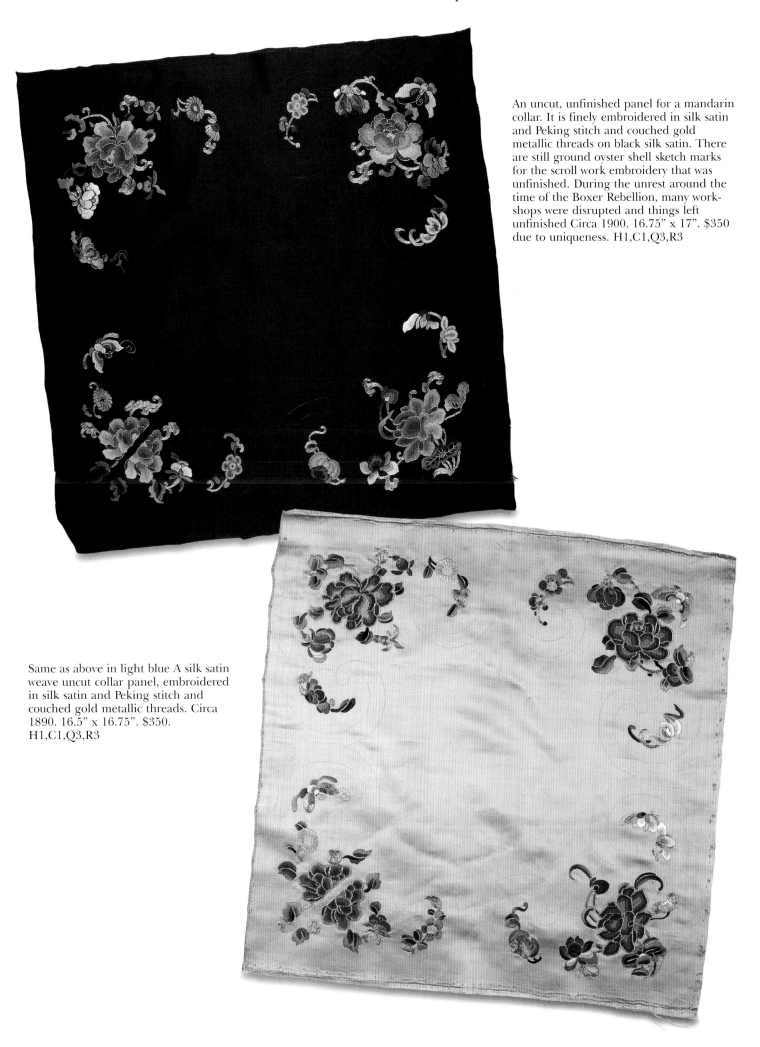

An uncut, unfinished panel for a mandarin collar. It is finely embroidered in silk satin and Peking stitch and couched gold metallic threads on black silk satin. There are still ground oyster shell sketch marks for the scroll work embroidery that was unfinished. During the unrest around the time of the Boxer Rebellion, many work-shops were disrupted and things left unfinished Circa 1900. 16.75" x 17". $350 due to uniqueness. H1,C1,Q3,R3

Same as above in light blue A silk satin weave uncut collar panel, embroidered in silk satin and Peking stitch and couched gold metallic threads. Circa 1890. 16.5" x 16.75". $350. H1,C1,Q3,R3

A panel of four brocade-woven uncut pockets with a flower motif. Circa 1890. 15" x 15.5". $275 due to uniqueness. H1,C1,Q3,R3

A black satin weave uncut panel, possibly for a collar. It is unusual in that there is no formal slit in one of the corner motifs to allow for the opening. The motifs are embroidered with couched gold metallic threads in a floral and basket motif. The scrollwork is unfinished. Circa 1890. 15.5" x 15.5". $350. H1,C1,Q3,R4

A very unusual uncut skirt panel of blue damask weave silk with a couched gold metallic thread dragon motif. It is rare to see these in panel form. 31.25" x 101.5" Circa 1890. $2000-$3000. We have never previously seen uncut panels such as this and were this made into a pair of apron skirts we would not value it at more than $1000. The value here is due to its unusual uncut condition. H1,C1,Q1,R1

An uncut panel of couched twisted threads on silk satin for a triangular belt pouch. Circa 1900. 4.5" x 11". $295. H1,C1,Q3,R4

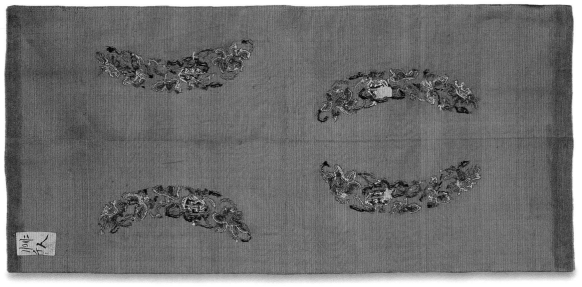

An uncut panel of embroidery possibly for a pair of shoes for a lady with bound feet. It has very finely embroidered silk flowers on china silk. Circa 1900. 13.5" x 6.25". $450. H1,C1,Q2,R3

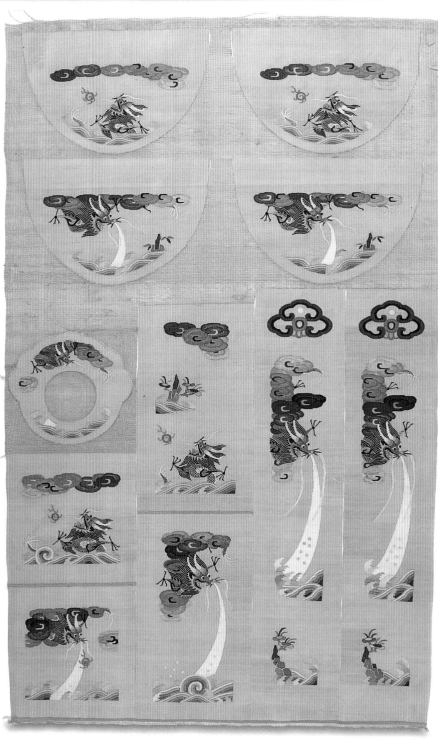

An unusual k'o-ssu woven uncut panel of an accessory suite including a watch holder, pouch, and fan case. Circa 1900. 16" x 24". $2500. H1,C1,Q1,R1

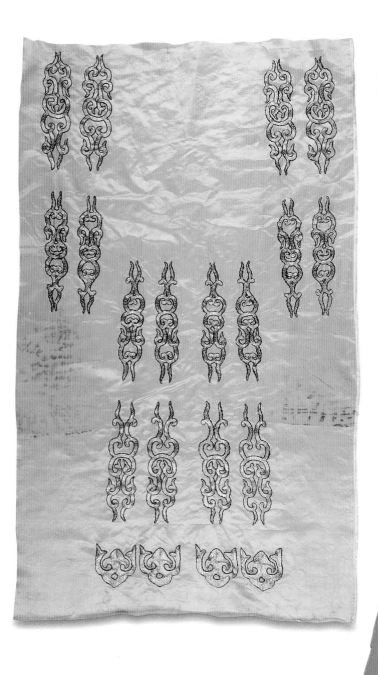

Late nineteenth or early twentieth century uncut aqua silk skirt inserts embroidered with gold metallic couched threads. The condition of the embroidery is good but there is some staining in the background. 18" x 31". $275. H2,C2,Q3,R4

Same as left in the folded position. 27" x 5.25".

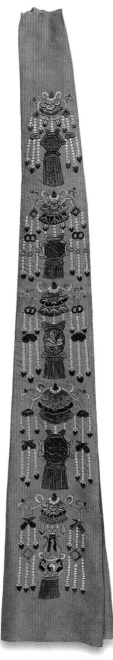

This is another example an uncut textile, this one of a hat tassel. The repeating basket symbols are embroidered, mostly in Peking stitch. Circa 1890. 28.5" x 15.5". $475. H2,C2,Q2,R3

An uncut embroidery of bright blue silk with silk satin stitch and couched gold metallic threads. Twentieth century. 12" x 17".$175. H1,C1,Q3,R4

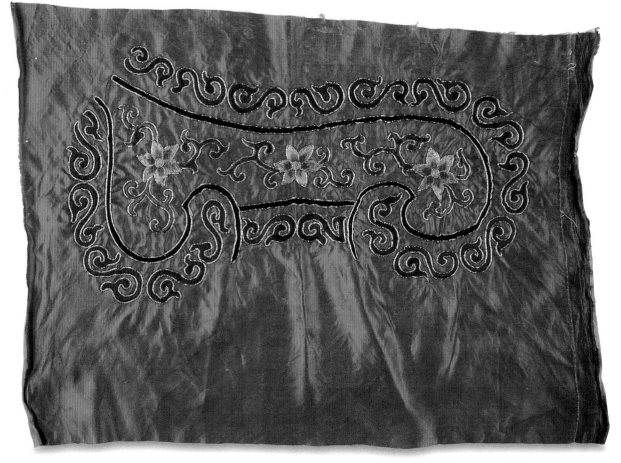

An uncut panel of embroidered robe trim. Note the later addition of the machine-embroidered monogram. This piece shows a full collar not usually seen in these panels. With the finished edges it was most likely used as a table cover. It is an interesting example of the reuse of a piece. Its basic value would be $200 because there are some parts missing and of its limited interest. Late nineteenth, early twentieth century. 27" x 30". H2,C3,Q3,R4

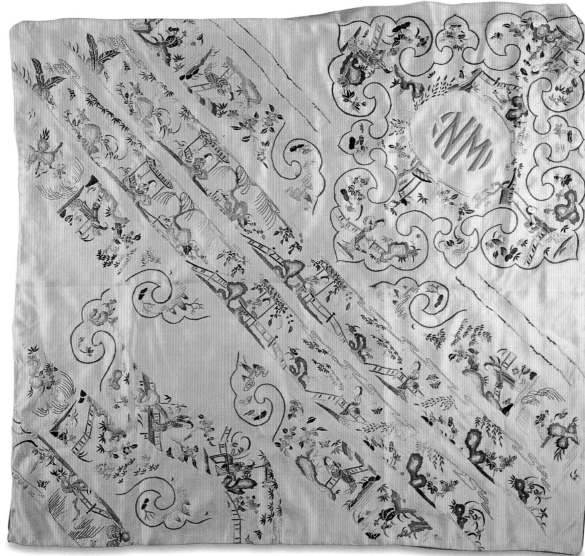

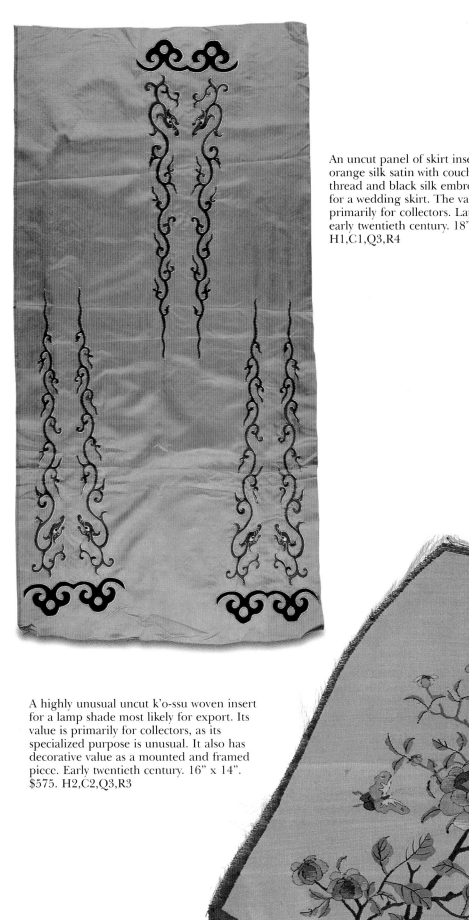

An uncut panel of skirt inserts of bright orange silk satin with couched gold metallic thread and black silk embroidery, most likely for a wedding skirt. The value here is primarily for collectors. Late nineteenth, early twentieth century. 18" x 36". $250. H1,C1,Q3,R4

A highly unusual uncut k'o-ssu woven insert for a lamp shade most likely for export. Its value is primarily for collectors, as its specialized purpose is unusual. It also has decorative value as a mounted and framed piece. Early twentieth century. 16" x 14". $575. H2,C2,Q3,R3

A single horseshoe cuff of good quality k'o-ssu. It is unused and in pristine condition. Circa 1880. 6" x 14". $500. H1,C1,Q1,R3

An uncut panel of brown silk satin embroidered with silk satin stitch and couched metallic gold threads. Water stained. Circa 1880. 16" x 27". $175. H2,C3,Q2,R3

A portion of a black silk uncut panel of trim for a Han-style jacket. It is finely executed in silk satin embroidery. Circa 1890. As is, $175; if complete with collar section and additional strips, $450. 15" x 39.5". H1,C1,Q3,R4

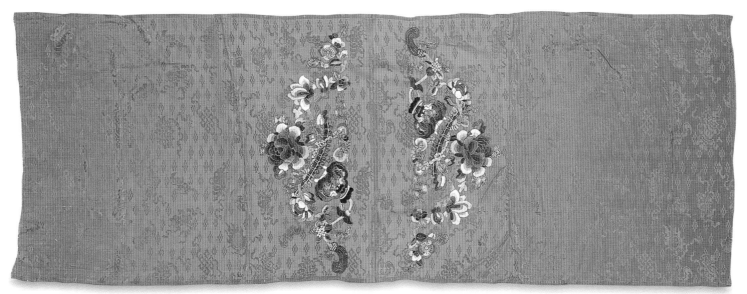

A fine blue-green silk brocade uncut panel embroidered with silk satin stitch
flowers, possibly for a pair of belt pouches. Circa 1900. 15.5" x 44". $175.
H1,C1,Q3,R4

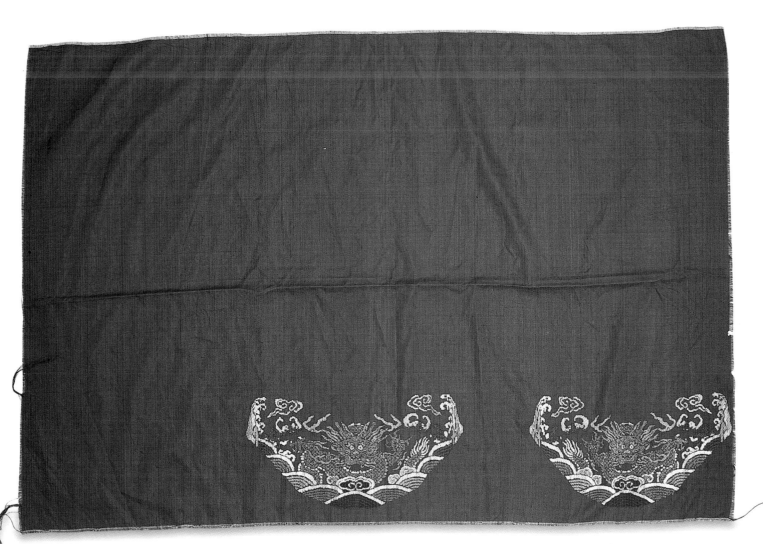

A pair of brocade uncut horseshoe cuffs for a dragon robe, woven
with enough fabric for sleeve inserts. Circa 1890. 28" x 42". $195.
H1,C1,Q1,R2

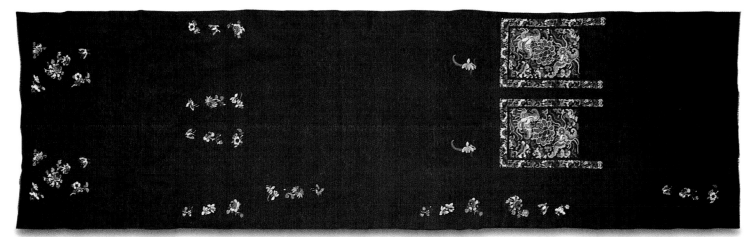

An unusual uncut skirt panel. It is one of three from the same collection. We are not aware of any others that have been available on the market and this is reflected in the price. Circa 1890. 30" x 102". $2000. H1,C1,Q2,R1

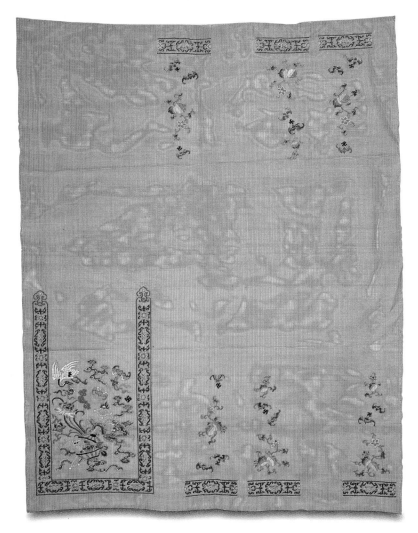

This is another unusual uncut skirt panel of exquisite quality. As an incomplete set with the panel shown below, they are in the range of $1500-$2000; if complete they would be more in the range of $2000-$3000 due to their rarity. Circa 1890. 30" x 38". H1,C1,Q2,R1

Second panel of above, 30" x 39".

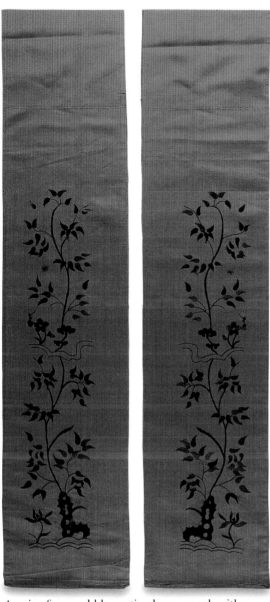

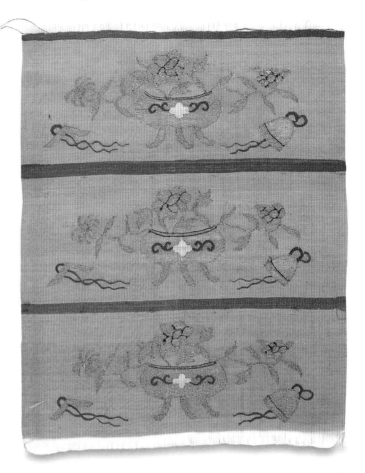

A pair of unused blue satin sleeve panels with black silk satin stitch. Circa 1890. 6" x 36" each. $195. H1,C1,Q3,R4

Four finely woven light blue silk and gold metallic k'o-ssu uncut purse panels, one separated from the other three. Circa 1890. 9.25" x 3.75" and 9.25" x 11.125". $200. H1,C1,Q2,R3

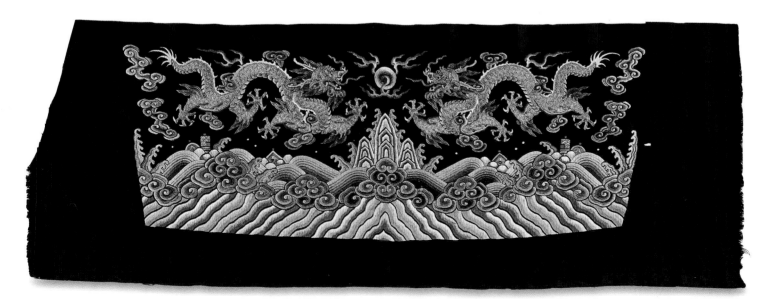

One of a pair of blue-black satin uncut upper sleeve bands from a consorts dragon robe. The embroidered colors include the imperial yellow and are done in silk satin stitch and gold metallic couched threads. They are in the style of the 1780s, but are more likely made in the 1880s. 27" x 9.5". $1275. H1,C1,Q2,R3

An uncut triangle purse or belt pouch embroidered with Peking stitch and couched peacock feathers and gold metallic thread. Circa 1890. 18.5" x 18". $275. H1,C2,Q3,R3

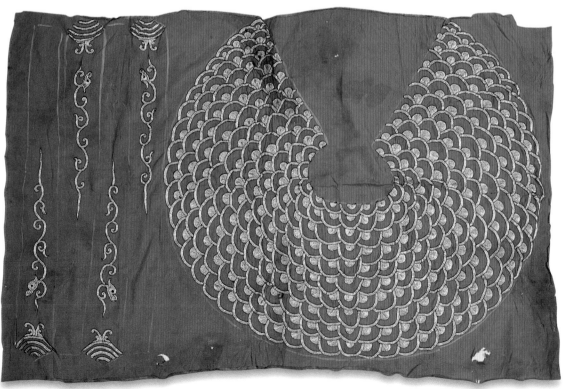

An uncut panel for a collar of couched gold metallic threads, forming a scallop pattern; together with robe or hat ties with embroidered stylized dragons. The oyster shell dust outlines from the workshop are still visible. Circa 1900. 43" x 28". $375. H2,C2,Q3,R4

Another uncut panel of robe trim for a lady's mandarin-style robe showing collar, neck bands, side trim for slits, shaped front band, and bottom bands. It is embroidered in silk satin stitch on white silk satin with couched cording and gold metallic wrapped thread. Circa 1900. 29" x 30". $275. H1,C1,Q3,R4

An uncut, unfinished pillow cover embroidered in silk needlepoint on silk gauze. 1890. 18.5" x 37.25. $750. H1,C1,Q1,R2

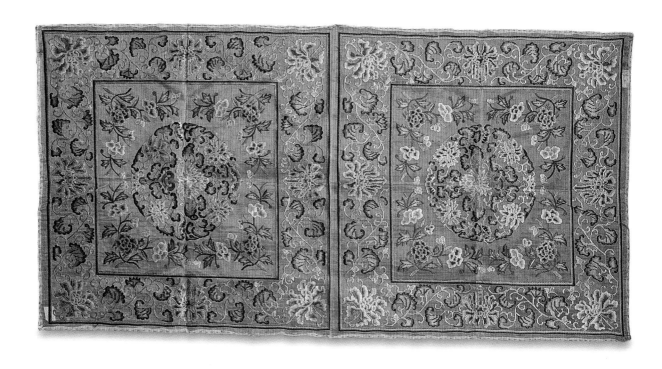

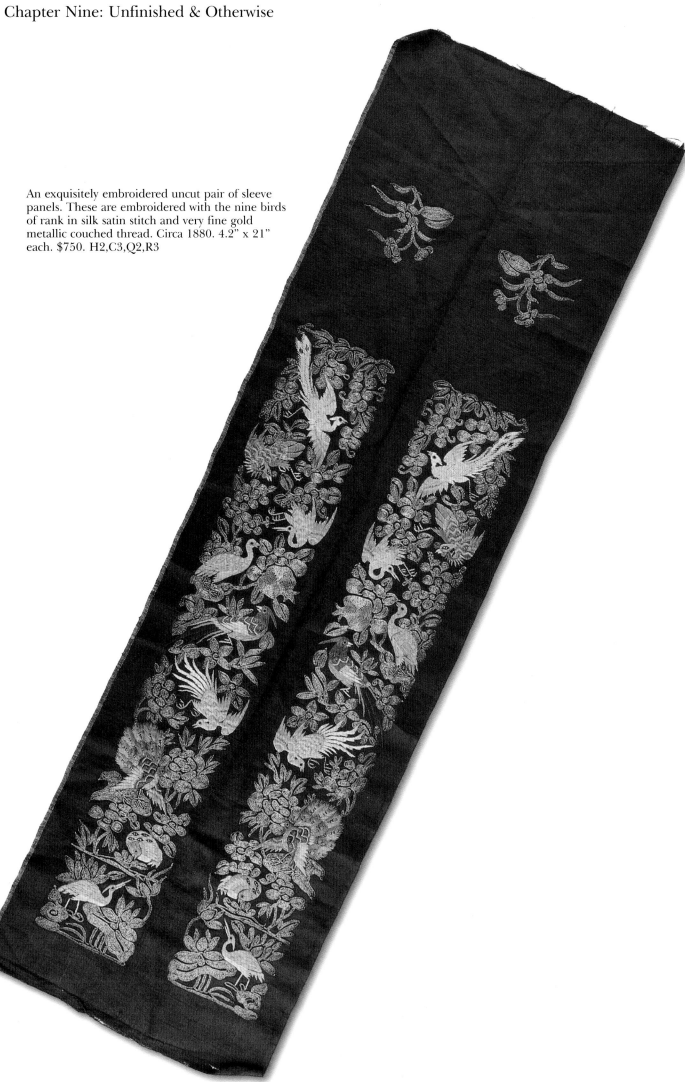

An exquisitely embroidered uncut pair of sleeve panels. These are embroidered with the nine birds of rank in silk satin stitch and very fine gold metallic couched thread. Circa 1880. 4.2" x 21" each. $750. H2,C3,Q2,R3

On Paper

These items were originally embroidered on cloth and affixed to paper backing and were sold by various workshops to be incorporated by cottage industry seamstresses into robes and other textiles. It is somewhat rare to find these in good shape and on original paper

A roundel of Peking stitch and couched gold threads on original paper backing. Circa 1870. 9" diameter. $100. H2,C2,Q3,R4

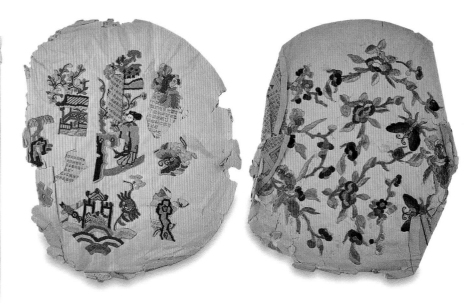

Two satin stitch embroideries on newspaper, one with figural images and one with floral images. Circa 1900. Approximately 9.5" x 12" each. $175 for the pair due to rarity, since few are affixed to Chinese newspaper. H2,C3,Q3,R4

A pair of exquisite unused sleeve bands embroidered on white silk satin with Peking stitch, satin stitch, couched gold metallic threads, and couched threads wrapped with peacock feathers, still on their original paper backing. Circa 1870. 3.75" x 19" each. $275. H2,C2,Q3,R4

Cross-stitch and brick stitch embroideries on paper, of longevity peach symbols with blossoms. The loss on the one is probably due to misuse as these are very fragile when removed from their backing. The boldness of color and design is one indicator of age. Chinese textiles at the end of the Ch'ing dynasty were made in haste with simpler designs and garish, bold colors, and an almost comical interpretation of images. Late nineteenth century. 10.75" x 4". $200. H2,C2,Q3,R4

A small pair of gold metal wrapped thread embroideries from another larger piece. They have been put on paper probably to protect the embroideries while waiting for reuse. Late nineteenth, early twentieth century. 3.25" x 3" each. $50.
H2,C2,Q3,R4

A section of trim embroidered with spun peacock feathers couched on silk with its original paper backing. Circa 1890. 29.5" x 38". $475.
H1,C1,Q3,R4

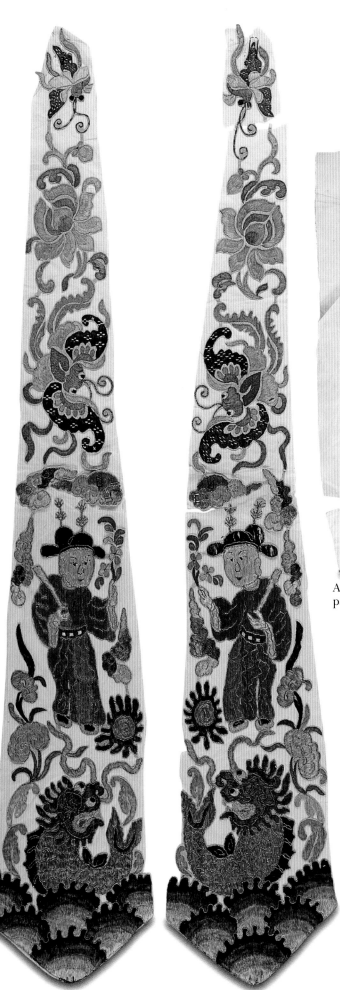

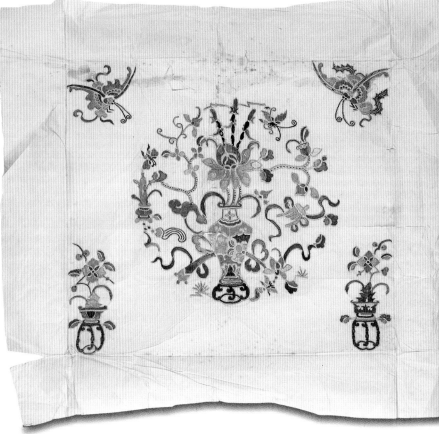

An early embroidery affixed to paper in very fragile condition, possibly for a panel or a table frontal. Circa 1855. 23.5" x 28". $275. H2,C2,Q2,R3

Embroideries on paper for tassels. Circa 1870. 4.75" X 25.5" each. $475 for the pair. H2,C3,Q3,R1

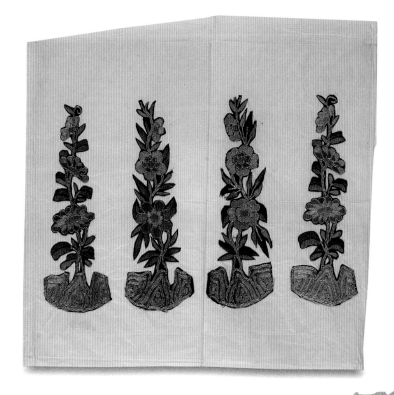

Embroideries on paper, possibly tassels for a robe or hat. These items have mainly collector value, but could be mounted as decorator pieces. Late nineteenth or early twentieth century. Approximately 2" x 6" each, 10" x 10" overall. $200. H2,C2,Q3,R4

A pair of embroidered roundels on paper for a robe. These are done in Peking stitch, wrapped peacock feather threads, and wrapped metallic threads. Second half of the nineteenth century. 7.25" diameter each. $250 due to condition. H2,C2,Q3,R4

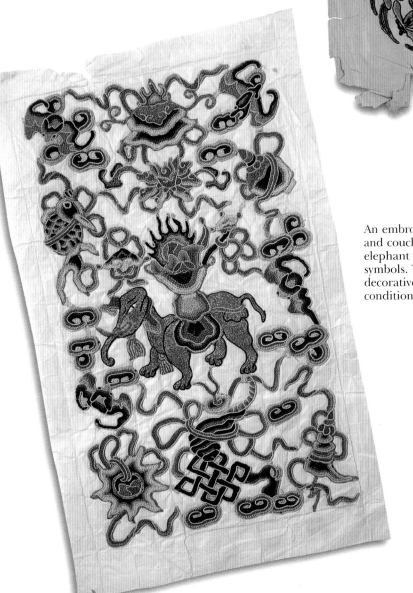

An embroidery on paper with Pekinese stitch and couched metallic gold thread, with an elephant and the eight Buddhist auspicious symbols. This was possibly for a small decorative panel. Circa 1890. $295. Excellent condition. H4,C4,Q2,R3

Remakes

Chinese textiles have always been considered items of value and silk, being a valuable and resilient substance, lent itself to continued use. It was a common practice to utilize fragments of earlier items such as robes and panels that may have been worn or otherwise damaged and repurpose them later into other pieces.

Lengths of cloth were given as tribute by the Chinese court to the peoples and monasteries of surrounding areas for their allegiance and services, and were commonly reused in non-designated manners.

Reuse through history was due to the quality and value of the pieces and it has continued even up to the present day. The more recent reuses are as decorative oddities or for the appreciation of the fine work and non-Western designs rather than as a need. We see fine Chinese textiles used in such diverse items as tray tops and lady's evening wear. Often these pieces, like a rank badges that is framed or made into a tray top, retain their original collector value by not being damaged during the reuse, but others are damaged beyond repair when they are cut up and restyled, such as the consort's robe that was made into a cocktail dress.

Many of these remakes came about with the opening of China to the Western world and the fascination of acquiring of things Oriental, but the practice continues even today with uses like pillow covers, purses, and other decorative items.

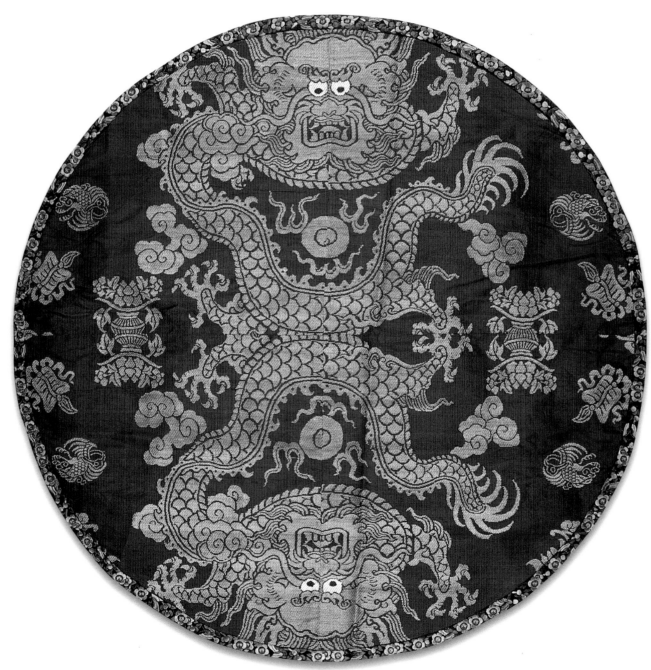

A pair of shoulder panels from an early style brocade-woven dragon robe made into a table cover. Circa 1890. 25" diameter. $225.
H1,C1,Q3,R4

A very nice pair of Peking knot sleeve bands that have been remade into a bolster cover with the addition of black silk satin. Value for the cut down sleeve bands alone would be $150. As incorporated into the bolster, $275. The sleeve bands circa 1890. The bolster cover circa 1910. 12" x 28". H2,C3,Q3,R4

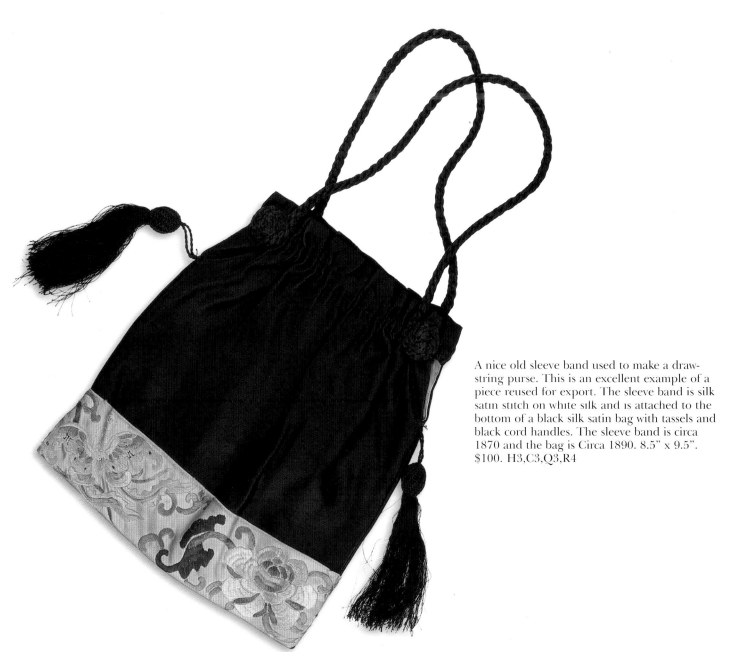

A nice old sleeve band used to make a drawstring purse. This is an excellent example of a piece reused for export. The sleeve band is silk satin stitch on white silk and is attached to the bottom of a black silk satin bag with tassels and black cord handles. The sleeve band is circa 1870 and the bag is Circa 1890. 8.5" x 9.5". $100. H3,C3,Q3,R4

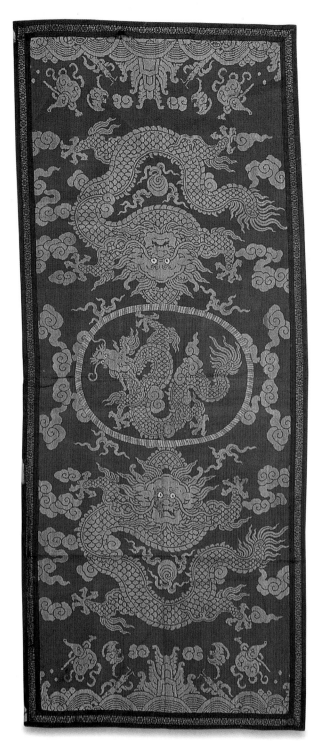

A table runner made from sections of a robe circa 1870 robe. It was most likely made up around 1900-1910 and consists of the front and back panels and the inner or ninth dragon of the robe. 45" x 20". $300. H2,C3,Q3,R4

A pillow or chair cover made from a roundel embroidered in Peking stitch. Circa 1850. The cushion of black silk satin was made later. 18" x 20". $150. H2,C3,Q3,R4

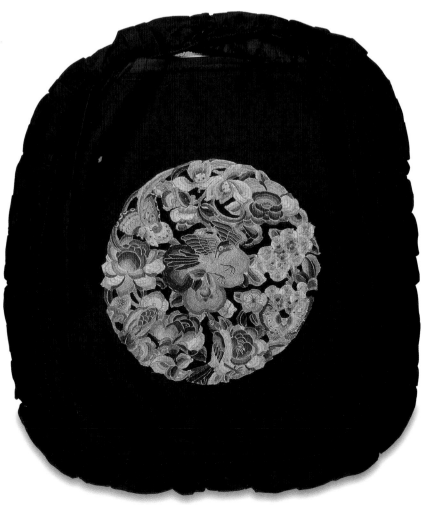

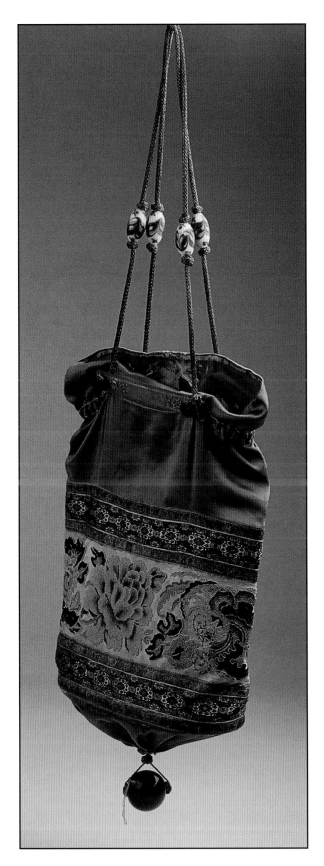

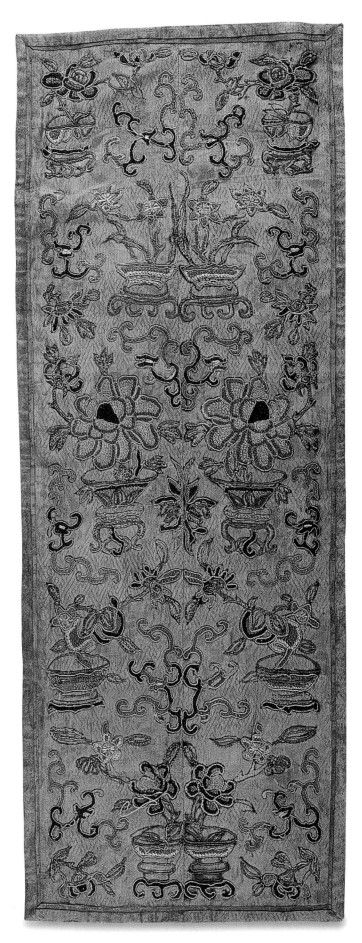

A "beggar's bag" made from a Peking stitched sleeve band, dusty rose silk and Venetian glass beads. The sleeve band is circa 1880 and the bag was made in the 1920s. 7.25" x 11". $295. H2,C3,Q3,R3

A pair of sleeve bands made into a panel. The bands are embroidered in Peking stitch and couched gold thread on a chartreuse silk background. The piece has some staining and may have been washed. Circa 1850. 12" x 26". $275. H3,C3,Q3,R4

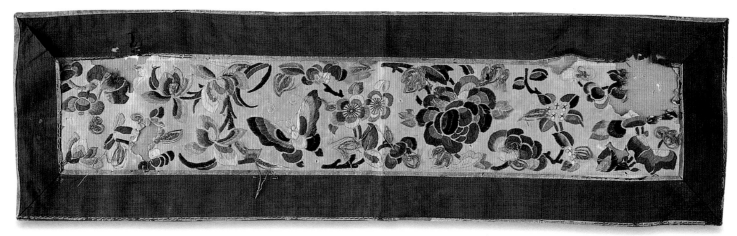

A band that was made into a panel and has suffered a great deal of staining and damage through the years to the point of pieces missing. This was value only as a study piece. Circa 1860. 4.5" x 20". H2,C5,Q3,R4

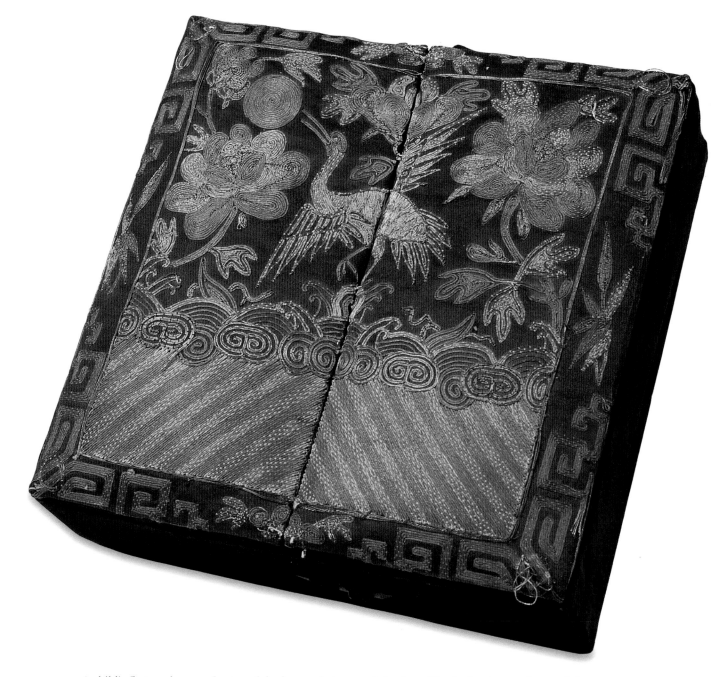

A child's first rank crane front rank badge made into a trinket box. The badge is complete and dates to 1890. The box is an aftermarket piece probably done in the 1920s or 1930s. 8.5" x 8.25" x 3". $450. The piece would actually have more value, around $650, if the badge were removed, restored and sold as a badge, however the cost of doing this would offset the difference. H3,C3,Q3,R3

What Not to Do with Chinese Textiles

Most higher quality antique Chinese textiles were made of very fine and resilient silk, but often the combined techniques of manufacture led to the breakdown of the threads in time. These techniques included the use of metallic foil wrapping over paper, which in turn was wound over silk thread, painted details, and even peacock feathers twisted into the thread and then woven or embroidered. In addition, some pieces were glued together. These exquisite assemblages often can be cleaned only with extreme care or not at all. Contact with water or other liquids will make the colors run, cause the structural paper to breakdown, and make the feather filaments disintegrate.

Light is also a great destroyer, as the earlier dyes were not light-fast and fading was common. Some pieces, drapes and throws for example, have been placed in areas where they have received extensive use or light damage. Other damages we have encountered are caused by old framing and mounting techniques that used backings and matting with acid-type board. Adhesives are another problem; some pieces were glued directly onto board or paper for framing and threads and fabric pieces being glued back together with whatever adhesive was at hand. And, of course, some pieces that were worn and used as table and cushion covers have permanent stains from spills.

Many textiles have been cut up for reuse. We have recently encountered a situation where a fairly unusual ch'i-fu was given to the owners over fifty years ago. Not knowing what they had, the piece was cut up and sections framed for a decorative use. In other situations people think nothing of using these beautiful and fragile fabrics for fashionable pillow covers, throws, and so forth.

Our work is not so much restoration as conservation. We strive to stabilize many of the pieces that are in poor condition in an attempt to keep the damage from getting worse. As in all types of conservation, some attempts are more successful than others.

Our guidelines regarding Chinese textiles, and any good textiles would be:
- Do not wash them
- Keep them away from anything that may stain or spill on them
- Keep them in subdued light
- Do not wear them
- Do not cut into them
- Do not attempt repairs without proper instruction
- Frame and mount the pieces with acid-free and museum approved materials and methods

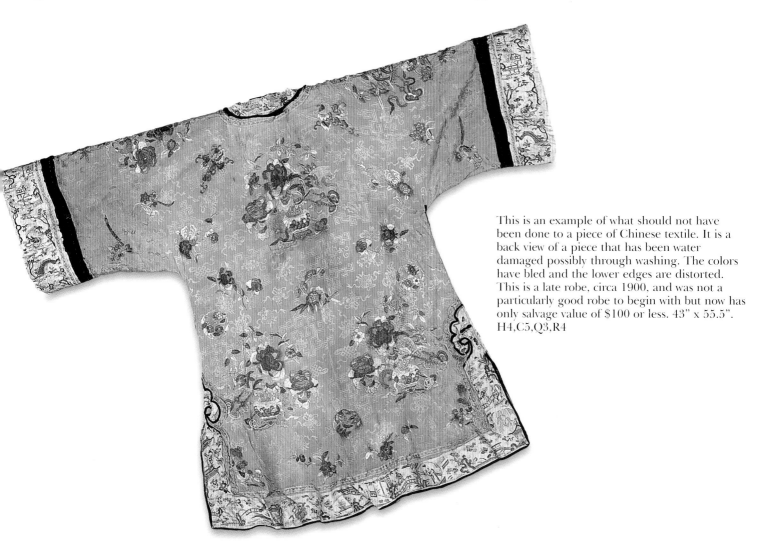

This is an example of what should not have been done to a piece of Chinese textile. It is a back view of a piece that has been water damaged possibly through washing. The colors have bled and the lower edges are distorted. This is a late robe, circa 1900, and was not a particularly good robe to begin with but now has only salvage value of $100 or less. 43" x 55.5". H4,C5,Q3,R4

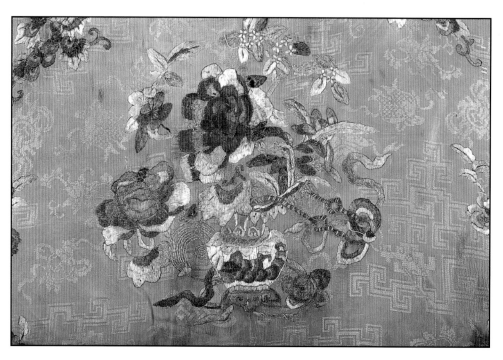

Detail of damage to robe on page 293.

Detail of damage to robe on page 293.

Detail of damage to robe on page 293.

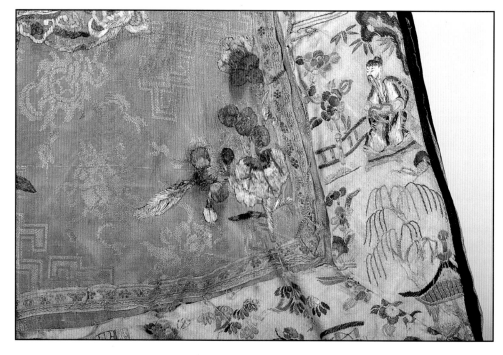

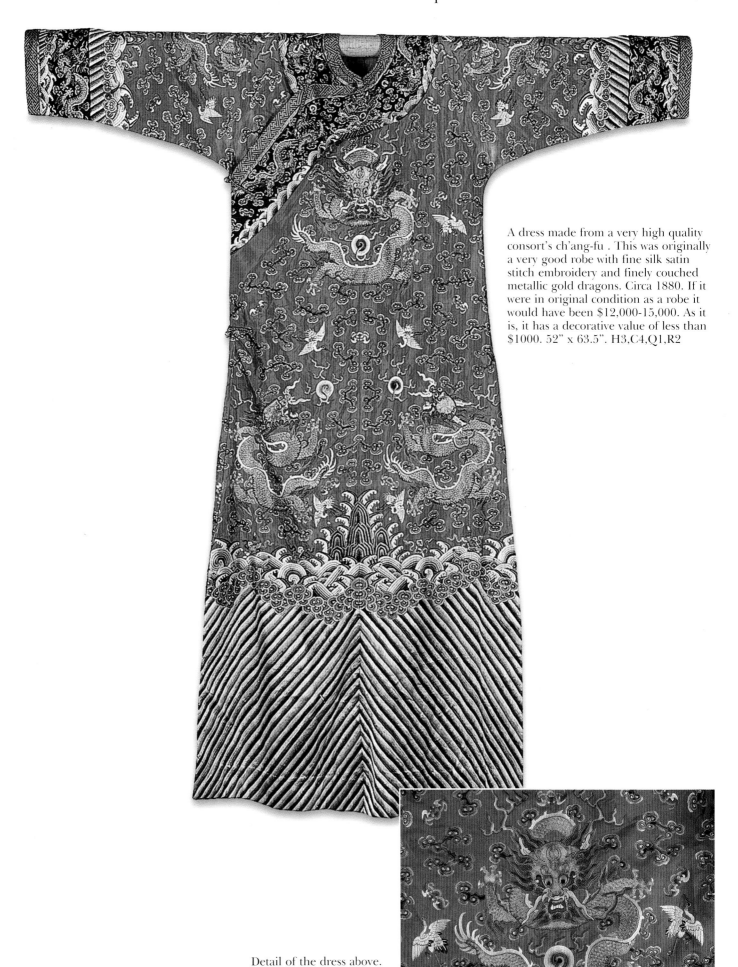

A dress made from a very high quality consort's ch'ang-fu . This was originally a very good robe with fine silk satin stitch embroidery and finely couched metallic gold dragons. Circa 1880. If it were in original condition as a robe it would have been $12,000-15,000. As it is, it has a decorative value of less than $1000. 52" x 63.5". H3,C4,Q1,R2

Detail of the dress above.

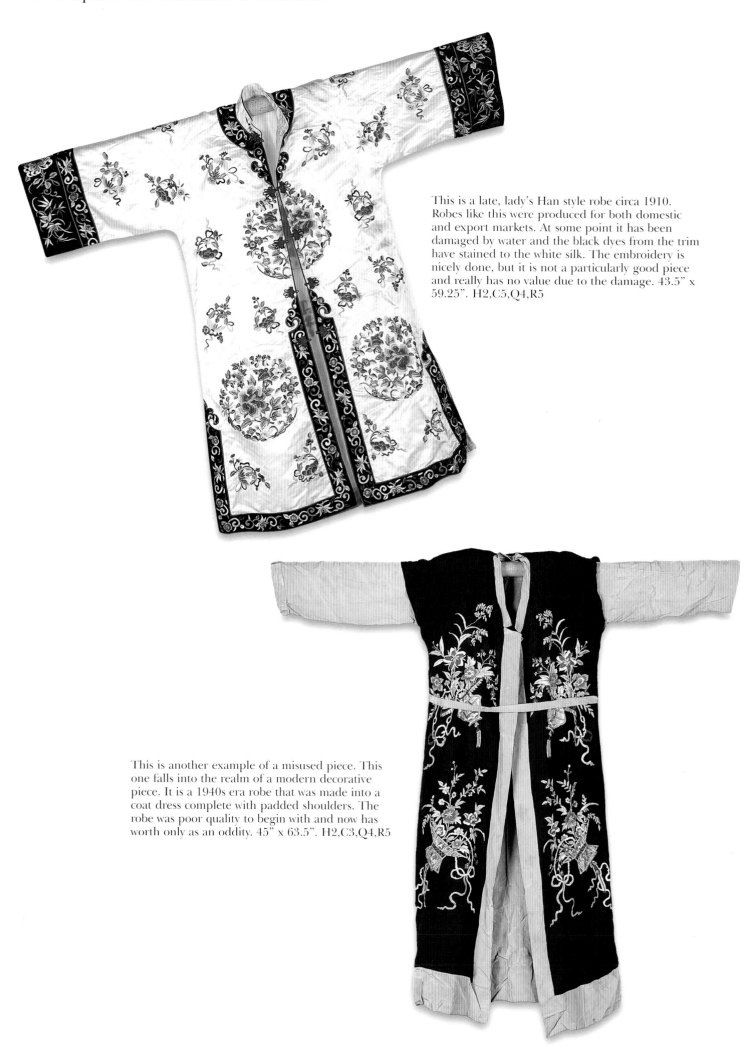

This is a late, lady's Han style robe circa 1910. Robes like this were produced for both domestic and export markets. At some point it has been damaged by water and the black dyes from the trim have stained to the white silk. The embroidery is nicely done, but it is not a particularly good piece and really has no value due to the damage. 43.5" x 59.25". H2,C5,Q4,R5

This is another example of a misused piece. This one falls into the realm of a modern decorative piece. It is a 1940s era robe that was made into a coat dress complete with padded shoulders. The robe was poor quality to begin with and now has worth only as an oddity. 45" x 63.5". H2,C3,Q4,R5

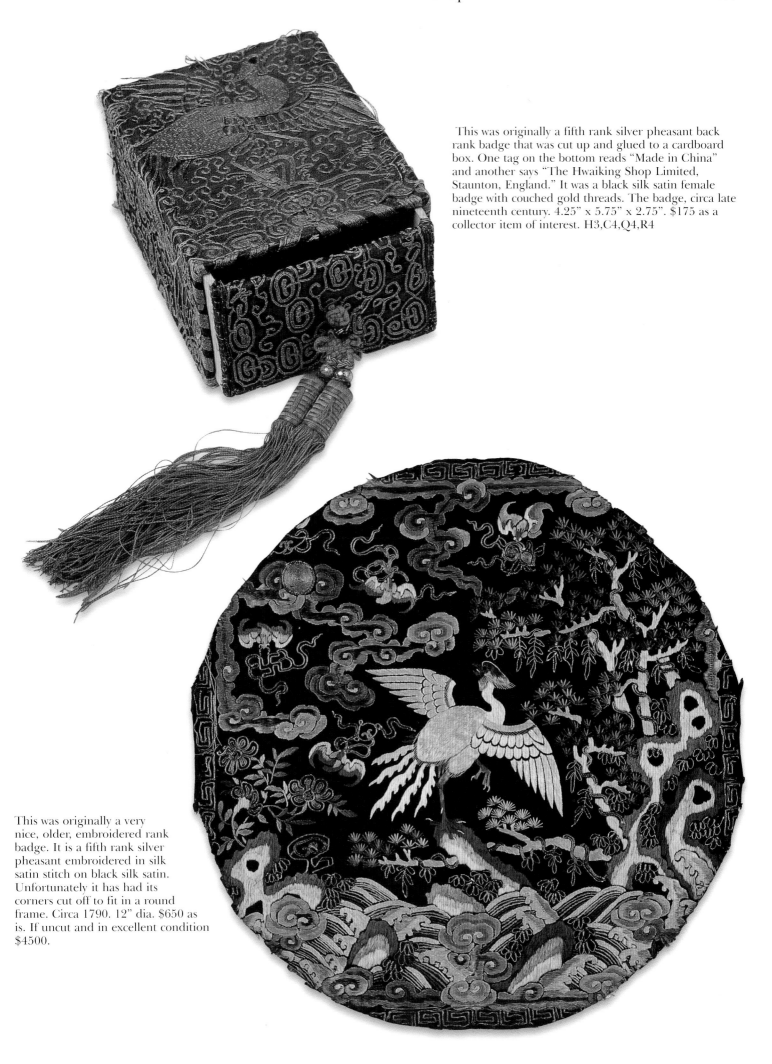

This was originally a fifth rank silver pheasant back rank badge that was cut up and glued to a cardboard box. One tag on the bottom reads "Made in China" and another says "The Hwaiking Shop Limited, Staunton, England." It was a black silk satin female badge with couched gold threads. The badge, circa late nineteenth century. 4.25" x 5.75" x 2.75". $175 as a collector item of interest. H3,C4,Q4,R4

This was originally a very nice, older, embroidered rank badge. It is a fifth rank silver pheasant embroidered in silk satin stitch on black silk satin. Unfortunately it has had its corners cut off to fit in a round frame. Circa 1790. 12" dia. $650 as is. If uncut and in excellent condition $4500.

Chapter 10
The Language of Textiles

There are many terms that are specific to textiles and the Chinese textiles discussed in this book follow a fairly prescribed format. The first consideration is, of course, the fabric itself.

Silk is the most common used in Chinese textiles. There were many garments and other items that would have been made of lesser and coarser fabrics, but due to wear they have not survived and are not considered collectible. Even silk fabrics vary in quality. Properly raised silk worms produced very fine and consistent threads, whereas poorly raised silkworms tended to produce poor quality thread and fabric. The finest sewing and embroidery threads were hand-spun and had a more uniform sheen and texture.

Other materials used include bast fibers such as **linen** and **ramie**. These were used mainly as backing and linings.

Metallic threads were made by pounding metal into fine leaf and twisting or winding it around a center core of thread or finely spun paper.

Weave Structures

K'o-ssu or kesi. This is a form of slit-woven tapestry. In weaving k'o-ssu the warp threads are very closely spaced and the colored weft threads are woven and then turn back and are woven in the opposite direction creating tiny slits where the colors meet and turn.

Brocade: The design is woven in by means of various colored supplementary weft threads as the weaving progresses. These extra threads are used only where required for the pattern and do not reach from salvage to salvage.

Damask: A weft or warp face reversible design woven into the textile. It can be solid and heavy, as when used for tablecloths etc., or extremely fine, as in lightweight delicate silks that are often used as a basis for embroidered clothing and decorative items.

Tabby or **plain weave:** The simplest of the weave structures with a simple over-under interlocking of threads that is balanced. It can range from heavy and coarse to something that has so little weight that it is hardly discernable in one's hand. Ex: China silk, Silk Habotai, etc.

Gauze: A fine open weave, usually using tabby or basket techniques, but occasionally with a pattern woven in.

Cut Velvet: A woven fabric utilizing supplementary warps to create rows of loops that are then cut into a pattern.

Satin: A broken twill weave structure consisting of five warp and five weft threads creating a smooth, usually glossy finish.

Surface Design

China has been famous for its beautiful embroidery and needlework for centuries. The following stitches are the most common, but there are countless variations of each used to create all manner of designs. These all have Chinese names which can be referenced in various other texts such as *Painting with a Needle* by Young Yang Chung. In this book we have used the Westernized names for ease of understanding.

Couching. An embroidery process where decorative threads, most notably metal-covered ones, are attached to the surface with a secondary thread that travels on the underside and is brought up to encircle the decorative thread and is brought back down through the surface layer this locking the decorative thread in place. The couching thread is often red to compliment the gold, but can be other colors especially when using silver threads to create variations. see page 113.

Satin Stitch. A stitch used to cover an area evenly and closely to create a smooth satin finish. Satin stitches usually are fairly short, unless they are couched down.

Brick Stitch. An evenly spaced stitch on gauze or other backing where the rows are staggered to resemble a brick wall.

Pekinese or **Holding Loop Stitch**. A form of embroidery where two threads are used, one to create a back stitch and the other stitched on the surface through the back stitch to create a curly-cue appearance.

Long and Short Stitch. This is somewhat like a combination of the brick stitch and the satin stitch, and is generally used to create gradations of color in a motif and is, as stated, a long stitch and a short stitch repeated.

Peking or **"Forbidden" Stitch.** This is also known as the seed stitch or the French knot. It consists of bringing the thread up from the bottom, tightly wrapping it around the needle three or four times and while holding the thread taut, inserting the needle back into the fabric right next to where it was brought up and drawing the thread through the wrappings.

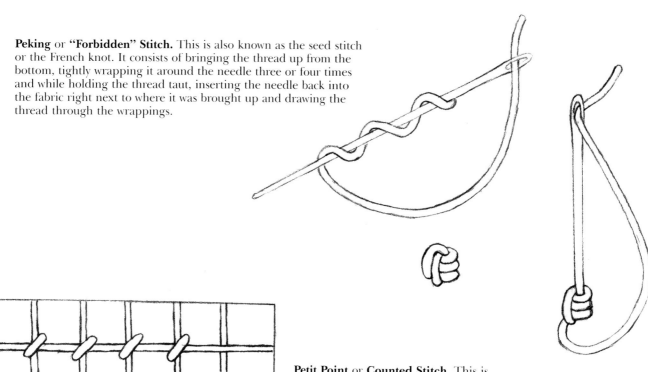

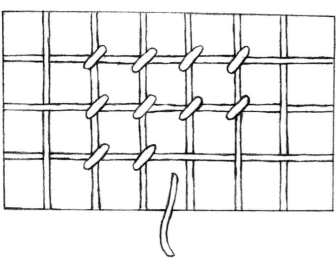

Petit Point or **Counted Stitch**. This is worked on a fine open-weave background in the same manner as the Western Gobelin needlepoint stitch only much finer.

Needle Weaving. This is most commonly used in the edging of belt hangings and pouches. Threads were sewn through the edge of the fabric to create parallel warps and the pattern is created by passing a needle and thread through the warps in a specific order.

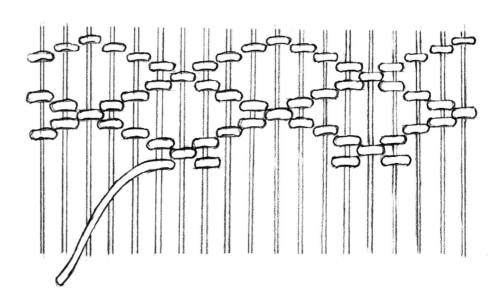

Stem Stitch. An overlapping backstitch used to outline other embroidered areas.

Split or **Mat Stitch**. Another outline stitch created that uses the same technique as the overlapping backstitch only bringing the needle up through the embroidery thread to create the "split." This is also used to cover large areas such as # 03-**03** [[**insert page number**]]].

Padded Stitch. This was used to create a three-dimensional effect in an embroidery. A wadding of silk batting was stitched down to the fabric in the shape of the motif, then satin or other stitches were worked over it to create a three-dimensional embroidery. It is seen in such diverse motifs as flowers and dragons.

Trims

Trims of many types were used as edgings on all types of Chinese textiles. Their main objective was to protect the precious silks and needlework from excessive wear, while adding decoration. Trims could be easily changed as needed without damaging the original piece. The following are some of the more common trim types:

Bias Silk: Usually satin or plain weave yardage cut on the bias and stitched on. This type of silk was also rolled into "snakes" to create the loops for the button and loop closures.

Woven Metallic: An edging of flat metallic threads woven with a fine silk warp to create an appearance of a sheet of metal. It was used on both clothing and decorative pieces. See page 58.

Embroidered: This is often used on skirts, jackets, panels, etc. It is usually a bias silk strip and embroidered with flowers, birds, bats, butterflies, and other motifs that enhance the textile it was used with.

Woven Non Metallic: There are many trims that fall into this category. The two most commonly seen are the complex weave structure, done on draw looms or Jacquard type looms and used for the court robes and elaborate hangings, and "Tea Trade" or tape woven trims. "Tea Trade" was a term used by European traders who came to China, because tea was an important Chinese export. Some were woven in Europe, but others were made in China. These were used on all manner of textiles and often in conjunction with embroidered trims.

Bibliography

Cammann, Schuyler. *China's Dragon Robes*. Chicago, IL: Art Media Resources LTD, republication of 1952 edition.

Chung, Young Y. *The Art of Oriental Embroidery*. New York, New York: Charles Scribner's Sons, 1979.

_____. *Painting with a Needle*. New York, New York: Harry N. Abrams, Inc., 2002.

Dickinson, Gary and Linda Wrigglesworth. *Imperial Wardrobe*. London, England: Bamboo Publishing Ltd, 1990.

Hironobu, Professor Kohara, and Professor Doctor Erling von Mead, and Shan Guoqing, and Doctor Ellen. Uitzinger *De Verboden Stad, The Forbidden City*. Rotterdam, Amsterdam: Museum Boymans-van Beuningen Rotterdam, 1990.

Hong Kong Museum of Art, *Heaven's Embroidered Cloths, One Thousand Years of Chinese Textiles*. Hong Kong: Urban Council of Hong Kong, 1995.

Jacobsen, Robert D. *Imperial Silks*. Minneapolis, Minnesota: Minneapolis Museum of Art, 2000.

Johnson, Beverly and David Hugus, Ph. D. *Ladder to the Clouds, Intrigue and Traditions in Chinese Rank*. Berkley, California: Ten Speed Press, 1999.

National Museum of History. *Chinese Costumes, Brocade, Embroidery*. Republic of China, 1977.

Thorp, Robert L. *Son of Heaven*. Seattle, WA: Son of Heaven Press, 1988.

Vollmer, John E. *Decoding Dragons: Status Garments in Ch'ing Dynasty China*. Eugene, Oregon: University of Oregon Museum of Art, 1983

_____. *In the Presence of the Dragon Throne*. Toronto, Canada: Royal Ontario Museum, 1977.

_____E. *Ruling from the Dragon Throne*. Berkley, California: Ten Speed Press, 2002.

_____. *Silks for Thrones and Alters*. Myrna Myers, 2003.

Watt, James C. Y. and Anne E. Wardwell. *When Silk was Gold: Central Asian and Chinese Textiles*. New York, New York: The Metropolitan Museum of Art, 1997.

Wilson, Verity. *Chinese Dress*. London, England: V & A Publications, 1986.

_____. *Chinese Textiles*. London, England: V & A Publications, 2005.

Index

Italicized page numbers refer to illustrations

US $79.95

9 780764 325380 57995

ISBN: 0-7643-2538-8